UNDER WESTERN SKIES

UNDER WESTERN SKIES

VISIONARY GARDENS *from the* ROCKY MOUNTAINS *to the* PACIFIC COAST

PHOTOGRAPHY *by* CAITLIN ATKINSON
WRITTEN *by* JENNIFER JEWELL

TIMBER PRESS
PORTLAND, OREGON

CONTENTS

Preface *7*

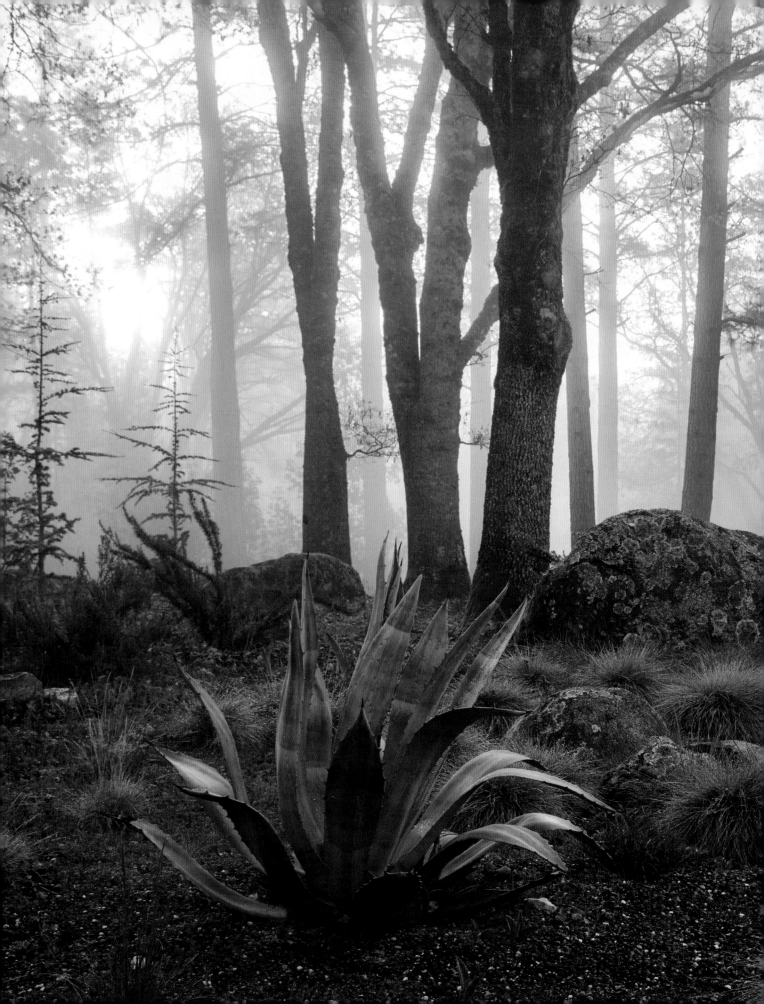

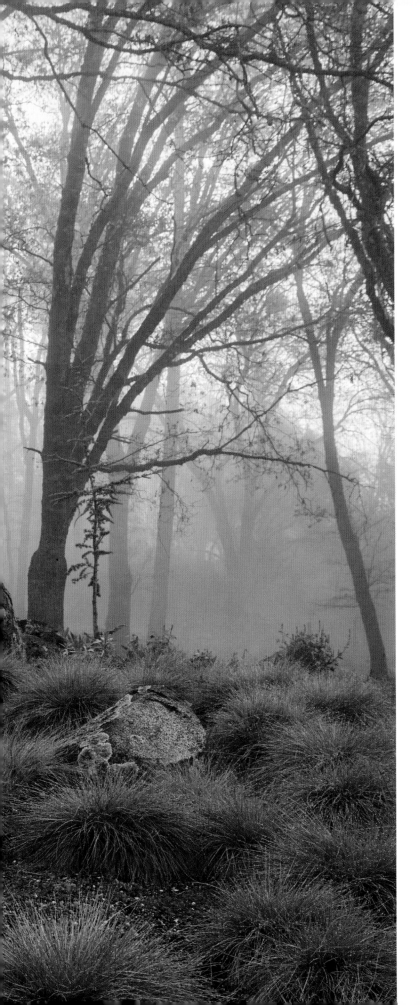

PREFACE

The seasons have shifted, the mad rush of spring and summer has come to an end. The quieting of plant life and shortening of days finds me finally at home. Home, a small old barn on the property where I grew up, the feeding trough now where I sleep, the milking room now the kitchen. Sitting at the dining table, my desk, I look out onto the granite rocks covered in moss and lichen jutting out of a sea of blue fescue. Outside, the ponderosa pines whirl above and the sweet smell of California black oak leaves luscious with the first rain of the season fills the air. I am in love with this land, connected to the very soul of the place in which I find myself.

I feel this same alliance to place through-out the American West—vast and awe-inspiring, filled with forested mountains, lush valleys, arid plains, rushing rivers, and a massive coastal shoreline. It is a land of aching beauty, built on dreams and myth. The West continues to enchant, but with the opportunities and possibilities comes the reality of living with severe weather and natural disasters. Life in the West sits in balance with the natural world, easily tipped or toppled. It is not an easy place to garden, but there is nowhere else I would rather be.

The start of my own garden, a stretch of compacted soil along a dusty dirt road, is not perfect, but I work the red clay, move rocks one by one, and slowly seed fescue,

7

lupine, and penstemon. Gardening allows me to enjoy the last rays of sun on a stand of rusty red buckwheat, take in the smell of the meadow in the cool of a summer's morning, feel an oak's delicate new growth in spring, and savor the sounds of crickets and frogs on a warm night. Gardening is the act of being fully present, accepting continual change, and looking to the future with excitement and optimism. Transformed by plow, cow, and man for years, this patch of dirt I am working may take just as long to turn into a garden, but I am caring for the land and cultivating a relationship with the environment around me. Little by little I change the soil as it changes me.

When I conceived of this book, I wanted to capture this connection to the land. I wanted to share my love of the West. Not just the grand vistas and estates with epic views, but gardens and people throughout this amazing place. This book is about gardeners tending the earth and connecting to what surrounds them—in the suburban front yard, the small-town back lot, the hilltop estate, and the urban botanical garden. Above all, this book is an ode to gardening everywhere, a celebration of people engaging with the natural world around them and creating beauty and meaning in a place they call home.

—*Caitlin Atkinson*

In some ways, our gardens are oases against the wider world. They are ballast, steadying us, masking the chaos, disorder, and stress of daily life—especially in urbanized environments. Our gardens help us to forget the world. In other ways, though, our gardens bring the world to us and are directly inspired by the wider world's cultures, concerns, passions, and fashions.

The Indigenous peoples of North America are, and were historically, deliberate, conscientious, and judicious cultivators and managers of landscapes for food, utility, medicine, and ritualistic plants, as well as for water, fire, and game conservation. When Europeans first started gardening on this continent, the gesture was often one of control and an attempt to allay fears about survival in the face of so much wild. Thankfully, today many gardens of the American West fearlessly draw on the natural beauty of the physical places in which they exist and serve as oases for wild plants and animals, too. They highlight our commitment to the survival of these very wild things we have now come to love.

Sometimes gardeners do not set out with the primary intention to create an articulated relationship with natural beauty or to contribute to conservation, and yet their gardens naturally and organically tend this way, as if instinctually. For other gardeners, a sense of relationship to place is the core motivating force behind why they garden and defines every aspect of how they garden. For still others, a garden is the perfect crucible for signifying, holding, and even expanding on cultural meaning past and present.

To my mind and experience, most gardens are a three-part alchemy between the riches and constraints of the natural and/or cultural history of the place, the individual creativity and personality of the gardener, and the gardening culture in which both the garden and the gardener exist. Each garden is a tapestry woven of these threads, whether intentionally or subconsciously. In some gardens, the warp or weft might be the thicker or thinner strand, leading to a different final effect. But there is always some particular beauty and particular lesson to be absorbed in observing how any garden's twining, animating forces are weighted and harmoniously interwoven to be in dynamic and interdependent conversation with one another.

In interviewing the people behind these gardens, the first questions I had were these: What does the natural beauty of your region mean to you? What does it look like, smell like? What physical image comes to mind? The specifics, of course, create each story, but there were some strong universal, very Western themes. Vast. Dramatic. Open. Dry. Wild. Unexpected. Diverse. Mysterious. All of which can be intimidating in a good way—in a way that puts humans in appropriate perspective.

Of course, the West, like any other human-defined compartmentalization, cannot truly be just one thing. This region is constantly being shaped by dynamic processes of time, season, and circumstance. What it means to be a Western garden or a Western gardener is prismatic and shifting, even as I write.

For the purposes of this book, Caitlin has chosen to photograph and I to write about a selection of gardens and gardeners in each of the five most commonly defined subregions of the West: Southwest, Southern California, Northern California, Intermountain West, and Pacific Northwest. The subregions are presented in the order in which they come into bloom each spring and by the length of their overall growing season. Caitlin's photographs offer a window into what it means to garden and grow in the West, and I hope the narratives provide insight and encouragement for us all, wherever we might live and however the climate might present itself in our own region.

The West and its climatic realities, its rich and complex cultural history, and its unparalleled—its *truly magnificent*—natural beauty, have raised, tested, and transformed many a would-be gardener into a more astute, resilient, resourceful, respectful, and collaborative one out of sheer necessity. From the searing light and dry heat of desert plains to the almost unlimited growing possibilities of the damp, green Pacific Northwest coast to the biting wind and short seasons at alpine heights to its grand canyons, wild rivers, and heroic trees, the West and its gardens and gardeners have lessons for us all.

—*Jennifer Jewell*

SOUTH

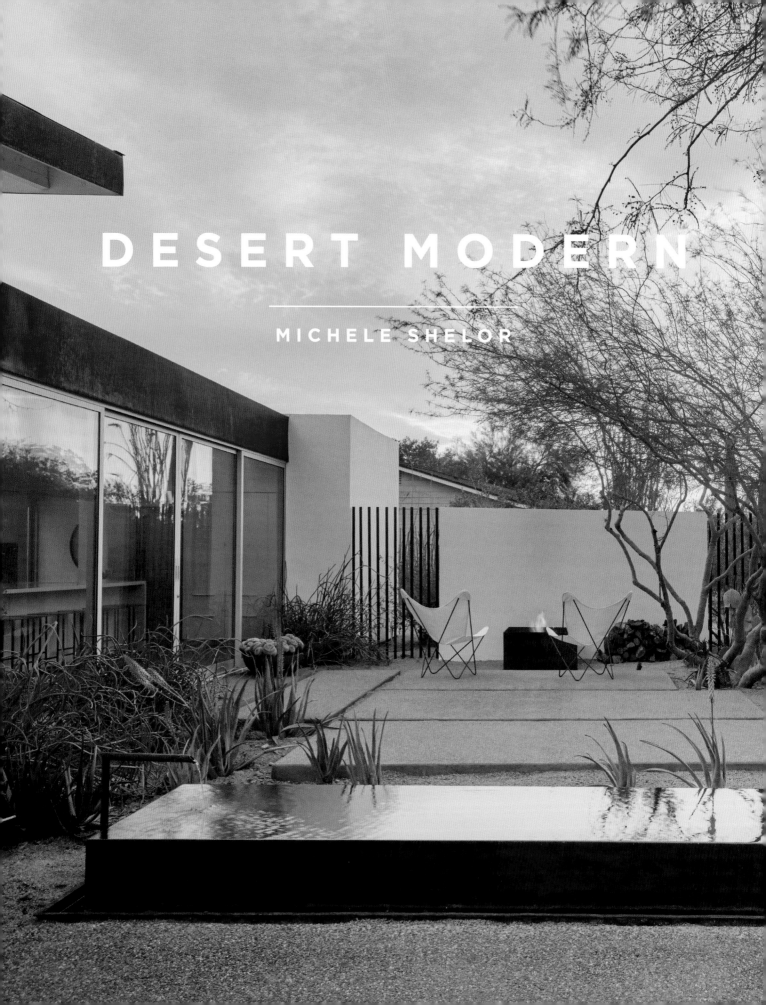

DESERT MODERN

MICHELE SHELOR

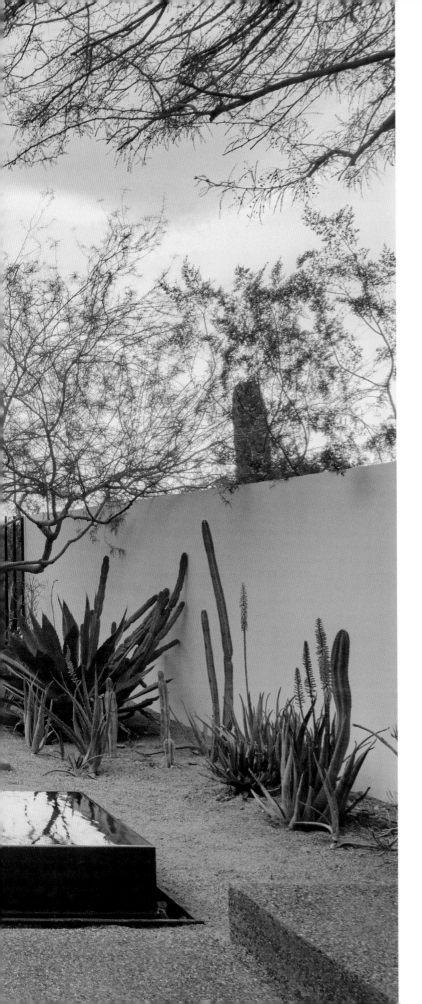

The Place

Phoenix, Arizona, is known for its mild winter, spring, and fall and its very hot summer, when temperatures can be over a hundred degrees for months at a time. It may come as a surprise, then, that this large capital city situated wholly in the Sonoran Desert can claim to be remarkable for its rainfall. The Sonoran is actually among the wettest of the world's deserts, receiving an average of 8 inches of precipitation annually. Summer heat is softened slightly by the onset of the monsoon season, which can bring (sometimes huge) thunderstorms from July through September. June is the driest month of the year, with an average of just 0.02 inches of rain, and July is the wettest, with 1.05 inches. Covering most of southwestern Arizona, northwestern Mexico, and southeastern California, the challenging landscape of the Sonoran Desert is characterized by an enormous diversity of plants, with more than 560 species.

The Person

"I wouldn't live anywhere else in the world," Michele Shelor says. "The desert offers a stark beauty, an almost sacred sense of solitude. In late winter and spring or after the monsoons come in summer, there's this bonanza of color from palo verde to the brittlebush blooming into a sea of yellow. But the real thing for me is the starkness. A lot of people just see dirt and rock, but I see beauty."

Michele lived for a while in Guadalajara, Mexico, where she was impressed by the feel of houses designed around intimate and beautiful enclosed courtyards. She also fell in love with their white walls, saying "There's nothing more beautiful to me than the starkness of the desert and the way shadows are cast on the white walls. It has spiritual connotations recalling Spanish missions like San Xavier del Bac in Tucson." Neutral backdrops also recall how bleached desert sand calls into relief silvery-foliaged plants. "There's a rich reflective quality of sunlight on a white wall, how it throws textural shadows of the herbaceous plants moving over it, gives a sculptural quality to cacti in front of it, even in how a water feature's dappled light plays against it," she muses. White walls also allow plants' forms to "become very architectural."

Michele spent her childhood summers on her grandparents' farm in western Kansas. She remarks on how that "is also a simple, spare landscape—stark in its own way. And one which I have come to love as beautiful, looking back on it. There's a similar loneliness in the desert that's very appealing to me."

Her father started an architecture firm in Phoenix in the late 1970s. Michele graduated from Arizona State University with a degree in history and political science and was working on becoming a teacher when she intuited she was not on her right path. While deciding what to do, she took a landscape design class at the local community college with local garden designer and native flora specialist Carrie Nimmer, who eventually said to her, "You should be a landscape architect. Let's go see Christy Ten Eyck."

Following an inspiring lunch with Christy and Carrie, Michele applied to a landscape architecture program. Having grown up with a modernist-architect father, design came naturally. She remains a lover of plants, but it is the making of space, the use of space, the architectural influence of landscape architecture that is of primary interest. "I'm interested in the spaces we can create outside—the landscape outside and how the plants become the beauty we use to fill in the corners of the spaces."

After working together at Steve Martino's office, Michele and Allison Colwell started their own design firm, Colwell Shelor Landscape Architecture, in 2009. Colwell Shelor is dedicated to "the creation of meaningful, vibrant environments that deeply

PREVIOUS PAGES: A thornless palo verde (*Parkinsonia praecox* 'AZT'), aloe, agave, and opuntia grace the inner courtyard of Michele Shelor's Phoenix garden. The open iron picket fence of Michele's design is an abstraction of the region's traditional ocotillo fences, allowing for small wildlife and air circulation as well as a sense of connection to the spaces beyond. Red pencil cactus (*Euphorbia tirucalli* 'Sticks on Fire'), Mexican fencepost cactus (*Marginatocereus marginatus*), and blue torch cactus (*Pilosocereus azureus*) run along the length of the wall on the right.

→ In the courtyard, desert-adapted plants lead the eye to the red sandstone hilltops beyond. Columnar San Pedro cactus (*Trichocereus pachanoi*) mimics the picket fence line. The minimalistic presentation of golden barrel cacti (*Echinocactus grusonii*) and nonnative yellow aloe vera (*Aloe barbadensis*) highlight the drama of their colors and textures. An Argentine giant (*Echinopsis candicans*) is featured in the white pot.

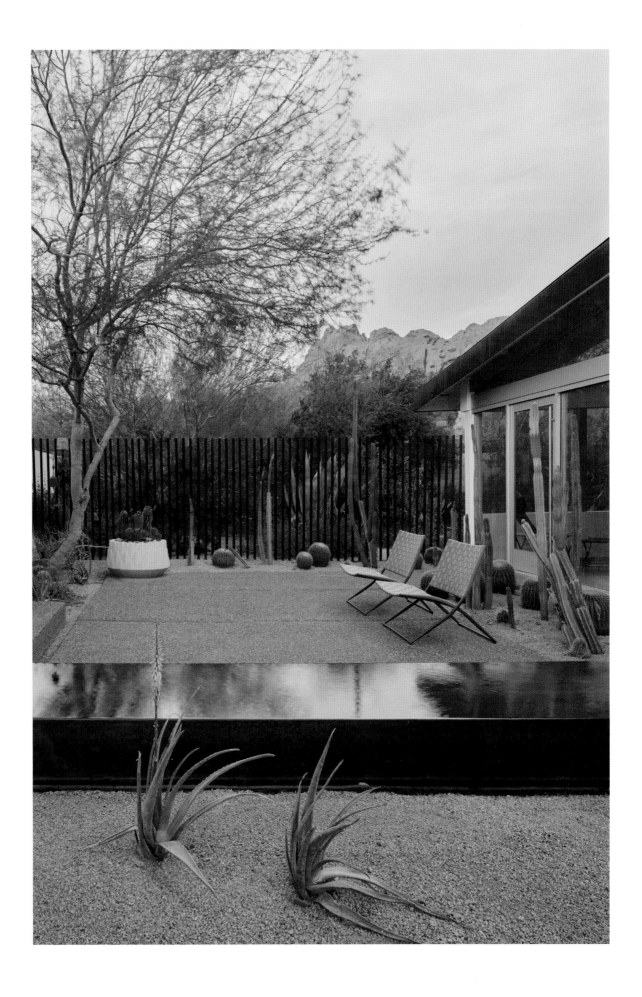

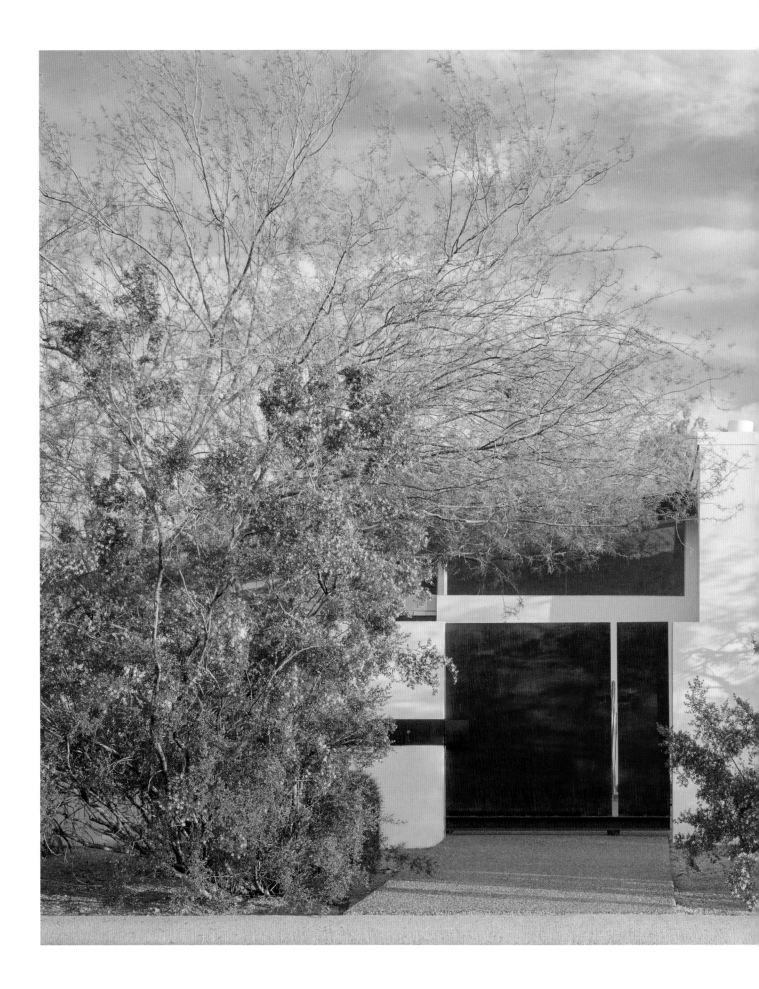

← White stucco walls and earth-tone doors are modernist references to the region's traditional architecture. Outside the front courtyard, Michele has planted only Sonoran Desert natives. A palo verde (*Parkinsonia aculeata*) drapes the entrance gate, and creosote bush (*Larrea tridentata*), *Agave americana*, and dinner plate prickly pear (*Opuntia robusta*) are among the plantings against the wall.

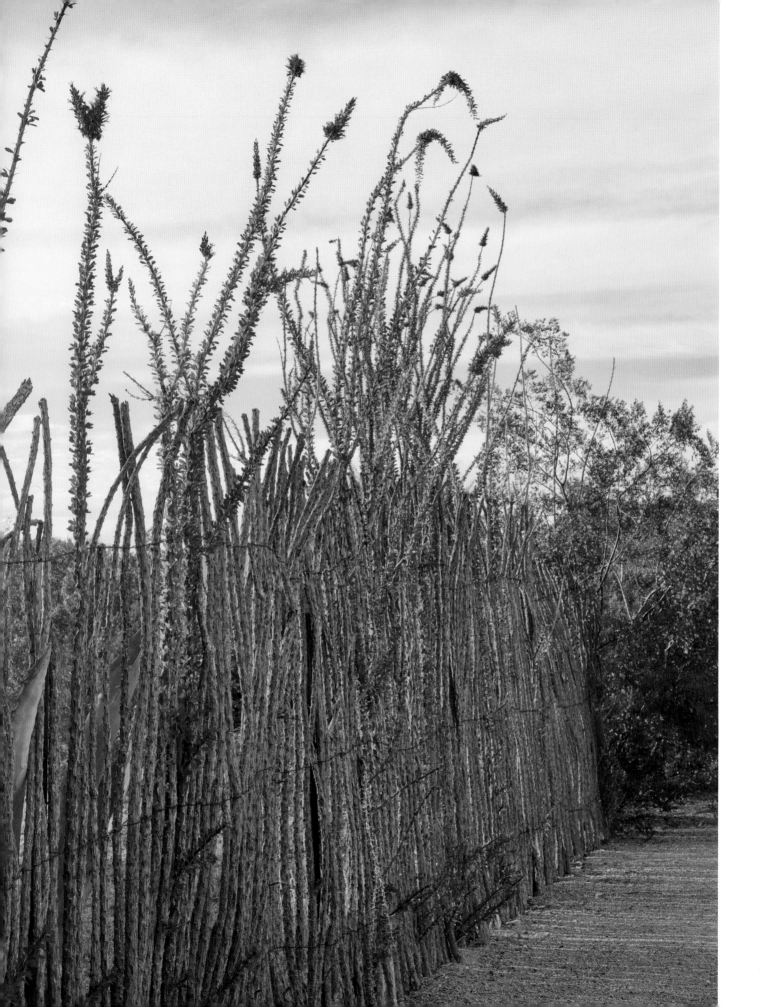

reference the cultural and ecological requisites of each site." They aim to "reach beyond sustainability to create living communities that are poetic and enduring, enhance livability, and provide ecological benefits to all."

The Plants

Michele and her husband, Philip Weddle, collaborate on both house and garden. "We decided early in our life together, especially after traveling, that we wanted a garden that was nothing but green. A symphony of different shades of green contrasting against white stucco walls," Michele says. Texture is also important to her. "Textures are really fine in the desert, and I'm very attracted to fine, thin lines, so there's something beautiful about the forms of desert plants in their distinctive spaces."

Michele's home garden is just over half an acre and faces a busy street. "We bought this midcentury modern house in 2008 and did a kitchen addition. Then we decided to create a walled front garden for a private inner sanctum space for ourselves and for entertaining." The carefully designed, small front courtyard garden epitomizes what Michele loves most: distinctive spaces with stark simplicity. Today, it is fully articulated with clean, sharp lines and native cacti and other plants of the Sonoran Desert and other arid regions. The garden is modern and yet timeless.

The Sonoran Desert is in fact quite colorful, but the desert as concept is muted in overall color tones. "I wanted the street frontage to feel like native desert, but as soon as you enter into the courtyard to see lush shades of green from different arid regions around the world. When we arrived, it was very much a creosote flat. I added the barrel cactus and some of the prickly pear." Several hybrid palo verde trees provide shade and privacy from the street and alley.

Michele respects the age-old philosophy that you design according to the constraints and gifts of your region as well as your own time capacity. "I need a landscape and garden that doesn't need much tending to survive and be happy. I'm not one who wants to be working in my garden all the time. I like to be in it, to view it, to look through my windows and see a serene and beautiful space."

The whole garden is on drip irrigation, and they use no fertilizer or other amendments. "These are climate-adapted, tough cacti and succulents," she remarks with some awe. To create privacy on the western side of the property, for example, they used ocotillo, a native Sonoran Desert shrub used by the region's Indigenous peoples for fencing and shade structures. Michele loved the idea of the house's straight lines being offset by an organic, light, airy fence that would shift in appearance through the seasons. "The ocotillo casts a gorgeous linear pattern across the gravel driveway,"

← Michele's take on a living ocotillo (*Fouquieria splendens*) fence. Only some receive irrigation to keep them green year-round. When the rains come in winter or the monsoon season, the entire fence leafs out.

she says. Along the fence there is drip every 10 feet. So, throughout the year parts of the fence are green and parts are brown—until the winter or monsoon rains arrive, when the whole fence leafs out.

Even when it is hot, the couple share dinner outside, enjoying the wildlife attracted to the garden and water. Michele says they see "quail, bunnies, thousands of hummingbirds, and butterflies. They are part of the life and drama of the space." The glass walls along the courtyard side of the house allow Michele and Philip to feel connected to the garden almost all day. Plants are uplit at night for extended shadow play and drama. "The form and subtle movement of the palo verde and agaves really come to life in a different way at night," she says. "Arizona has the best light, the best sunsets, and the courtyard is the best place to view them."

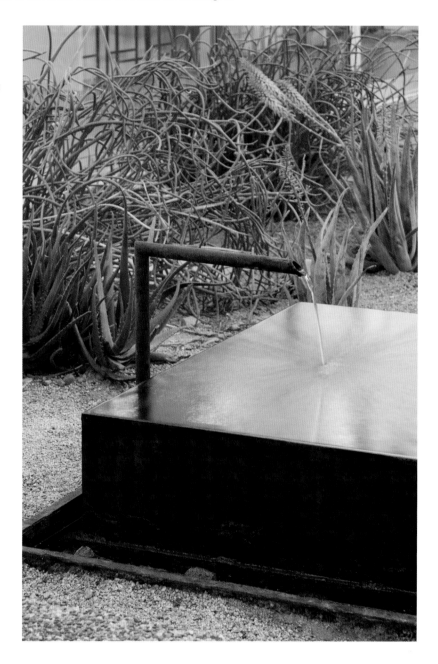

→ The rusted metal and clean lines of Michele's reflecting pool add soothing sound, movement, and a sense of oasis to the garden. The bright green playful twisting of the lady slipper plant (*Euphorbia lomelii*) near the water spout and succulent plant forms are in vibrant contrast.

→ **OPPOSITE:** A grouping of lady slipper plant (*Euphorbia lomelii*) and *Agave americana* grow inside the iron picket fence, with dinner plate prickly pear (*Opuntia robusta*) and *Agave* behind.

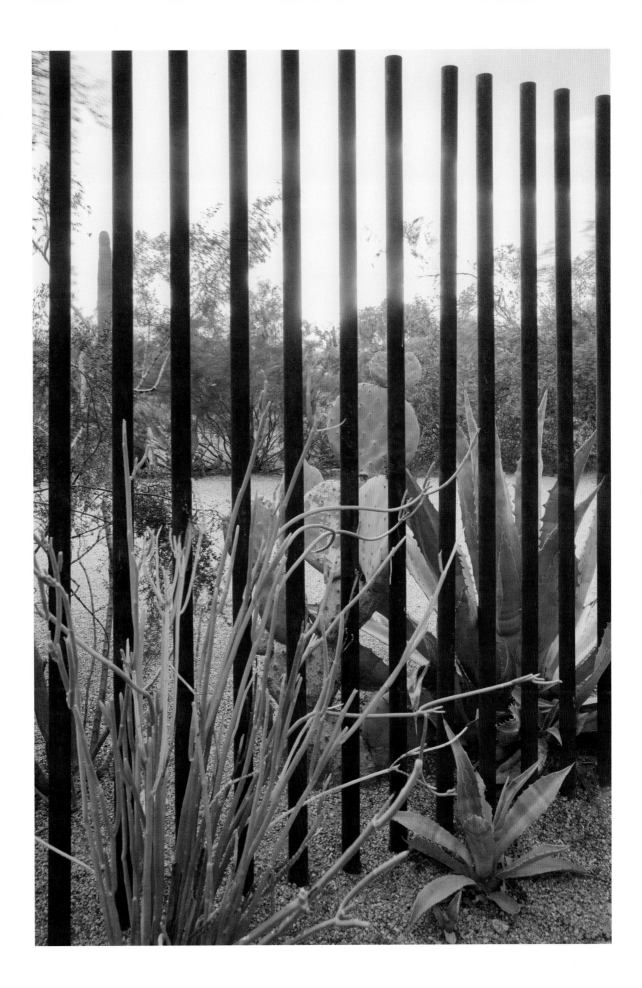

RANCHO ARROYO

VIRGINIA CAVE

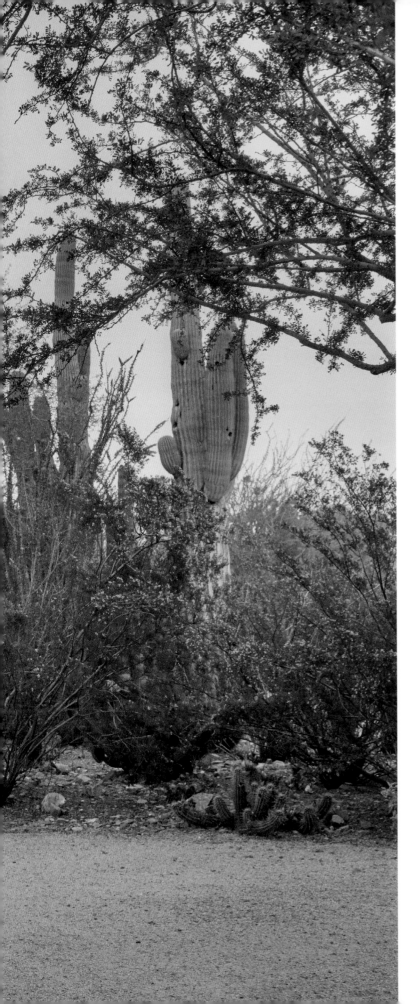

The Place

The Sonoran Desert bears a strong sense of the ephemeral. Persistent light, arid heat, fleeting rains of winter, and an often intense summer monsoon season result in quick, opportunistic greening of leaves and the colorful flash of blooms. An arroyo is an seasonal watercourse. It is a naturally formed, dry rocky bed most of the year, but it fills and runs quickly, sometimes violently, when rains arrive and over-whelm a sun-hardened watershed.

Rancho Arroyo is a circa 1926 adobe house and garden on the remaining acre of a former cattle ranch, which once straddled a long-established arroyo winding down from the slopes of nearby Piestewa Peak. As the fortunes of its original owners changed, parcels of the land were sold off until the property reached its current form—a long, deep, irregularly shaped lot. From the 1960s through the mid-1980s, renowned desert plant expert W. Hubert Earle, director of the Desert Botanical Garden from 1957 to 1976, owned Rancho Arroyo. He filled its garden with cacti and succulent specimens, prompting its listing on the National Register of Historic Places in 2003.

After Earle's death in 1984, the property changed hands several times. One group attempted to fashion it into a spa and then a Buddhist retreat center. It was in foreclosure and abandoned when Virginia Cave purchased the property in 2012. The water to the garden had been turned off for some time, so on her arrival there were exactly five living trees—three ironwoods and two very sad palo verdes—and seventy-five dead totem cacti, a few surviving saguaros, and "a lot of tattered prayer flags."

The Person

Born in England and raised in New York City, Virginia got serious about gardening as a young mother living first in New Hampshire and then in rural Vermont, where an old house, terraced stone walls, and fertile fields nurtured her real love of gardening. She went on to create and care for a garden on Sea Island, Georgia, and a penthouse terrace garden in Manhattan, before retiring to Phoenix in 2005.

Virginia is an antique and folk art dealer, and she found the history, artistry, and craftsmanship of Rancho Arroyo appealing. While she originally did try to re-create some semblance of Vermont or Georgia in the garden, she learned her lesson after heading out optimistically "with my little trowel and nearly breaking my wrist" by hitting the concrete-hard sedimentary caliche soil underlying many arid regions. She subsequently attended the Desert Botanical Garden's Desert Landscape School to learn about the plants native to her new place, how to choose and site them, how to grow and care for them.

Virginia does not view the desert's beauty as greater or lesser than that of the more temperate regions of her past. "It's different. You find substitutes for the plants you once loved but won't do here. For instance, I can't grow lilacs, but I can grow desert willow—they're both purple, they both bloom in spring, they both smell good. I can't grow hydrangeas, but I can grow *Cuphea*." She recently improved a section of the garden along her gravel drive by adding more flowering plants to the existing hedgehog cacti, including desert penstemon species and the desert orchid tree, *Bauhinia variegata*.

"Water—a symbol of money in Phoenix—and time are resources you have to be willing to choose to dedicate to cultivating a garden. Not everyone can, and not everyone is willing to make this choice even if they can. Some people lose themselves in books, cooking, or jigsaw puzzles. I love to lose myself in listening to the lovebirds roosting in the arroyo or in deadheading my winter pansies."

PREVIOUS PAGES: A lifelong gardener of English descent and transplant to Phoenix from the East Coast, Virginia Cave has fully embraced desert plants and created a lush and floriferous desert garden and cacti collection, including creosote bush (*Larrea tridentata*), boojum trees (*Fouquieria columnaris*), ocotillo (*Fouquieria splendens*), and many stately saguaro (*Carnegiea gigantea*) surrounding her historic adobe home.

→ **CLOCKWISE FROM TOP LEFT:** *Agave americana* in intimate conversation with wildflowers from a Southwest seed mix Virginia sowed around the property for additional herbaceous spring color.

Young totem cactus (*Pachycereus schotti*) and cardon cactus (*Pachycereus pringlei*) combine with yellow-blooming *Encelia*, with the setting sun glowing through an open ocotillo (*Fouquieria splendens*).

Rosa 'Lady Banks' drapes luxuriously over the fence, a rusty wagon wheel atmospherically positioned below. As a folk art collector and antique dealer for many years, Virginia likes both the form and function of found objects.

A healthy stand of purple prickly pear (*Opuntia macrocentra*) with its cheerful bright yellow blooms.

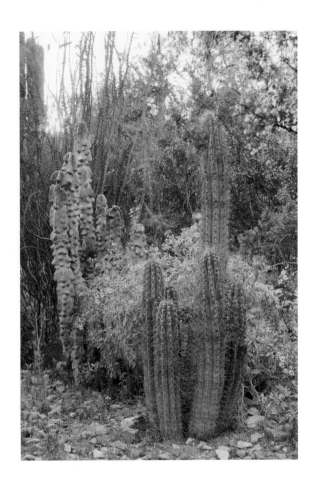

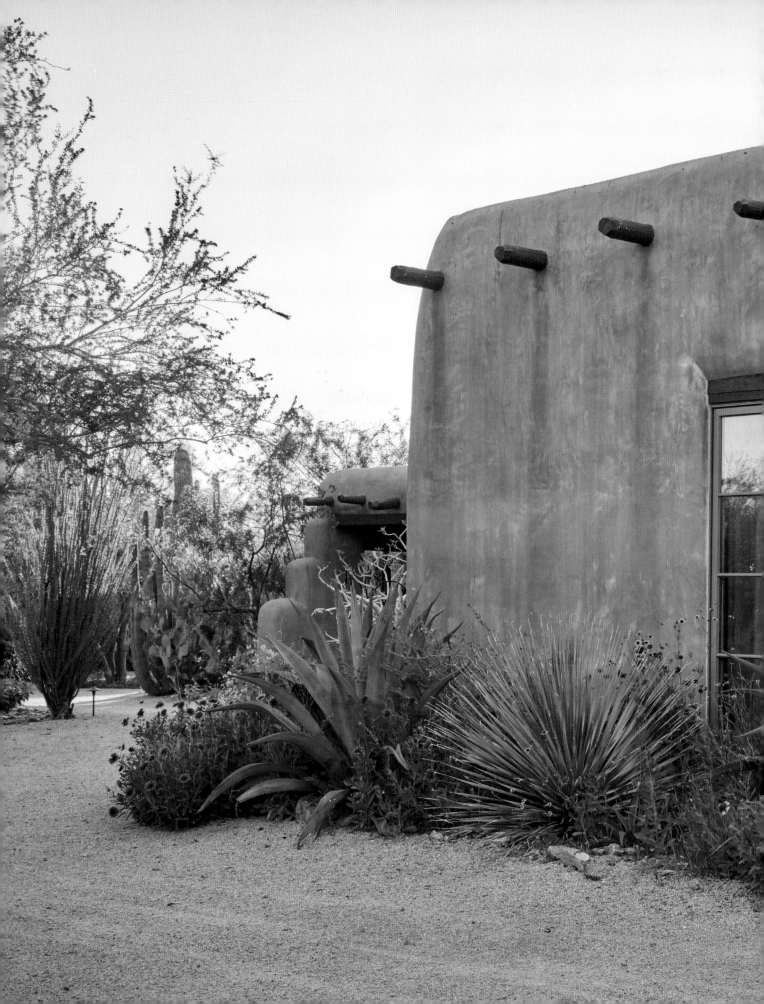

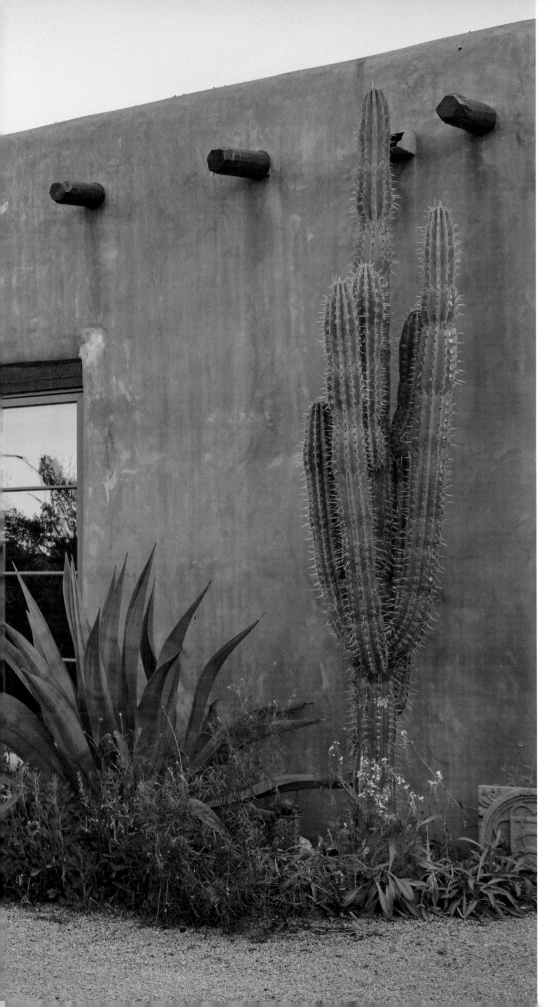

← *Pachycereus pecten-aboriginum* reminds Virginia "of an old Western movie scene with horse, rider, and cacti on a hill," so she placed it here near the house's front door as a good "opening statement." She softened the overall feel by underplanting the agave and yucca with softer herbaceous annuals and perennials like self-seeding coreopsis, clarkia, and blanket flowers (*Gaillardia*).

27

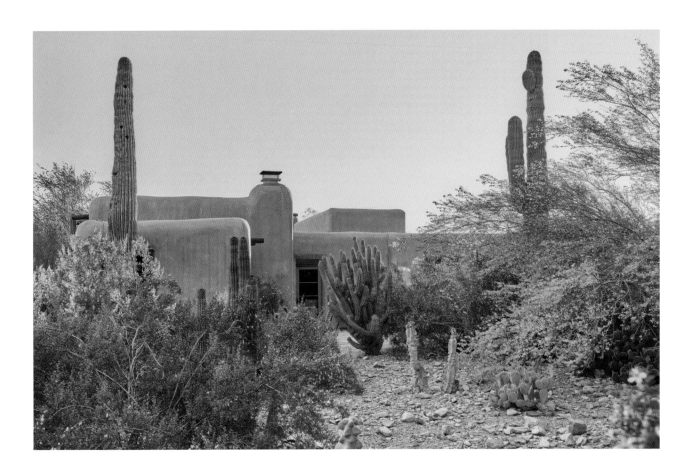

The Plants

The feel of driving into Rancho Arroyo is one of oasis, of trees and cacti sheltering and embracing the adobe buildings. The plantings screen the newer suburban development nearby, and the space feels large and secluded, inviting exploration and discovery of the cacti, desert ironwoods (*Olneya tesota*), mesquites (*Prosopis*), Arizona rosewood (*Vauquelinia californica*), and hopseed bushes (*Dodonaea*) lining the ocotillo fence lines, filling the view with life and form.

When Virginia began working in the garden at Rancho Arroyo, she paid close attention to what species had survived the loss of supplemental water. Although her preferred cacti are very drought tolerant, they still look best, as do the other plantings, with some supplemental irrigation throughout the year. In the beginning, she tried to only use plants native to the immediate region, but in time "made exceptions for love of plants from other desert environments." An airy grove of palo blanco trees (*Mariosousa willardiana*), which are native to the southeastern aspects of the Sonoran Desert in Mexico, remind her of white birch. The garden also features a boojum tree (*Fouquieria columnaris*), a native of Baja California. Although there is

↑ Blue palo verde (*Parkinsonia florida*) and creosote bush (*Larrea tridentata*) in yellow spring bloom brighten the more rigid structural cacti, including saguaro (*Carnegiea gigantea*) and totem cacti (*Pachycereus schotti*), growing along an arroyo-like garden path.

→ The property is named Rancho Arroyo for the historic natural arroyo that used to run from the nearby mountains through the original ranch. In tribute to that, Virginia had this recirculating arroyo constructed to wind diagonally through the back garden. Here it sparkles through a spiny ocotillo (*Fouquieria splendens*).

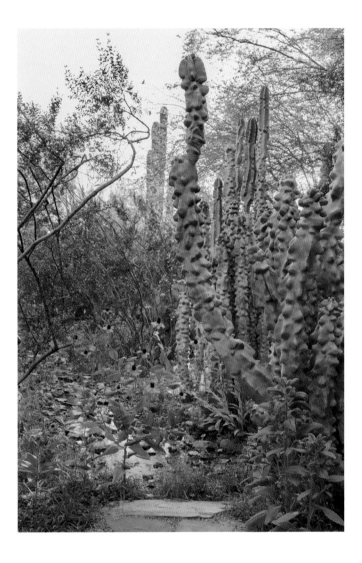

↑ A closely planted combination of saguaro (*Carnegiea gigantea*), totem cactus (*Pachycereus schotti*), and purple prickly pear (*Opuntia macrocentra*) are overlooked by a tall palo blanco tree (*Acacia willardiana*), a native of Sonora, Mexico. Virginia likes the old-fashioned cottage garden feel of the pink hollyhock and self-seeding sweet alyssum across the pathway from the cacti.

↑ Reminiscent of natural ephemeral creeks, the artificial arroyo adds a sense of oasis to the dry landscape and is a ribbon of green and colorful wildflowers in spring. Here it winds through totem cactus (*Pachycereus schotti*) and other dryland shrubs sprinkled with wildflowers like the yellow prairie coneflower (*Ratibida columnifera*).

a locally native pink fairy duster (*Calliandra eriophylla*), Virginia prefers red fairy duster (*Calliandra californica*), also native to Baja, because "it seems to attract the hummingbirds more than the pink."

Birds are another important element to the garden for her. "We have a flock of pigeons whom we call the Rockettes, which line up on the roofline," she says. "Some people hate them, but they don't bother me. They seem to get on with the little birds—cactus wrens, doves, quail, and many, many finches. When a hawk or owl comes into the ironwood trees, though, the whole garden goes quiet."

Along with large-scale revegetation, Virginia has also added a small recirculating arroyo along the back of the original house since "the property is named in its honor, but the arroyo was sold off years ago." Since "flowers and color are fleeting in the desert," she has seeded wildflowers and added plants with even subtle blooms like little leaf cordia (*Cordia parvifolia*) and Texas olive (*Cordia boissieri*), as well as gaillardias, clarkia, tiny snapdragons, and flax. "You have to pick a microclimate for the California bluebells," she says. "And while succulents are held up as great choices, they don't in fact do really well here. Sedums find it too hot and dry." Penstemons, though, are "very satisfying."

Virginia is out in the garden every day from February through May, but she stays inside in the heat of late June, July, August, and early September. "We put in beans in the veg garden in September, and that draws me back out." She feels "lucky that the Sonoran Desert has such high diversity to play with and that the Desert Botanical Garden helps to make native introductions available to gardeners."

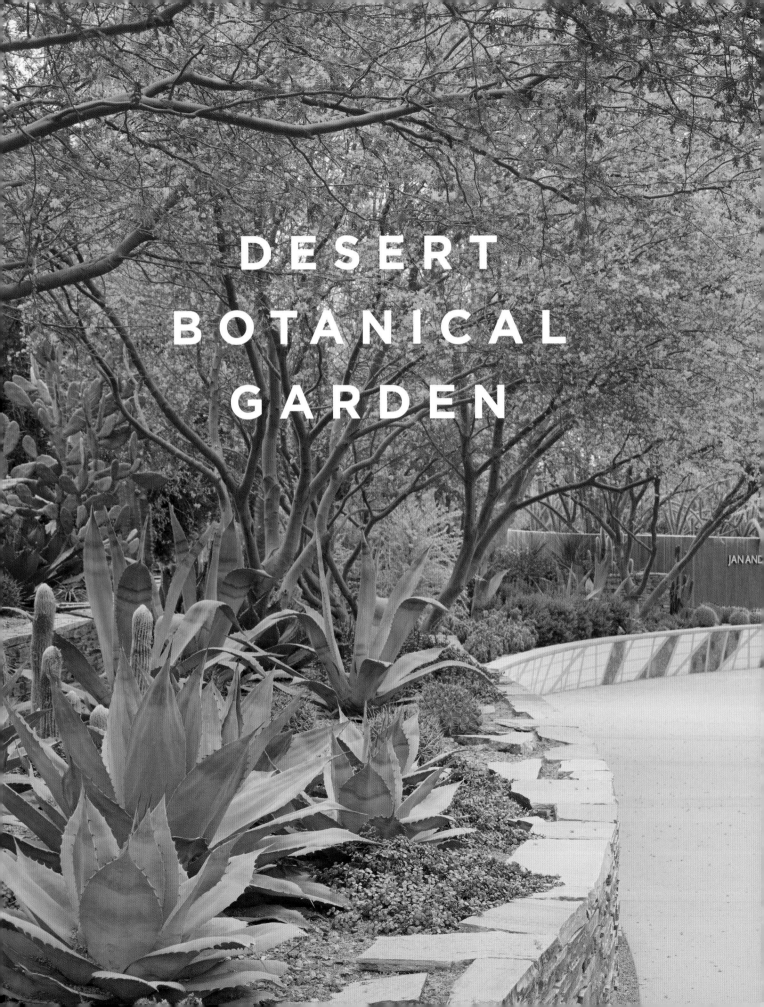

DESERT BOTANICAL GARDEN

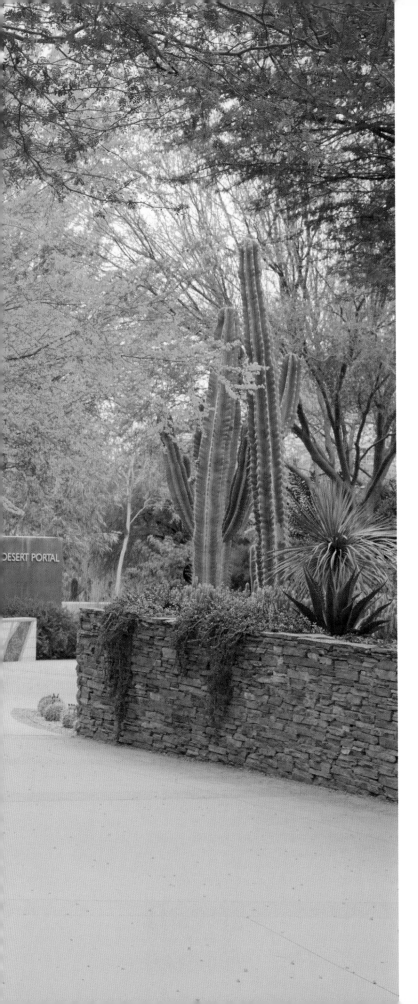

The Place

"Lush. Odd as it might sound, when I think of the Sonoran Desert, lush is the word that comes to mind," remarks Tina Wilson, director of horticulture at the Desert Botanical Garden. "The biodiversity of this desert is so high relative to other North American deserts," she explains, "that in my mind it *is* lush." Here, the green is fleeting and precious so when it arrives, "I really see the green—and I appreciate it so much." She describes looking out into the open space in spring or after a summer monsoon, "With the red buttes in the background and our palo verde in yellow bloom, our saguaros nice and big and juicy from the winter rains, I can picture the understory—the range of cacti like the prickly pear and other opuntia blooming. Everywhere you turn, there is something unexpectedly green and the desert is really alive, so vivid and colorful against a blue, blue sky."

The area that is now the Desert Botanical Garden was once primarily Sonoran Desert scrub, dryland vegetation of pale green, often leafless, palo verde trees and rounded glaucous blue-green forms of brittlebush, saltbush, creosote bush, and bursage. These are intermingled with many cacti and agave and stretches of

33

desert grassland beneath the watch of sedimentary, deep red clay or granitic buttes of the Superstition and Mazatzal Mountains.

The area holds evidence of Indigenous peoples as early as 300 BCE, with archeologists dating the Hohokam culture's extensive irrigation canal systems to as early as 300 CE and as recently as 1450. On the Akimel O'odham (Pima) and the Xalychidom Piipaash (Maricopa) cultures' territories, European settlers developed a farming community at the confluence of the Salt and Gila Rivers by the 1870s, and Phoenix grew from there.

The floral and faunal diversity of the Phoenix area is remarkable. Even though the average annual rainfall is just over 8 inches, with the most rain falling in March and then again in July with the monsoons, floristic surveys of the undisturbed desert areas of Papago Park document more than 135 species, forty-four genera, and forty-one families of plants.

The Desert Botanical Garden currently comprises 140 acres within Papago Park's 1200-acre preserved landscape; 55 acres of the garden's total area are under cultivation. The layout and design incorporate naturalistic trails, including the Sonoran Loop Trail, Center for Desert Living Trail, Plants and People of the Sonoran Desert Trail, and Desert Wildflower Loop, lending to the sense of meeting these desert plants and environments as they appear in the wild.

The People

Phoenix is currently the fifth most populous city in the United States. Even by the 1930s, the problems of sprawl and development were apparent to ecologically minded people, including a Swedish botanist and engineer for the local water use association, Gustaf Starck. He understood that as the settler population grew, the equilibrium of the flora and fauna of the desert ecology would be damaged or destroyed. Starck organized the Arizona Cactus and Native Flora Society in 1934. Originally just sixteen members, the society ultimately sponsored the founding of the Desert Botanical Garden in 1937 and it opened at its current site in 1939.

In 2018, the garden had more than 34,000 members, it welcomed close to 496,000 visitors, and was supported by 720 volunteers of all ages. More than 18,000 school children visited and were introduced to desert ecology and the beauty of desert plants. The garden's staff and nearly fifty community-appointed trustees pilot its desert-preserving mission. Executive Director Kenneth J. Schutz sees the natural beauty of the region in wholistic terms, "It's the sky, the buttes, the collection nestled among those buttes, framed by that sky. It allows for the combination of naturalistic displays alongside more landscape architectural presentation using form and shape to create outdoor living galleries of nature's masterpieces."

PREVIOUS PAGES: An allée of blooming palo verde (*Parkinsonia aculeata*) trees underplanted with statuesque *Agave parryi* on a main walkway at the Desert Botanical Garden in Phoenix, Arizona.

→ Palo verde (*Parkinsonia aculeata*), *Opuntia*, and *Yucca* near a geometric oasis water feature.

↘ Mass plantings of *Opuntia* spp. lead to mass plantings of columnar cacti.

FOLLOWING PAGES: The Desert Botanical Garden features trails and adjacent lands that preserve and protect the natural desert landscape.

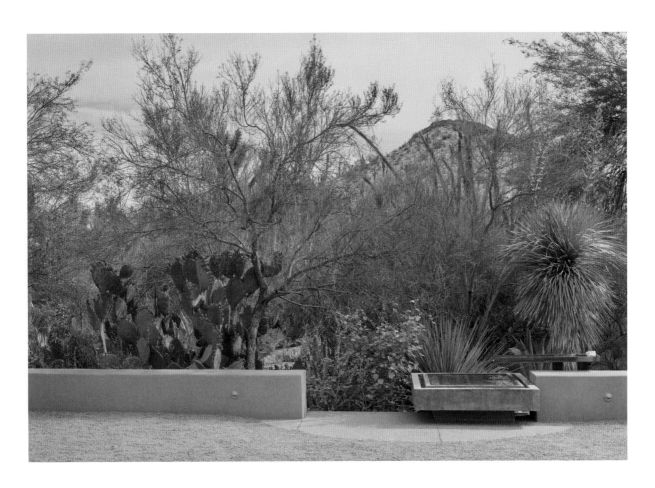

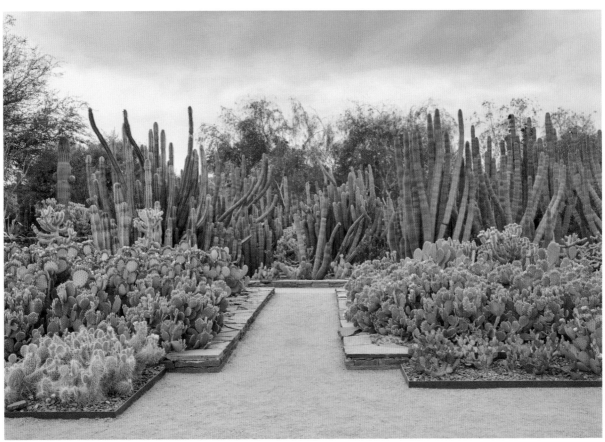

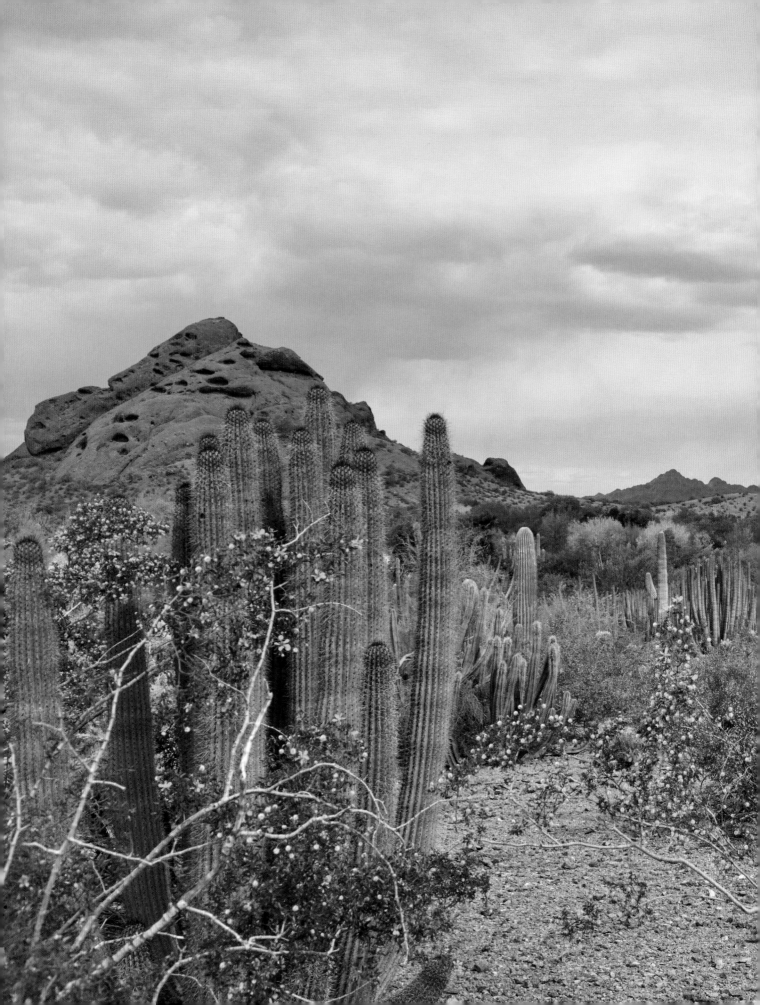

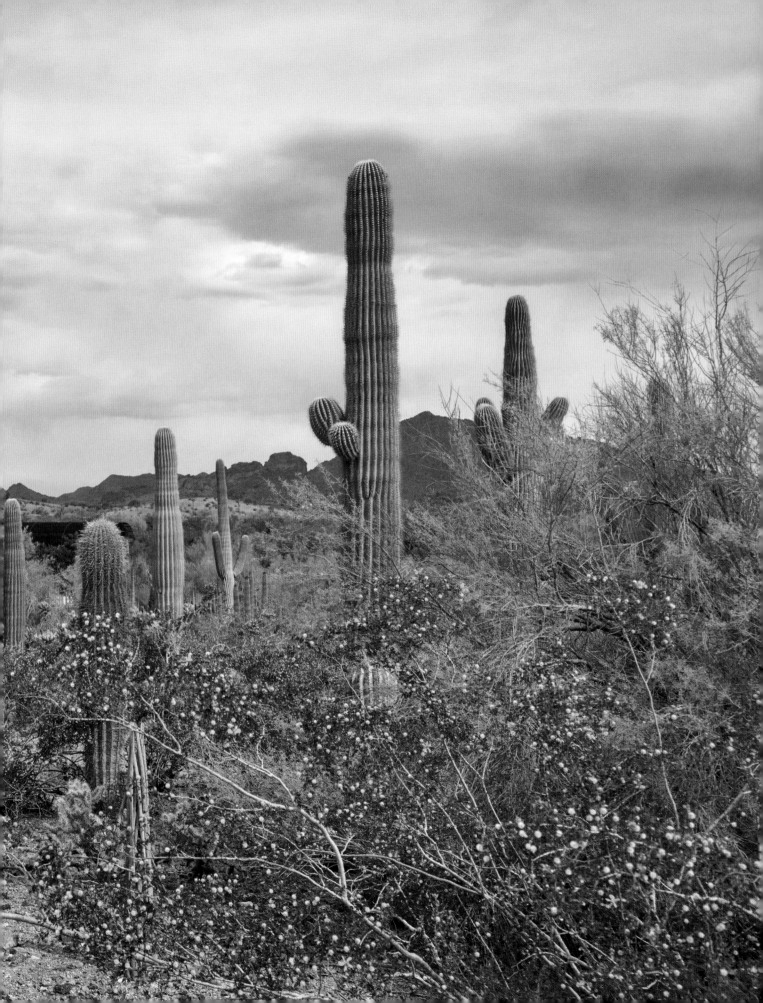

The Plants

When the Desert Botanical Garden opened, it had 639 plants in its collection. Today the garden cares for more than 50,000 plants representing more than 4400 species from deserts around the world; 379 of these species are rare or endangered. Kenneth Schutz summarizes the garden's work this way, "We've always been a collecting and research organization. We're seventy percent of the way to having a complete collection of known cacti and agave species [of the world], and by 2023 we'll be at eighty-five percent. Our responsibility as a world leader in this work—as affirmed by the International Union for Conservation of Nature selecting us as the host site for the international effort to conserve cacti, agave, and succulent plant species—is something we take seriously and humbly."

Significant collections within the cacti family at the garden include *Echinocereus*, *Mammillaria*, *Coryphantha*, *Ferocactus*, and South American cacti (especially *Copiapoa*, *Eriosyce*, and *Echinopsis*), while the agaves boast *Yucca*, *Furcraea*, *Hesperaloe*, *Manfreda*, and *Hesperoyucca*. The garden also features the world's most complete collection of the subfamily Opuntioideae. In both the Cactaceae and Agavaceae collections, significant numbers of specimens and collected seed are of "wild origin," making the Desert Botanical Garden a world leader in the conservation of wild germplasm.

Garden staff focus on the importance of engaging people with a love of and greater knowledge about the beautiful desert in which they live. "We take pride in presenting our plant collections in a way that offers the opportunity to be immersed in them," Kenneth says. "It creates that portal of interest/learning through beauty so you can get close and really see what you may or may not have seen or noticed before, so that your interest is sparked and you're inspired."

Maintaining the collection, Kenneth says, is a "balance of aesthetics and practicalities." He notes, for example, that the gardeners limb up the palo verde trees so they can display many understory plants below them, creating a greater density than one would generally see in the wild, but allowing visitors to see more overall. The staff also has to be cognizant of things such as making sure to not put potentially "dangerous plants" too close to the trail. And, while many gardens create planting plans so

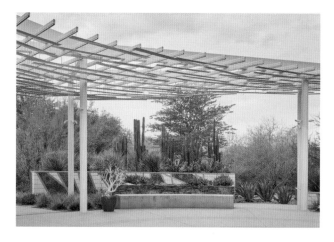

↑ **TOP:** A shady gathering space at the Desert Botanical Garden features displays of potted, raised bed, and in-ground desert plants from around the world.

↑ **ABOVE:** In one of the protected, high-tunnel plantings at the garden designed by Steve Martino, groups of Mexican fencepost cacti (*Marginatocereus marginatus*) stand out.

→ Saguaro (*Carnegiea gigantea*) is the iconic cactus of the Sonoran Desert.

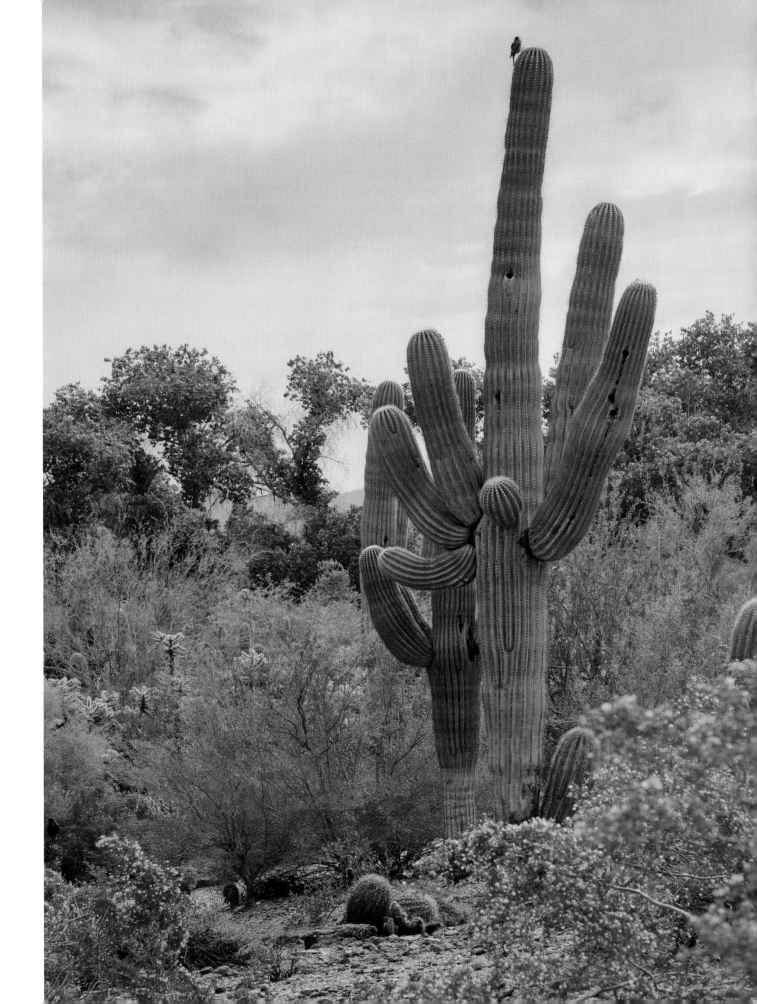

that the sun is at the visitor's back when viewing a bed, Desert Botanical Garden often plants "*into* the sun, allowing the spine patterns and forms of these specific plants to show off to best effect."

"At the forefront of our thinking is to keep assessing and ensuring we can care for these plants and curate them at the highest level" says Tina Wilson, reinforcing that Desert Botanical Garden also provides information to researchers around the world. Founded in 2000, the Desert Landscape School has trained both professional and amateur gardeners on best practices for using desert plants in conservation and in public and private landscape and gardening. Kenneth summarizes the importance of the work, "More and more, public gardens have to both protect the plants . . . in our care *and* inspire our visitors to want to do the same thing. We must share these precious objects in a way that optimizes the health and experience of both people and plants."

→ A line of palo blanco (*Mariosousa willardiana*) trees underplanted with *Opuntia macrocentra*.

↘ A mesquite (*Prosopis*) tree shelters *Opuntia* and other cacti, while a mass planting of *Aloe* blooms in the foreground.

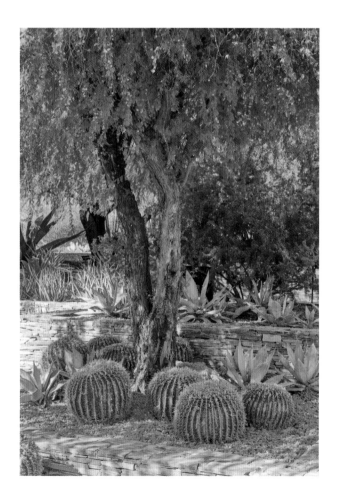

↑ A grouping of golden barrel cactus (*Echinocactus grusonii*) in the dappled light of an acacia (*Acacia*).

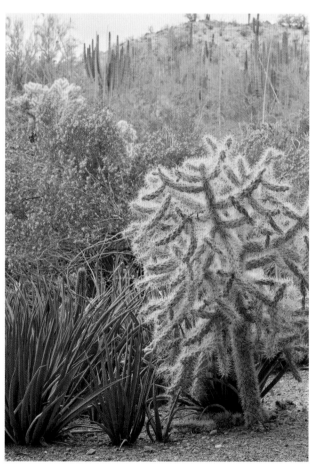

↑ A cholla (*Cylindropuntia bigelovii*) with its light-catching spines, beside aloes (*Aloe*).

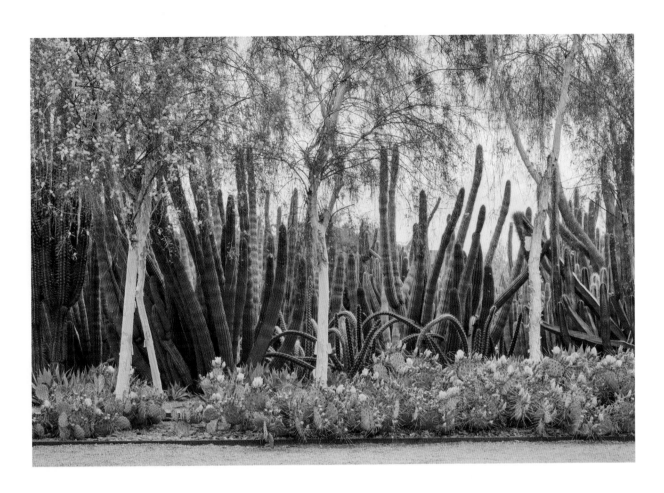
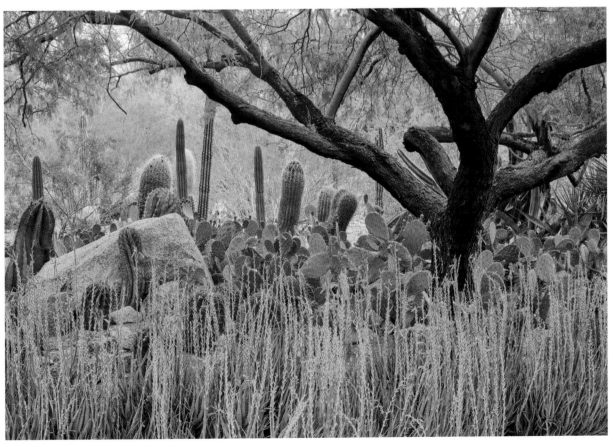

TANO POINT

KAREN STILL *with*
SURROUNDINGS STUDIO

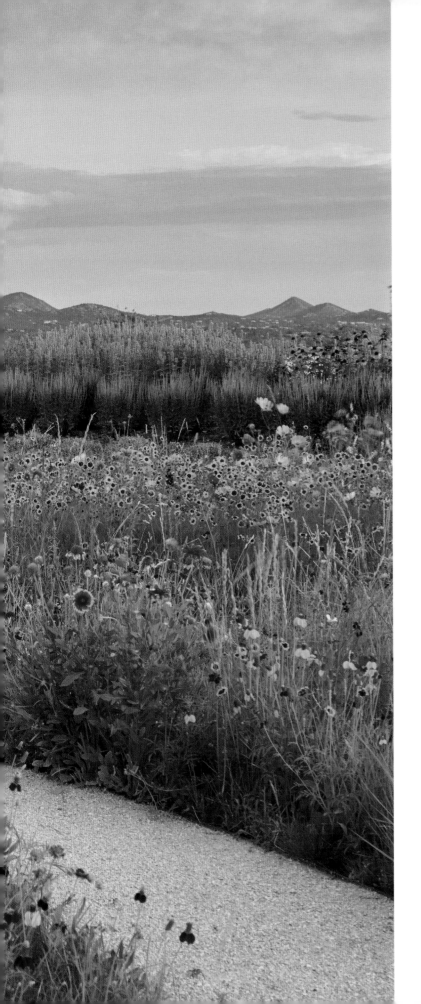

The Place

The 8-acre home and garden of Karen and Marc Still lies north of downtown Santa Fe in the foothills of the Sangre de Cristo Mountains. Three acres are cultivated, and the remaining five are left in their natural state of chamisa, sage, and pinyon and juniper woodland. The site is poised on a rise in a natural crook where the southern Rocky Mountains split at their convergence with the Rio Grande rift coming north. Here, the Colorado Plateau to the north and west meets the southern High Plains to the east. The Jemez Mountains and the 1.25-million-year-old Mogollon-Datil volcanic field flank the southwest. The geologic history of where they live inspires Karen and Marc daily. The rise and fall of the Basin and Range Province landscapes are in view to the far southwest, as are the Sandia Mountains near Albuquerque to the far southeast.

From the front garden courtyard of Karen and Marc's home, on a clear day the 360-degree views allow you to see all of this geologic drama stretching and echoing through time and space in full surround. Karen notes, "You can look down the Rio Grande rift and see just how an ice age carved out those landforms. The green ribbon of the Rio Grande runs through it all."

43

The People

Tano Point, named long before the Stills acquired their property in 2012, refers to the Indigenous peoples who lived throughout this region. In the valley just below the site is the city of Santa Fe, inhabited by people dating back to at least 500 CE and colonized by the Spanish in the 1600s.

While raising two sons and establishing her career, Karen would sometimes bring the kids to Santa Fe to get out of the Texas summer heat. When her youngest son graduated from high school, she bought a property in town and put in gardens with the intention of moving there full time. She met Marc in Texas around the same time and said, "I hate to tell you, but I'm moving to Santa Fe. I don't think this is going to work." He replied, "I will move mountains to make this work." They found and bought the Tano Point property together and shortly after were married in a small chapel on the property. Then they dug into renovations to the original John Gaw Meem Pueblo Revival Style house.

The plantings in and around the formal courtyards adjacent to the house and the 1.5-acre wildflower meadows and native land areas are the result of Karen's collaboration with Surroundings Studio, a New Mexico–based multidisciplinary design firm. The firm's founding partner Kenneth Francis was principal-in-charge and Joseph Charles served as native plant expert. Madeleine Aguilar assisted with the planting plan and palette choices. Karen is a very knowledgeable plantsperson, and Kenneth and Joseph emphasize that it was a "gift" to have a client who understood landscapes and "entrusted us to move forward with what was going to be an experiment."

Kenneth's practice has long been focused on innovative and sustainable water practices, and he and the studio are known for their stormwater-management and green infrastructure design. Joseph has visceral responses to the "amplified essential elements" of earth, wind/air, water, and fire or temperature on the Tano Point site specifically and in northern New Mexico generally. In choosing and siting plants for Tano Point, he kept in mind their need to live up to and stand up to "the big open sky, towering mountains, voracious wind, precious water. It's all about getting back to the basics. The elements are not subtle here in *any way*."

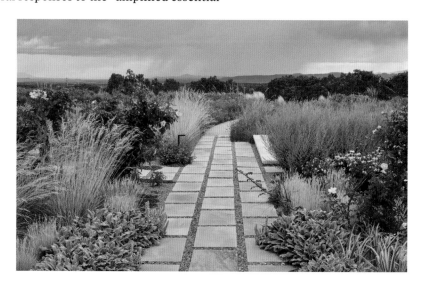

PREVIOUS PAGES: The back wildflower meadow provides a dynamic and seasonally shifting colorful foreground to the immensity of the Tano Point view. The meadow includes *Coreopsis*, Mexican hat (*Ratibida*), and blanket flower (*Gaillardia*). Annual hollyhocks (*Alcea rosea*) and *Cosmos* have crept in and been allowed to stay for the added personality.

→ Making your way up from the wildflower meadow to the house, the wildflower mix of *Coreopsis*, Mexican hat (*Ratibida*), and blanket flower (*Gaillardia*) gives way to a more woodland feel under the pinyon pines (*Pinus edulis* 'Boulder Blue'). A substantial blue avena grass (*Helictotrichon sempervirens*) lights up the left side of the walk.

↓ As you move out from the house, the cool blue and silver plantings such as lamb's ear (*Stachys*), *Festuca glauca* 'Boulder Blue', Russian sage (*Perovskia atriplicifolia* 'Little Spire'), and *Rosa* 'Sally Holmes' transition to the warm yellows, oranges, browns, and reds of the wildflower meadow.

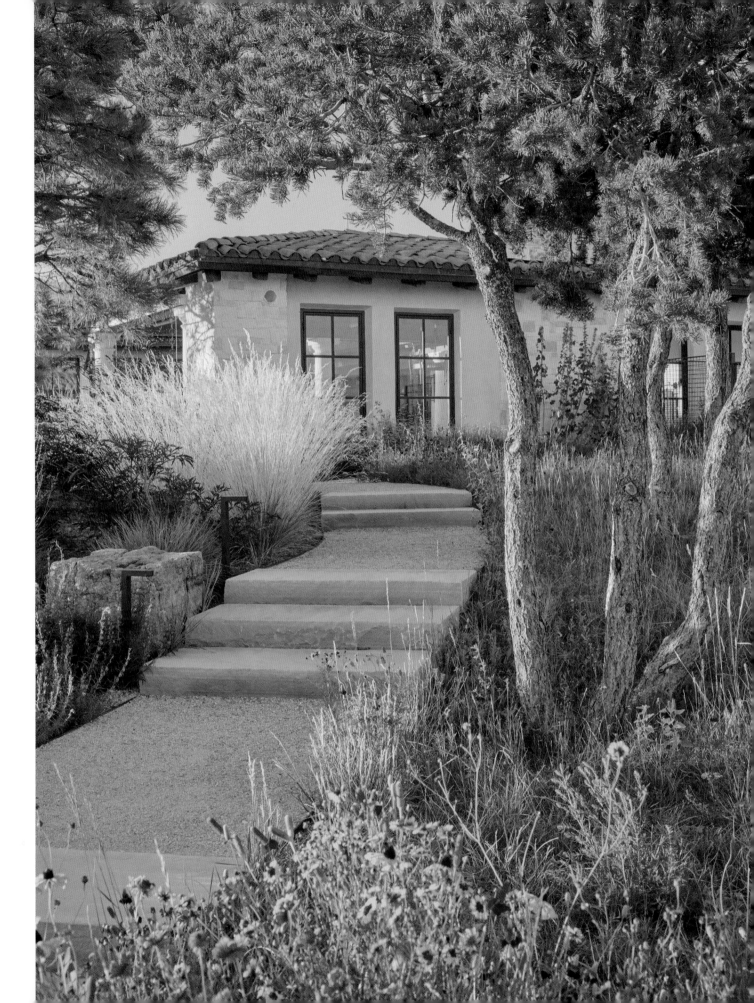

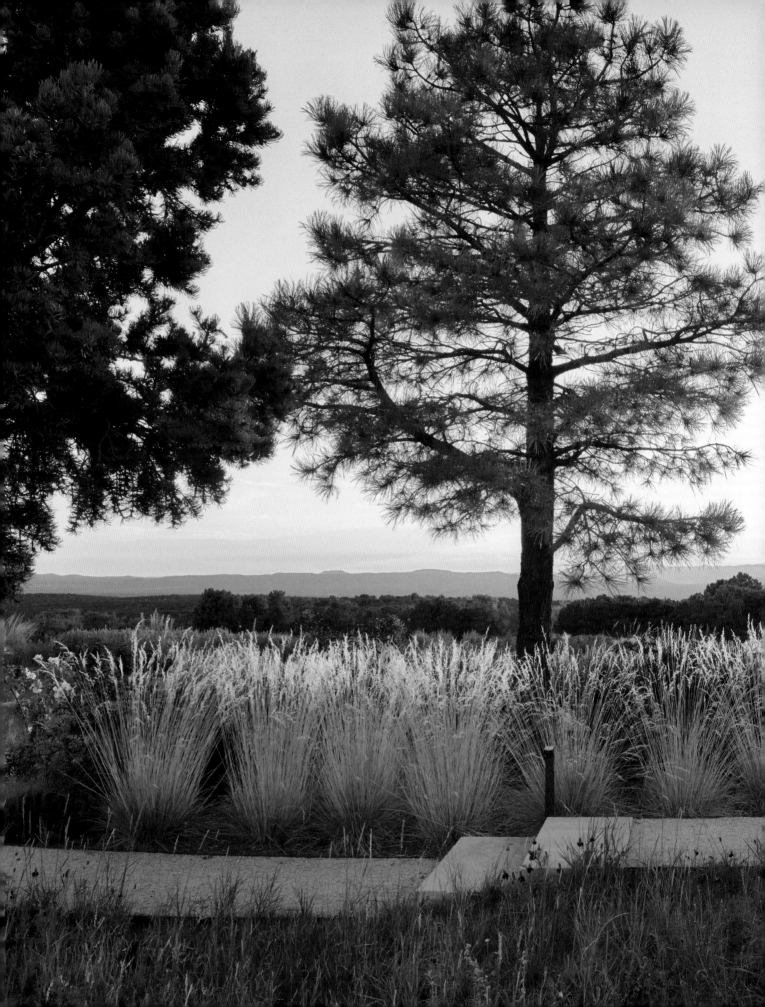

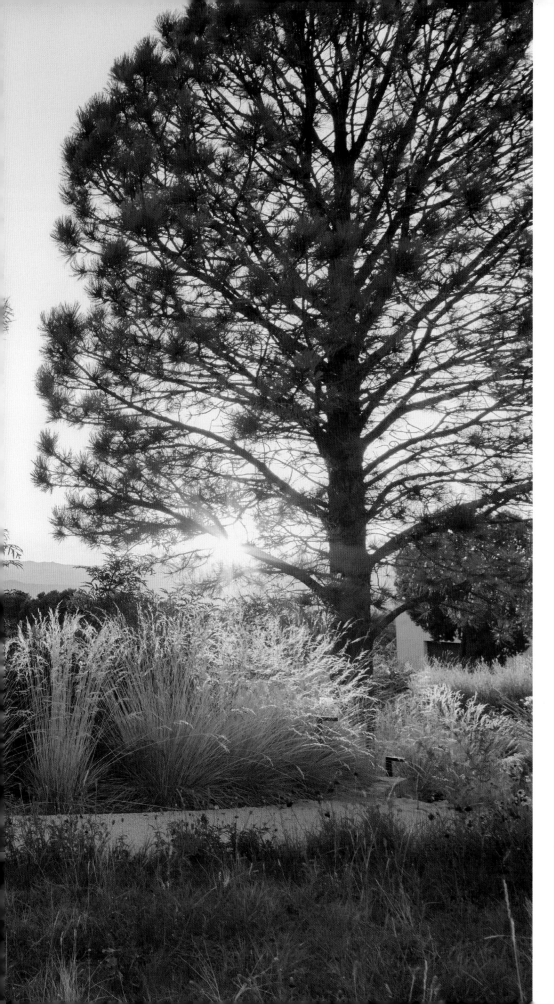

← The late-day heat and setting sun are filtered, framed, and captured by the line of pinyon pine (*Pinus edulis*) and Austrian pine (*Pinus nigra*) underplanted with blue avena grass (*Helictotrichon sempervirens*).

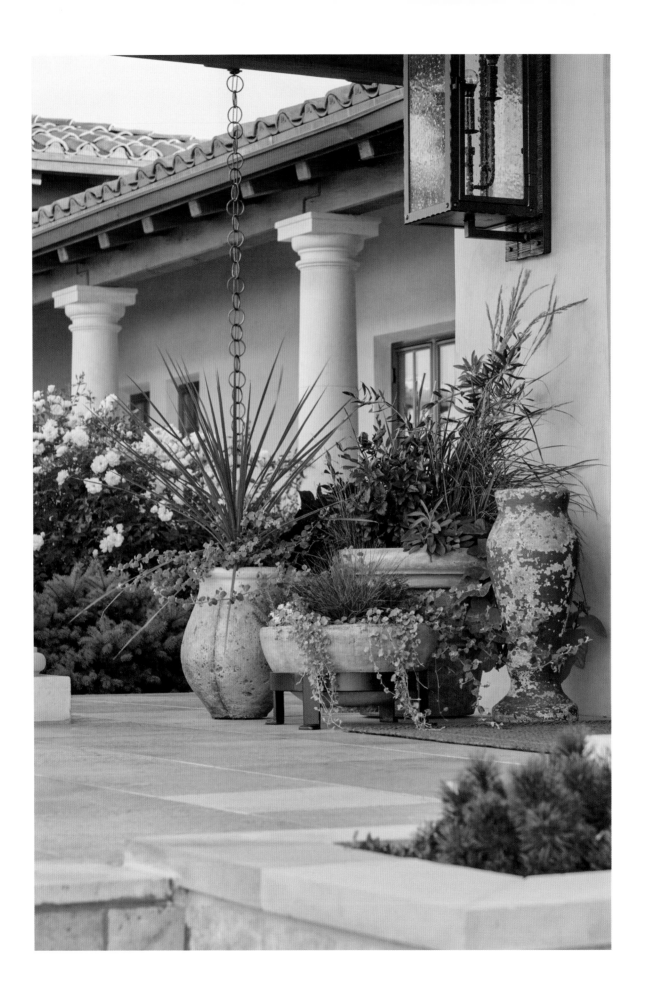

← Formal container arrangements off the house continue the cool blues, silvers, soft greens, and whites of the courtyard plantings. Here *Rosa* 'Iceberg' and *Cordyline* add structure to seasonally changed annual plant combinations.

↘ In the courtyard gardens, Karen and Marc wanted a more formal feel than the areas of the garden interfacing with the wildlands. They chose a combination of native and nonnative plants in cooling greens, blues, and white. Native pinyon pine (*Pinus edulis* 'Boulder Blue') is underplanted with Korean feather reed grass (*Calamagrostis arundinacea*) and *Festuca glauca* 'Boulder Blue' and to the left common white yarrow (*Achillea millefolium*) and *Potentilla fruticosa* var. *davurica* 'Prairie Snow' line the walk.

FOLLOWING PAGES: The evening sun and prevailing wind from the south and west sculpt the wildflower meadow's topography and plant forms. Giant sacaton (*Sporobolus wrightii*), *Agastache* 'Blue Fortune', and purple coneflower (*Echinacea purpurea*) add additional color and form to the more ephemeral native wildflowers below.

The Plants

The team agreed on a starting point of working with the vastness of Tano Point's view. Kenneth says, "In this land of extremes, we tried to draw them out and highlight/showcase them—areas in shade, areas in sun—to have people really feel and appreciate the temperature swings of sometimes forty degrees between sun and shade or between afternoon highs and the chill the minute the sun goes down." They wanted to capture the textural nature of the earth and the clarity of the natural light.

With such vastness and strength of site, the space immediately around the house became the focus for the first round of design work. Karen hand-drew the designs for the formal gardens and the courtyards, historically refuges from the elements. "With the view to the northern badlands, you can see weather rolling across the valley from two or three miles in the distance and watch as it approaches before slamming into the house and hilltop," she shares. The courtyards became important for their sense of softness, enclosure, and human scale. Marc loves purples and grays, and the couple wanted the courtyards to be cooling, calming, cultivated spaces. They felt okay including mostly nonnative plants in these spaces, focusing on more native plants the farther you moved from the house. "Joseph was brilliant with his wide-ranging seasonal species selections from the front entrance through to the back courtyards with careful gradient of colors—blues and purples and white," Karen emphasizes.

The extensive wildflower meadow is another of the great reveals, and it unfolds differently in each season. "Our mission for the wildflower meadow was for it to be a showstopper—an amplified representation of dynamic natural beauty," says

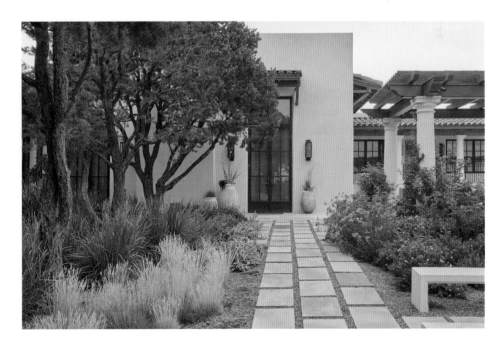

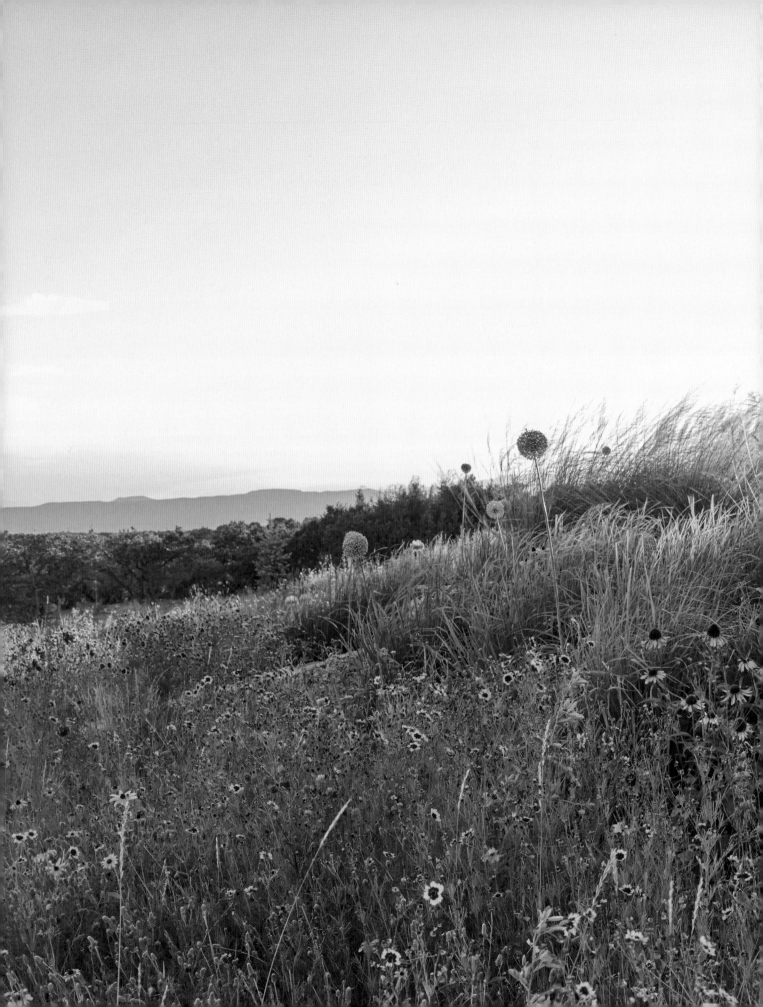

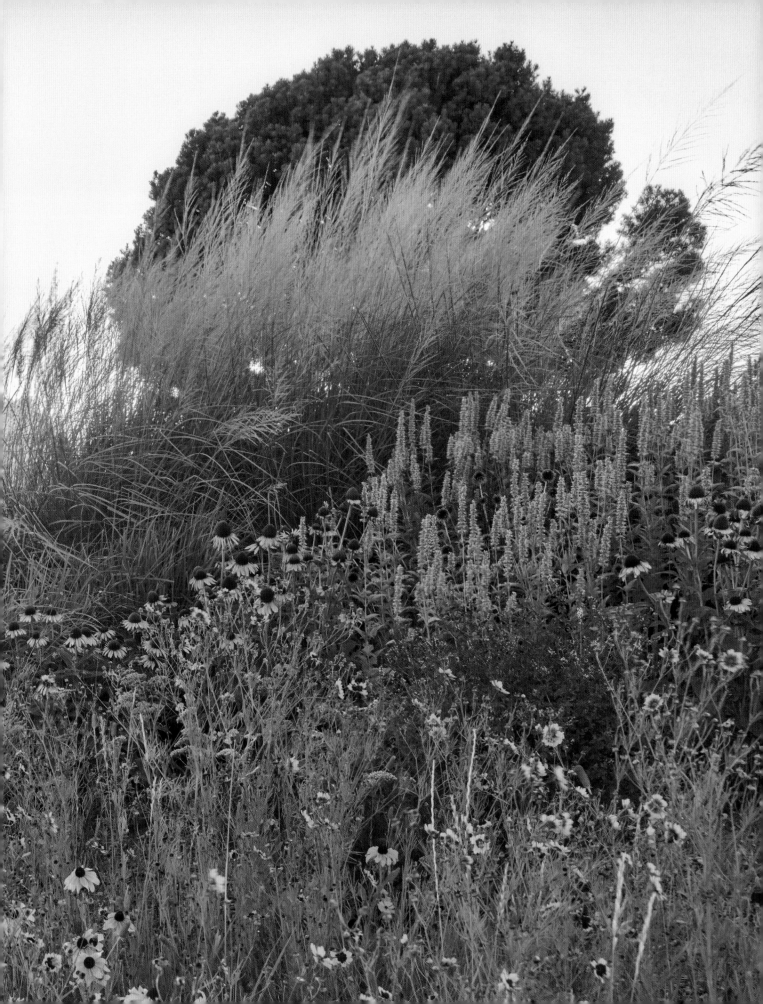

Kenneth. With the goal of not blocking the views, Kenneth and Joseph manipulated the grade moving out from the house. Subtle, long, sloping berms effectively block other buildings on one side, and mature pinyon woodland plantings (to supplement what was there) in another section mask a neighboring residence. "Some areas were seeded with a native grass and wildflower seed mixture in advance of the mid- to late-summer monsoon rains. Some areas are intensified with bucket plants to choreograph color and seasonality with limited irrigation for a little more control over color schemes as they play out," Joseph explains. They also designed for the effects of high winds, which regularly reach over 50 miles per hour in winter and spring, and erosion from heavy rain and snowpack melt.

All of the cultivated areas are on drip irrigation with precise zoning so that Karen can turn it on and off as needed. "We're on wells, so you cannot be too careful with water." The meadow and tended pinyon juniper woodland areas needed very little to no supplemental water after the first eighteen months.

Throughout the project, Joseph had a strong sense that especially the wilder native and climate-adapted meadow areas of this garden presented "an opportunity to educate and expand those who visit them. The palette of plants . . . used in breathtaking and artful ways, indicative of and adapted to this region, demonstrates that you can create an oasis that works with the environment and its ever-changing nature." Kenneth completes that thought, "It's beyond plantings. It's deep history and craft of the land and its people."

Karen says of the completed garden, "When the sun hits those wildflowers in the afternoon, or you can see the weather moving across the horizon through the frame of the plantings, it is magical. Everything is in intense focus: the colors, the forms, the shadows. Everything goes from the bright white of the day to these rich living colors, the reds and purples and oranges of late August." It is dramatic, and yet there are also moments, she allows, "when it's disarmingly silent. I was almost afraid of the silence at first. And up there all alone, when the wind comes up, there is something ancient and eerie, bigger than you. You feel everything that's been there before you. You can feel the people and the earth. It resonates, and you can see it. I love living in the middle of all that."

↓ An upper terrace border features nonnative cultivars that can stand up to the dry heat and provide long seasonal color, including terra cotta yarrow (*Achillea millefolium* 'Terra Cotta'), Korean feather reed grass (*Calamagrostis arundinacea*), globe thistle (*Echinops ritro*), *Agastache* 'Blue Fortune', and purple coneflower (*Echinacea purpurea*).

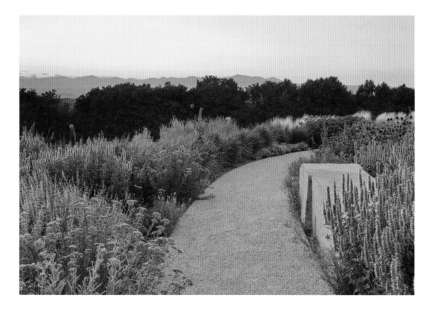

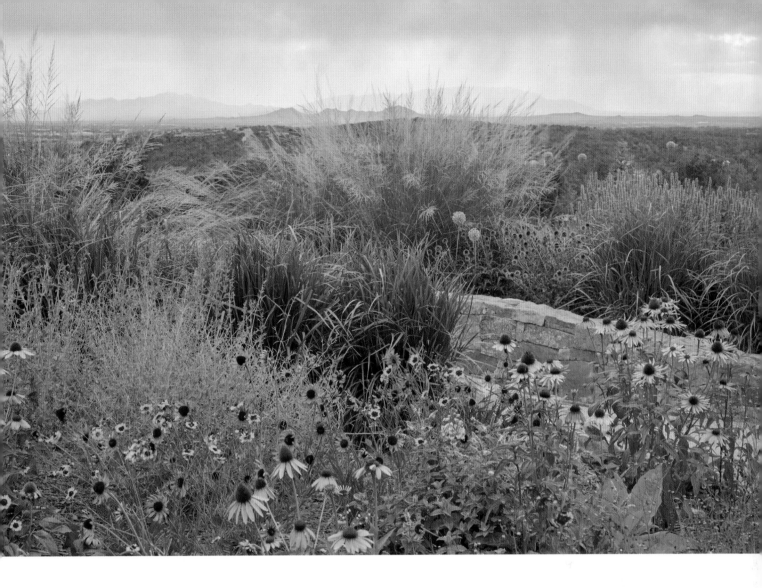

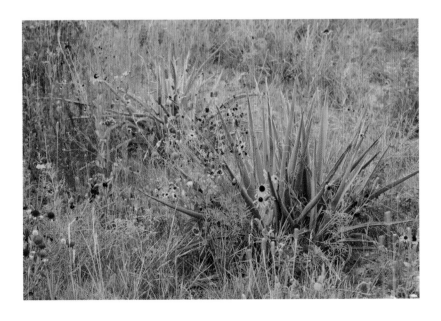

↑ Korean feather reed grass (*Calamagrostis arundinacea*), purple coneflower (*Echinacea purpurea*), giant sacaton (*Sporobolus wrightii*), and *Agastache* 'Blue Fortune' thrive in the wildflower meadow.

← Farther from the house on a lower slope is a second less-cultivated wild-flower meadow with the plantings feath-ered into the native scrub. Here native banana yucca (*Yucca baccata*) is soft-ened by seed-sown native blanket flower (*Gaillardia*), Mexican hat (*Ratibida*), and naturally occurring wild grasses.

RADICLE DESERT

ACADEMY FOR THE LOVE OF LEARNING
and CHRISTIE GREEN

The Place

"Water informs everything here. The first thing I think of is the beauty of extremes—of wetness and dryness—and the patterns of these on the land. I live on the Santa Fe River, and it feels dry here ninety percent of the time. But when the rains come, it's instantaneously wet and raging," landscape architect Christie Green says. "The topography is also extreme—high elevation mountains to eleven thousand feet alternating with dry, dry, flat plains."

At almost 7200 feet, Santa Fe is characterized as a semi-arid steppe environment with cold winters. Between winter snows and summer monsoons, the region receives an average of 14 inches of precipitation annually. The city is flanked to the east by the fault-block Sangre de Cristo Mountains, which rise abruptly from the valley floor as a result of tectonic plate faults and uplift, and to the west by the volcanic Jemez Mountains. Indigenous peoples have cultivated the region for thousands of years; archeological evidence in and around Santa Fe indicates agricultural activity dating back to 500 CE using traditional dryland farming techniques such as sunken check-dam sites.

The Person

Christie Green has never considered landscapes as something that could be made to serve her wishes, but rather as rugged personalities of their own. She acknowledges, "Okay, land, you were here first. This is your shape, and these are your ways. How do I concede to you?" Christie uses the word *concede* purposefully to highlight a sense that the land and nature set the rules, that we may learn from adapting to the land. "We are the only species who demands in the most arrogant of ways that the land accommodate and adapt to our comfort zones," she says. "I don't think it's our place in the whole scheme of things, especially aesthetically." She starts her design process with the question, "What's best for the land?"

Christie did her undergraduate work at the University of California, Berkeley, in cultural history, then started a landscape design business, Down to Earth, in her late twenties with the belief that she would change the world by helping people grow food in their backyards. "I was convinced that if the food was in such close proximity, people would understand how it's grown and the relationship to place and healthy soil, heirloom crops."

Christie eventually came to realize that she wanted to have an impact "at the housing development, city planning, and zoning scale." Graduate studies in landscape architecture stretched her design mind in good ways, she says, helping her to think creatively beyond the confines of a client's budget. But she also found in-the-box thinking that she questioned. When she wanted to focus her thesis on how fracking impacted the ecology and culture of western North Dakota, she was told "Landscape architecture isn't about that. It's about urban design—parks, schools, shopping malls." She completed the program, but decided to do her own thing. She called the new iteration of her business "radicle," a word play between the first embryonic root of a plant to emerge upon germination and the idea of being radical.

She aims to push the limits of what landscape architects do. "I love designing for whole systems," Christie notes. "Looking at systems from beyond political boundaries of individual ownership and at a whole ecosystem or a system like a watershed." She also likes designing for a much longer time frame than next week, even a time frame beyond her or her client's lifetime. "What I can see blooming from my desk is not good enough."

Christie has learned to think with humility. The second she thinks she knows something, the more she believes she needs to pay attention to what she does not know. When clients say they love a certain plant and want to incorporate it or that they hate the way another plant looks and they want to get rid of it, she likes to "invite a conversation wherein we talk about how a plant is structured, about why and how it *looks* that way." For instance, she might explain that thin leaves provide minimal exposure to sun, prickly hairs reduce transpiration. "It's like going to a museum with a docent,"

she points out. "If you understand how [something] grows and why, then you touch it and you *get it* as a living being, then there's some form of connection. There's no way there's going to be stewardship if there's not really deep connection. I guess that's what I think is most important. Not making a how-to-care-for list, but a help-each-other-care-about list."

The Plants

Academy for the Love of the Learning

In 2011, the nonprofit Academy for the Love of Learning opened a newly built 86-acre LEED Gold campus designed with founder Aaron Stern's objective "to awaken, enliven, nurture, and sustain the natural love of learning in people of all ages." The campus sits on land that was once part of the 2500-acre historic Seton Village, built between 1930 and 1946 by Ernest Thompson Seton, a wildlife artist known for his support for wildlife conservation and the rights of American Indian peoples. The goal was a naturalistic, peaceful space for guests and visiting students to be in during intense retreats, workshops, and classes.

Christie's first encounter with the Academy for the Love of Learning was in 2009, when she was invited to consult with the design and build team. She was greeted at the site with a list of the plants the team wanted where. "I just can't think like that. The plant species are the gravy. You have to start with how does this place/land work? What is it? How will you move in the space? What can we do here to reflect the culture and philosophy of the organization? How can the garden and landscaping embody what you do, who you are, and *where* you are?"

She pointed out that Seton's entire way of being was stewardship for the wildlife and honoring its Indigenous cultures. "He did not want to impose a Western white culture, so I worked to bring his ethic into this century and onto this land in this moment and into the culture of the academy with what we called the Learning Landscape."

The first thing she took on was the slope from Seton Castle down to the new facility because of real concerns about erosion damage during storms. "The academy is on a twelve percent slope. The engineers for the architect… treat[ed] water as a liability. And the Southwest is the *last* place water should be seen or treated as a liability. We need it, and we can use it to grow all kinds of things and hold the soil." Christie designed what is now known as the Ancestors Heirloom Orchard, an "ecologically beneficial series of berms for orchard trees and swales full of native species for habitat all the way down the slope. The detention pond [required by code at the bottom of the slope] has maybe never had water in it because the water, an asset, is being put to full use to water the orchard and swales." Any excess water is filtered by the soil and percolates back into the ground water.

At the top of the property lie the ruins of the historic Seton Castle, which burned in 2005. In and around these ruins, Christie created a design based on traditional Zuni sunken gardens, sometimes known as "waffle beds" due to their sunken square patterns with raised sides for capturing, directing, and holding what little rain falls. Here she built a dye and medicinal plants garden using flowering annuals and perennials.

In the front of the academy building is a more lush, serene mix of deciduous trees and shrubs, including Arizona sycamore (*Platanus wrightii*), black locust (*Robinia pseudoacacia*), *Robinia* 'Purple Robe', hackberry (*Celtis*), American purple ash (*Fraxinus americana* 'Autumn Purple'), and chokecherries (*Prunus virginiana*), among others. The rest of the property remains in its natural pinyon and juniper scrub state as open, green space that is accessible to the local human and wildlife communities.

→ The burnt-out Seton Castle adobe structure at the top of the academy campus was repaired enough to remain standing. To add to the sense of a ruin, Christie developed low naturalistic plantings that would reseed and migrate over time to run in, out, and throughout the structure. *Parthenocissus quinquefolia* clambers up the exterior wall near the original entrance.

→ **OPPOSITE:** Inside the old structure, a mosaic of creeping plants speaks of persistence and include snow-in-summer (*Cerastium tomentosum*), gray creeping germander (*Teucrium aroanium*), slender speedwell (*Veronica filiformis*), Jenny's stonecrop (*Sedum rupestre*), and rosy pussytoes (*Antennaria rosea*).

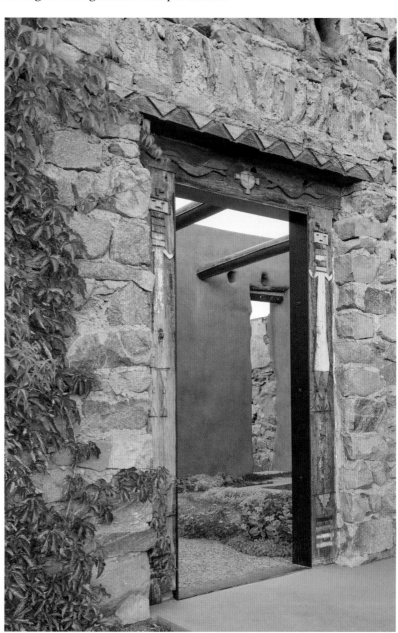

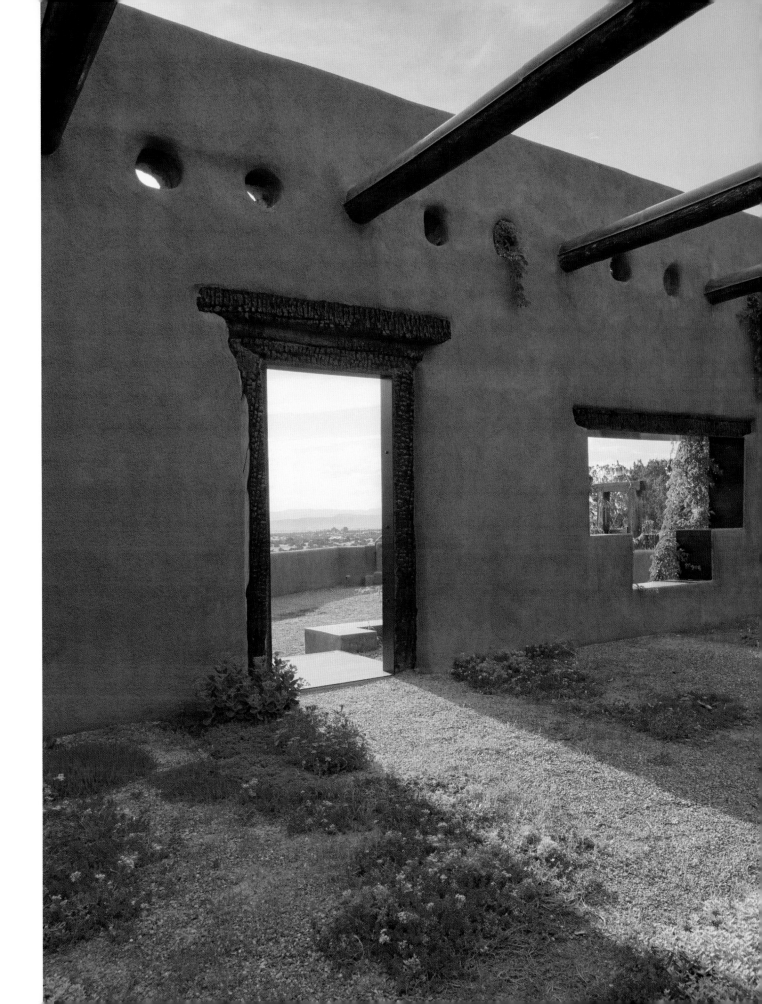

← Along the front face of the Academy for the Love of Learning, trees added for shade include oaks and hackberry. The terraced plantings offer the movement and seasonal colors of grasses including Mexican feathergrass (*Nassella tenuissima*) and switchgrass (*Panicum virgatum*).

61

↑ Walkways and trails around the Academy for the Love of Learning offer guests restful spaces in the natural environment. Here native pinyon pine (*Pinus edulis*) and juniper (*Juniperus monosperma*) woodland scrub is tied into the academy's landscapes with Mexican feathergrass (*Nassella tenuissima*).

→ Off the old Seton Castle ruin, a rock retaining wall holds the vegetable garden terrace, where an existing peach tree enjoys the sun.

← A weather-sculpted old pinyon pine (*Pinus edulis*) stands sentry over the hillside.

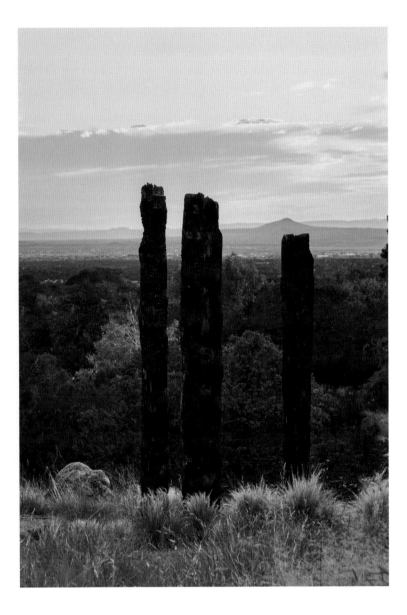

← Plantings along the front of a guest house include Mexican feathergrass (*Nassella tenuissima*), tying into other campus plantings, and the iconic white blooms of sacred datura (*Datura wrightii*).

↑ Three burnt wooden posts keep watch like totems off the corner of the Seton Castle ruin near the top of the academy's site, with the southwestern horizon spreading out across the valley below.

Christie Green's Home Garden

Christie's home garden is in southwestern Santa Fe. "When I came to my own home property, the land had been cleared and was bare. No one wanted my house and lot because it's situated at the base of a slope. Everyone wanted the view up at the top, and my two-acre lot was the one designated for the development's detention ponds. . . . But I saw this lot as the best, wettest place."

Like many designer's home gardens, Christie's is some part refuge, some part experimentation station, and some part home to all the orphans, castoffs, and leftovers from client projects. The garden is situated along the Santa Fe River in USDA zone 5. Christie did not draw a design for the space, but worked organically from the house out, experimenting with what would work on the land. She follows general principles of permaculture, with plantings needing more water and maintenance focused around the main house. She tries to have food growing wherever she can.

Christie designed a graywater system incorporating pumice wicks, also known as Watson wicks, wherein seasonal rainfall is directed into shallow bioswales filled with pumice/coarse sand to slow the percolation and filter any pollutants. Laundry and bathwater are run to the eastern side of the house, and on the western side a canale (a short, narrow trough that protrudes through the parapet of a flat roof) directs the roof water into another pumice wick, which ultimately waters shrubs.

"I did three large deep bioswales where the original single detention pond was sited," says Christie, and around these she sited riparian trees. On her outer perimeter slope, which carries runoff from adjacent properties and the road, she created a series of berms and swales on which she planted an orchard. "This effectively handles erosion as well as run-off from two main drainages cutting across my land to the detention pond." Similarly, there's a bit of a slope away from the house all the way around, and here she planted native wax currants and shrub roses that thicket to hold soil and provide habitat for birds. Christie does use some supplemental irrigation if she absolutely has to after the graywater. "But plants in my garden have to be tough."

In fall, Christie cuts vegetables back, works in compost, and plants garlic and a cover crop of field peas, rye, or wheat. Then she covers everything with straw until planting again in March. She lets ornamental and native plantings self-mulch and "doesn't groom much beyond that."

Art installations and creative projects with narrative intent lighten and add to the garden. For Christie, nothing is just one thing: food, habitat, erosion control, art, politics, or history. Rather, they are all integral to one another and they all feed us in some way: food is art is habitat is political commentary and is the history we are making as we go.

→ **CLOCKWISE FROM TOP:** Christie's home garden features native rabbitbrush and a straw bale wall, vestiges of a garden and art installation entitled "Germinate," in which she experimented with the bales as planters for drought-tolerant vegetable and flower varieties.

The farther from the house you move, the more dry-land natives predominate. A shrubby native cottonwood (*Populus deltoides* subsp. *wislizenii*) is great for bird habitat, and the native yellow-blooming snakeweed (*Gutierrezia sarothrae*) brightens the grassland.

Christie planted fruit trees like this *Pyrus communis* 'Summercrisp' pear on the slope above her home to take advantage of winter and late-summer monsoon runoff from above. The trees shelter and hold the slope and soils.

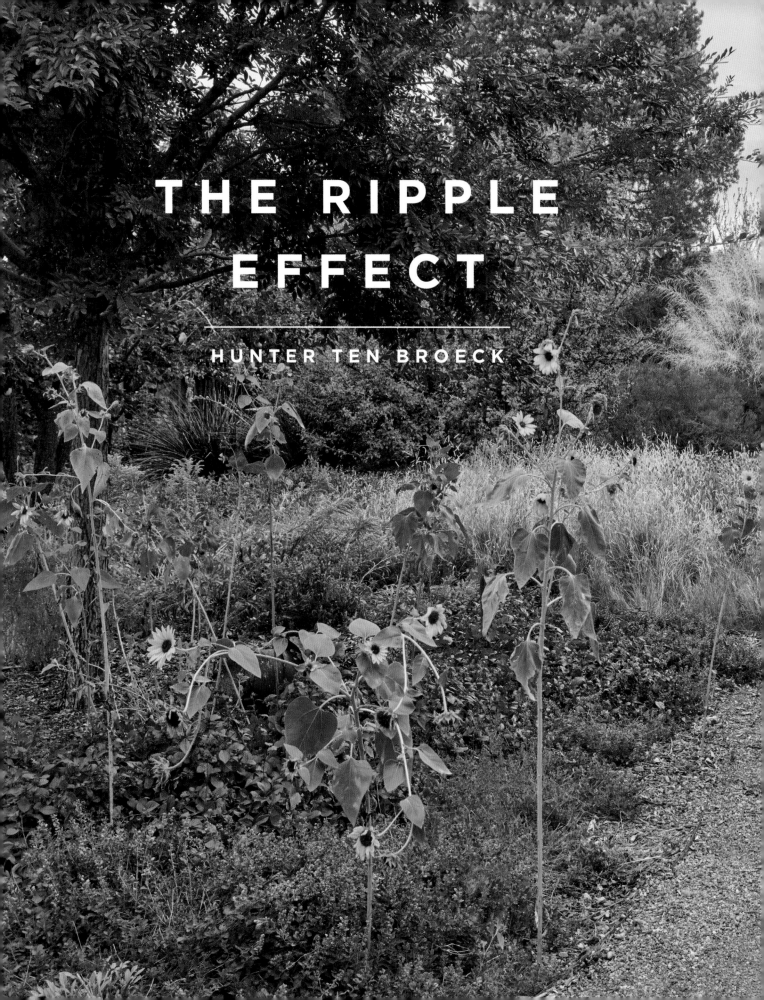

THE RIPPLE EFFECT

HUNTER TEN BROECK

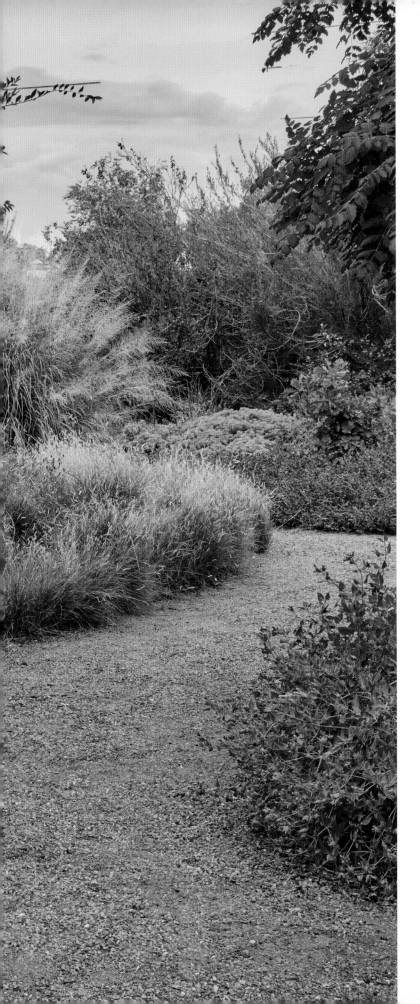

The Place

New Mexico includes four distinct biomes: forest, desert, grassland, and riparian. Albuquerque is influenced and enriched by them all, and the diversity of soils, plants, and microclimates within this intersectional space is integral to what landscape designer and outdoorsman Hunter Ten Broeck loves about living and gardening here. A collective wisdom is achieved in paying attention to each biome—how it holds and moves water, what plants grow where, and how wind and weather, cold and heat, seasons and other aspects interplay with the arid, high desert/basin and range topography and monsoon climate.

Albuquerque is situated at just over 5000 feet in a basin in the northern Chihuahuan Desert, flanked to the northeast by the granitic Sandia Mountains, which rise to over 10,600 feet from the valley floor. The Rio Grande runs north–south through the city. West of the river, the terrain is primarily comprised of sandy mesas studded with desert plants and volcanic escarpments.

Hunter Ten Broeck is in awe of how the area holds "all kinds of transitions—sandy grasslands, shrubby sage steppe, riparia

along the river in the valley, and then pinyon, juniper, and scrub live oak [*Quercus turbinella*] foothills leading into coniferous forest on the shoulders of the Sandias or the Manzano Mountains, where rainfall increases with the rise in elevation, and finally into the treeless alpine zones."

The Person

Although born in Houston, Hunter spent a lot of time throughout his childhood at a family cabin on Lake Champlain near the Canadian border. "That's where I started hiking and developing my outdoor orientation. It was there that I became interested in the whole ecosystem, how things worked together—how plants, geology, and weather interacted." After college in Maine, Hunter followed his now-wife Barb west. While working for the National Park Service in Bryce Canyon, Utah, and learning about the native plants of the West from a naturalist friend, Hunter became hooked on the power of plants and landscapes. In 1985, he, Barb, and their two young daughters moved to Albuquerque.

Hunter began working at a large landscape firm in 1986, when native, drought-tolerant xeriscaping was not the norm. He remembers how "the city leadership still believed and promoted the idea that the aquifer below Albuquerque was far larger than it was, so people landscaped as though they lived in Atlanta." He tried to push the firm to

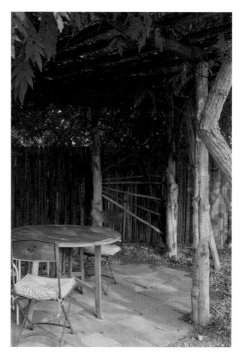

PREVIOUS PAGES: Hunter's back garden has evolved over time to better support birds and insects, with native and nonnative shrubs encircling a more open central island of native blue grama (*Bouteloua gracilis*). To replace an old cottonwood that succumbed to age, he chose an Allée elm (*Ulmus parvifolia* 'Emer II') (left) that will soon dominate the top canopy layer of the garden. A glowing native giant sacaton (*Sporobolus wrightii*) takes center stage in summer, and sunflowers are left to seed about as an attraction for goldfinches.

↙ Looking west in the back garden, three different islands join at an intersection of the pathway. Across from the Texas red oak (*Quercus buckleyi*) and to the left is the meadow of blue grama (*Bouteloua gracilis*), while to the right is the berm Hunter prepared for the giant sacaton (*Sporobolus wrightii*) grass, in front of which is a pool of desert four o'clock (*Mirabilis multiflora*).

← Hunter built this shady portal in the corner of the back garden for his daughter's high school graduation. Completely draped in wisteria now, it is a cool and welcome retreat in the heat of summer.

move toward more native, adaptive plants, but "finally, half out of inspiration and half desperation, we started WaterWise [their own design-build firm] in 1993 and haven't looked back." Several permaculture design courses informed his incorporation of edibles, fruit trees, and Mediterranean herbs into his projects, as well as grading sites for water capture, on-site retention and absorption, and harvesting.

The Plants

Moisture affects the plant palette. The higher mountain and foothill elevations of Albuquerque can have more than 35 inches of rainfall, while the drier areas get less than 8 inches annually. Temperatures in the low teens are common on winter mornings, and summer afternoon highs regularly hit the 100s. With more than 300 days of sun a year, the afternoons can be warm even in winter, whereas late afternoons and early mornings can be cool even in summer. "The point is that the plants that survive and thrive here are incredibly adaptable," Hunter explains.

Hunter aims to create a sense of refuge for native plants and wildlife, even creatures he might not really want, like coyotes, rabbits, and raccoons. "I'm definitely looking for ways to link my own garden and those I create for others to the acequia and natural riparian corridors and open areas, the bosque park in the middle of the city, and the wildlands beyond that. You can go to the bosque and see bald eagles and such, and I want to encourage that kind of livability."

Over the two decades they have been gardening on their quarter-acre lot, Hunter and Barb have continued to increase native and drought-tolerant species and have carved out outdoor rooms for living, working, and what he and Barb affectionately refer to as his "putterfussing" in the garden. Hunter's sister introduced him to the Texas ranger (*Leucophyllum frutescens*), only marginal for the Albuquerque climate. Hunter positioned some in the microclimate created near the south side of a stucco block wall and is pleased to report that "they are still looking good twenty-five years later." This success encouraged him to create more microclimates to extend the otherwise fairly short growing season. On the north side of this same wall, he's had success with bigtooth maple (*Acer saccharum* subsp. *grandidentatum*), a tree normally native to higher elevations but that thrives in his yard due to the way the wall shades its roots from the summer sun.

Fence lines are vertical green walls draped with native woodbine (*Parthenocissus vitacea*) and clematis. A daughter's graduation celebration inspired a new shade structure that invites people to the far back of the garden; it is now fully overgrown by wisteria. When building the shade structure, Hunter also downsized a full-sun native grass and wildflower meadow, put in a large double berm with sand added for drainage, and filled it with native mesa plants that are very happy. The highlight of this bed is now a large native evergreen bunch grass, giant sacaton (*Sporobolus wrightii*),

← A pear tree, existing when Hunter began to garden this land, is full of fruit in summer, and framed by a relatively young Chinese pistache (*Pistacia chinensis*) and a Texas red oak (*Quercus buckleyi*). A well-established Lady Banks rose (*Rosa banksiae*) covers the fence on the far left, and a native algerita (*Berberis trifoliata*) comes in from the right.

73

which "glows with the end-of-day western light across the space." He replaced the aging sentinel cottonwood tree with several others, native and nonnative, including an Allée elm, a cultivar that resembles the American elm but has resistance to Dutch elm disease. Like the cottonwood, the elm will eventually have a large canopy to support the many birds that visit.

Trees are not natural occurrences in the desert, except along riparian corridors. Hunter says, though, "with stormwater management, we can irrigate trees that would not otherwise live here to help create shade and habitat, reduce stormwater velocity and erosion, and filter pollutants." With this concept of human-made riparia in mind, he added two large cisterns to harvest rainwater from the house's roof runoff: an 800-gallon metal one on the western side and a 450-gallon SlimLine on the eastern side, complete with irrigation valves and timers. Overflow from these goes into French drains and swales for further irrigation. A lot of previous hardscape was reconstructed to create low-stacked stone walls and other new permeable driveway and flagstone paths. In all, Hunter now counts more than thirty trees on his lot. "I'm trying to nurture the levels of understory, the shade-tolerant shrubs and perennials underneath."

The old pear tree to the west of the grassland meadow is another focal point of the back garden, another illustration of the generally equal mix of native and climate-adapted nonnative plants that comprise the garden. Hunter is an advocate for native plants for their adaptability and the support they offer wildlife. "I have something blooming year-round to support pollinators throughout the seasons. I let things do what they do, let birds and other wildlife live their lives." He uses leaf drop for mulch and repurposes cut-back vegetation as compost or insulation against frost and to maintain soil moisture. For example, when he cuts back his desert four o'clock (*Mirabilis multiflora*), he uses the trimmings to pack a cage around his fig tree for winter insulation.

Much of what Hunter plants and how he maintains it comes back to his understanding that "water is precious. Water is life. We need to take care of it whether it's abundant or not. In the last twenty-five years, Albuquerque has cut our per capita water consumption by more than forty percent, since a study clarifying the depleted and diminishing aquifer was published." The general public is far more conversant in concepts of watersheds, aquifers, stormwater management, runoff, and conservation. "We have a precious resource in the desert, and there is an understanding that we could lose it if we don't work together."

→ Giant sacaton (*Sporobolus wrightii*) plays the starring role in the back garden in summer, with Mojave sage (*Salvia pachyphylla*), Lindheimer's muhly (*Muhlenbergia lindheimeri*), Parry's agave (*Agave parryi*), and *Artemisia versicolor* 'Sea Foam' adding seasonal color and texture. A young bur oak (*Quercus macrocarpa*) is coming along to the left, and desert four o'clock (*Mirabilis multiflora*) is much appreciated by the hummingbirds and hawkmoths.

↘ Mexican feathergrass (*Nassella tenuissima*) and little dwarf chamisa (*Chrysothamnus depressus*), gayfeather (*Liatris punctata*), and Parry's agave (*Agave parryi*) create a low-mounding and colorful combination that needs little water. In the warm microclimate created by the stucco wall, two selections of the Texas native *Leucophyllum frutescens* 'Green Cloud' (left) and the silvery 'Compacta', do well.

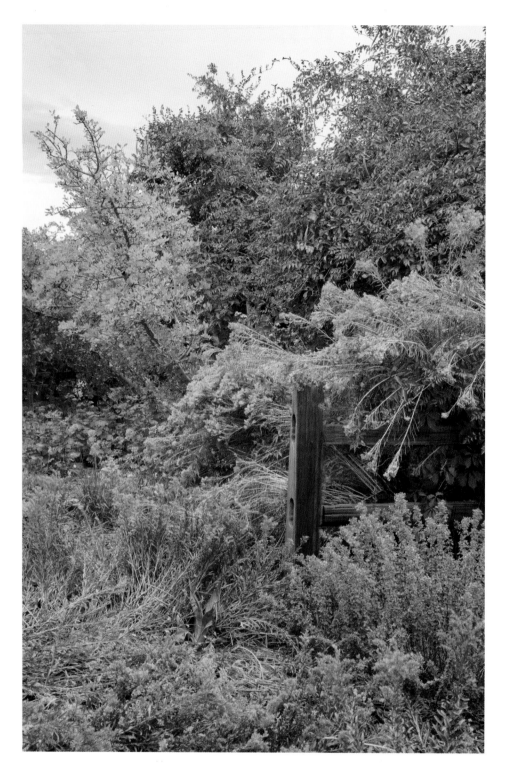

← On the eastern side of house, moving toward the back garden, goldenrods (*Solidago*) and rabbitbrush (*Ericameria nauseosa*), which is known as chamisa in New Mexico, blend together. The pale green native New Mexico privet (*Forestiera pubescens* var. *parvifolia*) leans over a patch of heritage raspberries and native golden currants (*Ribes aureum*).

→ In the cool shade of the back garden, giant sacaton (*Sporobolus wrightii*) plays the starring role, with goldenrod (*Solidago*) at its base and Mojave sage (*Salvia pachyphylla*), Lindheimer's muhly (*Muhlenbergia lindheimeri*), Parry's agave (*Agave parryi*), White Sands claret cup (*Echinocereus triglochidiatus*), and *Artemisia versicolor* 'Sea Foam' adding seasonal color and texture in turn throughout the year.

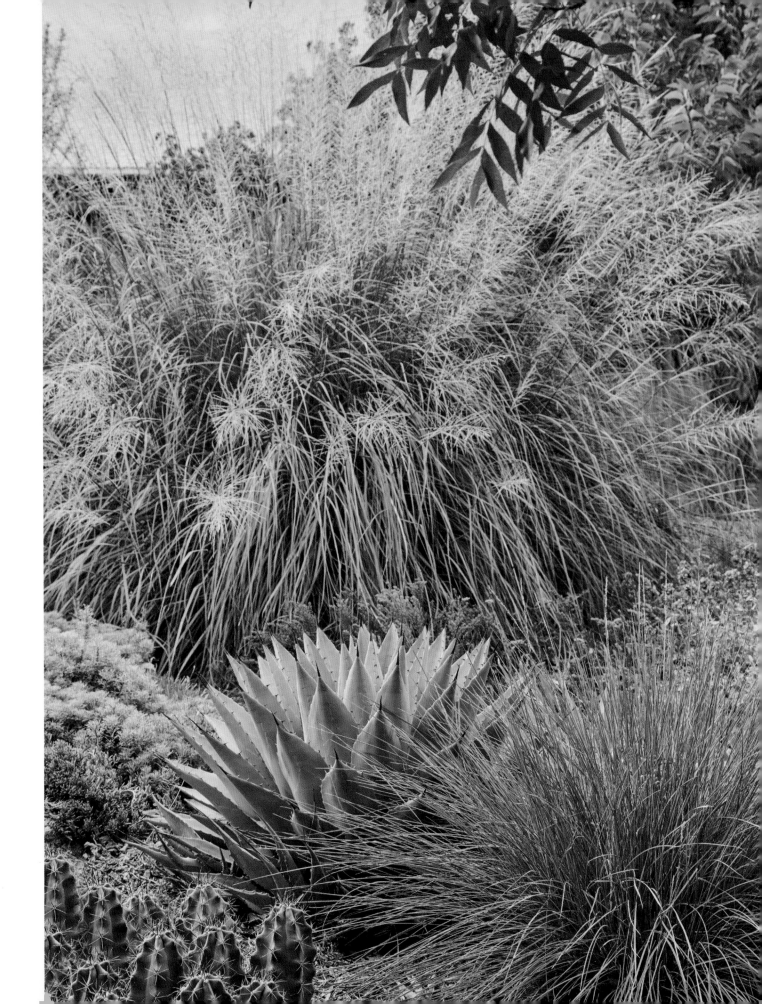

MARFA GARDEN

JIM MARTINEZ *and* JIM FISSEL

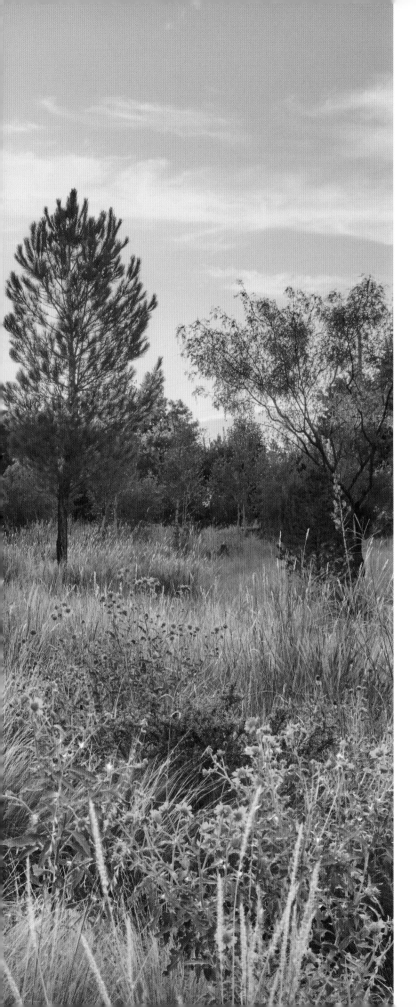

The Place

Marfa, a small city in the Trans-Pecos area of far West Texas, might seem an unlikely spot for a garden delivering messages of beauty, diversity, and sanctuary. The Chihuahuan Desert landscape appears sparse and has often been described as unforgiving.

At an elevation of just under 5000 feet, the region receives 16 inches of precipitation annually, with the vast majority coming with the monsoons from late June through early September. While there is more total annual precipitation than many strictly defined desert regions (less than 10 inches), most of Marfa's rain comes all at once, resulting in a glorious late-summer green and blooming period, but leaving the landscape drier than most for the remainder of the year.

The Rio Grande and its rift form a natural boundary to the south, and the Davis Mountains lie to the north and west. Ancient volcanic activity formed the upland grassland, known as the Marfa Plateau. In the past thirty-five years, Marfa's reputation as an avant-garde art and architecture/design hub has grown due to the Chinati Foundation,

a contemporary art museum on a former military base and known for its founder, Donald Judd, and his large permanent outdoor installations.

Garden designer Jim Martinez and his partner Jim Fissel first came to Marfa in 1997 to attend an art and architecture symposium at the foundation. Avid hikers and native plant enthusiasts, they had never been to this part of Texas and were amazed at the number of trails in the area—the seminal Guadalupe National Park is farther north, on the border with New Mexico, and the Chisos Mountains and Big Bend National Park are to the south. Marfa reminded Jim Martinez of where he grew up in northern New Mexico, where "grasslands run right up to mountains" in a similar way, the grasslands and scrub plants are distinctively aromatic, and "the light is very clear."

A year later, the two bought land on the northwestern edge of Marfa as a hiking outpost and a place for them to eventually create a home and garden, to live lightly on the land, and to experiment with the native plant diversity of the Chihuahuan Desert. Today, it offers them sanctuary and is home to myriad birds and other wildlife.

The People

Jim Martinez comes from cattle ranchers and gardeners. "My grandmother was a midwife and an herbalist," he says, remembering how she would wait for his two-week visit each summer to go hiking and collect the particular plants and herbs she needed. "She taught me how to collect without over-collecting. . . . She never shared

← A closeup look at the curated native grassland extending out from the main house. It is seeded with twenty to thirty different grasses and interplanted with native wildflowers, such as Mexican hat (*Ratibida*) and tickseed (*Coreopsis*).

→ This exterior entry court-yard features a serene and minimalist planting. The honeylocust (*Gleditsia triac-anthos*) provides canopy to a chisos rosewood (*Vauquelinia corymbosa* subsp. *angustifo-lia*), an upright *Yucca rostrata*, and an assortment of *Agave parryi* subsp. *neomexicana* and *Agave victoriae-reginae*.

her sources, but she always shared her knowledge. This was the land and plants of Native peoples." He describes his background as thirty percent American Indian, thirty percent Hispanic, and thirty percent "everything else you can think of."

Jim earned a degree in soil science at New Mexico State University in Las Cruces. His knowledge and love of the native plants of the desert West deepened while working for the U.S. Forest Service, which taught him about the plants and land of the Cibola National Forest and other areas of the San Mateo and Magdalena Mountains near Albuquerque. After working in the landscape industry in Austin and Dallas for two years, he started his own company, Landscape Contractors, Inc., around 1982. It even-tually grew to fifty employees and several partners/landscape architects, with Jim working fifteen-hour days. In 1990, for his own well-being, the company divided into smaller constituent parts, and he focused solely on design.

While Jim Martinez is the lead gardener of the two, Jim Fissel's input is invaluable, and they are "in it together." Jim Fissel is a user interface designer, and he creates 2D and 3D CAD garden drawings for Jim Martinez.

The Plants

The Marfa Garden was designed and created as a showcase garden for the unique range of plants found in the Chihuahuan Desert and the high plateau. "The Chihuahuan Desert has about thirty-five hundred native plant species. People think it

has very few and that they are all prickly. I wanted to introduce people to the plants of this area that are available at nurseries and to demonstrate that once they are established, they need very little from us and yet they give and give back," Jim Martinez says. He estimates there are upward of eighty or ninety distinct species in five areas of the garden: entry, southern exposure, eastern slope, forest, and grassy meadow.

"When I found this one-acre property in the northwest part of town, away from the town center, there was no water. So the first thing we did was to have a well dug," Jim Martinez recalls. They spent five years saving the money to build the house, during which time he was on the land every month, planting and establishing native trees. "The first trees were native live oaks [*Quercus fusiformis*] that grow in these mountains, and some littleleaf walnuts [*Juglans microcarpa*], which are found in the washes here." In time they also fenced the property for privacy and to deter javelina and antelope, both of which are "big issues" in the area.

The two positioned their new house so that the layout maximized the private back garden, with the living space oriented toward the garden rather than the street. They sculpted the land and incorporated a passive system of swales and diversions so that the water from the buildings' rooflines comes back into and irrigates the front garden. Shed roofs and stucco exteriors settle in with the landscape, and as a result of generous porches interfacing with the gardens, "there's as much exterior living space as interior."

When they first began working on the property, it was three-quarters grassland, half of which they left in its natural state. In the other half, gardens "revolve around new east- and north-side exposures and shelter and slope aspects," Jim says. "These areas most reflect the plantings of the mountains and the Chihuahuan Desert, but all reflect what is happening in nature."

After digging the well, establishing new native trees, and grading the land, Jim Martinez set to work clearing out a dead Arizona cypress hedgerow and lifting the canopy a bit. He experimented with planting the understory with plants that are less cold hardy, which gave him a good sense of what plants he could push beyond normal hardiness zones. Over time, this has become a woodland seam along the edge of the grassland, providing an aesthetic frame as well as a wind and privacy screen. On the sloping southern aspect created by the main house, he planted the caliche soil with littleleaf leadtree (*Leucaena retusa*), underplanted with agave, a blue variety of ephedra, and candelilla or wax plant. Although people often place agave in the open, Jim says, "They're under the canopy of trees here because when you see them in the wild with a little protection, they look and do better. These are little vignettes of what happens in nature." He notes these kinds of details while hiking and learns from them.

→ Looking east between the main house and guest houses, *Yucca rostrata* and native soaptree (*Yucca elata*) punctuate the pinyon pine (*Pinus edulis*) grassland feel. Perennial woolly paper flowers (*Psilostrophe tagetina*) intermingle with the grasses.

↘ The grassland diversity feathers out to conifers and other small trees closer to the house for wind and shade protection.

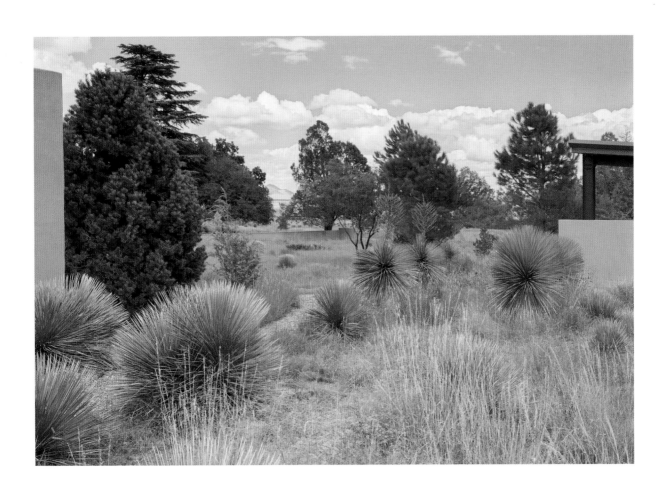
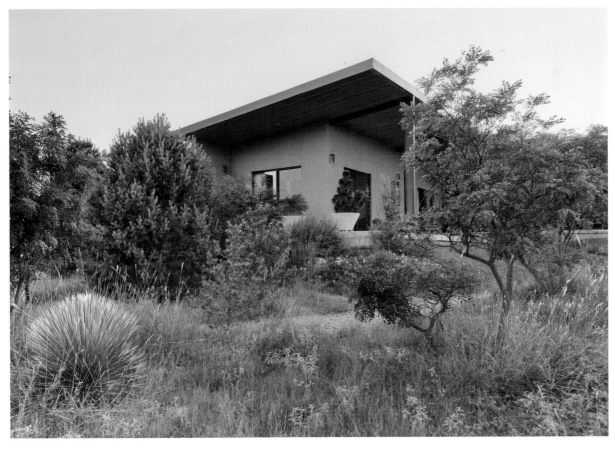

← Arizona cypress (*Cupressus arizonica* 'Blue Ice') frame a seating and fire pit opening in the grassland while looking back at the guest houses.

On the east-side slope, Jim Martinez has fashioned what he thinks of as the Bee Garden with antelope bush (*Purshia*), West Texas grass sage (*Salvia reptans*), and *Caryopteris*, the last being nonnative "but loved by the bees." On the northern side is the original grassland that was a mixture of weedy plants and natives and nonnatives and was heavily impacted by construction of the buildings. Jim reseeded the area with a native grass mix and then mulched with cutback from other grassy areas. "It took about five years to get it re-established, but we did it." There's another representative forest area between the native grass meadow and the meadow right around the house, planted with native Texas persimmon, desert willow, desert olives, and pinyon. Jim continues to seek out and experiment with native choices. He estimates that close to ninety percent of the selections in the garden are regionally native.

People ask frequently how much time this garden requires, and Jim Martinez's quick response is, "If I spend two hours a week, that's a lot. It doesn't require much, but consistency is really important." The grassland is cut back once a year in late winter. He deeply waters especially trees and shrubs once a month in the area's dry winters, but cautions that "You have to remember how these plants evolved. People tend to kill our desert plants with overwater. They evolved to withstand the long eight or nine months of dry. Use it to advantage." He uses very little supplemental input in the garden, "The volcanic soils are super saturated in everything but nitrogen, so I do fix this by planting legumes everywhere I can, and there are a lot of native legumes. I sometimes use a low-grade organic fertilizer."

Marfa is also in the center of the southernmost edge of the Central Flyway Migration Corridor in the United States. Jim emphasizes that among his primary intents with this native showcase garden is "to support a wide diversity of birds. You can't attract and support birds relying on different seeds, berries, nesting materials, and insects each season if you don't have a wide range of plants."

The one thing not on the property was standing water, so Jim has placed cisterns in the landscape, which he cleans and fills daily. "To watch buntings pulling down the grass seed to eat—or rabbits, or even a little red racer coachwhip snake who got into the birdbath and was swimming around to cool off the other day—that's the joy for me. Sitting on my porch every morning and watching everyone, then every evening the flocks of birds that come in to water and take a bath. It's pretty nice. If you have this kind of activity in your garden, you are doing something right."

→ Climate-adapted Italian stone pines (*Pinus pinea*) planted at the house edge of the grassland, with pinyon pine (*Pinus edulis*) nestled against the house beyond. A variety of *Yucca* species and interplanted perennial and annual wildflowers add height, texture, and color to the grassland.

↘ Woolly butterfly bush (*Buddleja marubiifolia*), blackfoot daisy (*Melampodium leucanthum*), and a small red penstemon thrive in a gravel path tucked next to natural rocks.

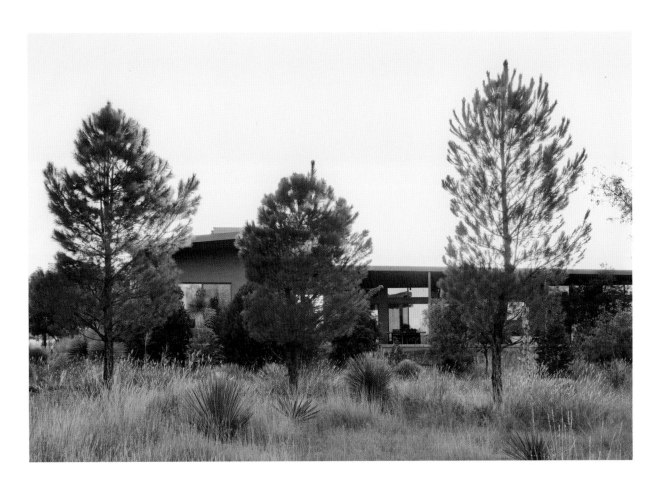

THE CAPRI

VIRGINIA LEBERMANN *with*

CHRISTY TEN EYCK

The Place

The Capri is a restaurant, bar, and garden. The garden is one part West Texas beer garden and one part ancient-seeming oasis, tapping into the deeply human need for communal refreshment and replenishment after long stretches—metaphorically or literally—of wandering in the desert. Virginia Lebermann opened The Capri in 2009. Since 2003, when she and partner Fairfax Dorn opened Ballroom Marfa, a nonprofit contemporary cultural arts space, they have helped to grow Marfa into an avant-garde arts and ideas town. "My focus [at The Capri] was to have a community gathering space in a Chihuahuan Desert native garden. The desert has a such a vibrant and compelling mystery. There are pockets of abundance out there, and I felt like we could emulate that somehow," says Virginia. "I wanted the fullness of the desert flora."

The Capri's main building sat abandoned—a former hangar from the days when Marfa was an active military base from 1911 to 1946—on a 2-acre site in the middle of town. It was "a really big, cool, old adobe building surrounded by beat-up old black top," says Christy Ten Eyck, founder and principal of Ten Eyck Landscape Architects in Austin. She

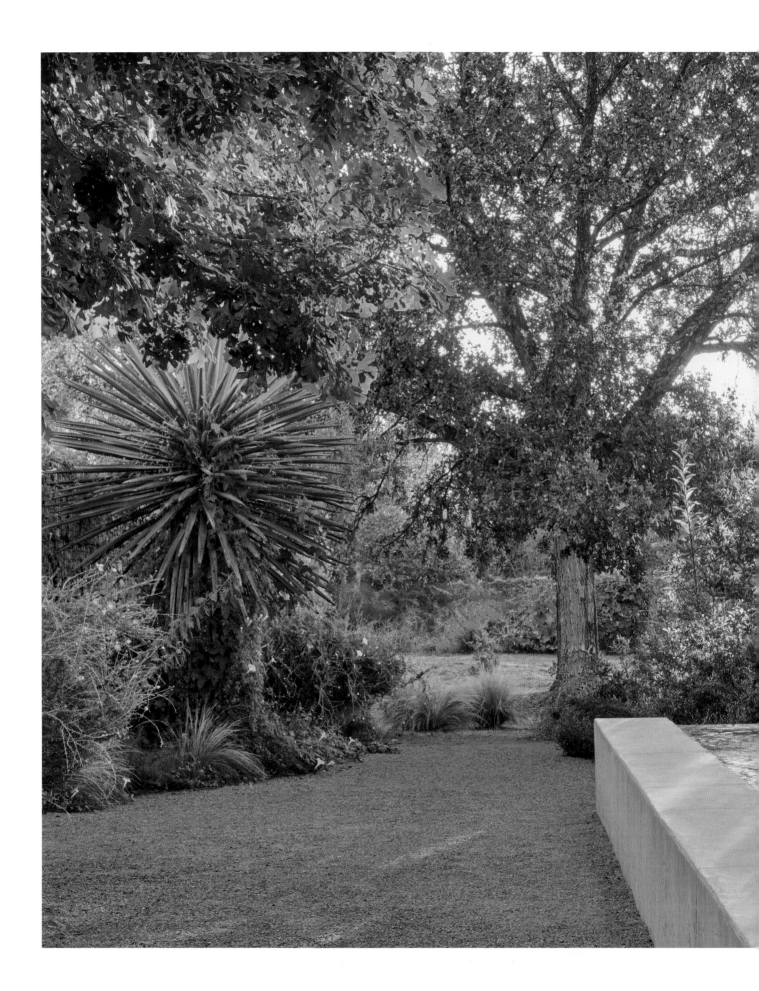

PREVIOUS PAGES: The front entry to Virginia Lebermann's iconic Capri restaurant in Marfa makes it clear that the Christy Ten Eyck–designed landscape is as intentional as the food and interior atmosphere, all of which are proudly "modern and very West Texas at the same time." Ornamenting the shade structure designed by Lake Flato architects are Ten Eyck–designed steel gates and gabion walls, offset by native desert honey mesquite (*Prosopis glandulosa*), ocotillo (*Fouquieria splendens*), *Agave parryi* var. *truncata*, and agarita (*Mahonia tri-foliolata*), with several cacti for even more texture.

← A cast concrete trough fed by the building's gutters is the central element of the beer garden. A mature Mexican elderberry (*Sambucus nigra*) grounds and softens the architecture of the fountain. Against the far gabion walls, bur oak (*Quercus macrocarpa*) and king dagger yucca (*Yucca faxoniana*) are silhouetted, softened by Apache plume (*Fallugia paradoxa*).

recalls visiting the site the first time, seeing an ephemeral creek with some scrappy cottonwoods along one side and a larger bur oak. She could just see the signs of how water moved across the space in a sort of swale cutting diagonally across the parking lot. "I live and work in drought-frequented areas as well as places that can receive inundating rains with flooding. So I am obsessed a bit with the absence and presence of water. Many times in our work, the path of water is only a memory, but it is an element I believe that is essential for people existing in arid lands."

The People

Virginia Lebermann grew up in southeastern Texas, where her family has ranched since the 1840s. "I've always been in wide-open spaces," she says. After deciding to take on The Capri as an idea and a reality, Virginia knew Christy Ten Eyck was right for the project. She had long admired Christy's design abilities but especially in that vernacular. "To see from the ground up is difficult," she affirms. "I put all of my faith in Christy's abilities and relied on Christy's eye."

Christy was born in Dallas. Her father worked for Mobil Oil, which meant a lot of moving around as she grew up. She earned a bachelor's in landscape architecture at Texas Tech University in Lubbock. Christy first built a name for her professional practice in Phoenix, Arizona, but she is clear that "Texas is home." She has lived in and worked out of the Austin area since 2011.

→ Two striking king dagger yucca (*Yucca faxoniana*) grow against the garden's entry gabion wall.

↙ The Hilfiker ArtWeld gabion walls are filled with rock from nearby Van Horn, Texas. Native live oak (*Quercus virginiana*), *Yucca rostrata*, and *Yucca pallida* add height and structure to the plantings, while Mexican feathergrass (*Nassella tenuissima*) and the low native silver ponyfoot (*Dichondra argentea*) add softness and movement.

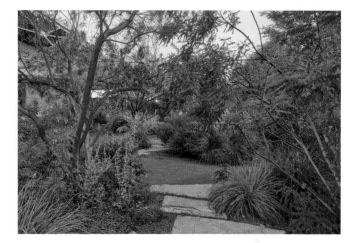

↑ TOP: In addition to the main beer garden courtyard, The Capri's garden features walks through the orchard, vegetable garden, and naturalistic back corners. Here a pathway leads into the wilder garden through an overstory of desert willow (*Chilopsis linearis*) and acacia (*Acacia berlandieri*) under-planted with *Muhlenbergia rigens*.

↑ ABOVE: Heading into the back beer garden at The Capri, a freestanding gabion wall constructed from local rock is offset by a single structural desert willow (*Chilopsis linearis*), under-planted with Mexican feathergrass (*Nassella tenuissima*) and deer grass (*Muhlenbergia rigens*).

← *Vitis* 'Roger's Red' climbs the rustic arbor framing the view from the beer garden out to the meadow and fruit tree orchard.

Christy says, "I'm a believer in owning your geography and being proud and supportive of each special place in the world. . . . Like Lady Bird Johnson said, 'I want Vermont to look like Vermont, and I want Texas to look like Texas.'" In Christy's experience, "There's so much reward in using the tough native plants that have the strength to carry on through drought, freeze, and flood, and that's what these plants have to do. A lot of people walking around Marfa might not ever actually get out in the landscape, but the garden at The Capri gives them the chance." She is also inspired by how people living in these climatic conditions throughout history have resourcefully adapted to their environments—capturing, directing, and holding water and using microclimates to site plants for water and exposure needs.

The Plants

A primary objective in The Capri gardens was using the plant palette of the surrounding desert, but "not minimalistic—rather lush, flexible plantings" to accommodate the many kinds of gatherings the venue would host, from intimate dinners to full musicals and other artistic performances. Virginia also requested lots of smaller spaces within the larger garden.

Christy laid out a design based on how water would move naturally across the space. She included distinct areas for a vegetable garden, orchard, beer garden with a rain fountain, fire pit, meadow, entry, and parking. Throughout there are stone gabion walls to help define spaces as well as rainwater cisterns and smaller water elements. The central rain fountain in the main patio area is fed by the gutters of the main building. When it comes alive, "It makes rain a celebration and an event of its own." The fountain is recirculating, but in periods of rain it overflows, and swales and arroyos redirect the excess into the orchard and meadow.

In the wilder beer garden area, Christy incorporated blue and sideoats grama, Mexican elderberry, native mesquite, desert willow, Apache plume, and shrubby dogweed (*Adenophyllum*). In the existing ephemeral creek, they added bullgrass and alkali sacaton. Cottonwoods were present along the side creek, so they brought a few into the garden as well. They planted a little orchard of apricots, peaches, and apples and used *Yucca faxoniana*. Christy also added some native live oaks to the interior of the garden.

Although Christy oversaw the design and install, Jeff Keeling became The Capri's staff botanist. "He's really expanded the diversity of natives we have," says Virginia proudly. "He propagates specimens from my family's ranch, and he works with local growers of native plants from New Mexico and throughout Texas." Jeff estimates there are close to 400 species in the garden.

Now that it is mature and has proved that it can frame both human celebrations and the changing seasons, the garden has far exceeded all of Virginia's expectations and

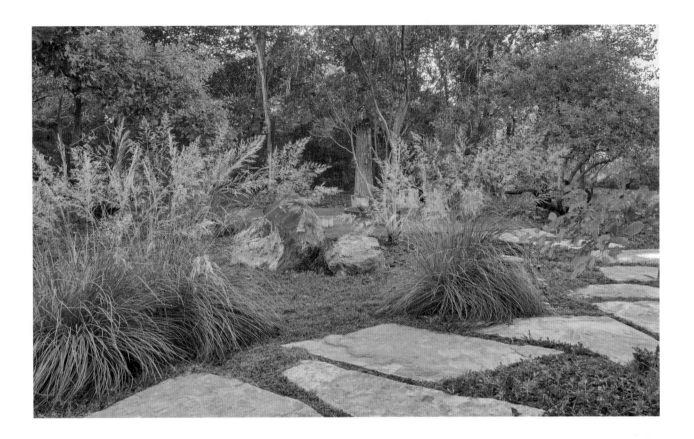

↑ Heading to the wilder gar-
den, the pathway transitions
from local Van Horn flagstone
to decomposed granite. The
corner in the path is drama-
tized by a stand of mature
bullgrass (*Muhlenbergia
emersleyi*).

her husband's, Rocky Barnette, who is also the head chef at The Capri. "The garden
was planted with tiny starts. . . . I believe plants want to create their own forms and
relationships as they grow, so best to start small and young if not from seed," Virginia
says. In terms of care, there's very little supplemental feeding—fish emulsion, if
anything, on an as-needed basis. "The flush of green in the monsoon is amazing," but
even in winter "when the space is at its most sculptural," it moves her.

The garden "felt like it took a long time to mature, especially with one of the most
severe droughts on record in Texas between 2010 and 2013," Virginia remembers,
and she sometimes wondered if it would ever grow out of its awkward juvenile
stage. "Then magically, it did. The process of it growing in has only added to the
richness of it."

In a perfect embodiment of the nature of us as humans and our health and makeup
being deeply intertwined with the food we eat and the land it came from—and how
when our food comes from the land we live on, we are very literally one with the
land—Rocky routinely incorporates edible flowers and greens from throughout The
Capri gardens into the menu throughout the seasons. Not just fruit from the orchard
or grapes from the vines, but greens and flowers "like yucca blossoms" from the
native Chihuahuan Desert plants.

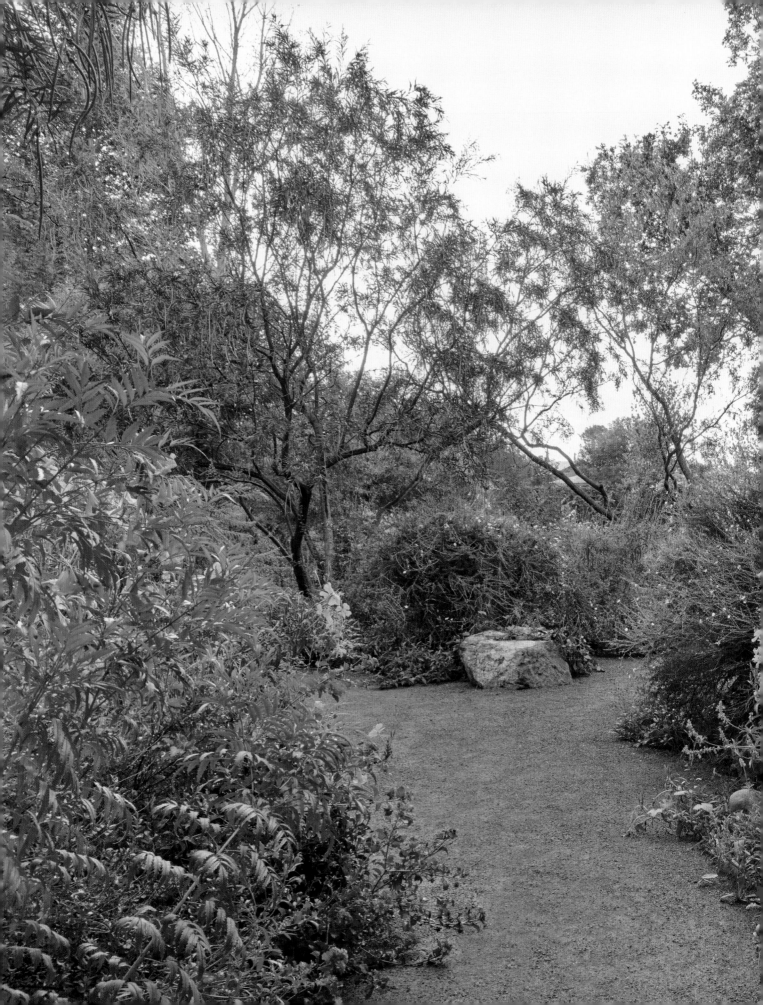

← These drought- and heat-adapted selections are presented with an intentional lushness that belies the climate in which they thrive. Here the diversity includes honey mesquite (*Prosopis glandulosa*), desert willow (*Chilopsis linearis*), esperanza (*Tecoma stans*), *Lantana horrida*, *Salvia greggii*, desert senna (*Senna covesii*), *Salvia farinacea*, and an evening primrose (*Oenothera*).

101

THE CAPRI

SOUT
CALIF

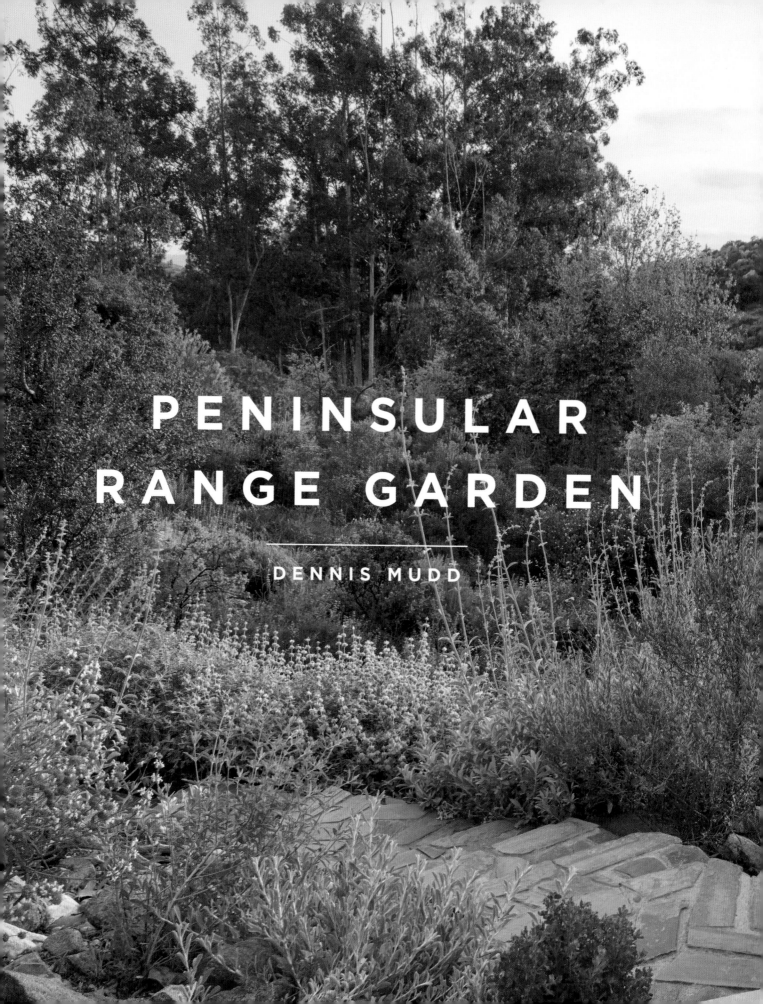

PENINSULAR RANGE GARDEN

DENNIS MUDD

The Place

"The foothills of Southern California's Peninsular Ranges, in particular the coastal sage scrub, the chaparral, the riparian lands, and the oak woodlands" epitomize the natural beauty here, reflects Dennis Mudd, a tech executive and the founder of Musicmatch, Slacker Radio, and Calscape. "It's absolutely fascinating how it all fits together, how everything relies on everything else, everything has its place. There's this harmonious inter-relationship between the plants, animals, weather, and land forms. It's joyful to watch this in motion."

Dennis and his wife, Pam, have aspired to create an equally rich and diverse native plant oasis in their home garden outside of San Diego. In the wild interior foothill slopes of the southern coastal scrublands, a mounding gray-green mosaic of plants blankets the hillsides, sweeping around and cushioning large, pale, weather-smoothed granite rock formations. Up close, you get a sense of the rugged harsh-ness of the complex ecological community that survives seven to nine months with-out measurable precipitation. The spiky, glaucous, aromatic dryness of *Artemisia*, *Yucca*, golden yarrow, cacti, white sage and other *Salvia*, *Eriogonum*, *Mimulus*,

and more create low-growing forms sculpted by year-round wind and sun. By some estimates, less than fifteen percent of this unique habitat remains in its natural state due to intense urbanization throughout the Los Angeles and San Diego Basins.

Winter rains (an average of only 2.5 inches in each of January, February, and March) course over and around, down and through the intricate topography. The areas near larger native oak, manzanita, toyon, sugarbush, ceanothus, and wetter riparian areas are what Dennis describes as "islands of fertility," which have taught him how plant colonies have coevolved to live together in these unique and exacting soil and weather patterns.

The People

It was the mountain biking that did it. Dennis Mudd took up biking in the hills around his home as a way to "keep his head on straight" while working long and intense hours as a software developer. The more he biked, the more he noticed. Eventually, he began slowing down and even stopping to look closely at flowers, plants, trees—at whole landscapes. He noticed their seasonal transitions and the quality of the air, the colors, the scents, the light. Not a plant person by upbringing, Dennis became deeply connected to the nature surrounding his home. In time, he decided to try and bring the feeling of well-being this place offered him into his own garden.

Nearly twenty miles east of the coast, in USDA zone 9a–10b/Sunset Zone 7, the Mudd garden is close to 7 acres. It comprises the original 2-acre suburban parcel purchased

PREVIOUS PAGES: Dennis Mudd's native plant garden draws inspiration from local drought-adapted chaparral and supports both plant and wildlife biodiversity and health. The stairway leading from the house into the lower parts of the garden is full of long-blooming perennials for nectar and pollen, including the aromatic and rare San Diego willowy mint (*Monardella viminea*), sawtooth goldenbush (*Hazardia squarrosa*), California aster (*Symphyotrichum chilense*), and the sages *Salvia dorrii*, *Salvia apiana*, *Salvia mellifera*, and *Salvia clevelandii*. Larger shrubs include bigberry manzanita (*Arctostaphylos glauca*), which provides early-spring flowers and late-season berries, and coyotebrush (*Baccharis*), which provides much-needed late-season flowers.

→ Entering Dennis's large suburban garden, the lush wildness of it is a welcome surprise. Here, a large Engelmann oak (*Quercus engelmannii*) provides canopy over the entry plantings of black sage (*Salvia mellifera*), California fuchsia (*Epilobium canum*), bush sunflower (*Encelia californica*), and woolly blue curl (*Trichostema lanatum*). California poppy (*Eschscholzia californica*) provide flashes of bright orange in season.

← The hillside border between the bocce ball court and the house features sweeps of larger native dryland perennials now grown together under the coast live oaks. Yellow bush sunflower (*Encelia californica*) and purple sage (*Salvia dorrii*) stand out in the early summer season.

← The wildland canyons and hillside portions of Dennis Mudd's property outside of San Diego are home to native grasses, rabbitbrush (*Ericameria*), and *Yucca*. The diversity and tenacity of these Southern California chaparral ecosystems is what informed and inspired the native plant garden he now tends around his home.

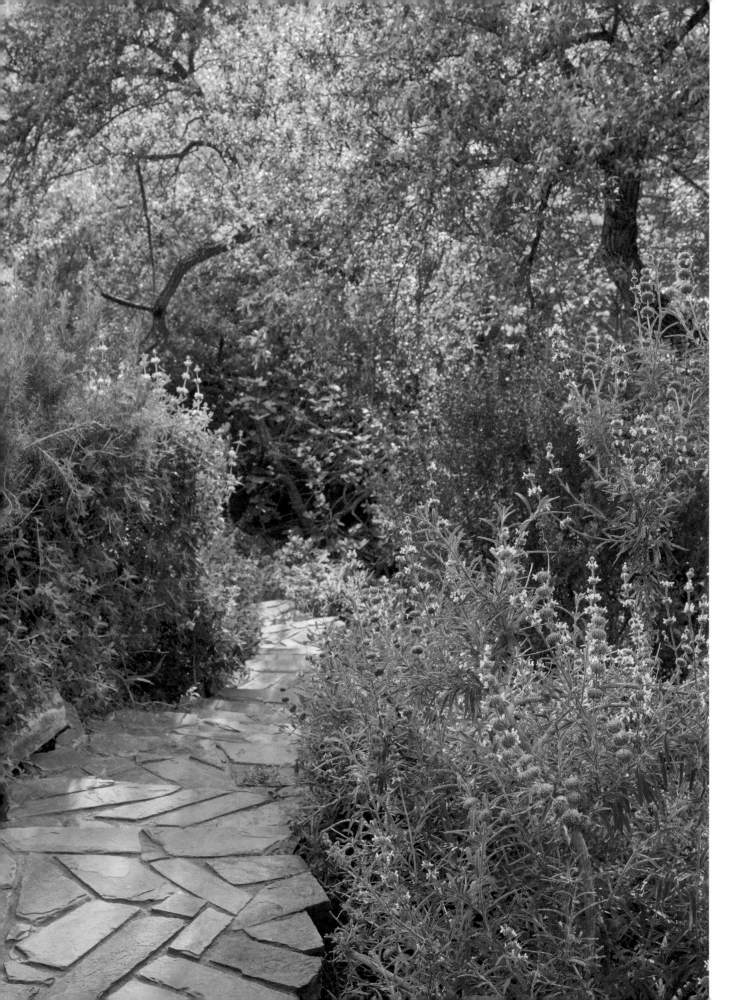

← Along a walkway leading down into Dennis's constructed riparian garden, native *Salvia* species and California sagebrush (*Artemisia californica*) are sheltered beneath the canopy of red willow (*Salix laevigata*).

almost twenty years ago and behind that an additional 5 acres of native habitat in a south-facing canyon.

Dennis began to transform the cultivated area around the house in earnest almost ten years ago. He got through a few false starts with a professional landscaper who installed a drought-tolerant—but not native—plant garden and then a native plant expert who installed plants that were native to California, "just not native to this exact region and they couldn't survive our low rainfall and hot dry summers."

By his own admission, Dennis was not a good plantsman at the outset of his garden project, but he *was* good at understanding and developing systems. He eventually learned to trust his own intuition. He began to research and observe his area's truly native and endemic plants and their relationships to one another, the topography, and soil type. He turned to native plant nurseries of his area, reference books on plants of San Diego County, and to the many decades of accumulated knowledge and information held in the University of California, Berkeley's Jepson Herbarium and in the ranks of the California Native Plant Society.

The Plants

Restoring the nature of his garden with aesthetics and diversity in mind, Dennis mimicked nature's plant pairings and placements, paying "particular attention to the elevation they preferred in the wild, as this is a pretty good proxy for how much water they need." For irrigation, he created artificial riparian areas, which mimic natural seasonal creeks, seeps, and washes. In winter they serve as water catchment basins. In summer he irrigates just these artificial riparian areas. "They add water into my ecosystem just like natural creeks and ponds add water to dry areas during California summers. The water seeps down into the soil and it's up to nearby plants to reach their roots out to the moister riparian soils." The larger shrubs and trees "reach their roots out sometimes thirty to sixty feet laterally and as much as sixty feet down" and then pull water up and share the moisture supply with the smaller plants around them.

Planting at the very beginning of the rainy season and watering plants by hand as needed in the first year, "especially now that the soil is so healthy" and Dennis is much "more attuned to where specific plants want to be in the topology and in their plant communities," has really improved plants' establishment rate and long-term success. Dennis avoids drip irrigation altogether, which he found through experience and research limited plant root growth and association with other plants' root systems, thereby discouraging the rich mycorrhizal life created by these root networks in healthy native soils.

"The plants work together. Some growing toward the sun, some growing toward the shade of another to get away from the summer sun," he marvels. These kinds of

"adaptations and cooperative strategies to survive never fail to fascinate me." Even the way the plants brown up in midsummer and retreat into a protective dormancy is remarkable to him. "The most amazing thing of all," he shares, "is to then see these plants and this land when the rains arrive," most commonly in December. "It's wonderful. There's an explosion of greenness, flowers, and wildlife."

Dennis says that the plants are "just half" of what inspires him now. He admits he "knew very little about insects, butterflies, birdlife, or lizards." In the first few years of the garden restoration, the rabbits, mice, and gophers increased to the point of obvious imbalance, but he refused to use poison or other harmful eradication methods. A family of great horned owls settled into the garden, and all Dennis had to do was watch as the equilibrium returned.

He purposefully increased his efforts to provide wildlife habitat. In 2017, the Mudds even transformed their chlorinated swimming pool into a naturalistic pond, incorporating "native endemic aquatic plants: cattails, bulrushes, seep monkeyflower, willows, spiny rush, scarlet monkeyflower all around the pool edges." Delicate southern maidenhair ferns fill the crevices of the rock falls created to mimic the rock formations of the foothills. With the introduction of fresh moving water, "the insect life, ninety-nine percent of which have no interest in humans and all of which are critically important to the wildlife food chain, has gone through the roof and so has the birdlife. Hummingbirds, blue, green, and night herons are regulars." The garden's botanical diversity brings in close to fifty different bird species throughout an annual cycle. In addition to birds, bass, bluegill, and crappie fish, which he researched for the pond, "turtles, bats, hundreds of dragonflies, and other insect predators provide incredibly effective insect abatement. It sometimes seems as though there's more life in the air than there is space in the air."

When asked about the importance of gardening overall, he responds with care. "I read a biography of a famous student of Alexander von Humboldt recently, a big advocate for the power of direct observation. There's a story of Humboldt asking his biology students to dissect a small fish and describe everything they saw. When they thought they were done, he said to do it again and look for more. After about a month of this, someone asked, 'What was the most amazing thing you saw?' and the response was 'How little I saw the first time I looked.' It's such a treat to be living my life here, surrounded by nature I get to see so carefully, so closely. The things I learn just by watching on a day-to-day basis are incredible. There are hundreds of other lives here—plants, birds, butterflies, moths—I'm living in a truly interconnected web of life."

→ Dennis rewilded what was a pool into this pond-like water element off the house. The fresh water has attracted a wonderful and healthy new diversity of insects and birds to the garden. Here the cheery yellow faces of seep monkeyflower (*Erythranthe guttata*) colonies grow along the rock and float on the water below with the help of light rafts Dennis secured there.

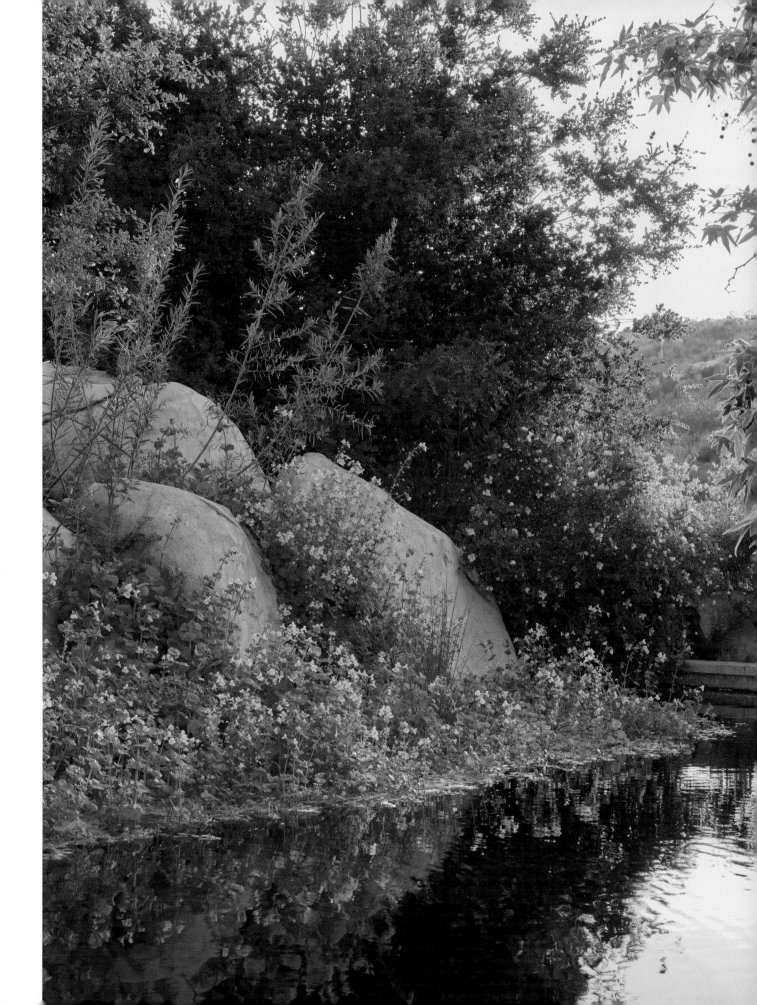

← Water-loving California bulrush (*Schoenoplectus californicus*) and southern cattail (*Typha domingensis*) grow in the naturalistic pond, with its rafts of seep monkeyflower (*Erythranthe guttata*) beyond. The white trunk of a sycamore (*Platanus racemosa*) gleams in the setting sun.

→ **CLOCKWISE FROM TOP LEFT:** A view down to the bocce court is framed by coast live oak (*Quercus agrifolia*) and coyotebrush (*Baccharis*) on the left, with showy penstemon (*Penstemon spectabilis*) spikes rising above. A striking chaparral yucca (*Hesperoyucca whipplei*) blooms behind the court edge.

Closeup of native companion plants in Dennis Mudd's garden. Yucca, artemisia, and yellow bush sunflower (*Encelia californica*) stand out.

An overview of the native plant garden to the native chaparral beyond seen through a scrim of *Salvia dorrii* verticillasters just beginning to fade. The repeating mounding forms, variety of textures, and varying shades of silver and green add dimension to the whole mosaic.

The entry courtyard has a casual structure to it, circling around a native western sycamore (*Platanus racemosa*).

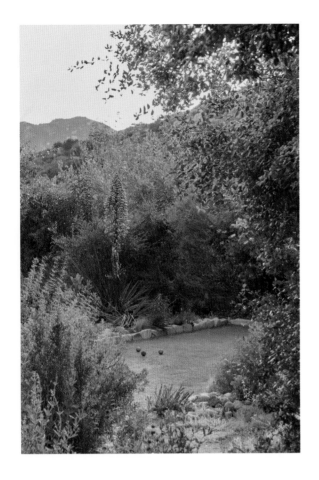

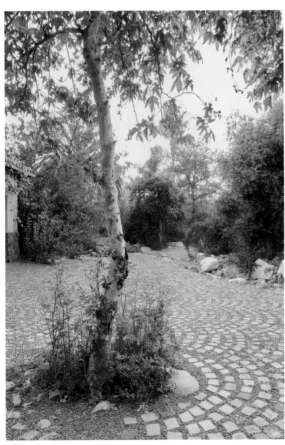

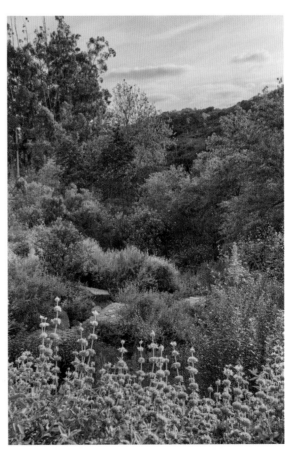

NATURE GARDENS

NATURAL HISTORY MUSEUM OF LOS ANGELES COUNTY

The Place

Nestled in the middle of the Los Angeles Basin, a bowl created by the rise of the Santa Ana and the Santa Monica Mountains on three sides, the city of Los Angeles has been an unrelentingly human-built environment for a long time. Wild nature at times seems very far away, yet a remarkably diverse urban nature persists in vacant lots and sidewalk cracks, in parks, and in gardens.

The Nature Gardens are 3.5 acres of designed landscape surrounding the Natural History Museum of Los Angeles County, situated in Exposition Park, just southwest of downtown. The Natural History Museum's centennial in 2013 inspired a major renovation of the building and grounds beginning several years before the event itself, including the transformation of what had largely been asphalt parking lot into the Nature Gardens, designed specifically to support and study urban wildlife habitat.

"The urban environment is something of a scientific frontier," says Carol Bornstein, the Nature Gardens' director. "Private property and public spaces—libraries, parks, schools, and commercial sites— are incredibly important in helping to

preserve or reestablish corridors that connect Indigenous vegetation because so much land is gone. The built landscape has the capacity to support plants and animals right here in the city. When every little piece of open urban land is put together, there's a lot to work with. It all makes a difference."

The People

Lila Higgins, the senior manager of community science, and Dr. Brian V. Brown, the curator of entomology and head of the museum's Entomology Department, also care for the Natural History Museum's Nature Gardens. The master plan for the project was developed over several years and was spearheaded by landscape architect Mia Lehrer and her team at Mia Lehrer + Associates (now Studio-MLA), an award-winning urban landscape architecture firm known for thoughtful and culturally resonant landscape solutions and designs in the Los Angeles area. Lila and Brian were part of a team of museum scientists who served as advisors to the designers, builders, and architects conceptualizing the urban ecological laboratory and habitat garden. Carol Bornstein joined the team in 2012; she contributed to the design of the California native Pollinator Meadow and the Get Dirty Zone and has steered the gardens since their opening.

Carol, a Michigan native, has degrees in botany and horticulture and is known for her advocacy for designing gardens with plants native to California and other summer-dry climate regions. Lila, who spent her early years in the United Kingdom, is an entomologist by training, coauthor of *Wild LA: Explore the Amazing Nature in and Around Los Angeles*, and a nature play advocate. Brian was born and raised in the Toronto area. For each of these transplants, the nature they found in Southern California was nothing like any of their birthplaces.

Sometimes an unfamiliar region's natural beauty is an acquired taste, one requiring a mindset shift. "For most living organisms, water equals life and lack of water is dangerous," Lila notes. "But when you change your concept of what is *enough* water—what water's presence, even in small amounts, looks like—your idea of beauty can change too. This happened for me in really getting to know the Mediterranean climate of Southern California." Similarly, overcoming the public's preconceived notions of beauty to make a meaningful space for habitat can be a basic challenge. For Brian, a garden that is not noisy with the life of insects and other fauna at all stages of life "is not beautiful, no matter what it looks like. It's lifeless." He saw it as his charge to help create a space for visitors that would convince them of the same.

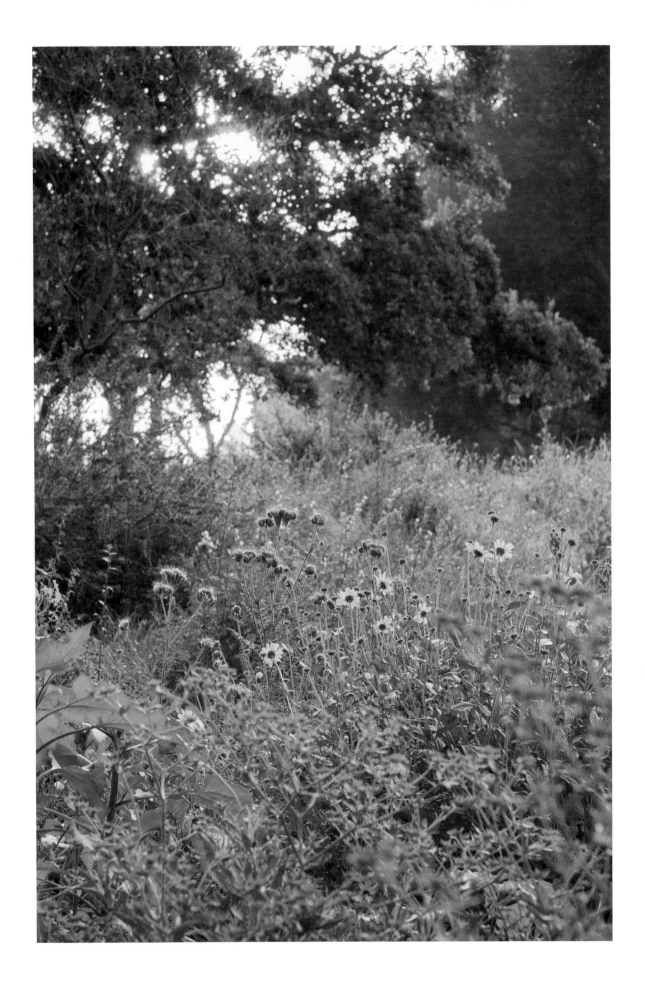

← CLOCKWISE FROM TOP
LEFT: Smaller *Agave victoriae-
reginae*, *Manfreda scabra*, and
variegated *Agave tequilana*
grow along the wall's base,
softened by the finer textures
of California fuchsia (*Epilobium
canum*) and sundrops
(*Calylophus berlandieri*). The
top of the wall is crowned by a
giant *Agave americana* flanked
by desert spoon (*Dasylirion
wheeleri*) and chaparral yucca
(*Hesperoyucca whipplei*).

The organic willow play struc-
ture by willow sculptor Patrick
Dougherty has been replaced
several times and is a favorite
element tucked into a green
corner of the garden's interac-
tive Get Dirty Zone.

A *Dudleya virens* subsp. *hassei*
enjoys the drainage and expo-
sure of its raised position in
the wall.

Against the trunk of this non-
native *Eucalyptus robusta*, one
of the few existing trees when
the Nature Gardens went in, a
vibrant blue tansy-leaf phace-
lia (*Phacelia tanacetifolia*)
shows off at one corner of the
native Pollinator Meadow.

The Plants

While the wilderness may be hours away by car for the more than 4 million residents
of Los Angeles, "the Nature Gardens help to make our nature more visible, in full,"
says Lila. This includes the landscape's history, along with its climate, plants, birds,
and insects. "The Nature Gardens is not a restoration project," emphasizes Carol. "It's
a creative, urban interpretation of a habitat garden. Every plant chosen has to serve
an essential habitat purpose." Fourteen distinct spaces wrap themselves, green and
relaxed, around the northern and eastern sides of the Natural History Museum, fea-
turing around sixty percent native plants and roughly 600 species in all. The Living
Wall features tall vertical shards of sandstone arranged to create raised planters and
plenty of crevices for small dry-climate plants and animals to lodge themselves in,
whereas the Edible Garden has more formal raised beds. The Pond is a large natural-
istic and restful water element. One of the two Pollinator Meadows is an expansive
all-native plant meadow in the far northeastern corner of the museum grounds; it has
something in bloom most months of the year, and a diversity of flower forms, plant
families, and colors to attract and support the widest diversity of visiting insects.
The other meadow features a mix of native and exotic species bordered by a formally
clipped native hedge.

"We wanted to tell the story of the plants and animals you might see in your own
backyard, on your way to school, or on your street as well as the story of the native
plants," Lila says of the original team's work with Studio-MLA. "We included intro-
duced plants that are drought tolerant and provide habitat, so it was not always an
either-or scenario," continues Brian. Nonnative plants are also integral to the cultural
history of the city, with an "evolved aesthetic" that's come to be associated with the
place but that is nevertheless distinctly different than the aesthetic derived from
native plants. Brian notes that plants such as "nonnative palm trees, eucalyptus,
jacaranda, and bougainvillea are often comfortingly familiar and orienting to human
residents of the city."

The team also wanted to help tell the story of water in the region. The Pond rep-
resents the headwaters of the Los Angeles River, which connect to a riparian wood-
land zone, which provides year-round water sources. The Dry Creek Bed reflects
the ephemeral nature and sources of water in Los Angeles, which are dry much of
the year. Finally, the very angular, concrete and stone Urban Waterfall symbolizes
the story of the Los Angeles River and many rivers in the developed West, which
are channelized with concrete in a way that's convenient for development, but very
disruptive to ecological systems, by constraining flooding, among other processes.
The riparian area in the garden's woodland and the Pollinator Meadow, says Carol,
"accurately reflects the dominant plants along creeks in the local mountain ranges,
and vignettes in the Pollinator Meadow are impressions of California's many grass-
land plant communities."

To create a meaningful habitat, Studio-MLA and the museum team worked to communicate complex realities, including such facts as: large expanses of glass in the built environment, though adding light to interior spaces, are a serious hazard on the exterior for birds; decomposed granite creates permeable pathways, but overused in expanses that are too large are also lost opportunities for plants and animals. Finally, they wanted visitors to understand that plants and animals evolved to live in an arid environment can cope with seasonal drought and the natural water cycles. "Preserving the dry landscape can be imperative to these plants and animals," Brian says. "Irrigation increases the presence of water-loving invasive plants and animals, which choke out natives. People say they love our native horned lizard, for example, which relies on native ants, such as harvester ants, as one of its primary food sources." Irrigated landscapes, he explains, have invited and encouraged nonnative, invasive Argentine ants, which exclude native harvester ants from an area, which in turn excludes horned lizards and in all likelihood whatever else feeds on native ants and horned lizards.

Healthy biodiversity, however, means wildlife is attracted to a garden "not just to visit briefly for nectar, but to fulfill a lot of their life cycle," which requires not just flowers, but trees and grasses that support "nesting, feeding young, hunting, and mating." Brian is finding the greatest number of insects in the "plantings along the edges of the Woodland, the Edible Garden with its year-round herbs and flowers, the native flowers and grasses of the Pollinator Meadow, and the fresh water of the Pond—so attractive to insects."

→ Near the *Agave americana*, a smaller *Manfreda scabra* provides scale and bright red fairy duster (*Calliandra eriophylla*) flashes warmly, while yellow-blooming brittlebush (*Encelia farinosa*) (above) and bush sunflower (*Encelia californica*) (below) add contrast to the blue-green color and massive forms of the agaves. Pale purple trailing indigo bush (*Dalea greggii*) fills out the scene.

↙ The naturalistic pond at the Nature Gardens supports an incredible diversity of birds and insects with its riparian and aquatic plant species, including western sycamore (*Platanus racemosa*). Native cattail (*Typha latifolia*) and yellow seep monkeyflower (*Erythranthe guttata*) root on the pond bottom and native maidenhair fern (*Adiantum*) does well in pocket plantings around the rock ledges.

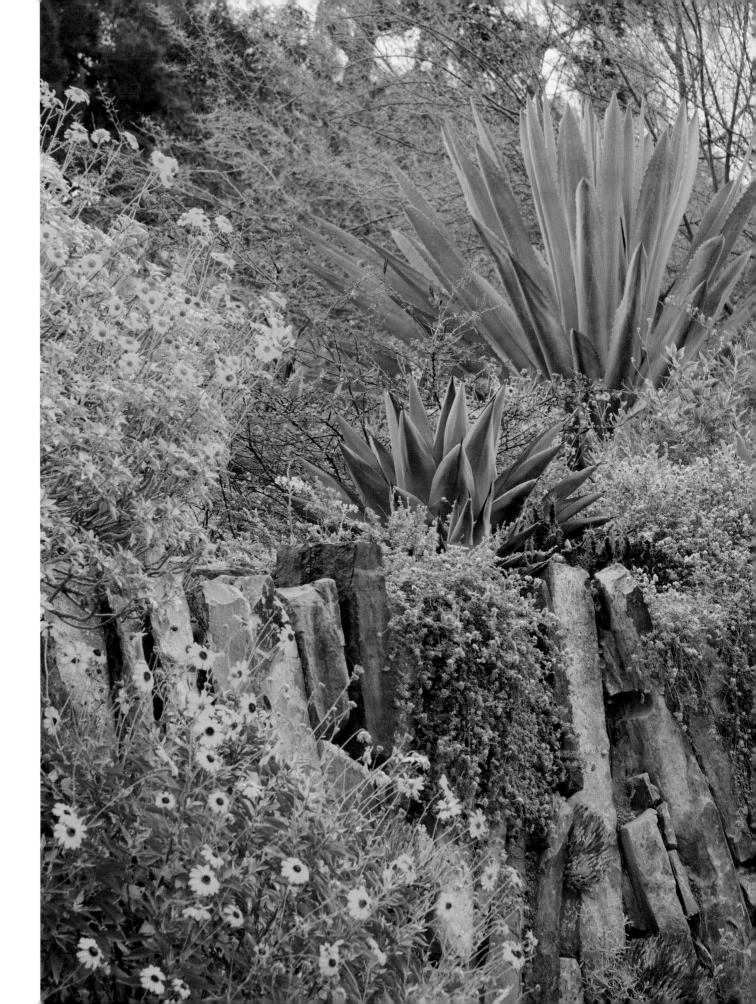

Lila happily reports that, "We've had three hundred five species of insects observed in the Nature Gardens . . . nine species of dragonflies and damselflies, which mostly rely on the pond because dragonflies and damselflies lay their eggs in water, fourteen species of butterflies, nineteen species of hoverflies aka flower flies, forty-five species of scuttle flies, sixteen species of bees, and thirty-four species of beetles—my favorite group of insects." A Listening Tree Station, where an amplifier below ground is connected to sensors on the roots of a coast live oak tree, allows visitors to hear in real time the water moving through the soil and into the tree roots, bringing to life otherwise invisible living systems.

Intentional design helps children and families to safely experience nature here in other ways, too. Hands-on activities are available throughout the garden, including in the Get Dirty Zone, which includes a nature build area, and in the Edible Garden, where staff-facilitated planting, harvesting, and washing stations are located. A Hummingbird Feeder Zone, a Bird Watching Platform, and an Urban Bat Monitoring Station are examples of the science being conducted in the museum's newly established Urban Nature Research Center.

→ In a lower portion of the garden, near the water play zone, a valley oak (*Quercus lobata*) provides shade for people and the underplanting of native *Carex*.

↓ A shady seating area beneath a nonnative cork oak (*Quercus suber*) allows visitors to look out across the Pollinator Meadow.

Another aspect of intentional design was "allowing people to be physically in every layer . . . as you move through the garden," says Lila. The design team harnessed an elevation gain of almost two building stories to help visitors "see straight into the tree canopy, look down over the whole watershed of the garden, and conversely look up into oaks, alders, walnuts, and sycamores from the lowest levels and play areas." Part of the job of the garden, says Lila, "is to help move people along the nature experience continuum," no matter where they might be on it. "As we lose more natural landscapes, the more unfamiliar we become with wild places." The Nature Gardens works to help visitors maintain or develop a familiarity and comfortableness with such wildness, and in turn to increase how and why we value the nature of that wildness, even in the city.

EDENDALE
GARDEN

DAVID GODSHALL

The Place

Echo Park is a densely populated neighborhood of central Los Angeles that was originally named Edendale. The neighborhood has an often-hilly nature and a somewhat bumpy history. Economic development began with the renovation and restoration of the Echo Park reservoir in 2005.

Resident and landscape architect David Godshall, cofounder of Terremoto Landscape, has lived in both Northern and Southern California. "While I'm deeply moved by and wax nostalgic for the accessible wild nature of Northern California, . . . when I think of natural beauty, I think of the nature I visit with most frequently right now and where I grew up," he says, speaking of the Angeles National Forest in the San Gabriel and Sierra Pelona Mountains. But, he adds, "I live in a layered, complex, densely populated city, and I find great beauty in the largely constructed landscape of the city as well. It's complicated."

Echo Park is culturally diverse, with more than half the population "Latino and here a long time, and the other half of the population young creatives making their way. Three doors down from us is a garden we refer to as 'Abuelita's garden.' It's a classic

Mexican-American garden cared for lovingly by an older woman. It's rich with roses and geraniums." None of those plants are native to Southern California, but "it comes from such a good place, you can tell the person who takes care of it loves it dearly." In another layer of the cultural history of plants in his neighborhood, he continues, "there's an invasive tree of heaven [*Ailanthus altissima*] forcing its way through a crack in the concrete behind our office, along with a tangle of other invasives. Even there, there's beauty in the information plants can provide to you."

David finds plants like these—and the pockets of native vegetation that grow alongside the neighborhood's steep historic stairways—examples of a "magical realness very specific to Los Angeles. It derives from the grim fact that people have developed this place monolithically. In so many areas, no remaining native vegetation exists. West of Highway 101 until more or less the ocean was once the reference point, botanically speaking. Now it's gone. It's all a complete construct, a fiction of sorts." While tragic in very real ways, David muses, if there's no going back, then what we make going forward is up to us. "We're free to pick our new destiny."

The Person

"In this moment of political polarization, resource scarcity, and ecological decline, it's important to build gardens that are appropriate, forward thinking, and ecologically robust. It's also important that we don't go about or think about our garden-making in ways that are polemical or more polarizing or puritanical," David declares of his own philosophy. "We need to allow room for nuance, interpretation, and gray areas because that's where there's dialogue and civilized conversations. . . . Native and non-native species *can* coexist. While this might seem like political allegory, I think the two things are inseparable."

David had "an idyllic childhood skateboarding around" in what he describes as the classic post-war California suburb of Tustin in Orange County. He did his undergraduate work in art and architecture at the University of California Santa Barbara and then moved to Echo Park. He worked for four years doing hands-on design and construction and got "a little junky apartment," which he improved by starting a "pretty intense" potted garden. His mother, upon seeing this, asked if he had ever considered landscape architecture, a profession he was not really aware of at the time.

Reading *City Form and Natural Process: Towards a New Urban Vernacular* by Michael Hough taught him that most standard landscaping supports almost no life, a "searing" revelation. David earned a master's in landscape architecture at University of California, Berkeley, and then joined Surfacedesign in San Francisco. After a few years, he and Alain Peauroi founded Terremoto, with David in a Los Angeles office and Alain in San Francisco. They are "spiritually united" in how they see, think about, and do work. *Terremoto* is the Spanish word for earthquake, or more literally, moving earth.

PREVIOUS PAGES: At the top of David Godshall's garden in Echo Park, an old *Jacaranda mimosifolia* provides shade, structure, and the wisdom of having survived there for a very long time. Looking from the interior of the garden to the front gate, David has added cooling silver-leafed and textural companions including common artichokes, white sage (*Salvia apiana*), and black sage (*Salvia mellifera*) cascading onto a wooden boardwalk. Just over the fence, a cutting-grown *Opuntia ficus-indica* 'Burbank Spineless' is a gesture toward the wild Echo Park hillside plants whose tenacity David admires.

→ On the street side of the front entrance, *Agave attenuata*, "collected from plants with pups in the neighborhood," stands out against the fine-leaved California buckwheat (*Eriogonum fasciculatum*), along with native sages (*Salvia*), *Artemisia* and *Dudleya*. "It's a partially native garden and partly culturally native," says David, "an interweaving of ecology and culture."

FOLLOWING PAGES: In this seating area outside the house, artichokes float around above perennials like St. Catherine's lace buckwheat (*Eriogonum giganteum*) and *Artemisia californica*. The taller shrubs are *Ceanothus* to the left and quailbush (*Atriplex lentiformis* subsp. *breweri*) to the right.

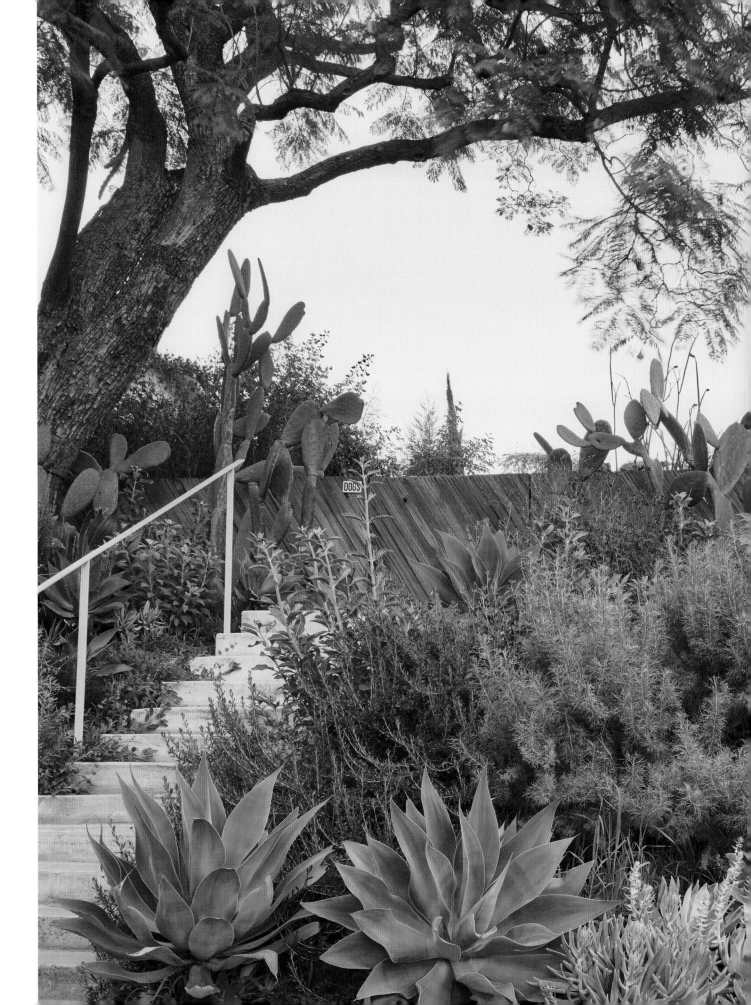

← In the upper garden, a sculptural piece of driftwood is framed down the walk by the old *Jacaranda mimosifolia* tree above, *Opuntia ficus-indica* 'Burbank Spineless' behind, and feathery cassia (*Senna arte-misioides*), white sage (*Salvia apiana*), and black sage (*Salvia mellifera*) on both sides.

→ "This little combination is like the cover of a cheesy romance novel," laughs David, who loves the contrasting forms, textures, and habits. A little white rose, in fragrant bloom for six to eight weeks early each summer, twines around *Opuntia ficus-indica* 'Burbank Spineless'. "It's a perfect Echo Park combining of worlds," he points out. "An attractive discord."

The Plants

Being versed in both horticulture and ecology can lead us to a place of constant judgment, seeing only what we deem to be ugly or insufficient. But David asks, "Does that get us where we want to be?" Finding the "layered, lovely marriage between beauty and function, design and heart" is important to him. "You can't talk about gardens and not be talking about philosophy."

David and his architect wife, Lauren, first planted their garden in 2013. "I started with an idea, but I tinker and bring things home to experiment with for work projects. And so there's no clear narrative." It's a living design in process. The garden is all in the front, spreading from the street side of their 8000-square-foot lot up to the diagonally arranged wooden-slat fence and then down gradually to their 900-square-foot house. For now, "the back is a wild, chaotic, happy mess."

The garden mostly comprises species native to Southern California, "because that's the ecologically important thing to do," David says. "And to their credit, they're magic. They work. I have to water them very little, and birds and lizards and spiders and other animals live with and interact with my garden, which I love." The overall feel is silver and succulent, an essence captured in free-spirited little white rambling roses twirling themselves around opuntia and agave.

← Sunlight pours down the quailbush (*Atriplex lentiformis* subsp. *breweri*) tunnel leading to the upper garden, while artichokes and *Salvia apiana* hold down the corner.

↓ A wide sweep of California buckwheat (*Eriogonum fasciculatum*), grows beneath the *Opuntia ficus-indica* 'Burbank Spineless'.

The garden feels lighthearted, fresh, and substantial all at once. The plant choices provide a "very particular, strong Southern Californian aesthetic, which I do wholeheartedly embrace," says David. But he admits there are also lots of "weird happy accidents and unlikely marriages." He points out a large old jacaranda, a flowering tree associated with Los Angeles since the early 1900s, when it was first introduced. It provides graceful age and scale, bloom, and habitat. "It would be a tragedy born of puritanical narrow-mindedness to rip it out, so it stays. Likewise, I have a giant *Philodendron selloum*, which I think collides poetically with the native black sage [*Salvia mellifera*] and yarrow [*Achillea*] that are next to it. This philodendron has no business being in Southern California, and yet here it is, and it feels at home."

The backyard also features a treehouse for their boys. David and Lauren have a basic philosophy of "open structure, loose spare parts," wood and sand and feral garden plants and a big piece of driftwood for climbing. David shares, "Allowing for nuance and unplanned fun in how I raise my children or plant a garden. It's my way of trying to be hopeful about the future."

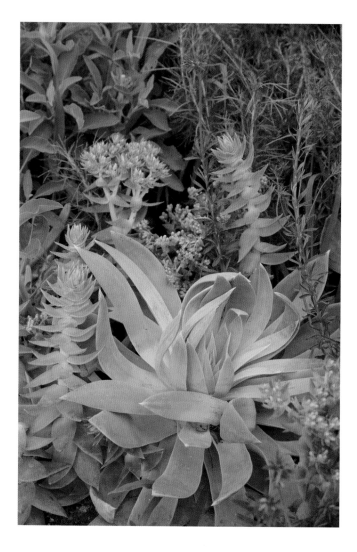

↑ *Agave attenuata* thrives in a pool of ceanothus in front of a volunteer elderberry (*Sambucus nigra*). David has not pulled out the elderberry, even though it doesn't have leaves for eight months of the year, because it self-seeded and has survived here, so "it's earned its place."

↑ Green on green on green, texture on texture on texture: a healthy *Dudleya brittonii*, a succulent native to Baja California, is cushioned by white sage (*Salvia apiana*) and *Artemisia californica*.

→ As you enter the front gate, black sage (*Salvia mellifera*) and white sage (*Salvia apiana*) flank the path and to the right "a giant philodendron, I don't have the heart to rip it out," David laughs. "Thematically it doesn't fit. It's a tropical outlier in the garden," but it's happy, so he lets it "do its thing, adding to the mash-up nature of Echo Park" that he loves.

NATIVE

GATHERING

GARDEN

and

CHUMASH

INDIAN MUSEUM

KAT HIGH, BARBARA TEJADA,
and BRIANNA ROTELLA

← Weather- and time-formed coast live oaks (*Quercus agrifolia*) under-planted with a colony of agave outside the Chumash Indian Museum.

The Place

The Santa Monica Mountains rise abruptly and ruggedly along the coastline northwest of Los Angeles and east of Ventura County. Positioned between the heavily populated San Fernando Valley and Los Angeles Basin, they are a vital remnant wildland area for native plant communities and native wildlife.

The mountains rise from sea level to the 3114-foot summit of Sandstone Peak, creating high biological diversity due to the varieties of slopes, exposures, and geology. The Mediterranean climate yields hot, dry summers and an average annual precipitation of just 19 inches. The aridity is mitigated to some extent on the southern side of the range by coastal fog that cools and adds humidity, supporting ferns and other moisture- and shade-loving genera. The northern side is drier and tends toward sage and other shrub chaparral outside of seep meadows and riparian areas, which thread throughout the entire range.

Spanning some forty miles east to west, the Santa Monica Mountains are part of the traditional homelands of the Tongva and Chumash cultures and home to many cultural archeological sites of significance, some dating back close to 15,000 years. The Tongva and Chumash have actively tended and shaped the land and its plant and wildlife communities for food, medicine, utility, and cultural purposes, benefiting the health of individual plant populations as well as the entire ecosystem.

Fire has always been a formational influence in this region. So, too, the Santa Ana winds—extremely dry, hot, downslope winds generated most often in autumn when cooler, dry, high-pressure air inland over the Great Basin and Mojave Desert works against low-pressure weather coming in off the Pacific Ocean. When the winds occur, fire danger increases across Southern California, but perhaps especially in the thickly vegetated and steeply sloped mountain ranges. In November 2018, half the area of the Santa Monica Mountains was damaged by the Woolsey Fire. The grounds of the Chumash Indian Museum in Thousand Oaks was among the land burned. Losses included the historic structures, a replica Chumash village, and an ethnobotany garden around the museum, which is slowly being restored.

The People

Kat High is a plantswoman, storyteller, basket maker, and teacher of Hupa descent. She has lived in the Santa Monica Mountains' Topanga Canyon for more than forty years. "The Western European concept of a beautiful garden is not a Native concept," Kat explains. "We see beauty and utility in an elderberry collected as a dry dormant stick in the winter waiting to be used as a long straight rod, or in a willow without nodes and perfect for a basket." To Kat's eye, a plant's value is often tied to its utility, and these attributes are integral to how she understands and cares for the plants of her environment.

When Kat was training as an occupational therapist in the 1960s, one of the tools of the profession was basket-making, a skill she took to naturally. Only later did she learn that her Hupa ancestors were noted for their baskets. In the 1970s, Kat became involved with the American Indian community in the Los Angeles area. She studied under many elders and mentors to learn about the Hupa world view and their ethnobotanical practices.

Kat has dedicated herself to educating others about Indigenous plants and their utility, both in her own garden, known as Kidiwische Corner (*kidiwische* means "butterfly" in the Hupa language), and with organizations such as the Chumash Indian Museum. She is supported in her outreach there by museum staff including Barbara

↖ All the plants in Kat High's home garden in Topanga hold cultural meaning and history. Here she introduces a young person to mugwort (*Artemisia douglasiana*) on the edge of her graywater pond. She uses the leaves to make a medicinal tea and aromatic dream sachets, said to promote lucid dreaming.

↑ Kat High, a basket maker, working with dog bane (*Apocynum cannabinum*), a patch of which she has cultivated in her home garden. "You gather this in early winter after the leaves fall, and crush the stems until the outer bark breaks off and the soft core is left to work with. This material, once wound, is used as a binding in the construction of canoes, houses, and ceremonial items that looked like macramé."

→ One of Kat High's
willow baskets.
Willow is a common
material for granary
baskets, used to
store acorns or other
seeds and nuts.

← Coast live oaks (*Quercus agrifolia*), shaped by wind, weather, and time, in the woodlands adjacent to the Chumash Indian Museum mark the beginning of the museum's trail system and educational plant walks.

143

NATIVE GATHERING GARDEN AND
CHUMASH INDIAN MUSEUM

Tejada, the museum's chairperson and an archaeologist working to ensure any newfound artifacts or remains are properly handled, and Brianna Rotella, a cultural anthropologist and volunteer who works to develop the museum's ethnobotanical plant collection and interpretative materials.

The Plants

In Kat's home garden, she grows native plants for her basketry and classes. She focuses on teaching people about "what you can use and to approach gathering in a more spiritual way by giving thanks to the plants, by stating your intention for them, by offering tobacco as a reciprocal gesture, and by singing songs when you go gather."

Plants in the Chumash Indian Museum's ethnobotanical garden are signed with the common English name, scientific name, and Chumash name, with additional information from the California Native Plant Society. Brianna states that use of the

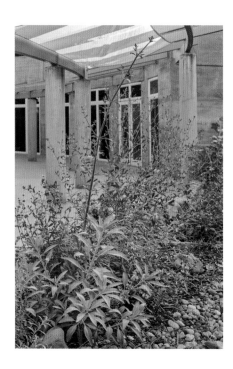

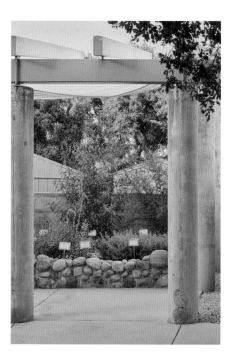

↑ A closeup of one of the ethnobotany beds at the Chumash Indian Museum, featuring sacred white sage (*Salvia apiana*) used for medicinal and ceremonial purposes, black sage (*Salvia mellifera*), and California bee plant (*Scrophularia californica*).

↑ Sacred datura (*Datura wrightii*), growing from a burned out stump on the grounds of the Chumash Indian Museum, which suffered a lot of damage to the outdoor cultural displays in the 2018 Woolsey Fire.

↑ The exterior pillars of the Chumash Indian Museum in Thousand Oaks frame the ethnobotanical garden documenting the plants used by the Chumash people for food, utility, medicine, and ritual. The garden is divided into different sections, including an area devoted to basketry plants.

Chumash names is an "important principle for acknowledging that these native plants had names and rich histories prior to Europeans being introduced to them and giving them new names." Cultural names are included, as possible, for the Mitsqanaqań (Ventureño), Šmuwič (Barbareño), Samala (Inezeño), Kagimuswas (Purisimeño), Island Chumash (Cruzeño), and yak tiťu yak tiłhini (Obispeño) languages. Visitors also learn from the way the garden's plants are grouped—either as you might find them in nature or by how they are used. Barbara notes, "This garden is different than what people might think when they hear the word *garden*. Ethnobotany highlights different aspects of the native plants and how they are cultivated, interpreting and helping to illuminate the relationships the Chumash or other Native people have with these plants and plant communities." For instance, the Riparian/Basketry Garden features plants notable for their use in Chumash basketry, many of which are also riparian plants, such as giant wild rye (*Leymus condensatus*), basket rush (*Juncus textilis*), and soap plant (*Chlorogalum pomeridianum*).

Barbara also believes in featuring plants that are decidedly not beautiful year-round. "They each have their distinct spaces and times, beauty and value in the annual progression of life. This ebb and flow of seasonal interest is particularly noticeable in the Fruits and Flowers Garden, which features plants like California wild rose [*Rosa californica*] and California blackberry [*Rubus ursinus*]. Both . . . are easy to overlook when just green or in winter when they lose their leaves, but are bright and eye-catching in bloom or when full of ripe berries or hips—all of which are edible and medicinal."

Staff-led nature hikes from the museum often start in the garden, introducing people to the plants they will encounter on the trails. As they learn about the plants' Chumash ethnobotanical histories, Barbara says, "most people who are not of Native descent are often being introduced to this living, dynamic . . . human community for the first time, too." She says, "the garden connects people to a sense of place and a sense of perspective set in context of larger history. It's ecologically important, of course, but connecting people to the land they live on is equally powerful."

For Kat, gardening at its essence means being in dynamic balance with the plants of her larger place. "I work to enhance their well-being, my well-being, my community's well-being, and the plant's interactions and relationship with its associated birds and rocks." In this way, and in these gardens, she models that all the world's a garden to be cared for and lived with conscientiously.

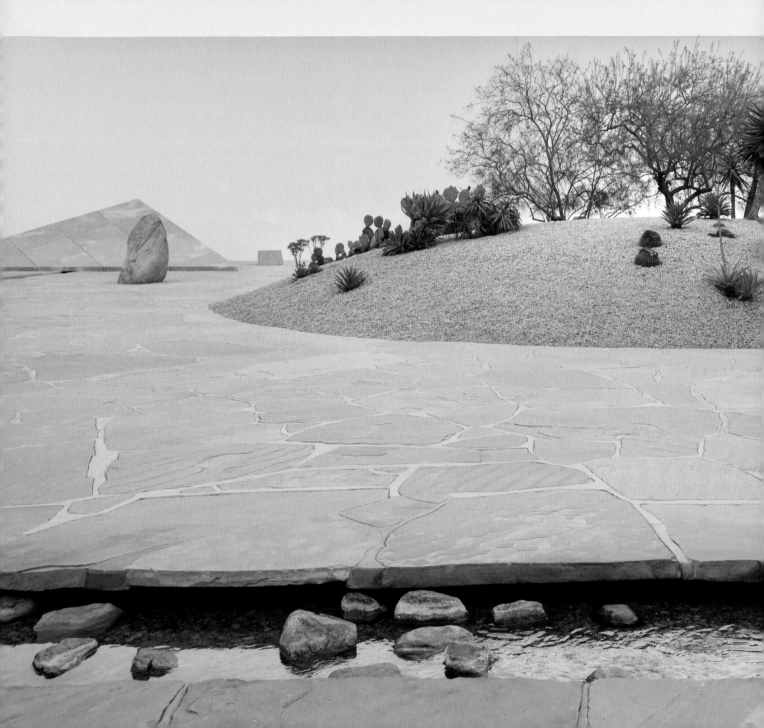

CALIFORNIA
SCENARIO

ISAMU NOGUCHI

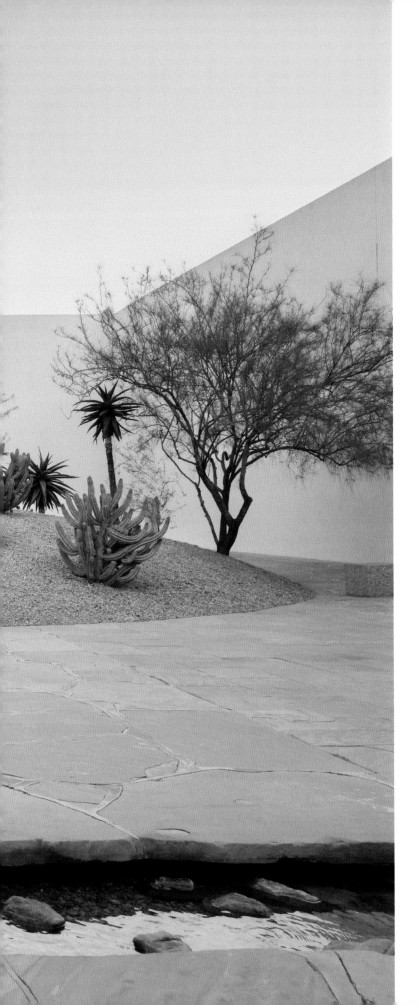

The Place

Costa Mesa was once a rural community south of Los Angeles. Now an integral part of the greater Los Angeles Metropolitan Area, the city is crisscrossed by large highways including the 405, the 73, and the 55. Other than a handful of small urban parks, the largest green spaces remaining in the community are golf courses. The Santa Ana Mountains are miles of highway away to the east, and the Pacific Ocean is miles of highway away to the south and west. As a resident deep in this metropolitan maze, it might be hard to recognize that you are situated in the geographic feature that is the broader Los Angeles Basin.

In Costa Mesa, deep in a land of business parks, is a vast shopping center called South Coast Plaza. First developed in 1967 by the Segerstrom family, the original South Coast Plaza was built in what had been their lima bean fields. By the 1980s it had become a business park as well as a mall. In 1979, Henry Segerstrom approached the Los Angeles–born Japanese modern artist and sculptor Isamu Noguchi (1904–1988) to design a landscape for a courtyard between several tall buildings within the business park.

147

The resulting award-winning sculpture garden entitled California Scenario is in many ways, according to Dakin Hart, senior curator at the Noguchi Museum in New York, "a rich and sometimes ironic abstraction of and statement on" the changing landscape of California writ large—especially as altered by human activities. The project was "one of [Noguchi's] most fully integrated landscape compositions."

Being a privately owned public space, the garden's fate is to some extent at the mercy of its landowners. The complex has been sold twice since its inception, but by and large the landowners and the City of Costa Mesa "understand the space as an asset, and they have changed it very little," Dakin says.

The People

Isamu Noguchi, one of the twentieth century's most critically acclaimed sculptors, was born in Los Angeles to an American mother and a Japanese father. According to the Noguchi Museum, "Through a lifetime of artistic experimentation, he created sculptures, gardens, furniture and lighting designs, ceramics, architecture, and set designs. His work, at once subtle and bold, traditional and modern, set a new standard for the reintegration of the arts." Noguchi "discovered the impact of large-scale public works in Mexico, earthy ceramics and tranquil gardens in Japan, . . . and the purity of marble in Italy. He incorporated all of these impressions into his work, which utilized . . . stainless steel, marble, cast iron, balsa wood, bronze, sheet aluminum, basalt, granite, and water." All of these elements are found in California Scenario.

When Henry Segerstrom first approached Noguchi, "he was interested in and open to Noguchi's ideas. The only real parameters were the physical parameters of the surrounding buildings," notes Dakin Hart. "The garden is an amenity." Dakin has seen how it makes the surrounding built environment more livable. "I love to watch how people come to it, how they move through it—from brides and fashion shoots by students to kids running around gleefully climbing on boulders and jumping over a river."

The space and design are reflections "on the simultaneous vastness and intimacy in all the different landscapes of California. But it is also a cautionary tale," says Dakin, "about manipulating it too much at our own peril." Ultimately, the garden is Noguchi at "his most abstract but also his most empirical. He really saw sculpture and these kinds of public landscapes as having civic purpose. . . . What he produced in California Scenario is really meaningful as a manifesto and statement on the world we live in and how we have altered it and what the consequences are."

PREVIOUS PAGES: California Scenario, located in a commercial plaza in downtown Costa Mesa, is an abstraction representing the state's most primary native landscapes. The garden has six main elements. Here, Desert Land sits across from Water Use, representing watersheds, rivers, and constructed/directed waterways. In the distance is Water Source, a triangular fountain representing higher elevation headwaters and snow pack.

→ Water Source, from which water originates, has its own inner water falls that create both sound and movement in the otherwise quite static space.

FOLLOWING PAGES: Desert Land, which is set apart but ever more encroached upon in the space, represents the rich desert spaces of California. The native plants here include selections of desert willow (*Chilopsis linearis*), low-growing beavertail cactus (*Opuntia basilaris*), barrel cactus (*Echinocactus*), ocotillo (*Fouquieria splendens*), and *Agave*.

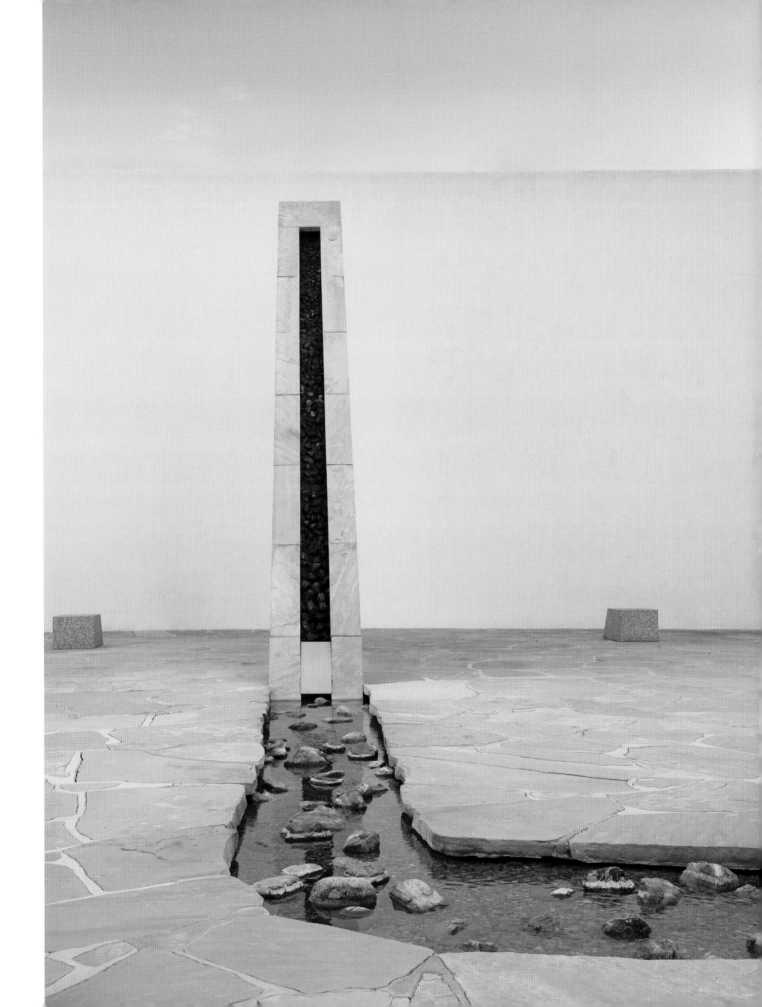

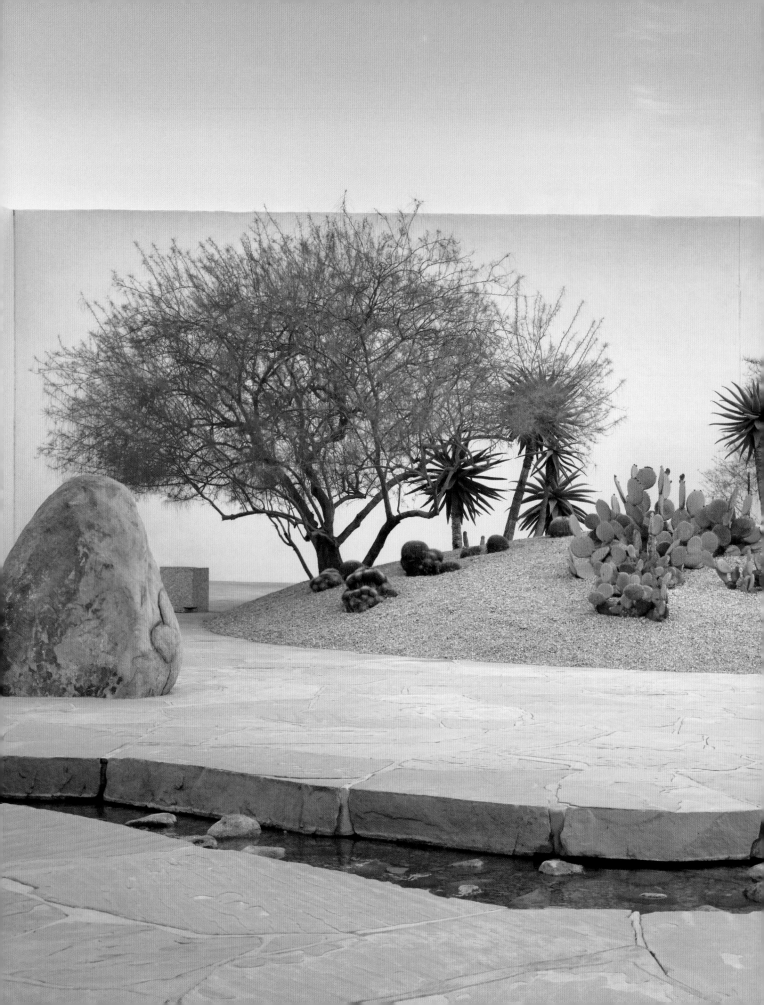

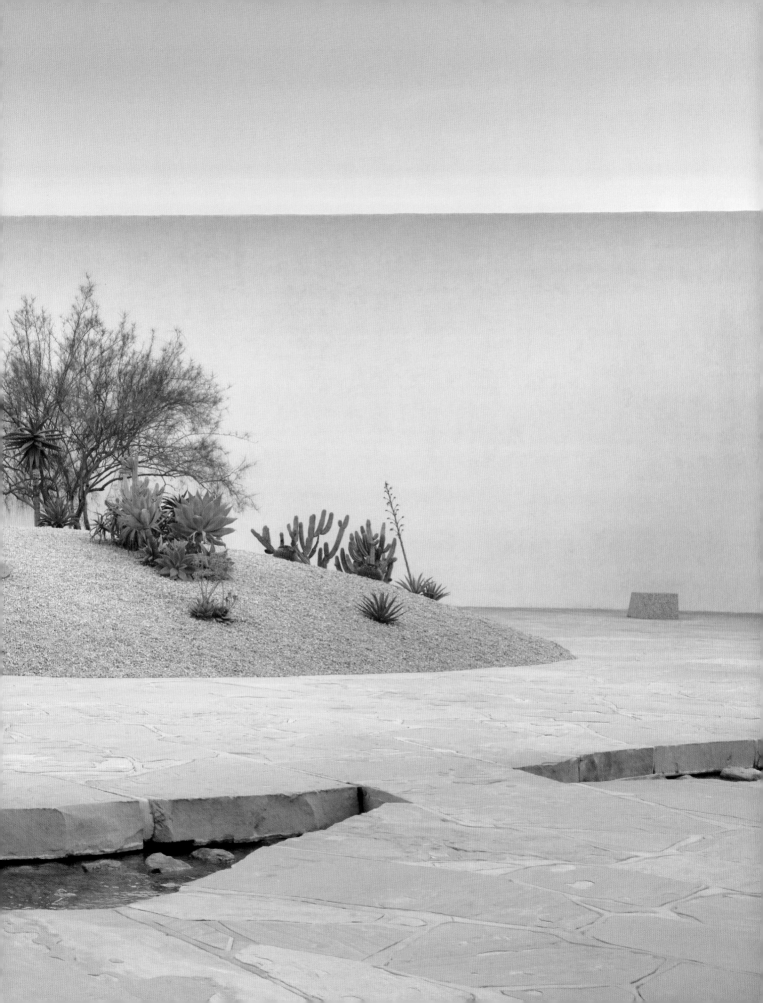

The Materials

The 1.6-acre public sculpture garden includes six distinct elements: Forest Walk, Land Use, Desert Land, Water Source, Water Use, and Energy Fountain. Each represents a different aspect of California's native landscapes—from desert to mountains and forests to riparia—and the design and manifestation of these areas signifies Noguchi's understanding and thinking about how each of these are altered and used. The centerpiece of the design is *The Spirit of the Lima Bean*, a sculpture of dramatic proportions, composed of fifteen rust-colored granite rocks cut precisely to fit together. The lima bean motif is a reference to the space's previous life as a lima bean field.

The design and construction make playful and sculptural use of big boulders and water features across the hardscape and relatively open space between elements. As noted by Dakin, these elements are very much a narrative "about water and water movement and use in a desert, areas which have become 'gardens' through how we move water around and introduce and make use of technology." From the powerful, abstracted lima bean to the water rill narrowly making its way across the fully exposed flagstone hardscape from an industrialized mountain to an impersonally reflective pyramid form, the space becomes a human-made analogue for what California's landscapes once were as well as an analogue for what a garden is. California Scenario, an isolated sculptural gardened space in the midst of the built urban landscape, speaks to the idea that all of California is now a cultivated space.

↖ Forest Walk features an abstracted wildflower meadow on a wedge-shaped hill enclosed on three sides by redwoods (*Sequoia sempervirens*).

↑ A central focus in the garden is *The Spirit of the Lima Bean* sculpture of fifteen granite rocks, cut and pieced together by Noguchi. It is a direct reference to the Segerstroms, who had a long history of lima bean farming on this land before developing it into the South Coast Plaza, for which they commissioned this garden.

→ Water flows through a hardscaped channel from the triangular Water Source, representing higher elevation headwaters and mountain snowpack from which California derives much of its water, to Water Use, a pyramid of polished Sierra white granite. The '"land" through which the water makes its way is exposed and somewhat barren.

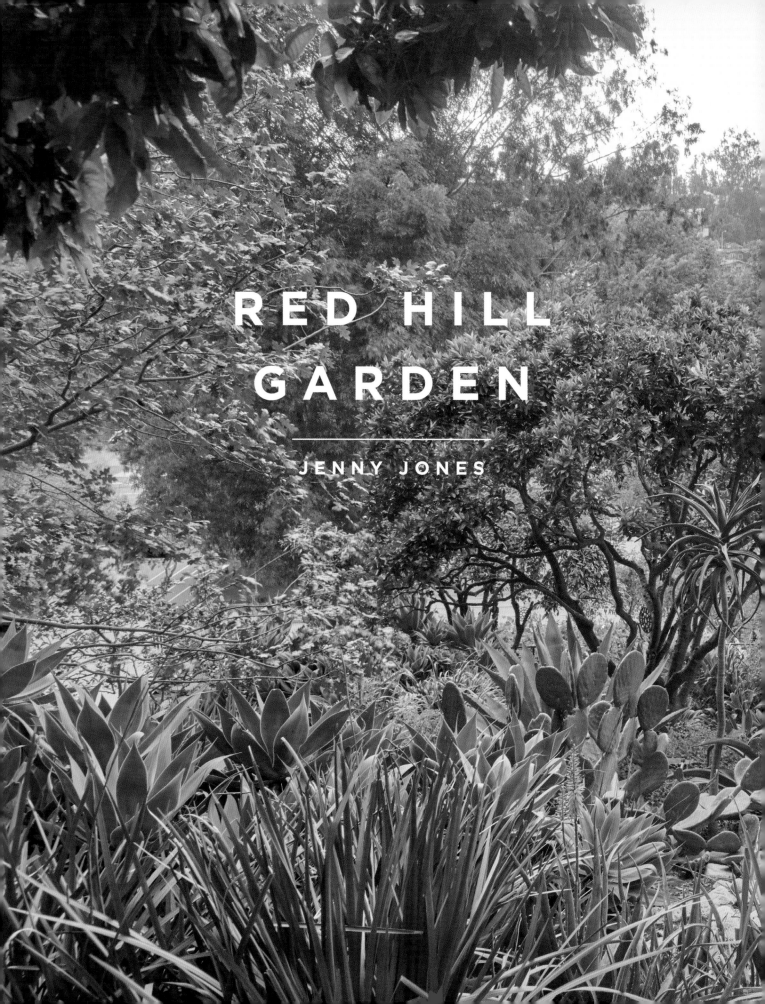

RED HILL
GARDEN

JENNY JONES

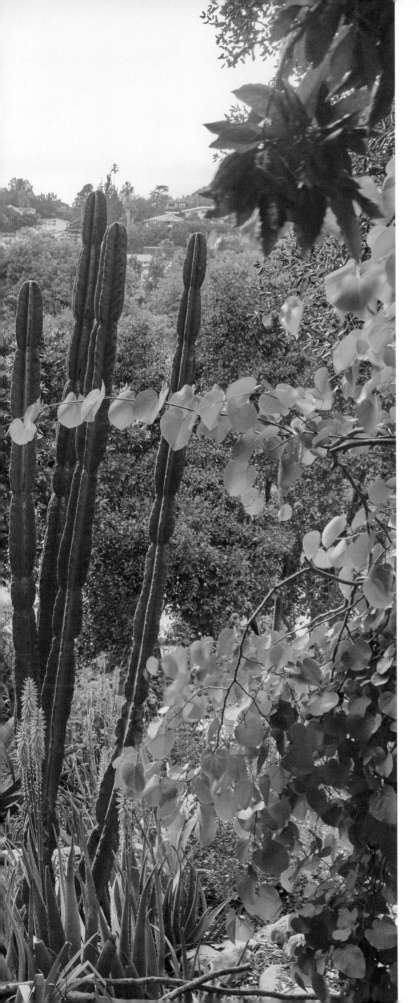

The Place

Jenny Jones and her family live in a hilly area of Echo Park known as Red Hill, a name reflecting the socialist and alleged communist leanings of the artists and free-thinkers who began living there in the late 1800s. The population of the neighborhood remains widely mixed, socioeconomically and culturally.

That diversity is what Jenny loves about her storied neighborhood of Echo Park, about the dense and vast city of Los Angeles, and the larger Los Angeles Basin. Over the decade Jenny has been living, working, and gardening here, she's come to appreciate how "the larger natural beauty is not dissimilar from the constructed beauty." In both arenas, diversity is the greatest commonality and strength, "diversity of plant choices, native and introduced, diversity of landscapes large and micro, of people, cultures, architectural styles, building materials and techniques."

When she gets out of the city and is surrounded by the truly native environment known as the Southern Coast Bioregion, Jenny can visualize more clearly her location's context within the larger Los Angeles Basin. One thing that fascinates her—and she gardens and designs with

155

this in mind—is the incredible importance of the "diversity of microclimates, microgeographies, and microtopographies. You can drive forty-five minutes and move from a secluded mountain arroyo that feels damp and rocky down into the Los Angeles Basin that feels dusty, arid, and hot, and then all the way down to the beach, which feels breezy and coastal." Even within the city limits, a plant responds differently to "light, wind, soil . . . to whether it's at the top of a hill or bottom of a gully, at the mouth of a river or at the headwaters. That's been part of the fun of learning to work with plants here. Something might work great in one spot, but not two feet over."

In her landscape architecture work, "We create little gardens that are homages to people and their places, and diversity is the key to connecting them. In Los Angeles, we can and do grow it *all*. Then you layer on top of that the intense diversity of the people and culture . . . it is so, so, varied." Trying to organize so many influences can feel "chaotic and overstimulating," but, she emphasizes, laughing, "it's also really fun and energizing."

The Person

Jenny did her undergraduate work in environmental studies at the University of Virginia in Charlottesville. She was always interested in being outside and, while she grew up doing garden work, she was not raised among plantspeople per se. Her interest in using plants to create space came later. After college, she participated in Teach for America in Oakland, California, where she taught middle-school science for three years.

Jenny then earned a master's degree in landscape architecture at the University of Virginia, and she and her husband, Sam Baker, moved to Los Angeles. This was the first time she had her own garden. Jenny joined the team at Terremoto Landscape, a firm known for its dedication to natives and to boundary-pushing design.

Jenny's initial experiences of her new hometown were very urban. Over time she, Sam, and their young son, William, slowly began to work their way out of the city to the mountains, to Big Bear Lake, to the coast. The city is so big "it's not easy to get away from the built environment." Jenny keeps that in mind as she considers how and why the gardens and landscapes she designs in the city are used and needed.

The Plants

"There's a certain vastness to the natural beauty of Southern California," Jenny notes. "And my garden, in contrast, is so tiny. It is very culturally constructed, but as I walk through I get little snippets of the natural beauty: sage tumbling down the wall, an

PREVIOUS PAGES: Looking northwest from Jenny Jones's back garden on Red Hill in Los Angeles' historic Echo Park neighborhood is her neighbor Rhett's long-established, eclectic garden featuring many mature fruit trees. Center is a white sapote (*Casimiroa edulis*), a fruit tree brought north by Spanish monks from Mexico, whose fruit is "custard like, something akin to a paw-paw." Behind it are mature citrus trees pruned up for their elegant trunk forms to show, and in front a vertical night-blooming cereus (*Peniocereus greggii*).

→ Jenny and her husband, Sam Baker, crafted the shade awning in the garden behind the house. Pink rock rose (*Cistus* 'Sunset'), *Salvia mellifera*, *Eriogonum cinereum*, *Erigeron*, and artichokes lighten the force of *Agave americana* and *Agave tequilana*. The diagonal rough-hewn cedar, Jenny notes, "creates beautiful wavy shadow lines, and as it weathers it gets kind of forlorn and dramatic."

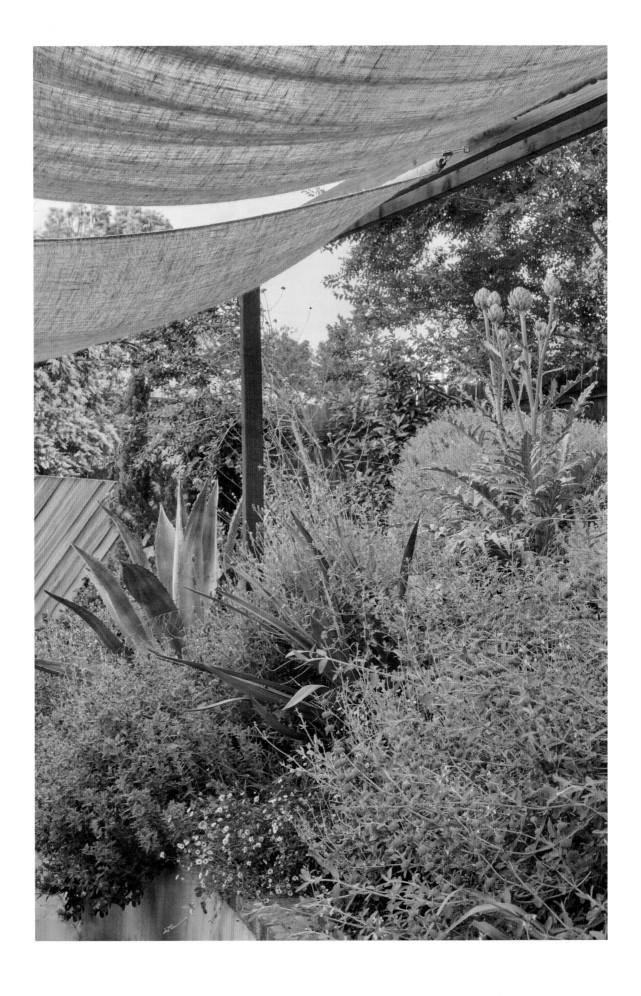

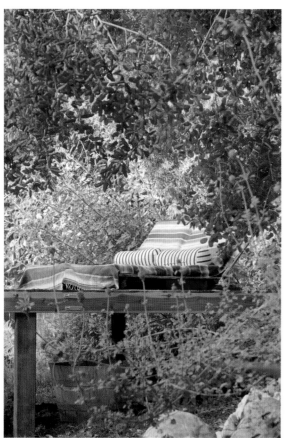

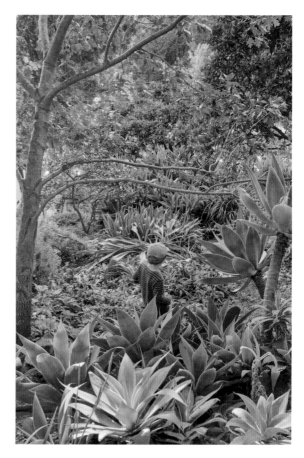

← CLOCKWISE FROM TOP
LEFT: Beneath one of neighbor Rhett's limbed-up citrus trees, *Agave americana* and *Agave attenuata* are situated, with a smaller aloe in bloom in the foreground.

Stairs built into the hillside run along the side of Jenny's garden, accessing each terrace level. At this juncture, *Agave attenuata* and pink Jupiter's beard (*Centranthus ruber*) intermingle, while staghorn ferns (*Platycerium*) roost in the trunk of a mature privet (*Ligustrum vulgare*), limbed up to form a canopy.

Jenny, with permission, often harvests pups from neighbor Rhett's *Agave attenuata* patch to plant in her garden or in clients' gardens. Her son William is making his way across from one garden to the other. Native hummingbird sage (*Salvia spathacea*) is the far groundcover in the dry shade beneath the native black oak (*Quercus kelloggii*).

At the topmost layer of Jenny's garden, her husband, Sam Baker, crafted a treehouse-like sitting platform in the shade of a California live oak (*Quercus agrifolia*), which looks out across a wonderful territorial view. Behind the spot is their traveling *Romneya coulteri*.

understory of heuchera." The lot is only 33 feet wide, so getting the visual scale with the plants she wants in the space is one of the challenges.

In an unusual arrangement, the upper half of the terraced back garden is open to the neighboring seven gardens on either side. She says, "The connection is so strong here. There is an open flow of people, plants, wildlife, produce. The neighbor one house over encourages people to come pick his citrus. The neighbor three doors down encourages my son to come play, and he just walks through the backyards to get there." This sense of community is a value Jenny's family has embraced wholeheartedly. "Our gardens are all different, so sharing them is like having our own miniature botanic garden. It's lovely."

Rhett Beavers is a retired landscape architect whose garden takes advantage of the Mediterranean climate, and Jenny sees him as the "charismatic megafauna" of their community garden ecosystem. He taught her a great deal about gardening in their particular urban microclimate, which is his focus. "He's got these beautiful old citrus trees—orange, tangerine, lemon, and lime—remnants from a community orchard back when this area was a refuge for communists and socialists. He prunes them impeccably. He also has decades-old succulent specimens, including agaves and aloes."

Initially, Jenny made the mistake of thinking that gardening in Los Angeles was just gardening with great weather all the time. After some initially poor plant and site choices, Jenny has skewed her garden additions toward natives as she's learned more about the Southern California flora. "I think of my garden as a microcosm reflecting the diversity of microclimates, topographies, light, and shadow. Its elements distill the big natural scale around us into the tiny scale of my lot," Jenny says. "One example of that is that everything in my garden blooms late—simply because I am on a partly north-facing slope. There has been a learning curve in accepting and embracing micro-subtleties like that." In another example, Jenny and Rhett initially disdained an existing California native Matilija poppy (*Romneya coulteri*) because they thought it looked weedy and scraggly. "Rhett said, 'Just wait. Don't touch it.' And over the years we've watched it and its incredible spring bloom of large white flowers that look like fried eggs, move around the garden—up or down the slope, to the left or the right a little—adjusting to where it needs to go. The intimate scale of our garden [allows us to see] how individual plants behave over time in interesting ways: how they move, how their form changes depending on slight changes in condition."

Now, swathes of cistus, *Salvia clevelandii*, *Salvia mellifera*, agave, dudleya, artichokes, and heuchera thrive "all mashed up together." Classic Italian cypress and native Tecate cypress (*Cupressus guadalupensis* var. *forbesii*) march up the hill, as well as ceanothus, "strong charismatic elements, one in a standard tree form, one a larger natural form, and some groundcover." Native buckwheats are among her favorite garden perennials. "Those flowers in late summer!" she exclaims. Her

collection includes ashy leaf buckwheat (*Eriogonum cinereum*), California buckwheat (*Eriogonum fasciculatum*), and Saint Catherine's lace (*Eriogonum giganteum*).

Jenny and family garden organically, making their own compost and creating a positive feedback loop with "the chicken, egg, compost, manure ecosystem dialed in." Sam has tried keeping bees, and "vegetable gardening is on the list of things we're aiming to get better at." With no working irrigation system, she waters deeply by hand, placing a hose on a plant and setting a timer for thirty minutes. Jenny top-dresses the garden with homemade compost twice a year, even the natives, which she acknowledges "may not live as long with the extra fertility, but they will look better." In a recent addition to their efforts to not only support the diversity of their garden plants, but to work within a self-supporting continuum, in what Jenny refers to as "permacultural aspirations," they have added a graywater system that captures and pumps water from the bathroom and laundry up the hill to water their fruit trees.

In his garden, neighbor Rhett has slowly handcrafted dry-stacked stone walls over the years, hand carrying small batches of rocks from his excursions. Jenny has also started building up her own walls this way, slowly, so that his and hers will eventually meld in a twist on walls—not blocking one garden from the next, but rather creating a continuum between the spaces. "Each rock has a character and a personality. You need to touch each rock carefully so that you know them and you know where they're supposed to go," Rhett once told her, in what she affectionately thinks of as a Rhetticism. "I've carried every rock for the patio and walls, building the process and relationship between me and these shared spaces."

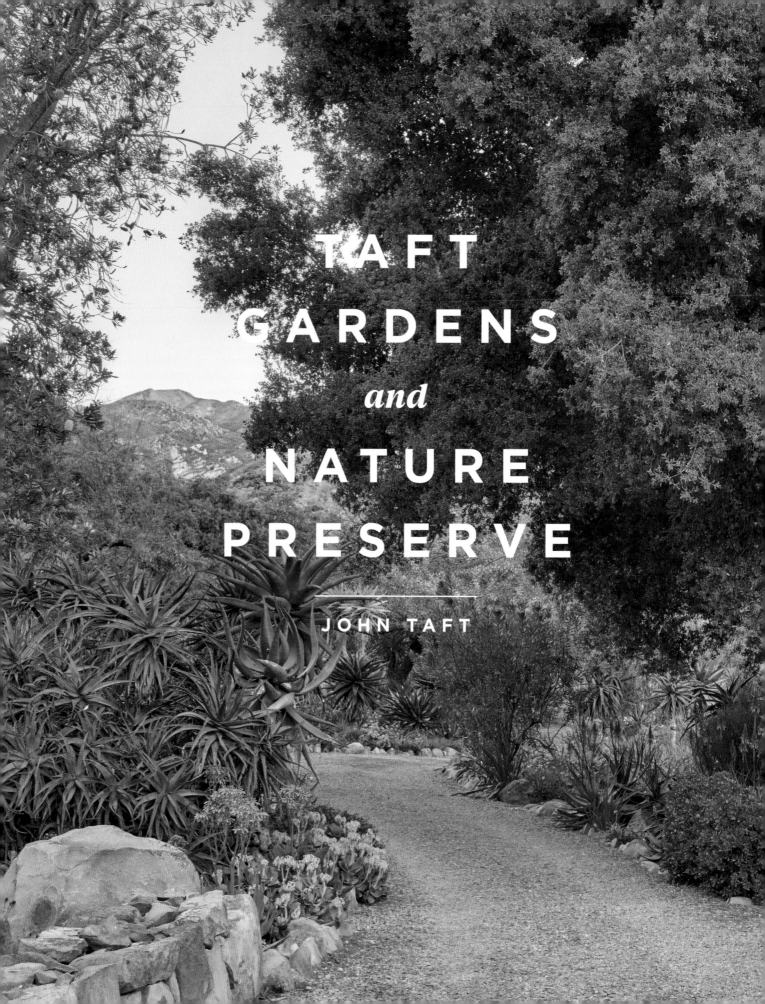

TAFT
GARDENS
and
NATURE
PRESERVE

JOHN TAFT

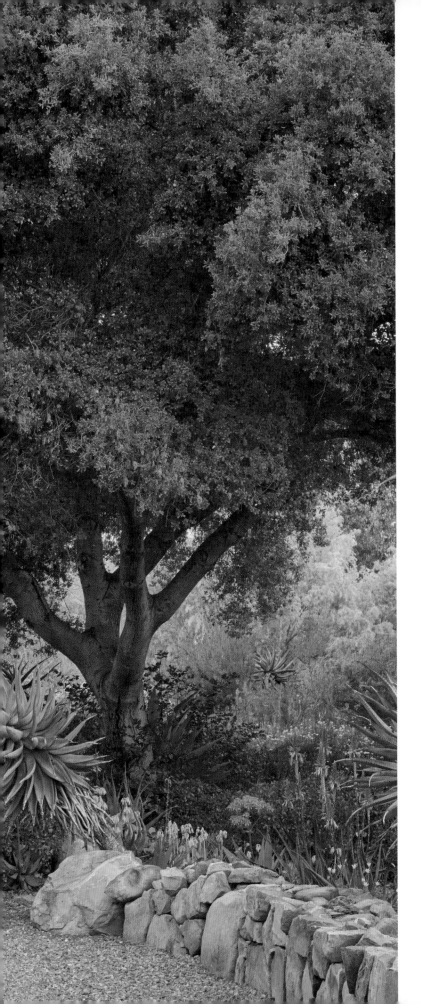

The Place

The little town of Ojai, the name a
derivative of the Chumash people's word
for moon, sits in a small valley on the
southern edge of the Topatopa Mountains
due east of Santa Barbara and less than
sixteen miles from the Pacific coast. In
one of the steeply rugged, dry, and rocky
canyons to the west of Ojai, on the edge of
the Los Padres National Forest, is a can-
yon in which gardener and philanthropist
John Taft has conserved a 264-acre parcel
of land known as the Taft Gardens and
Nature Preserve.

The area enjoys a typical Mediterranean
climate, with the majority of the 21+
inches of rain annually falling between
November and March, and it is catego-
rized as a California montane chaparral
and woodlands ecoregion. Manzanita and
oak savannahs dominate in the lower ele-
vations, while conifer forests tower above.
Such stretches of preserved wildland are
increasingly rare in in this ecoregion,
where habitat degradation, fragmentation,
and loss to the pressures of development
and urban sprawl have been common
narratives since the gold rush. The natural
habitat of the California condor, once
close to extinction, is in the Topatopa

Mountains, for example, and a range of native plants from spring annual wildflowers to ancient conifers are endemic here.

All these factors—the distinct climate and topography, the Ventura River watershed, and the increasing rareness of the wild things that have coevolved here—are reflected in the area's gardens.

The Person

John Taft was born near Ventura, and he considers the region *his* native habitat. Home is symbolized by "the rolling golden brown hills of California, covered in deep green oak trees. I've loved this land since birth." He's also loved plants since he was a little boy and was drawn to the study of nature and biology. John set out to create his own financial freedom so he could dedicate his life to growing things. He went into real estate and property management and "worked, worked, worked, worked" toward his self-set goal of being able to retire by the age of thirty-five, which he did. By the mid-1960s, he had taken up his calling "on behalf of nature." Rachel Carson's *Silent Spring* was published in 1962, and in 1969 Ohio's Cuyahoga River famously burst into flames due to its high level of pollutants; environmental awareness and concern were on the rise throughout the United States at the time.

For the next twenty years, John worked and traveled with the National Audubon Society, making documentary movies about remote places, often in the West, focusing on environmental degradation and the land–wildlife connection, specifically as it related to birds. His last film was about Australia's Outback and New Guinea, where he took his young family for several months in the mid-1970s, a first introduction to what he found to be beautiful and spectacular native plant life.

His love of nature and bird life grew throughout these years and became integral to his creation of the Taft Gardens and Nature Preserve, first conceived of after John and his wife, Melody, bought 264 undeveloped wildland acres in Santa Ana Canyon outside of Ojai in the 1970s. John initially researched planting it out in citrus and avocado. He brought in an expert agriculturist who drove him all around. The man said, "You could put in oranges, but that would be a shame, wouldn't it?" John ultimately heeded this thought and followed his desire to create a display garden of plants he loved from other arid areas of the world on a small portion of the land, while preserving the bulk of it for native habitat.

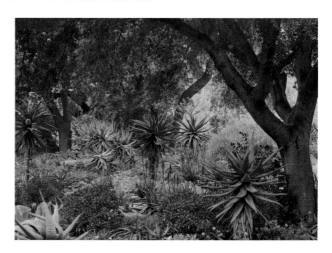

PREVIOUS PAGES: The plantings beneath the native live oaks (*Quercus agrifolia*) as you enter the Taft Gardens and Nature Preserve speak to the owner's vision for a low-water garden of plants of Australia and South Africa in the Southern Californian chaparral. The forms and colors of these plants are bright and bold against the foothills. Here, low South African *Cotyledon* forms pink-blooming mats, and tree aloe (*Aloe arborescens*) adds height on the right, while hardy jade plant (*Crassula ovata*) and more blooming *Aloe* line the left.

→ Variegated *Agave americana* is framed by two live oaks (*Quercus agrifolia*), with a view of a California sycamore (*Platanus racemosa*) in the grassland opening behind.

↓ Along the drive into the garden, masses of colorful South African plants, cacti, several blooming *Aloe*, *Cotyledon*, and *Pelargonium* light up the live oak (*Quercus agrifolia*) understory. The dark green jade (*Crassula ovata*) plants provide fresh green form along the front edge of the planting.

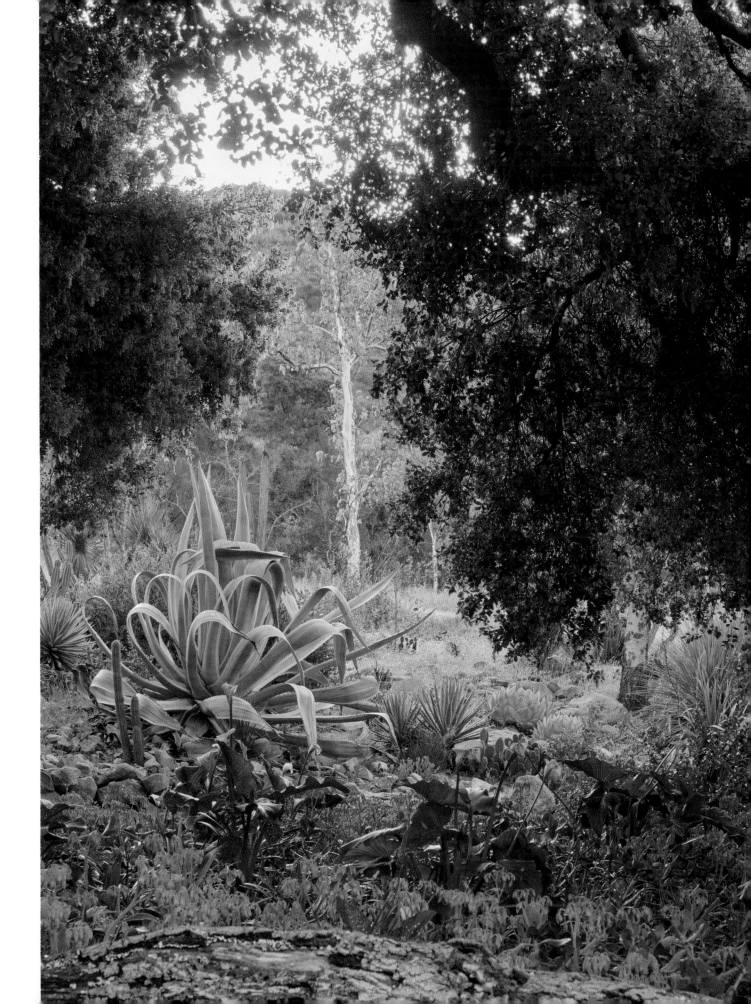

↙ One of the Taft Gardens' grand old California live oaks (*Quercus agrifolia*) sets the stage for South African *Leucadendron* (center left) shrub, pincushion plant (*Leucospermum*), and small sugarbush (*Protea*) (lower left). Low-growing orange African daisies (*Arctotis auriculata*) and purple *Delosperma* fill out the planting.

TAFT GARDENS AND NATURE PRESERVE

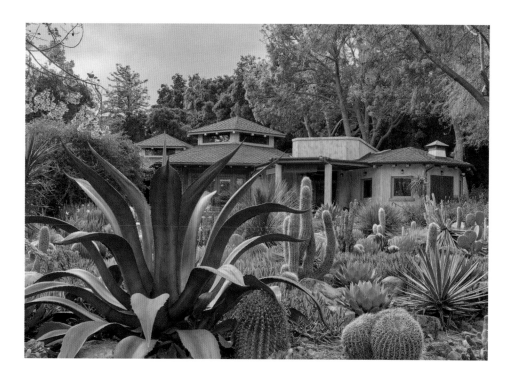

← The central garden around the Taft Center's educational and event pavilion features full sunlight and hardy cacti, *Agave*, and *Yucca* from North and South America.

→ With Taft Mountain on the horizon, a grouping of blooming *Aloe* are fronted by *Pelargonium* and backed by South African *Searsia pendulina*.

↘ Under a magnificent California live oak (*Quercus agrifolia*), John has a stone-ringed meditation grove. Beyond this is a species of grass tree (*Xanthorrhoea*) that has never bloomed, but he thinks it might need fire to set seed.

The Plants

The road through dense coast and canyon live oak woodlands that leads to the garden rises and twists, quickly leaving the built environment behind. Plant displays soon begin to skirt mature oaks. They seem to be swathes of native yucca, perhaps, and a meadow of large bunchgrass-like plants conjures thoughts of deergrass or beargrass. But the mass of elegantly slender, almost ghostly 7-foot white flower stalks rising from this meadow are actually pools of Australian *Xanthorrhoea*, known as grass tree. The vivid orange inflorescences of the aloes in bloom, large globe-flowered proteas lighting the tips of broadleaf evergreens, fuzzy yellow floral acacia panicles dangling from willowy branches gradually make it apparent that this is not a California native plant garden. Yet, somehow, with its rugged dryness, emphasis on texture and form, and many shades of greens, it is surprisingly complementary to the quintessentially Southern California landscape that surrounds it. Large old native oaks punctuate and provide structure and shelter to the space, playing foil to the garden's many exotic Australian and South African succulents and other dryland plants whose big, bright orange, yellow, white, and red blooms boldly occupy the space.

Although John loves the landscapes and plants of California, when researching plants for his dream garden the nearby South Africa and Australia display gardens at the University of California Santa Cruz Botanic Garden caught his eye for their bold, bright, colorful, and structural forms. He quickly realized that their zones were "sort of sister climates to Southern California." They seemed so different and

more compelling, to his eye, than what he found to be the far more subtle native plants of his homeland.

Having already traveled widely in Australia, in 1986 John traveled for four months around South Africa, meeting plantspeople, touring different plant communities, and collecting seeds and cuttings for his garden to be. John met and hired young South African horticulturist Laurence Nicklin to help him build the garden. As his South African garden collection and planting progressed, acquaintances introduced him to Australian plantswoman Jo O'Connell, who also subsequently emigrated to California to work on the garden. While John was the lead on the layout and design of the young garden, Laurence and Jo gave input on the design and plant placement and laid the foundation for the specimen Australian and South African plants that Taft Gardens is now known for.

In the early 1980s, John established the Conservation Endowment Fund, a non-profit organization based in Ojai, to which he deeded the garden and open space with the mission to "educate, explore, preserve." The Conservation Endowment Fund and the land and garden are now under the leadership of John and Melody's daughters and granddaughter, Jenny Nicklin (who married Laurence) and Julia and Jaide Whitman.

After his lifelong interest in flowers and wildlife, one key for John is the relationship between birds and plants. "The symbiotic relationship between birds and flowers tell a story of working together, to watch our native hummingbirds flock for nectar to the flowers, even those of plants from other parts of the globe, is a joy."

→ In a grouping of *Aloe* under live oaks (*Quercus agrifolia*), John planted a comparison study of a South African *Euphorbia* with a very similarly formed but taller North American cactus just behind it. At the back of the planting, a nicely rounded *Leucodendron* shrub leads the eye out to the native wildland foothills.

↙ A colorful planting on a trail leading out to wildland and Taft Mountain beyond features pink spires of South African *Watsonia*, a red *Leucospermum* catching the light, and deeply hued *Restio* at center.

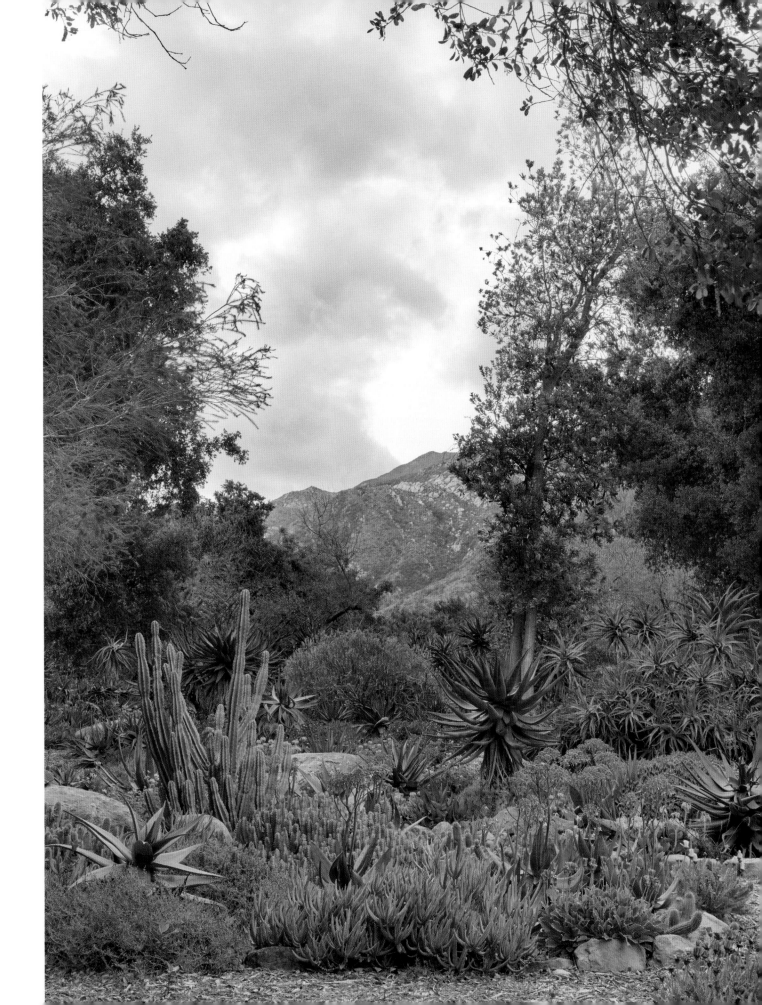

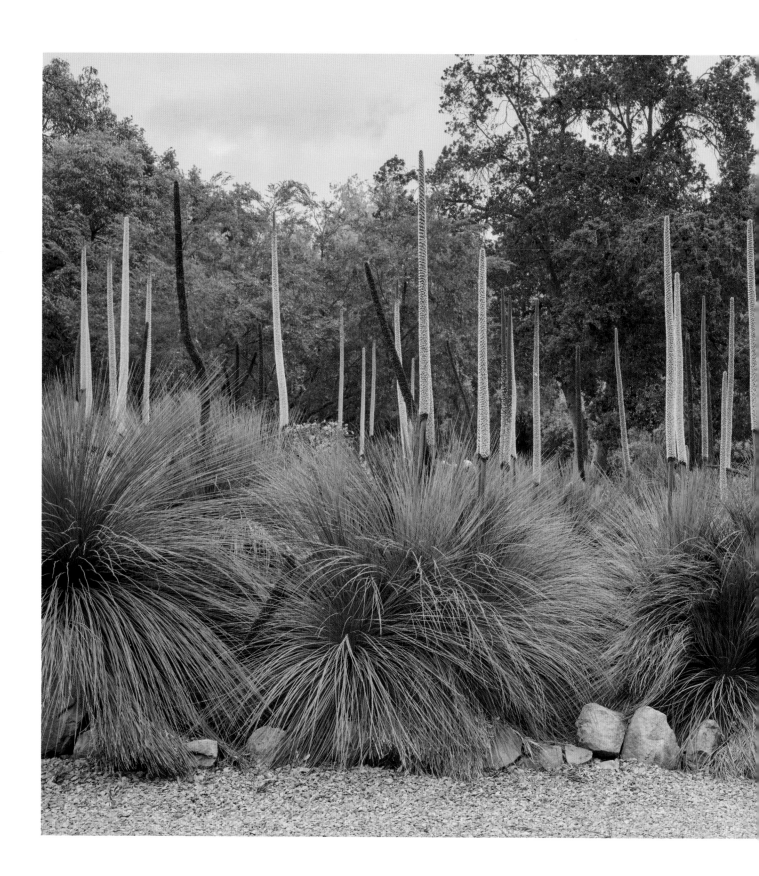

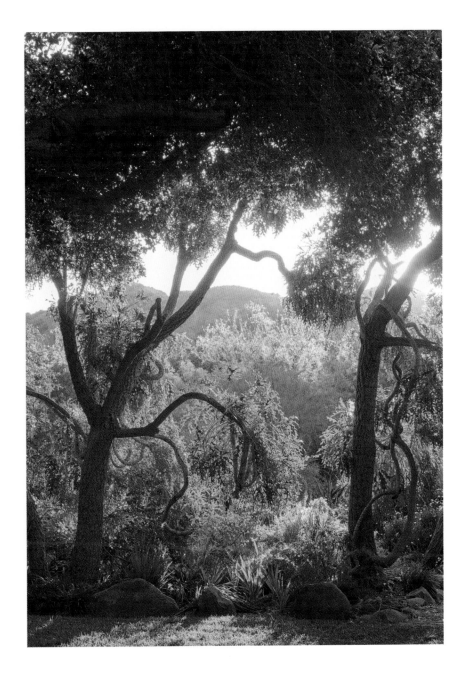

← Masses of seed-grown Australian grass trees (*Xanthorrhoea australis*) seem reminiscent of California native bear grass, but are even showier.

↑ South African cabbage trees (*Cussonia spicata*) are backlit by the setting sun over the Southern California foothills.

173

TAFT GARDENS AND NATURE PRESERVE

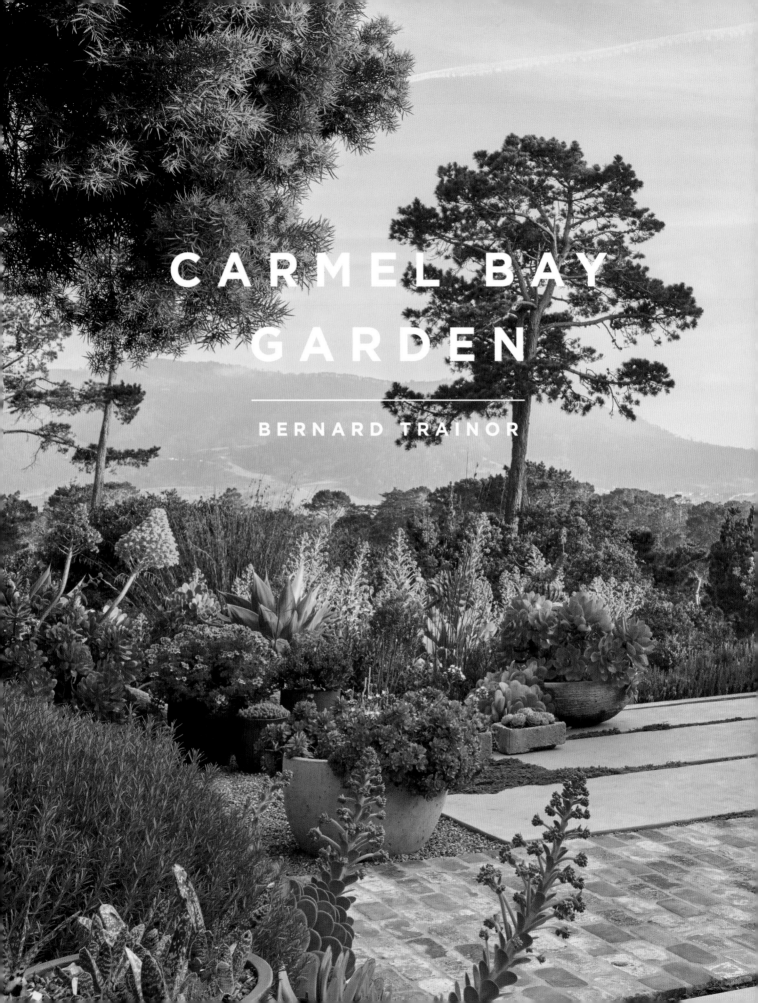

CARMEL BAY
GARDEN

BERNARD TRAINOR

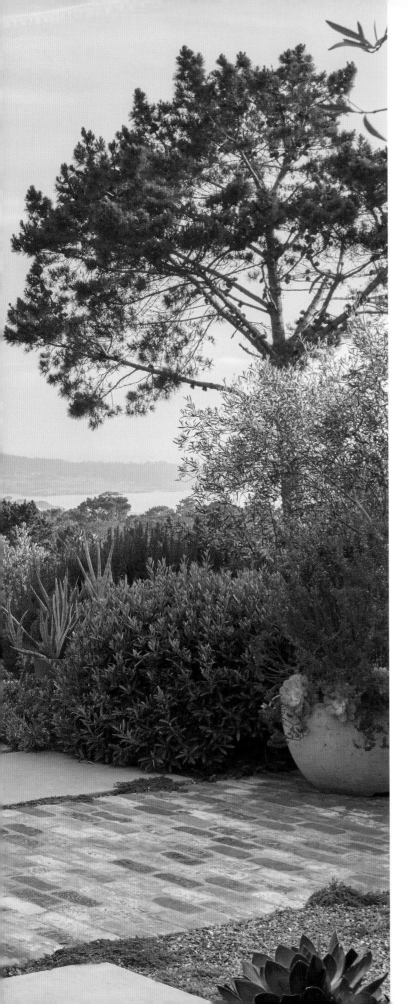

The Place

Carmel-by-the-Sea is a small town on a small bay on the central coast of California, just below the larger Monterey Bay. Carmel Bay is formed by the mouth of the Carmel River, the headwaters for which are deep in the Santa Lucia Mountains, which hug the coast quite closely, spreading south and east from there. The scrub, oak, and grassland-clothed slopes precipitously meet with the Pacific on their coastal side, culminating in the iconic, rocky bluffs of Big Sur twenty-five miles to the south.

The area receives just 18 inches of rain a year, which falls primarily between December and the end of March. The ocean and coastal fog influence most mornings and evenings and help to maintain fairly mild, even temperatures year-round. Carmel-by-the-Sea receives no frost to speak of and significantly less extreme daily evapotranspiration than inland areas of California. While that sounds quite paradisiacal, gardens and plants here have to endure almost unrelenting sun, wind, salt air, and lean sandy/rocky coastal soils along with summer drought-compelled dormancy.

For landscape designer Bernard Trainor, the natural beauty of his hillside home

177

is not embodied in the grand, epic moments, but rather in the processes required to result in such beauty. "I'm enamored and overwhelmed by natural beauty, but when I dissect that, I remember how challenging it is for nature to get to the beauty. . . . I might love a flower in its season, but I also know that there were forty-eight other weeks of the year of this plant enduring, surviving, and preparing for that flower. It's this resilience and adaptability that is the most beautiful to me. How plants figure out how to go underground, go dormant, shed limbs or leaves to survive. I used to look at beauty and now I look at the steps that brought this beauty to me."

The Person

Bernard Trainor was born in Australia and raised in a similar Mediterranean climate to that of his current home, with rugged and enormous views, summer drought and fire, and winter rains. He underwent several years of advanced training and apprenticeships in England, including seminal time with the late plantswoman and designer Beth Chatto, who in many ways pioneered a broader understanding of climate- and condition-appropriate gardening. This ethos "was deep within me even before my gardening apprenticeship," Bernard says, and he credits Beth for cementing it. Additional training included the English Gardening School at the Chelsea Physic Garden, an educational and medicinal garden established in 1673 in the heart of London. Bernard has been designing gardens of note since 1995, when he relocated from Australia to the Bay Area. He founded his own studio in Monterey in the early 2000s, and by 2004 he and his wife, Melanie, and their daughters settled in Carmel-by-the-Sea.

The importance of both the natural and cultural history of a place is a strong theme in his work. Bernard's years of training in England and his twenty-five years of creating gardens in California has only strengthened his understanding of landscapes as "repositories of meaning." Bernard strives for his landscapes and gardens to "foster a deep connection" to their place, for his designs to look inevitable and as though they "sit lightly and have grown out of the landscape." To his mind, "When people and place are in harmony, that's when a garden is beautiful. A successful garden is a feeling, not a formula."

PREVIOUS PAGES: Bernard Trainor's home garden grounds the view with a combination of container and hillside plantings. Beneath mature native oaks and pines, rosemary, aloe, agave, and pelargonium let you know you are in a gardener's garden. Bernard uses his containers to experiment. At the edge of the stairs (left) is the "great foliage" of *Aeonium nobile* and across the path (right) the spiky foliage of a variegated *Sansevieria cylindrica* rises above a pruned olive (*Olea europaea* 'Little Ollie').

→ Bernard likes the "design tension" between the engineered concrete water feature and the organic stone outcrop of the hill above. The 5-foot by 27-foot trough is accented by two South African rushes, the more upright *Chondropetalum elephantinum* and the more rounded *Chondropetalum* 'El Campo', which do not seed around "at all."

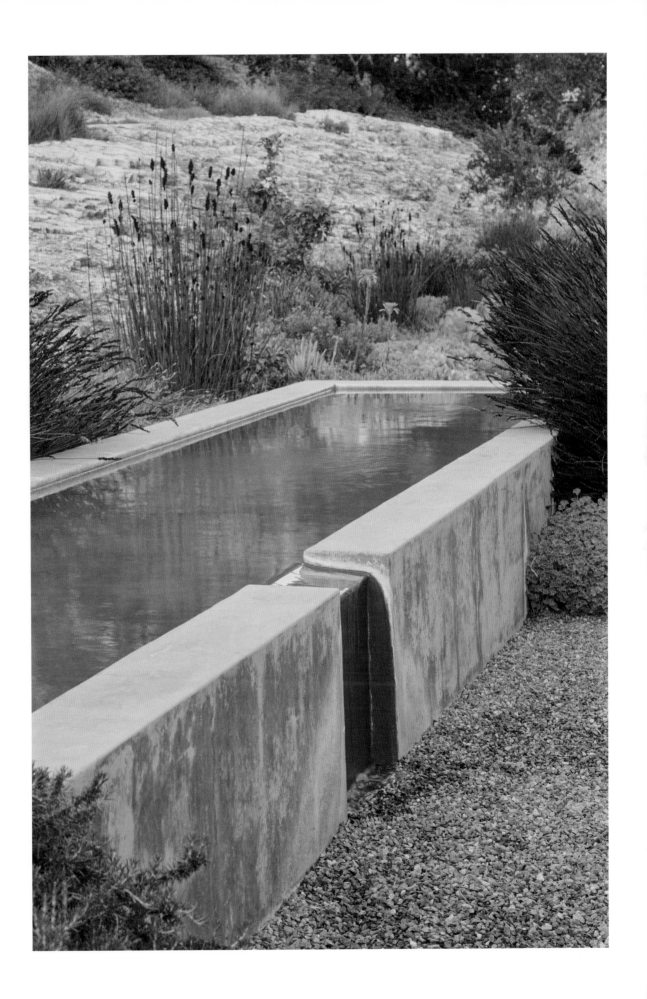

← Hugging the stairs is an unirrigated and colorful community of succulents, restios, *Carex*, and small shrubs. A silvery *Dicliptera sericea*, native to Brazil, is a tough lavender-like choice for this spot. Across the stairs, a mounded *Pittosporum crassifolium* 'Nana', native to New Zealand, always has this "bright look."

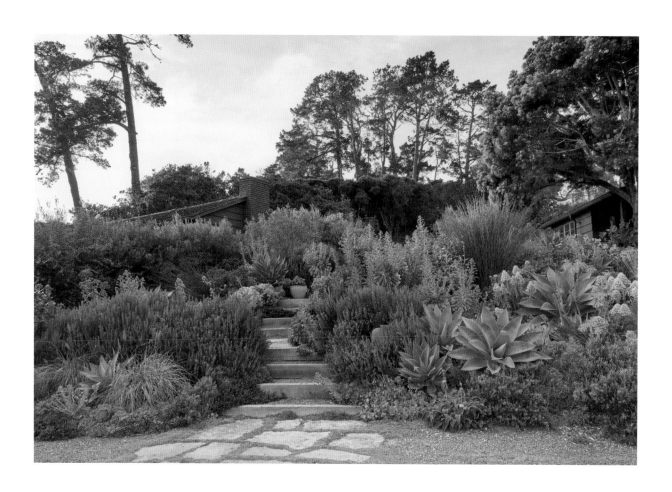

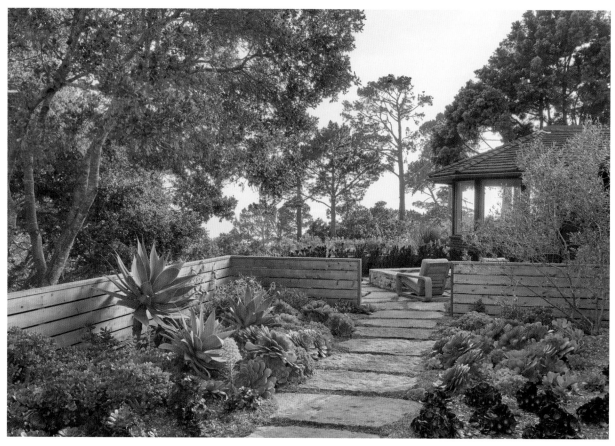

The Plants

When Bernard and Melanie purchased their property in 2011, the steeply sloping site leading up to and around the 1940s-era home and guest house was essentially a blank slate, with the exception of some mature native trees beautifully sculpted by wind and sun, including California live oak (*Quercus agrifolia*), Monterey pine (*Pinus radiata*), and Monterey cypress (*Cupressus macrocarpa*). Another fixed design consideration was the sand-hued rock that forms the garden's base; there was very little real soil and either no drainage or very quick, sandy drainage. Bernard has used this natural though variable foundation as opportunity: stairs leading from one garden level to the next are inset into the stone face of the slope, and off the main living area of the house a trough-like water feature artfully abuts a particularly large stone outcropping characteristic of the land.

Gardening for himself, for his own interests, desires, and pleasure was "a huge liberation," he says. "With clients, I have planning and timelines, regulations, earthquake and structural considerations. One of the things I am trying to transcend here are rules, so that I am experimenting with anything and everything. . . . I try to catch myself when I think inside the box, and I ask myself: 'Is that true? Is that not true?' If I can't answer, I experiment."

Many of Bernard's designs are known for their spare, clean-lined modern elegance, as highlighted in a 2019 retrospective of his decades of work, *Bernard Trainor: Ground Studio Landscapes*. But he wanted this garden to be all of those things *and* plant-rich, "cohesive, not visually jarring," with a lot of cultivars and species. Any plant that catches his interest and is from one of the Mediterranean garden zones of the world is fair game to trial and combine with others lushly, artistically, even playfully.

Working with nature to accommodate extreme summer drought—and many Mediterranean plants' tendency to go dormant and deciduous—Bernard has learned to enjoy the ragged, enduring look of plants that he knows will revive with winter rain. He also makes ample use of succulents from the very small to tall and stately. Drought-adapted California native evergreens and grasses or grass-like plants, which hold their forms and seed heads throughout the seasons and catch the wind and light dramatically, are also well represented. The densely planted garden is a tapestry of textures and shades of green. This abundance of plant life organically pools around, swishes beside, and drapes over paths, softening the harder edges and lines of natural stone and built hardscape. While he does not provide supplemental irrigation indefinitely, he does carefully water plants to get them established. His many potted plants require more water.

Bernard's plant selections and combinations are ways to expand his own professional skills and eye. Manzanita might find a place next to cape rush, rosemary, and olive, sheltered by native oak canopies or underplanted with specimen sedges and

ground covers—all while clinging to the slope's contours. Bernard trials how and where his plants are growing, how drought and sun tolerant they are, how well they might take to different kinds of pruning or care.

"This garden is a hybrid of the cultural and natural history that I have experienced and loved," he says. "I'm inspired by plants I see and thinking how I might grow them—native and non." After many years working with others on their gardens throughout California, he's found many nonnative plants to admire, and he includes them in his own garden as direct references to places he's visited or to local history, such as "mission gardens and other older gardens of the region that might have been left to their own devices for long periods without care or water or tending. From these kinds of historic sites, I have chosen the survivors."

Bernard feels acutely that for many years now "there's been a disconnect between what nature provides in our places and our human-created ability to use endless resources and grow whatever the hell we want." He wants to look back to nature and consider what we can do with far fewer resources. The clues are out there, he insists, "historic and present, in areas of our own culture and in other cultures." Bernard tries in his own garden and in his ongoing garden design to always be researching and experimenting. "We just have to hope that we're all being considerate and thoughtful, taking in the whole picture. Our gardens should reflect our ability to adapt."

↖ Across the bocce court, an *Echium candicans* 'Pride of Madiera' is in full bloom. Bernard diligently pulls seedlings, but notes "You have to be careful with this one in mild climates." The silver, South African *Plecostachys serpyllifolia* is backed by a pool of silvery *Cotyledon orbiculata*.

↑ A more than fifteen-year-old bonsai jade plant (*Crassula ovata* 'Gollum') is highlighted against the background plantings of *Chondropetalum* 'El Campo', *Arctostaphylos pajaroensis* 'Warren Roberts', and live oaks (*Quercus agrifolia*) beyond.

→ Along the pathway on the hillside above the house, Bernard has inverted a dead tree into an organic sculptural piece. Once a fort for his children, it is now a trellis for *Vitis* 'Roger's Red'.

MARWIN
GARDENS

SANDI MARTIN

The Place

Watsonville lies in the lap of the Pajaro Valley along California's central coast. The valley is created by the curve of Monterey Bay to the west and the southwestern edge of the densely forested Santa Cruz Mountains to the east. The confluence of alluvial plain, the Pajaro River watershed, dense redwood forests, ample year-round sun, and an annual average of 25 inches of rain has always made this idyllic spot appealing for human settlement, beginning with the many Ohlone peoples who have lived here for over 10,000 years.

To the northwest of Watsonville proper, on one of the early rises of the Santa Cruz Mountains, Sandi Martin and her husband, Art Winterling, have been tending to 15 acres for the last forty years. Their property is surrounded by several state parks that protect old-growth and second-growth redwood forest ecosystems. Sandi was captivated from the moment she first walked up the northern slope through untended, overgrown thickets around old apple and avocado orchards and crested the hill at the top of the parcel. The view that met her was of redwood forest and the Pajaro Valley to the south and east and Monterey Bay to the south

and west. "It felt like I was home. I lay down on the soil and knew this is where I have always been meant to be. I finally got here."

To Sandi's eye, the beauty of her place lies in "the vastness—the confluence of the hills rolling to the north, the density of the old trees, the whole ocean south, the misty air as the fog banks come and go from the ocean onto the rolling land and up the hillside, and back out."

The Person

"I am a child of the '60s," Sandi says matter-of-factly. "Art and I bought this property to be in nature, to be closer to the land, and to live off the land as self-sufficiently and caringly as we could. We wanted to steward the land—the environment, the plants, the animals, the insects—and to grow our own food."

Born and raised in California's Central Valley, Sandi was greatly influenced by her father, "a gardener, a rock hound, and a lapidarian." All of these influences are reflected in her garden. "I grew up gleaning, harvesting, and processing fruits and walnuts and vegetables left over after the commercial harvest every season, year-round, so I think it's in my genes to see plants as food, as beauty, and as integral to life."

She lived, worked, and gardened in Davis from 1965 to the late 1980s, earning her bachelor's in biological sciences and a Ph.D. in physiology. During graduate work at the University of California, Davis, Sandi spent time at the botany greenhouses, raiding their garbage cans for discarded plants that she could propagate and resell at garage sales. She also spent a lot of time at the school's renowned arboretum, where she fell in love with the great diversity of California's native plants.

In 1979, Sandi and Art bought this property, which they call Marwin Gardens, an amalgam of the beginnings of their two last names. For the next decade, the two traveled on weekends from Davis to the site, clearing overgrowth, building their house, renovating the avocado orchard, and adding Meyer lemon and Satsuma mandarin trees, two crops that Sandi cultivated for commercial sale. In 1989, Sandi retired from her academic work and the pair moved to the land permanently.

The Plants

The shaded road from Watsonville to Sandi's property snakes upward along creeks and through a redwood forest with a dense fern understory. The entirety of the property's entry drive is a gardened space she calls the Swale. It's the first space she cultivated, and frothy mounds of a variety of California native buckwheats (*Eriogonum*) in pink and yellow and white, as well as salvias, manzanitas, cacti, and succulents, are all lushly interplanted among native live oaks, fremontias, and conifers.

PREVIOUS PAGES: From the top of Sandi Martin's Watsonville hillside garden looking southwest, the adjacent land progresses in rhythmic ridgelines and valleys toward the horizon. A striking restio (*Thamnochortus spicigerus*) stands out beneath the canopy of an avocado (*Persea americana* 'Hass') just left of center here. To the far right silvery swathes of *Salvia heldreichiana* (a selection by John Whittlesey being trialed) and *Salvia africana-caerulea* ease down the slope. A remarkable *Persea americana* 'Bacon' stands watch at the downhill corner of the guest house.

→ Self-seeding and hybridizing buckwheats (*Eriogonum*) form a frothy groundcover to an *Echinopsis* Sandi has had for years. "The fruit is edible and tastes like crème brûlée," she says. A beautifully pruned *Arctostaphylos manzanita* × *densiflora* 'Austin Griffiths' is just behind, with a Moroccan mound (*Euphorbia resinifera*) at its base.

FOLLOWING PAGES: Framed by the gnarled arm of an old avocado (*Persea americana* 'Bacon'), the rolling ridgelines lead out to the horizon. Beneath, one of Sandi's hybrids of *Salvia fruticosa* blooms beside *Lavandula* 'Goodwin Creek Grey' and a mature Meyer lemon (*Citrus* ×*meyeri*).

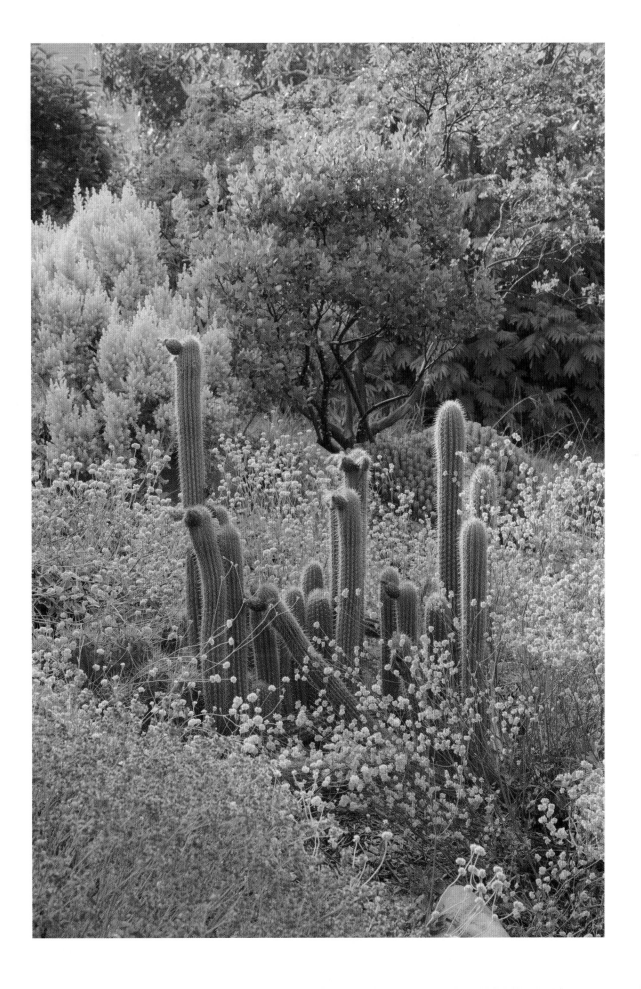

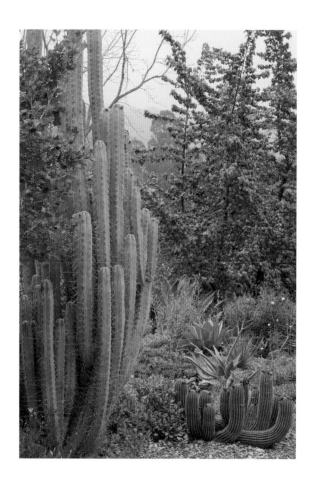

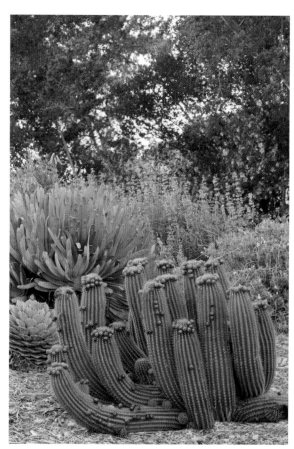

A vignette along
Sandi's driveway swale garden
includes *Echinopsis lagen-
iformis* standing tall on the
left, giant Argentinian cactus
(*Echinopsis candicans*) below,
with *Aloe* and *Agave* behind,
and a tall ×*Chiranthofremontia
lenzii* 'Griff's Wonder', an
intergeneric cross between
Fremontodendron and
Chiranthodendron. A hybrid
buckwheat (*Eriogonum*) has
self-seeded throughout.

St. Catherine's lace
(*Eriogonum giganteum*) grows
by the gate into Sandi's fenced
Inner Garden. *Salvia cha-
maedryoides* is below, the dark
foliage of *Salvia madrensis* is
to the left. On either side of
the top of the gate is *Croton
congestus*.

At the top of the orchard in
Bill's Garden, named for a
beloved brother-in-law and
gardener, an Argentine giant
cactus (*Echinopsis candi-
cans*) prepares to bloom
in front of a fan aloe (*Aloe
plicatilis*), *Salvia munzii* 'Baja
Blue', and *Salvia leucantha*
'White Mischief', while yellow
Fremontodendron 'California
Glory' blooms at far back.

The fenced Inner Garden's
summer abundance, in back
of the house and off of Sandi
and Art's breakfast nook
includes *Hebe* 'Icing Sugar',
Penstemon 'Apple Blossom',
a fuchsia-colored *Dahlia coc-
cinea* hybrid, *Salvia* 'Waverly',
and elephant head amaranth
(*Amaranthus tricolor*). Just
right of center, a Peruvian
daffodil (*Ismene ×deflexa*)
holds its own.

"I am catholic in my plant tastes. And as a gardener, I'm a compulsive collector," she notes wryly, indicating the more than ten distinct garden spaces on the land. Sandi has a solid eye for color, size, texture. But, she is quick to point out, whereas a designer might say "This space should have a tall and a short, a pink and an orange," she lets her plant choices be driven by what she likes.

In addition to grouping in collections, Sandi also groups plants by general region or climate of origin. She has re-created a cloud forest, Baja California, and South Africa in individual gardens. She also has themes that speak to personally influential people: Bill's Garden, named in memoriam of a favorite brother-in-law, and Julie's Garden, named in memoriam of an influential artist friend from her Davis days. Stones from her father's collection are polished or inlaid in stone walls and pathways. Her garden, like many good gardens, reflects the narrative of her personal history.

Sandi is interested in native and climate-appropriate plants and the efficient use of resources they represent. "I like my garden to be in continuity with the natural land-scape, to not be dissonant or abrupt . . . I do transition gently to the plants [not native to this immediate region] I collect closer to the house, but especially at the edges of my gardened property, I like to use mainly California natives artfully so that they interface with the native environments harmoniously."

The site offers a fabulous diversity of topography, "You're up, you're down . . . there's sun and shade, there's exposure and shelter," she says. Climatic nuance, however, is not to be underestimated, "It can be cold and damp and hot and dry all in one day here. The ideal is to wake to cool and foggy conditions, which burn off at about ten o'clock, then suddenly it is eighty degrees. The cooling fog breath comes in again about four o'clock." With so many different physical exposures, elevations, and soil conditions, maintenance is always ongoing and there is not one regimen.

The only part of the garden on regular irrigation is the deer-fenced half acre around the main house, which she calls the Inner Garden. This is where Sandi's most tender, subtropical, and often floriferous plantings are. She justifies the well water used for this space because of the abundant bird and insect life that comes for nectar, pollen, and nesting. Caring for her plants over the years has also called for analytical think-ing. "I live in a Mediterranean climate. I have a lot of Mexican and Central [and] South American plants, and I originally assumed they didn't need summer water. But I was discounting the importance of the Mexican *chubascos*, the weather pattern of strong rain squalls with an extreme amount of rain in a short amount of time in the rainy season along the Mexican Pacific coast." It took her a long time to understand why her plants were not doing as well as she thought they should without supplemental summer water. Now, when the chubascos start in Mexico, she hand-waters the plants that would be getting the rain in their native environments. Similarly, she hand-waters her Coloradan and High Sierra plants deeply once or twice a week in the summer to simulate the afternoon showers they would get in the wild. She is careful to wait for a

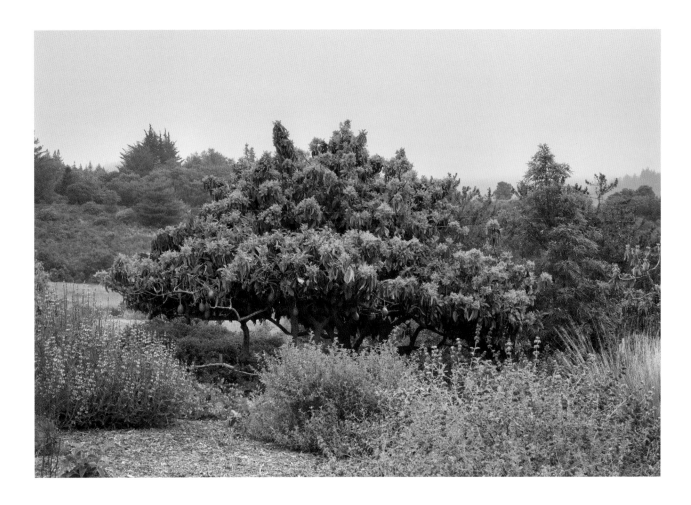

cool, foggy morning or late afternoon, though, as watering in the heat in California can activate fungal diseases including *Phytopthora*.

Sandi starts and ends each day in the garden, religiously watering, pruning, harvesting, and applying nontoxic deer and rabbit repellent. She deadheads vigilantly and composts the remains in old plastic bags until they rot. She does this by filling bags with green waste and water, sealing them with a rock in the sun, and letting the mixture rot. Once it turns into "black food," she pours it around the drip lines of the avocados and citrus trees for a perfect full-circle loop. She never plants nonnative plants that might "get away from the garden into the wild," and any potentially invasive weed or other seed heads she vigilantly quarantines in paper bags and burns. "The idea that I would introduce something here that would pollute the environment is anathema to me. The views, the time with the plants . . . it's as ritualistic and spiritual as it is pragmatic."

↑ A mature avocado (*Persea americana* 'Bacon') is under-planted with black sage (*Salvia mellifera*) (left), one of her own hybrids of *Salvia africana* (center), and *Salvia* 'Blue Lime' (right).

→ *Salvia spathacea* 'King Crimson' grows along what Sandi calls her "corralitos" fencing, which she crafts from dead or windfall redwood branches around the property. Behind the fence, *Ceanothus* 'Concha' catches the sunlight.

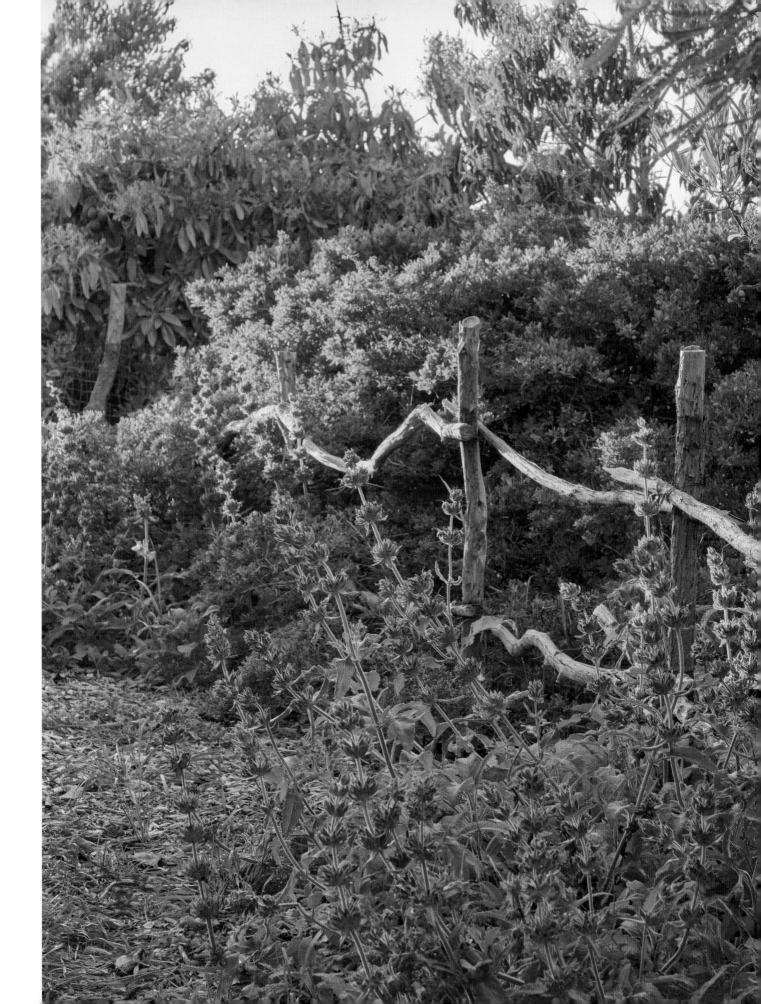

↑ Sandi's Rose Garden is an exuberant overgrowth of roses and perennials, where only the most resilient and fragrant rose selections remain, including *Rosa* 'Tamora', *Rosa* 'French Lace', and *Rosa* 'Catherine Mermet'. Gravenstein and mutsu apple trees bloom at the back, and breadseed (*Papaver somniferum*) and cream-colored California poppy (*Eschscholzia californica*) self-sow with abandon throughout.

↑ *Salvia elegans* and giant cape restio (*Rhodocoma capensis*) provide a textural contrast on the slope at the corner of the guest house.

→ A sea of self-seeding buckwheats (*Eriogonum*) connect succulents and cacti, including *Echinopsis lageniformis* on the left.

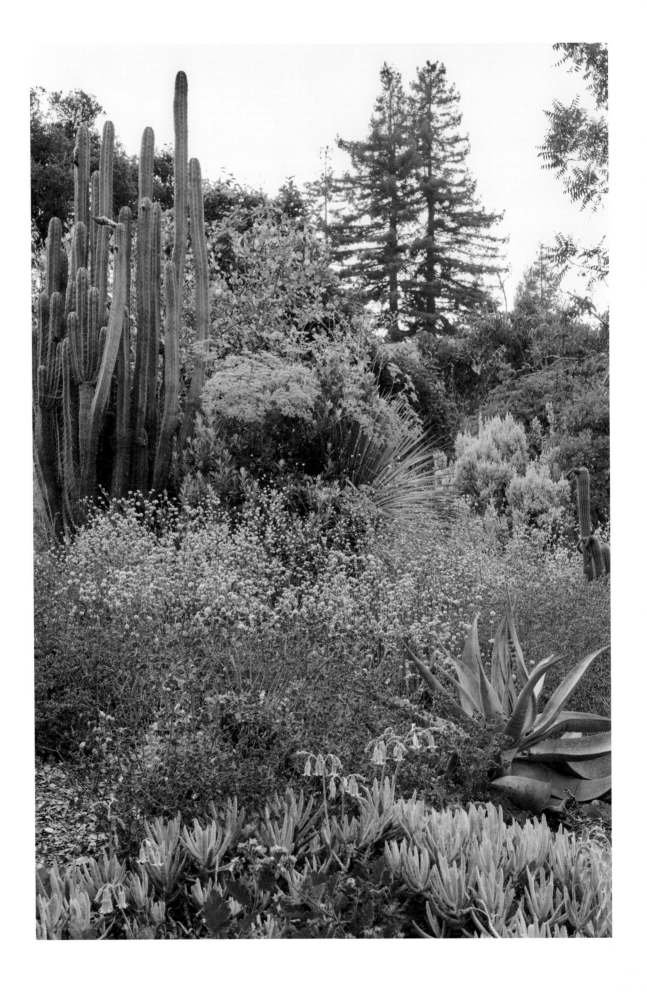

SILICON VALLEY
NATURE RENURTURED

RONALD KOO *and* MIWA HAYASHI

with LESLIE BENNETT

← Ronald Koo and Miwa Hayashi's suburban Los Altos front garden is full of colorful and edible plants chosen to feed humans and a diversity of insects. *Aloe* 'Hercules' stands before the front door, with the russet-colored succulent *Graptoveria* 'Fred Ives' at its base. Blue chalksticks (*Senecio serpens*) is an easy-care groundcover, its glaucous leaves contrasting with the bright orange California poppy (*Eschscholzia californica*). A hybrid of native foothills penstemon (*Penstemon heterophyllus* 'Margarita BOP') and native *Verbena lilacina* 'De La Mina' adds other shades of blue. Three pineapple guavas (*Acca sellowiana*) form a hedge and provide masses of fruit in autumn.

The Place

Los Altos is on the San Francisco Peninsula in the Santa Clara Valley, historically known as "The Valley of Heart's Delight" because of its vast fruit orchards. That geography means that there is a sense of water almost everywhere. The Pacific Ocean opens outward, west of the Santa Cruz Mountains; Los Altos sits at the base of the Santa Cruz Mountains overlooking the San Francisco Bay to its east. Surrounding the bay, as the point of intersection between the expansive upland and inland watersheds and their destination in the ocean, are rich, filtering grassy marshes and wetlands. The city is in the rain shadow of the Santa Cruz Mountains, however, which equates to just over 15 inches of precipitation that fall over fewer than sixty days of the year.

Los Altos has long been a densely built, human-centric environment. The area transformed from fruit orchards to suburbia starting in the 1960s. The larger forces of nature that are ocean, bay, and the mountains persist in their presence, but the details of nature are harder to find. Details like how to live with the water constraints of the region and how to support practical and aesthetic biodiversity are problems of a sort that engineer Ronald Koo works on in his off-engineering hours at home.

The People

As a child in Grass Valley, California, Ronald Koo loved the ponderosa pine forest that was his "childhood backyard" and the manzanita of the foothills. Manzanita is now the most prominent plant of his Los Altos front garden, just as it was a place signifier of his early life.

Ronald works as an inventor, innovator, and electrical engineer, and he brings this creative approach to his cross-cultural suburban home garden as well. While doing his undergraduate and master's work at MIT, Ronald lived in the famous Baker House. He says, "It's the only complete building in the United States by Alvar Aalto, whom people consider the father of the modernist Scandinavian/Finnish architecture movement." He traces his love of innovative modern architecture and design details to his years there.

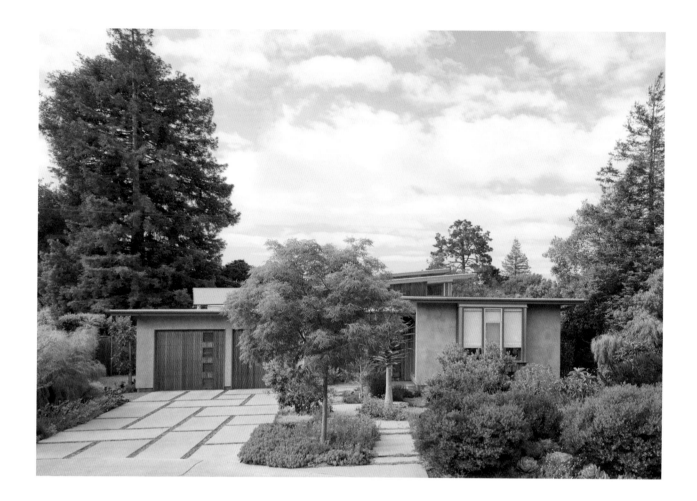

When Ronald and his wife, Miwa Hayashi, a Japanese-born scientist working at NASA, "the rocket scientist in the family," met and married in 2007, they shared a love for a modernist design aesthetic and a desire for a landscape that reminded them each of home. They soon found an opportunity to design and build their own modern house and garden on a "classic Californian suburban neighborhood cul-de-sac." The two were meticulous in siting the house for light, in the layout and construction, and in the many practical and aesthetic details—from the tatami room, a traditional Japanese room with rice-paper walls, bamboo mats, and simple furnishing in the back of the house for Miwa, to special windows and door handles.

The opportunity to help design the house serendipitously provided the chance for Ronald to design the gardens around it as well. He knew he wanted a garden reminding him of Grass Valley in the front. The back garden, onto which the tatami room opens, is a traditional Japanese garden for Miwa. The side yards were envisioned as connective spaces between the two personally and culturally significant landscapes front and back. Throughout, they wanted to be able to have edible plants for harvesting and cooking the foods they love.

↑ A relatively young Chinese pistache (*Pistacia chinensis*) stands at the front of the Koo garden and is slowly developing the widely rounded, shade-providing canopy for which it is known.

→ Blue chalksticks (*Senecio serpens*) and the larger succulent form of *Agave desmetiana* 'Variegata' are interplanted with foothills penstemon (*Penstemon heterophyllus* 'Margarita BOP') and the native *Verbena lilacina* 'De La Mina'. Ronald says, "This combination captures the abundance of spring and attracts an incredible variety of insect diversity and the noise of life."

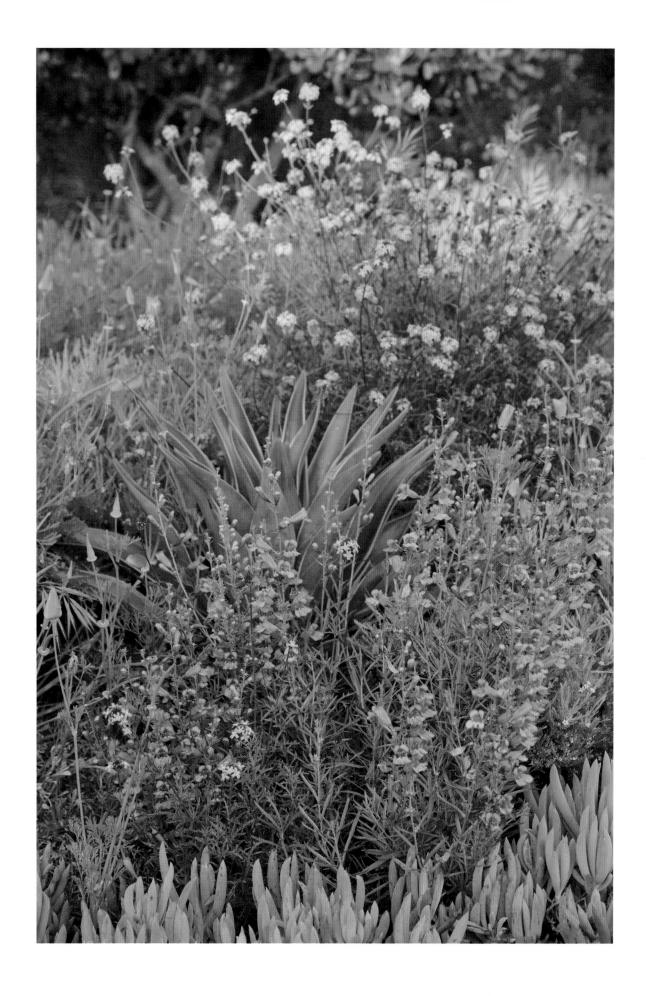

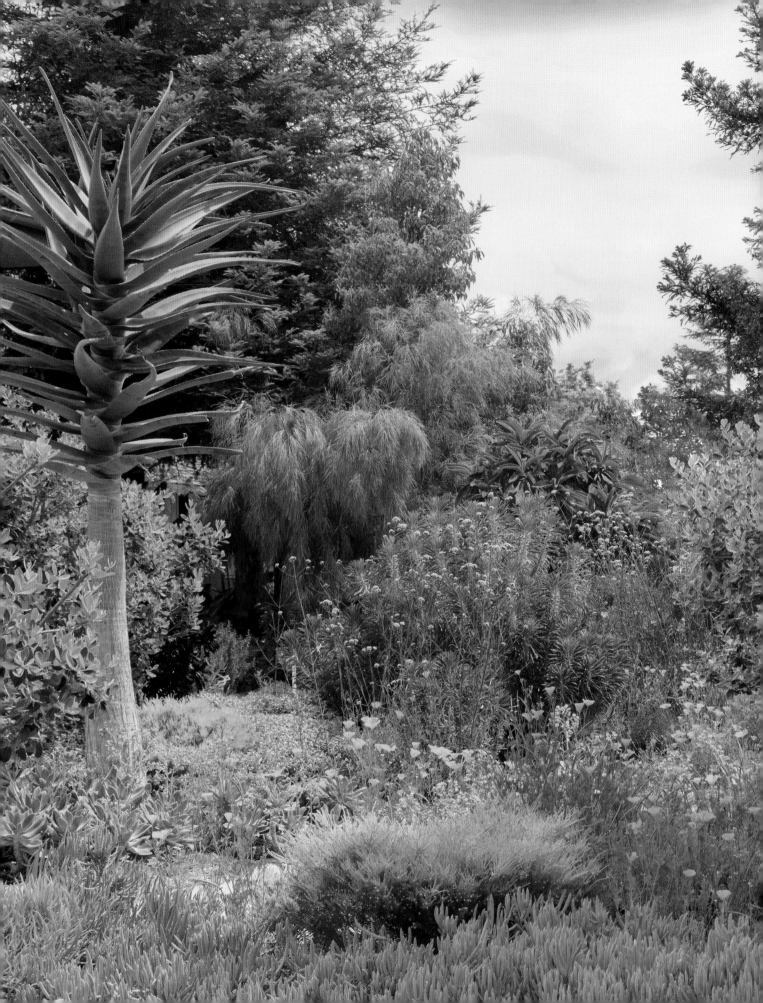

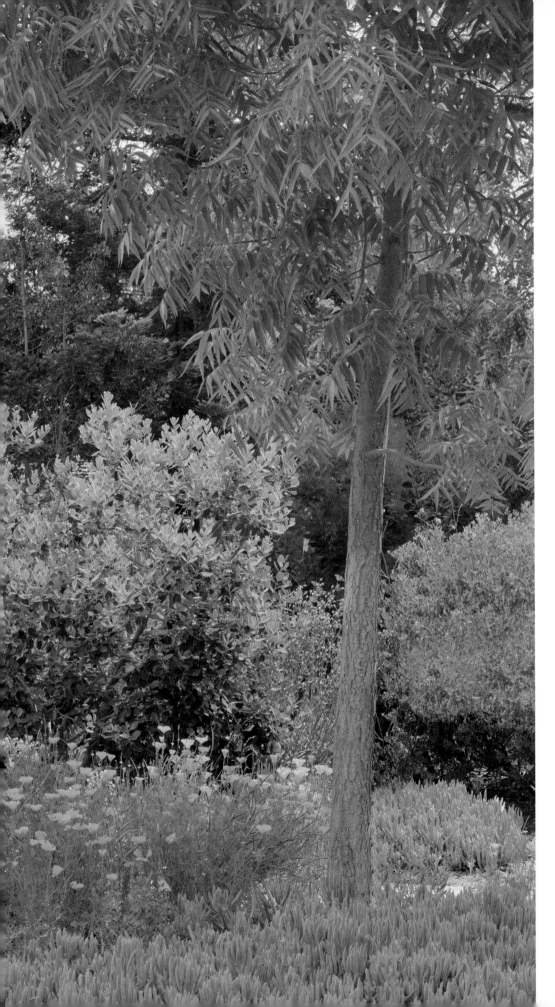

← In the front garden, Ronald likes the California poppies going everywhere and unifying the plantings, "they are so quintessentially representative of *here*." *Aloe* 'Hercules' is balanced by *Pistacia chinensis*, while *Senecio serpens* grounds the scene. Purple *Verbena bonariensis* and pink *Calandrinia spectabilis* accent the shrubs.

203

SILICON VALLEY NATURE
RENURTURED

The Plants

Ronald actively experiments in the front naturalistic garden, rather than in the more formulaic, traditional Japanese garden in the back of their modern ranch house. A tall pistache (*Pistacia chinensis*) fronts a lush hedge of manzanita (*Arctostaphylos*) behind which silvery pineapple guava (*Acca sellowiana*) peek out. Golden California poppies bloom above silver succulent groundcover, and the feathery foliage of bamboo, with its edible young shoots, softens the line between Ronald and Miwa's driveway and the neighboring lot.

The house itself was designed to take full advantage of what rain does fall, with rainwater from the roof stored in a cistern beneath the driveway. Graywater from the Japanese bath waters trees and large shrubs in the garden. The water-permeable driveway helps to eliminate potentially polluting runoff into the region's abundant and already overtaxed surface water. The garden does have an irrigation system, which Ronald monitors carefully. It comes on every four days in summer, less in the shoulder seasons, and is off in winter with the rains.

Initially, Ronald worked with a landscape designer to create his naturalistic Grass Valley front garden, which did not require any irrigation. He generally liked it, but Miwa did not love what felt "harsh and messy" to her, so he rethought the garden design. He knew he wanted more edibles than the original native plant garden had included. He had loved working and eating out of the vegetable garden as a child and had recently discovered the joys of foraging edible weeds and native plants. Lastly, Ronald wanted to pay homage to "The Valley of Heart's Delight."

Enter Leslie Bennett, garden designer and founder and owner of Pine House Edible Gardens, who specializes in low-water, edible, and culturally resonant landscapes. Leslie ushered in Ronald's "Grass Valleyesque Landscape 2.0" in 2012. They kept the manzanitas and the pistache from the original planting and introduced many groundcovers, flowering plants, and edibles—including ones referring to Ronald's Chinese American lineage and Miwa's Japanese roots, such as sudachi (*Citrus medica*), loquat (*Eriobotrya japonica*), bamboo (*Phyllostachys*), persimmon (*Diospyros*), and even edible ginger. "It's slowly gotten a little more wild," says Ronald, who admits he likes to experiment with seeds to increase the plant density and wildness by tossing them onto the ground and seeing what happens. This accounts for the parsley, wild mustard, and edible shingiku or garland chrysanthemum (*Glebionis coronaria*) that looks like groundcover showing up and filling in open areas.

Not wanting to use any chemicals, as he is "leery of them in the environment," Ronald realized early on that if he was not going to fall back on those kinds of easy fixes he had to figure out how to solve problems another way. When he noticed a proliferation of whiteflies in his front garden, he researched the issue. He learned that with "the correct predatory wasp diversity, you can keep whitefly and aphids in

pretty good check," but you also need "a lot of groundcover with small flowers" to attract and support this kind of insect population. So he and Leslie introduced more yarrow (*Achillea*), garland chrysanthemum, native buckwheats (*Eriogonum*), annual wildflowers, and native and nonnative succulents. Ronald believes it's possible for everyday people and their gardens to increase biodiversity as a whole.

Leslie grew up loving the iconic landscape of California's "rolling golden hills" and oaks, defined by "scrubby, dry, tough, summer-dry plants." But she appreciates people who are not used to it, having had an English-born mother and a Jamaican-born father who both had to "adjust their own sense of what is beautiful and grew to love the California landscape." Leslie considers cultural resonance: "Gardens connect us to our larger places and even act as containers, reminding us of other important places in our lives. This is really the essence of what gardens are all about."

In the "plant-rich" Koo garden, Leslie sees the welcoming bank of manzanitas as really indicative. For her, "plants are a great lens to figure out where I am, wherever I am in the world." She was excited when Ronald asked her to redesign the front yard as a metaphoric Occidental West and the backyard to represent Japan. When she started on the Koo garden, Leslie had actually been living in the Grass Valley area and had become more aware and informed about manzanitas, which she thinks of as "magical beings" historically linked to California's ecology and to Indigenous peoples' food and medicine. Ronald's love of manzanita, for example, illustrated her belief that "every garden represents a number of gardens over time and space—the native space, the Indigenous cultivated space, maybe the previous homeowners, and your own previous landscapes." In its very suburban environment, Ronald and Miwa's garden is "a very Californian garden," which she thinks makes it all the better, as a very cross-cultural "place within place."

LANDS END LOOKOUT

SURFACEDESIGN

GOLDEN GATE NATIONAL RECREATION AREA

37.47°N, 122.30°W

ELEVATION 0-584 FEET

← The naturalistic and carefully designed native plantings around the Lands End Lookout park along San Francisco's rugged coastline celebrate the natural beauty and history of the region. The repeating lines of wooden posts arranged throughout the landscape were created from recycled timbers sourced from forestry management in Presidio Park. Their linear, rippling placement pattern across the dunes repeats the patterns formed by the standing pine, oak, and Monterey cypress on the upland edges of the site and hint at human and climatic interactions over time.

The Place

The city of San Francisco's westernmost jut of land is known as the Lands End Lookout, which is part of the larger Golden Gate Park National Recreation Area. Once a windswept point protected by miles of sand dunes, Lands End stretches 20 acres and has an elevation rise of more than 500 feet from the beaches to the coastal bluffs.

The entire region is part of the traditional homelands for the Indigenous Ohlone and Miwok peoples. Since Spanish settlement of San Francisco in the 1770s, the site has consistently attracted interest for the uninterrupted views of the Gulf of the Farallones and the vast Pacific Ocean. In the 1880s Adolph Sutro, a wealthy San Franciscan and later mayor of the city, purchased the undeveloped land. Sutro eventually built a private railway to bring city residents to the extensive indoor swimming facilities known as Sutro Baths and created Sutro Heights Park, a formal public garden ultimately abandoned, on what is now Lands End Lookout. Today, people remark on the wildness of its land in such close proximity to the city.

All gardens and designed landscapes are liminal spaces, knitting together one place with another, past times with present and future times. The designed landscapes now at Lands End moderate ongoing interactions—sometimes tense, sometimes harmonious—between the ocean, the land, and the dense urban area. Each leans into, pulls away from, and encroaches on the other again and again. Indicative of this, Sutro's grand schemes for the recreational developments that now lie in ruins form part of the history of this site, each layer of history having been overwritten by fire, flood, landslide, time, and age.

In 2012, a new interpretive center was opened at Lands End, a collaboration between the National Park Service and the Golden Gate National Parks Conservancy, a non-profit organization that enhances access, recreation, and educational programing. The conservancy has been partnering with the National Park Service on park support since its founding in 1981. Their motto is, "Parks for All, Forever."

The Person

Roderick Wyllie is an award-winning landscape architect with Surfacedesign, Inc., the San Francisco firm he cofounded in 2001 with his partner in work and life, James A. Lord. Born and raised in the area, Roderick completed his undergraduate degree in music and went on to earn an MLA from the Harvard Graduate School of Design. But, he says, "the landscape here in the Bay Area is imprinted on my everyday thinking in ways I don't even realize. The beauty of this place is tied firmly to the coast and the wild and variable landscapes we see along the coast and the dramatic prospects that are created along that edge."

Between his undergraduate and graduate studies, Roderick took an internship at Filoli, a private house with 20 acres of formal gardens twenty-five miles south of San Francisco that has now become a National Trust site. "It was such a unique experience to be in and with that garden across seasons." His time at Filoli not only taught him what it takes to care for and manage a garden over time, but the power of such a dedicated, lived experience.

Roderick developed a strong understanding of spatial design and a passion for plants as individuals and gardens as experiences. He also considers himself a serious student of classical gardens. "There is so much to learn from traditional gardens . . . like managing slopes and thriving in tough climates. Look at Italian Renaissance gardens!" he exclaims. "They're always working with water—too much of it, too little of it, allocating it, and moving it. There's so much to learn from them about efficiency and logistics."

His admiration of traditional design might not be immediately obvious in Surfacedesign's clean-lined work, "because our training is as modernists, which emphasizes an efficiency of materials, which can also translate into decisions about soil and plant selection." The firm's stated ethos is of "cultivating a sense of connection to the built and natural world, pushing people to engage with the landscape in new ways." In their use of proportion, of framing, and elegantly directing movement and view through a space, however, the elements of traditional design are foundational. Roderick and his team value how gardens frame and direct our perception of things—visually and philosophically—showing visitors where to go, how to get there, what to look at, which determines what's important and what should be hidden.

To Roderick, the Bay Area's inherent beauty derives from "a kind of ruggedness. . . . There's something rough and dynamic, confronting and exciting about it, how you can read geologic time in the bluffs." Created by tectonic plates continually running headlong into one another over millennia, the bluffs embody this physical immediacy. He says, "It can't be overestimated that landscapes and gardens are sensual spaces. . . . I want, if possible, to give that fully immersive sensual experience to others."

→ From the top of the Lands End Lookout, the land slopes away to the visitor center and the ocean below. The mounding plant forms reflect the waves and the land beneath them. Repeated yellow lupine, silvery *Artemisia californica*, and fresh green coyotebrush (*Baccharis*) create a green tapestry.

FOLLOWING PAGES: Naturalized land adjacent to the Lands End Lookout project provides a view across the ruins of the Sutro Baths and out to the bay.

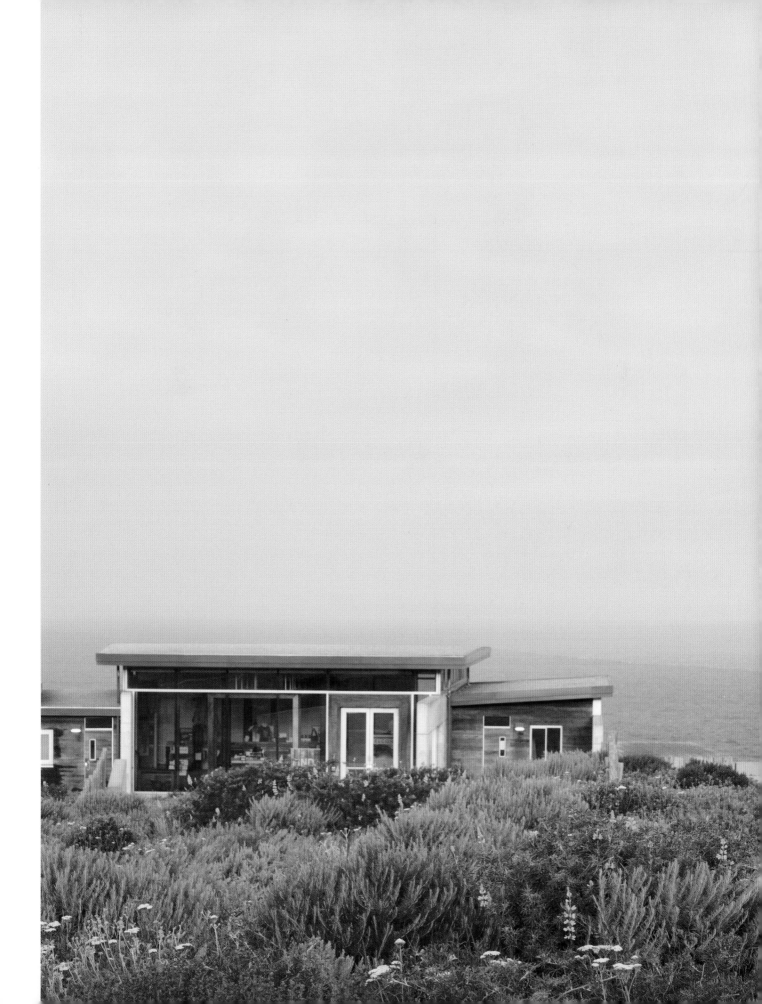

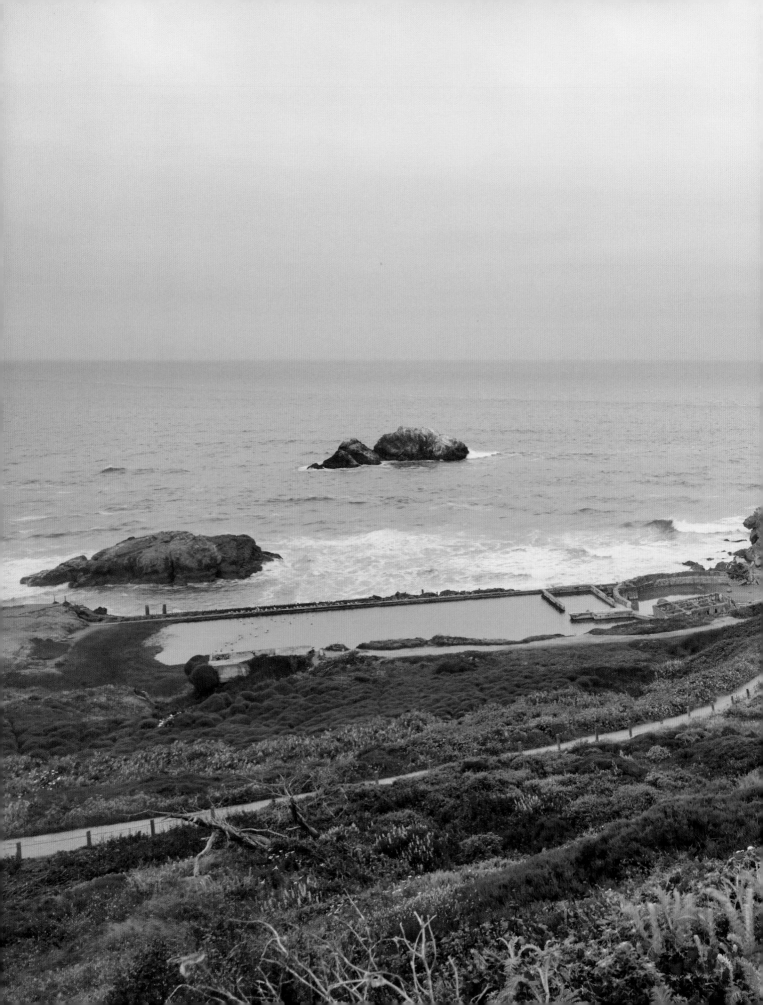

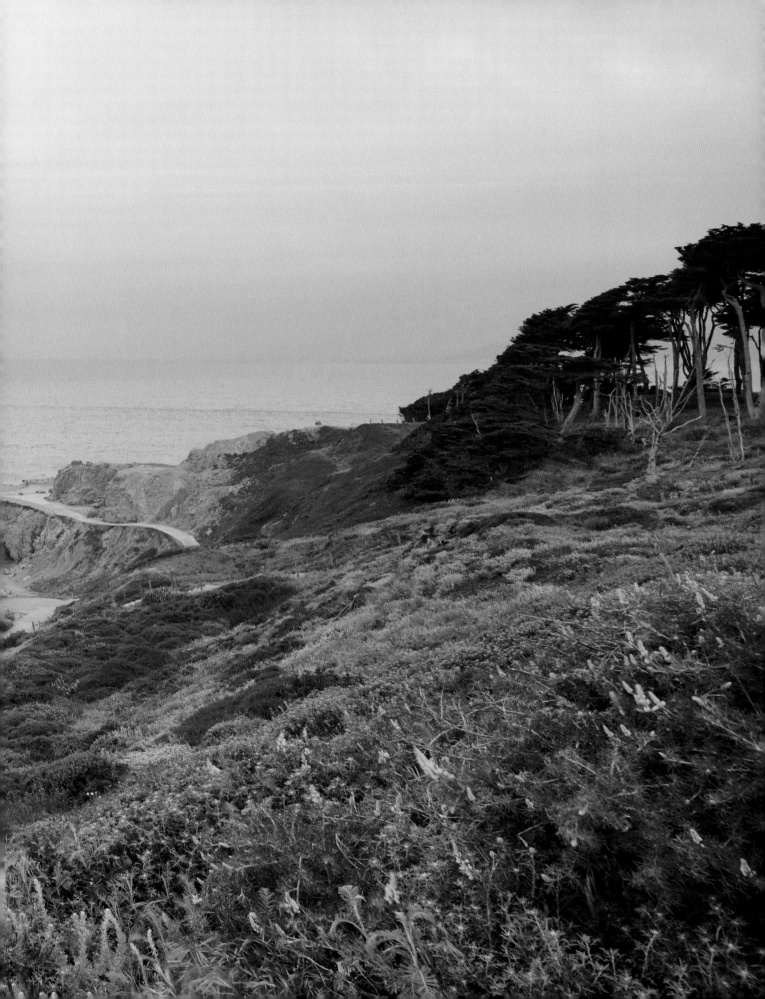

The Plants

The "natural resilience and ruggedness" that Roderick loves about the Bay Area is what he aimed to celebrate in the design of Lands End. "The materials have a simplicity that can withstand the fairly tough coastal environment. Instead of fighting that, we sought to celebrate the toughness." He chose plants and materials to echo the slope and curves of the land and that would "not only weather well but make visible and accentuate the beauty of the constant change weather continues to bring."

When Surfacedesign first took on the commission, the site was little more than an expanse of hard paving. Today, the acre around the new welcome center consists of sweeps of native coastal species, "all from seed or cuttings sourced from this exact watershed and propagated by the Golden Gate National Parks Conservancy nursery," on rolling soil berms mimicking a natural rolling dune environment. By both conservancy mandate and Roderick's desire, there is no supplemental irrigation, "so there's something of a conceit of restoration back to native." Thanks to careful design, the line where the native coastal dune and bluff scrub, coastal prairie, or coastal oak and pine landscapes end and the designed landscape of the park begins might appear to be nonexistent. The goal was to make the park a bridge between the visible ruins on site and the parking lots and nearby squadrons of apartment buildings.

The seemingly straightforward "series of concrete dune screens, the simple vernacular wood elements" all subtly work with the site. They "help with the way the sand gathers and create and protect dune formation and stability [and] they register the slope of the land out toward the water," Roderick says. Similarly, the vertical concrete walls and screens "work off the architecture of the buildings to extend them out into the landscape. They frame the view of the water . . . helping to manage its enormity." The benches serve double duty as retaining elements, giving them "some visual as well as real weight." The repeating lines of wooden posts—recycled timbers sourced from forestry management in Presidio Park—in a linear, rippling pattern across the dunes repeat the patterns formed by the standing pine, oak, and Monterey cypress on the upland edges of the site and hint at the idea of neglected pier moorings.

↓ The architectural elements of the Lands End visitor center, such as the concrete wings coming off of the building and the solid wood benches, help to bring the expansive space into human scale. The benches were crafted from dead trees culled out of Golden Gate parks.

The structural elements shape the space for the sweeps of native plants, which also mimic the contours of the land, the movement of water and wind. Mounding groups of bush lupine (*Lupinus arboreus*), dune tansy (*Tanacetum bipinnatum*), coastal manzanita species, seaside daisy (*Erigeron glaucus*), seaside paintbrush (*Castilleja wightii*), and coast buckwheat (*Eriogonum latifolium*) provide a seasonally shifting palette of silvers, grays, blue-greens, and deep greens accented by the seasonal flowers—cool yellow lupine stalks, golden yellow button-shaped tansy, purple daisy faces, red flames of the paintbrush, and frothy white turning to cinnamon as the buckwheat blooms age.

Reinforcing "where you *are* in the world" is always a primary design consideration for Surfacedesign. The partners on the project considered how "people of all abilities can *be* in the spaces, which is access in really technical ways—walkways, grade, sight lines." But they thought about access in other ways, too. They wanted visitors to experience through all the senses, not relying on just the sense of sight, and from as wide a variety of possible cultural and historic backgrounds so that the greatest number of people feel truly welcome. The team met with many groups, including representatives from the Ohlone people, whose potential use of the site again for traditional and ceremonial gatherings was incorporated into the final design.

"And yet for all of that," Roderick says, "the design is simple. It does not hit anyone over the head with a narrative. Rather it provides shelter, it provides openness and space, it encourages curiosity . . . daydreaming space to transcend, expand, explore," which, Roderick says, is an intangible element he believes is of "unquantifiable value in designed landscapes."

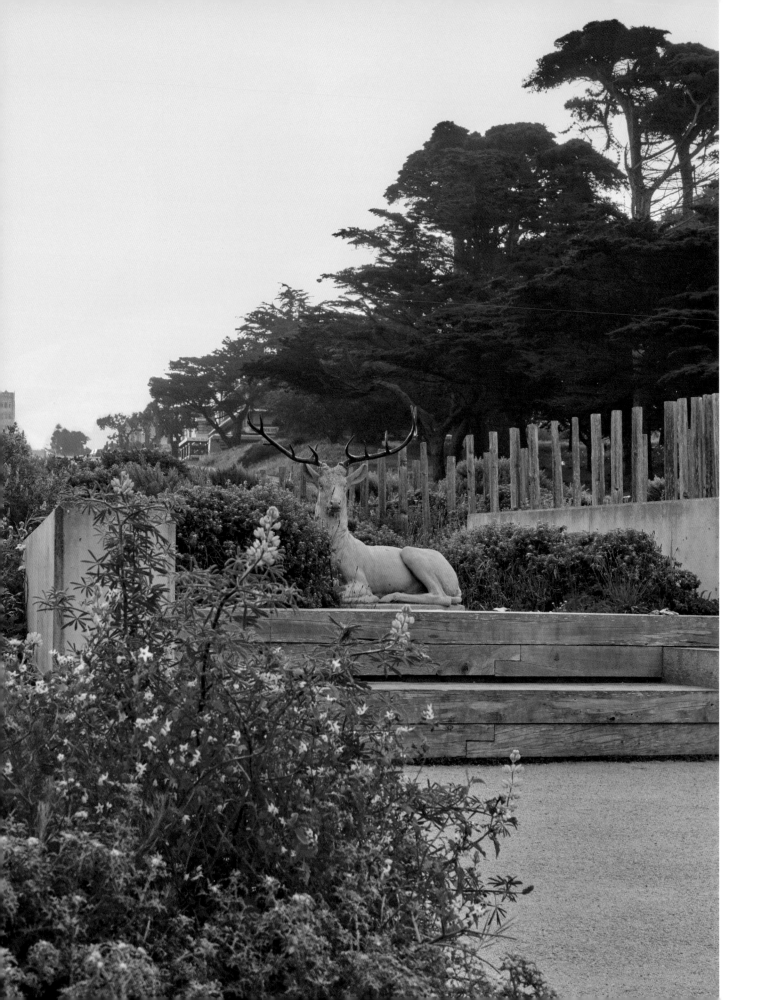

← A self-sown *Solanum* climbs
through a yellow lupine next
to the visitor center. The stag
statue was original to the
Sutro Gardens and adds to
the cultural narrative of the
site. Welcoming benches meet
Surfacedesign's standards for
universal access and meet ADA
standards for accessibility.

→ The undulating dune topog-
raphy is mirrored by the plants.
California sagebrush (*Artemisia
californica*) and coyotebrush
(*Baccharis pilularis* subsp.
consanguinea) weave back
and forth, with flashes of
red, self-seeding paintbrush
(*Castilleja*) popping up.

HOG HILL

MARY *and* LEW REID

The Place

Sebastopol is a sleepy little town in Sonoma County. A little over sixty miles north of San Francisco and twenty miles inland from the coast, it is tucked into a point in the Coast Ranges where the hills roll fairly gently and grasslands and plains spread between rockier ridges. Receiving an average of 30 to 35 inches of rain each year, with no snow and little frost, this bountiful region has a longstanding history of attracting settlement, from the Coast Miwok, Pomo, and Wappo peoples whose ancestral lands these are to Russian and Spanish colonists who arrived from the mid-1700s through the early 1800s.

"Even if you just had a tent on the site, it would still be gob-smack beautiful," says Mary Reid of the 140-acre hilltop property in Sebastopol. "The sea of fog in the early morning, the conifers of surrounding forest peeking up out of it. It's like a Japanese painting." Mary is firmly a "top of the hill" person who likes to see the whole sky and the clouds and weather across wider landscapes. There is a constant sense of dramatic movement here.

The People

Mary Reid was born and raised in the Bay Area by an avid gardener mother. Mary and Lew met and married in Mill Valley in the early 1980s, when she was studying landscape architecture at the University of California, Berkeley Extension. For their first dates they showed each other their favorite nurseries: he introduced her to Half Moon Bay Nursery, and she introduced him to Western Hills Nursery in Occidental. By the late 1980s, they began looking for a quiet country retreat a bit farther north.

When they found the hilltop property in Sonoma County with stretching territorial views across the rolling hillside of the region, it was pastureland. As avid plants-people—Mary by then a professional landscape designer and Lew a passionate plant collector and propagator—they knew they wanted to craft a garden. This passion project directed how they spent their time and money, and travel became focused on places where they could learn about and collect and source new plants. Over the years, they collected and shared "upward of fifty Australian species" with horticulturists at Strybing Arboretum (now the San Francisco Botanical Garden), who grew them on and from which many, including *Callistemon sieberi*, were introduced to the trade as result of the couple's efforts.

When designing the garden, Mary did not want to compete with the views and sense of space on the site. In 1990, she went to England for a six-week course with landscape designer John Brookes at the Royal Botanic Gardens, Kew. In her home garden, Mary adopted Brookes's design philosophy of overlapping geometric shapes to create a fluid and manageable progression across the space. "It's important to understand

PREVIOUS PAGES: Mary and Lew Reid's garden is a rich mix of specialty natives and Mediterranean-climate plants from around the world arranged across the landscape in painterly strokes. *Melianthus minor* (left) abuts a salmon-colored *Salvia greggii* cultivar, which blends into a mounding *Anemanthele lessoniana*. Across the path, *Carex comans* 'Bronze' contrasts with the green glazed pot at the bend. Behind that, *Cotinus* 'Grace' is backed by a half-moon arc of limbed up manzanita (*Arctostaphylos*). *Sedum telephium* (lower left) leans over the smooth silver foliage of *Salvia officinalis* 'Berggarten'.

↖ The glaucous color and shapely form of this South African cabbage tree (*Cussonia paniculata*) highlights this turn in the garden path, into which creeps a prostrate *Acacia pravissima* 'Kuranga Cascade'. Behind, a towering yellow *Robinia pseudoacacia* glows.

↗ White-striped century plant (*Agave americana* 'Mediopicta Alba') floats on rounded waves of *Lavandula angustifolia* and is framed by the bright pink inflorescences of *Salvia canariensis* on both sides. *Rosa* 'Sally Holmes' and *Robinia pseudoacacia* are in the distance.

→ Two thatching reeds (*Thamnocortus insignis*), a male and a female plant, arch over *Hebe* 'Caledonia' and between them the deep burgundy foliage of *Eucomis* 'Sparkling Burgundy' stands out. Behind, the *Cornus capitata* 'Mountain Moon' is "one of the most beautiful things in the garden."

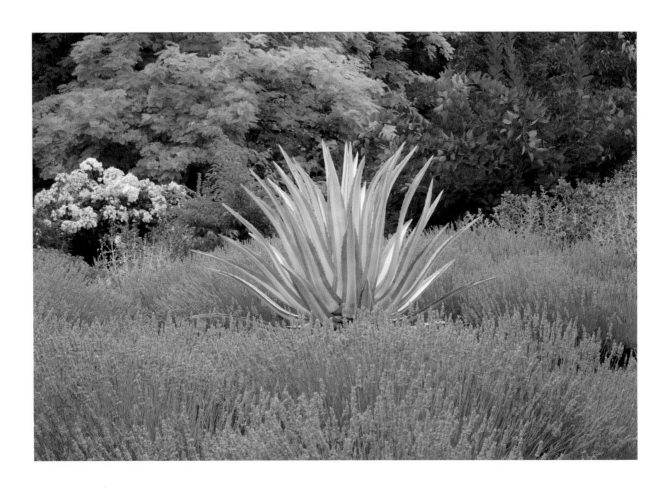

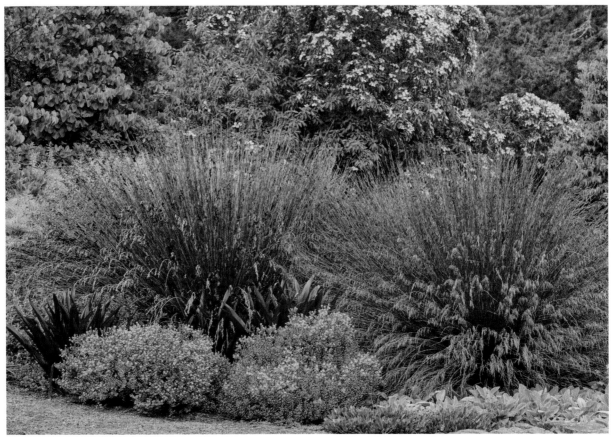

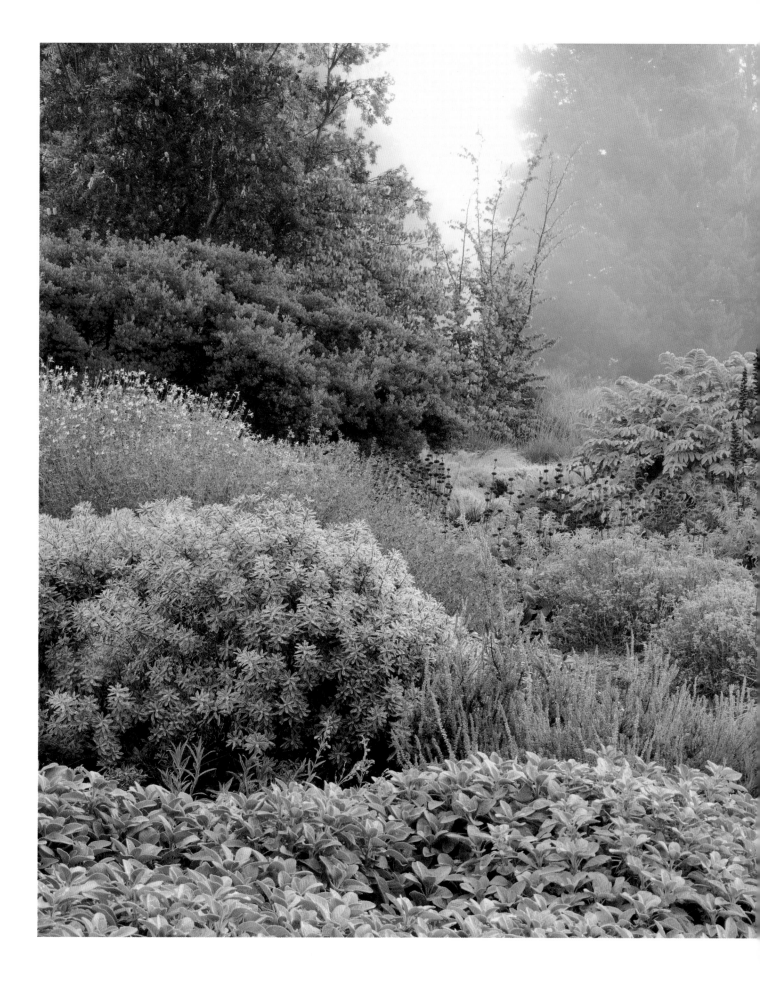

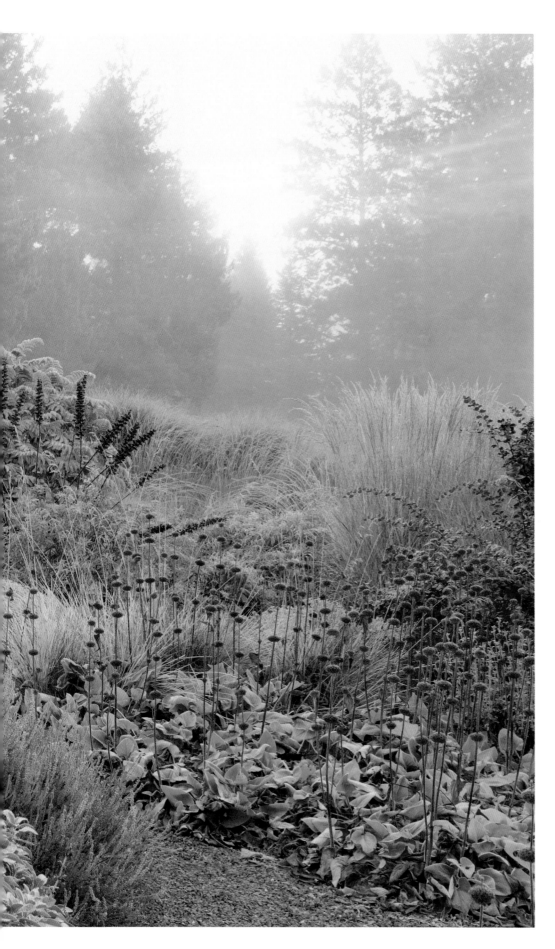

← The spiky inflorescence of *Melianthus major* draws the eye across interweaving stands of *Salvia officinalis* 'Berggarten' at lower left, *Grevillea lanigera* above that, and Jerusalem sage (*Phlomis russeliana*) at lower right. In the top left, a coast banksia (*Banksia integrifolia*), native to Australia, rises above manzanita (*Arctostaphylos*).

where you are when you design a garden. In an urban area, I would want to attract your attention to the center of the garden, away from the harshness of urbanity. But here," she explains, "I wanted the garden to direct your eye out."

The Plants

Two tall cabbage trees (*Cussonia paniculata*) create the first strong sense of something interesting going on at the entry to Hog Hill's 3-acre garden. Stone walls line curving 4-foot-wide gravel pathways as the garden's plantings open out and down toward the southeast, fields and forest beyond.

The original structural elements of the garden that existed when Mary and Lew bought the property were few: a dawn redwood (*Metasequoia glyptostroboides*), a white oleander, a dwarf Japanese maple, a "beautiful, ancient, possibly Israeli cercis" (*Cercis siliquastrum*), a row of fir trees, and the hilltop itself. Lew propagated more than fifty percent of the 6000 plants, "many kinds of plants, as well as twenty to thirty or more of each kind," that constituted the original planting. For years afterward, he continued to propagate replacements for mass plantings of the lavenders, hellebores, phlomis, spireas, daphnes, grasses, and more. He is proud of also having propagated "our most distinguished trees and shrubs" from plant material and seeds from Kirstenbosch National Botanical Garden in South Africa, Quarryhill Botanical Garden in Sonoma County, and individual plantswomen and plantsmen. Mary and Lew laid out, prepped, and planted the whole garden with the help of Lew's father (an engineer) and one other gardener. Additional local craftspeople created the stonework from materials sourced on site.

In the beginning, Mary, who "thinks in plan view," tried not to think of plants first, but of how to shape the space. To mitigate the deer factor without detracting from the views, the Reids mimicked a successful deer fence at plantswoman Betsy Clebsch's house south of San Francisco. Two 4-foot-high fences, set 5 feet apart, are almost invisible in a mature garden and keep deer out, as they will not jump over two obstacles without enough room to land and jump again. The system has worked for over two decades.

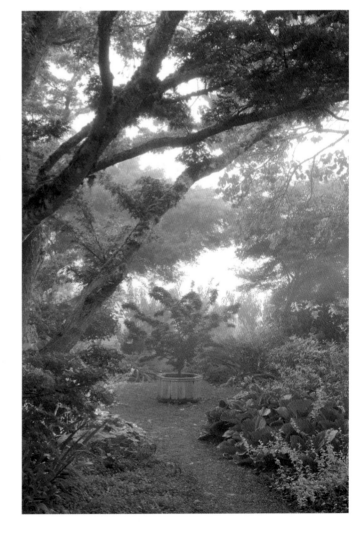

→ A Japanese maple (*Acer palmatum* 'Red Spider') with brilliant red samaras holds the focus here, underplanted with *Pennisetum*. In the sunlight behind is a magnificent yellow *Robinia pseudoacacia*.

↓ Through diffuse light, a potted Japanese maple marks an opening along the garden path. An expansive planting of *Bergenia* 'Silberlicht', a gift to them after a memorable visit to Harland Hand's Oakland garden, runs along the front of the border on the right.

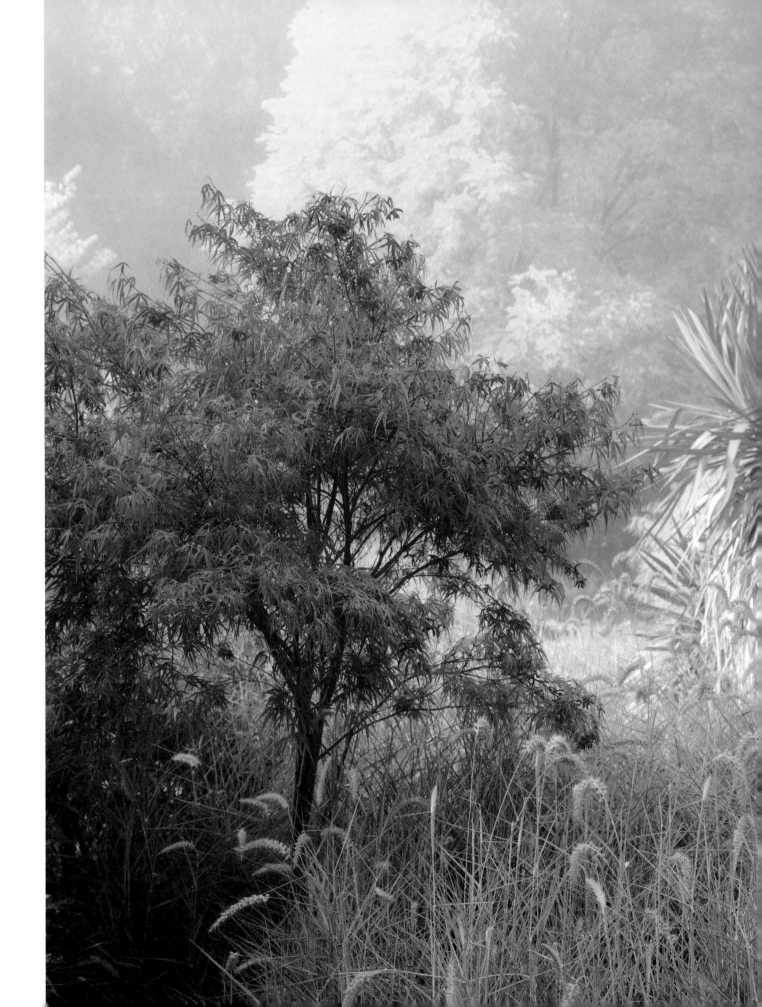

Mary organized the garden design around color, although not in terms of floral display so much as in gradients of foliage, followed by massing plants in sweeps. Mary planned repetitions of the same plant or colors and forms that play point and counterpoint throughout the garden. She kept in mind colors "as they move and shift in seasons," and she worked carefully with color echoes, planning views so she "could be in one part of the garden and look into another area with color connections, so that the color could be seen at large and small scales at the same time." Wandering down one of the sunny pathways, for example, an aqua-colored pot serves as a destination focal point in front of you, and a complementary dusky reddish purple tone is carried throughout the planting.

While many California native plants are showcased in the Hog Hill garden, natives have never been an organizing priority. Nor was drought tolerance, although the majority of the plants are Mediterranean climate in origin and drought adapted and many are interesting perennials from around the world. Shapes and growth habits conducive to the flowing, open design they envisioned were key to both Mary and Lew.

They have learned which plants are truly happy in their microclimate, which is "something of a banana belt" at their elevation, meaning they can grow plants that are too tender for neighbors just downhill. Mary and Lew have learned to remove even beloved plants, like *Stipa tenuissima*, which proved to be invasive. Having grown up in California, Mary is naturally water conscious, and they carefully calibrate their combination of drip and spray irrigation for drought-tolerant plants versus the thirstier, often Asian, plants.

The maintenance of such complex plantings over such a large space is nonstop. Mary cuts things back when they show their first hint of green in spring. She has never used chemical fertilizers on the garden, but instead top-dresses the entire garden once a year with composted turkey manure. Over the years, Mary has overhauled certain areas but the "color foundation" she began with has remained. Recent acquisitions include "an enormous show-stopper restio" (*Cannomois grandis*), recommended by friend and plantswoman Flora Grubb, with whom Mary and Lew have swapped many plants they've each collected over the years.

Knowing that her creativity needed another outlet as her physical gardening days waned after shoulder surgery, Mary took up watercolor painting. Now her list-making of things to do in the garden has given way to taking "great, great pleasure" from simply painting in the garden, enjoying the views of their plants, the landscape, and the whole big sky above and beyond.

→ Lavenders (*Lavandula angustifolia*) and penstemon underplant *Rosa sericea* subsp. *omeiensis* f. *pteracantha*, a coral bark Japanese maple (*Acer palmatum* 'Sango-kaku'), and a mature dogwood (*Cornus florida*) cultivar. The spent flowers and seed heads of *Heptacodium miconioides* are just showing at the upper left.

↘ Morning light in the garden plays off the accents of pale pink *Penstemon* 'Hidcote Pink', cheery red *Salvia greggii*, and two different roses of this planting. Spikes of *Juncus*, wands of *Leucadendron salignum* 'Summer Red', and clouds of mature manzanita shrubs at the back add textural focal points and mass. Ribbons of *Salvia* 'Berggarten' offer bright spots to lead the eye through.

↓ This aged *Cercis*, here when Mary and Lew began their garden, provides shade for western sword fern (*Polystichum munitum*), against *Helichrysum petiolare* 'Limelight'. Other plants of note are *Rhododendron degronianum* subsp. *yakushimanum* (lower left) and the white-outlined deep green leaves of *Abutilon* ×*hyrbidum* 'Souvenir de Bonn' (right).

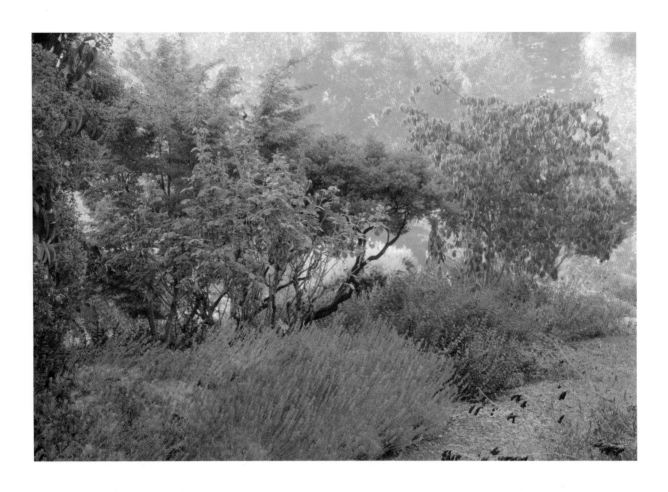

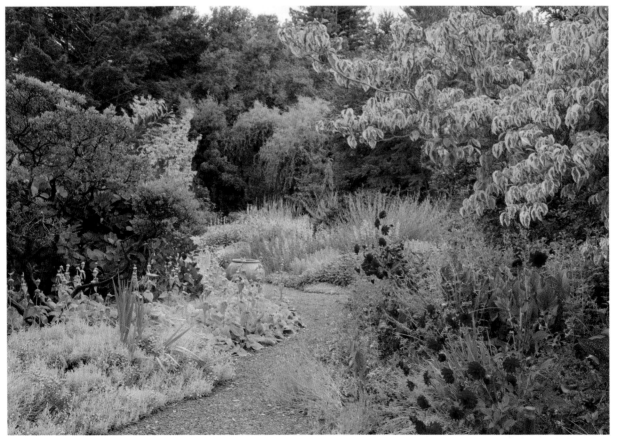

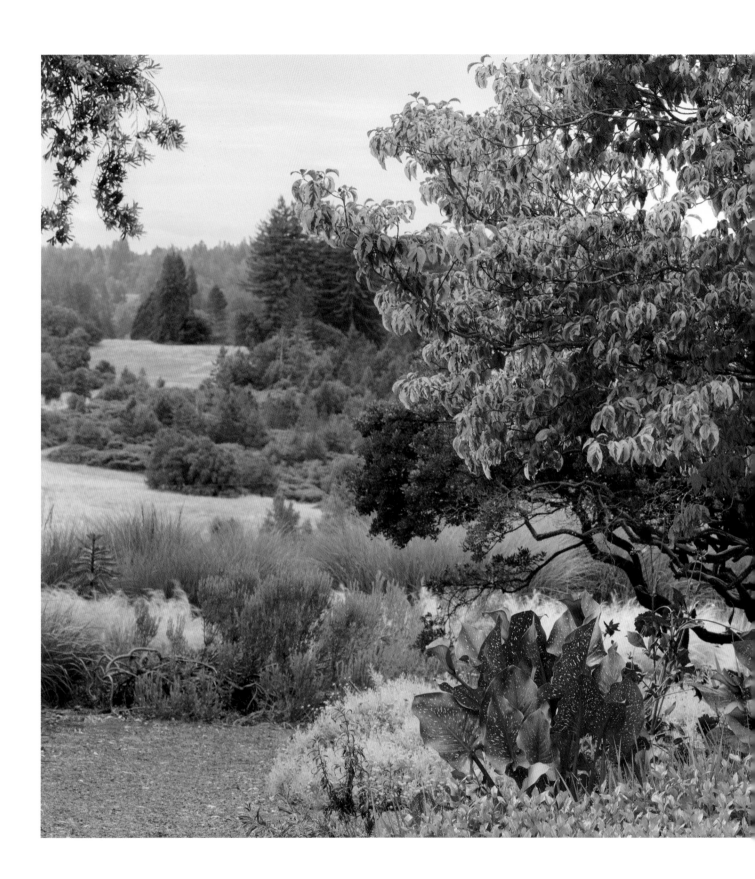

↑ A ceramic sculpture is positioned beneath the branches of a mature katsura tree (*Cercidiphyllum japonicum*), with the arching wands of *Stipa gigantea* just behind and a pale form of California fuchsia (*Epilobium incanum* 'Solidarity Pink') below.

← A bold grouping of orange calla lilies (*Zantedeschia*) play under a variegated dogwood (*Cornus florida* hybrid). Behind, a *Santolina* leads the eye to a *Leucadendron* on the far side of the paths.

SEBASTOPOL LOCAL LOVE STORY

PHIL VAN SOELEN

← Plantsman Phil Van Soelen enjoys the view of his Sebastopol garden from this chair tucked in the back corner. Two pruned-up *Arctostaphylos* 'Monica' share the scene with coyote mint (*Monardella villosa* subsp. *farnciscana* 'Russian River'), a selection by Sherrie Althouse, his longtime partner in the California Flora Nursery. *Heterotheca*, taller woolly blue curls (*Trichostema lanatum*), and blue-eyed grass (*Sisyrinchium bellum*) are in the mix calling in the many hummingbirds and bushtits who also love this corner.

The Place

Sebastopol not only has a longstanding agricultural and horticultural history, but also a legacy of conservation and native plant advocacy. Rich and varied soils and topographic features, including the alluvial soils on the Santa Rosa Plain, helped the Russian River region agriculturally by supporting fruit tree orchards and the vineyards for which Sonoma County has become so well known. The region has always been home to wildflower-rich grasslands, valley oak savannah, and wetlands including ephemeral vernal pools.

As the relatively gentle hillsides of the inner Northern California Coastal Ranges rise on either side of the plain, the soils (including serpentine soil outcrops on which botanical diversity reaches epic levels), topography, and associated plants diversify accordingly in the relative shelter of the mountains. As noted in *A Flora of Sonoma County* by Catherine Best, the floristic richness of the county is created by the broad range of elevation from sea level to 4000 feet, the wide variety of soils, and an abundance of habitat types. Sonoma County has a significant number of rare and endangered plants. Many rare species are endemic to the area based on their association with very specific soil types found here.

Documentation of the native plant diversity of Sonoma County goes at least as far back as famed nineteenth-century botanist Milo Samuel Baker, a professor of botany at the Santa Rosa Junior College who established its extensive herbarium collection. Vine Hill Preserve, stewarded by the local chapter of the California Native Plant Society, holds the only remaining wild populations of several rare plants Baker described, including Vine Hill manzanita and Vine Hill clarkia.

Plantsman and gardener Phil Van Soelen, for ten years the manager of the Vine Hill Preserve, says, "Sonoma County in some ways seems like a microcosm of California as a whole. It has an incredibly beautiful coastline, deep Northern California redwood forests, a mild Mediterranean climate, amazing topography of hills and mountains of the Coast Ranges that parallel the coastline, creating many microclimates. The San Andreas Fault runs down the western side of the county, so you get geologic diversity due to one type of rocks on one side of the fault and another type on the other. Put a

229

few million years on top of that geology and you get a topography where a huge diversity of plants can evolve and find their places. We don't have deserts, but we have pretty much everything else that makes California rich. It's pretty much perfect."

The Person

Phil attended the California Institute of the Arts in Southern California and he often drove home to the Pacific Northwest on breaks, which regularly took him through Sonoma County. Feeling that Sonoma was a perfect mix of the look and feel of the Pacific Northwest and Southern California, he settled there in 1973.

In 1981, he and fellow plantsperson Sherrie Althouse opened California Flora Nursery, now one of the oldest California native plant nurseries in the Bay Area. When they first opened, the number of interesting native plants on the market was pretty slim. Now the diversity is much broader and expanding all the time—in part due to Sherrie and Phil and the work of other independent and conservation-minded native plant enthusiasts, who not only propagate and introduce plants to the trade but also educate the public about how to successfully garden with native plants.

Phil's twenty years focused on protecting the region's rare plants through his work with the California Native Plant Society, as well as his forty years as a native plant nurseryman, have made him realize that his own relatively small town garden is "an important reservoir of botanic diversity. As a long as I am here, I will try to pack my garden full of richness."

→ Near the back porch *Trillium albidum* grows against the base of the wall, along with airy pink spikes of *Heuchera* 'Old La Rochette'. The creamy monkeyflower is Phil's introduction, *Mimulus* 'Creamsicle', selected from seed hybrid experiments. This area enjoys bright shade from a large live oak (*Quercus agrifolia*) much of the day.

↙ The bunchgrass *Calamagrostis ophitidis*, endemic to California and introduced to cultivation by Josh Williams, grows out of a silvery California fuchsia (*Epilobium*). Taller silver white sage (*Salvia apiana*) is accented by the bright silver of *Eriogonum crocatum* (right foreground) and scarlet bugler (*Penstemon centranthifolius*).

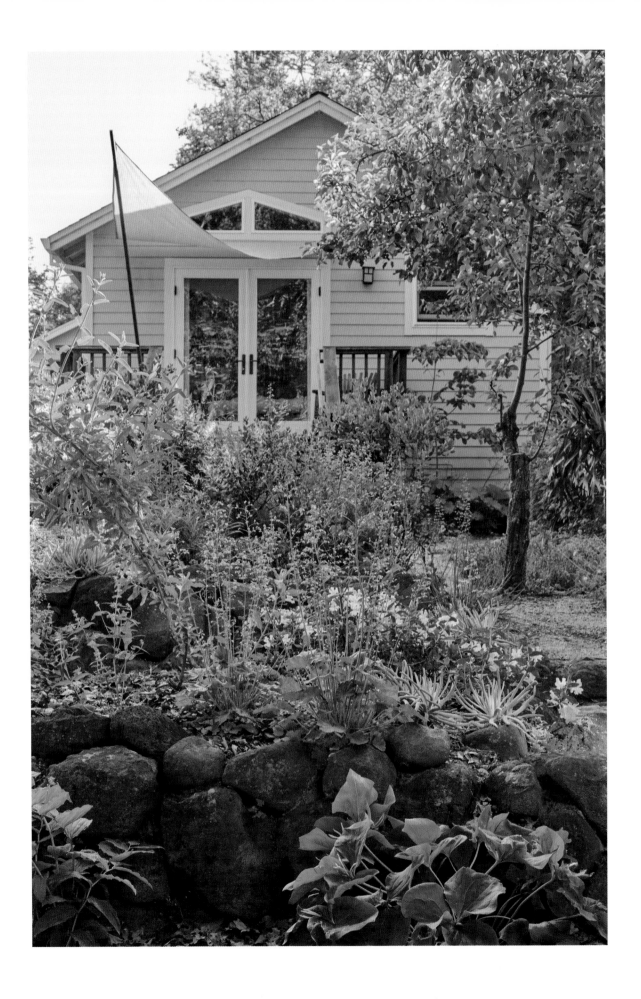

The Plants

The story of Phil and his wife Mary Killian's garden dovetails with their long-term relationship. "We started dating seventeen years ago. I could look out my old kitchen window and see the back garden at Mary's." Phil brought plant offerings from Cal Flora for the garden while they were dating. Although it was her garden first, when he moved in in 2015 they agreed he would be "head gardener." The city lot measuring 150 feet deep by 60 feet wide with east–west exposure is home to an abundance of native plants, many dating back to the early days of their courtship.

"It's becoming so painfully clear that we are in an extinction event. The richness and diversity of Sonoma County is something that's continuing to disappear before my eyes, between the dominance of grapes and the area's so-called 'development,'" Phil laments. "The only place other than the nursery that I have any control is in my own little garden with Mary. I try to see that the garden reflects the richness of the flora of California in all the ways it can."

This reservoir of biodiversity includes collections of small trees, like dogwoods (*Cornus*), woody shrubs including a significant number of manzanita (*Arctostaphylos*), herbaceous flowering plants, especially buckwheat (*Eriogonum*), coral bells (*Heuchera*), and penstemon, succulents including *Dudleya*, geophytes like iris and brodiaea, and ephemeral wildflowers, including *Clarkia*.

Phil describes his process as the "shotgun approach," meaning he packs in as many species in as many families as possible for good genetic diversity and to cover the needs of the animals he feels lucky to attract. His fence line features several genetic strains of local pipevine (*Aristolochia californica*), which is the only larval food source for the local population of pipevine swallowtail butterflies. He has taken care, however, to leave "several open soil ground areas around the garden where ground-nesting bees will be comfortable" and to provide year-round floral nectar sources. "It makes me so happy to lay in bed, look outside, and see the garden looking like a wildlife version of LAX with butterflies, bees, and birds all flying by." While Sebastopol does not house the same abundance of diversity as it did a century ago, "there's still a certain level of fecundity that can be attracted that's just wonderful."

Phil tries to seek out as many "local forms" of plants as he can, even if they are common. For example, on the grounds of a nearby school, he noticed a locally native California oatgrass (*Danthonia californica*), which he collected to grow on, as he did with another native ryegrass from another local sighting. "Luckily, I have a nursery and some skill with propagating. So really, I start looking and collecting plants for my own self-interest and garden to establish them before I even think about selling them."

Like many plant collectors, though, Phil cannot help including some worthy non-natives that strike his fancy. The buckwheat *Eriogonum umbellatum* var. *aureum*

→ **CLOCKWISE FROM TOP LEFT:** A naturally occurring hybrid *Arctostaphylos* on the right that Phil grew from a semi-hardwood fall cutting and *Arctostaphylos* 'Monica' on the left. Phil loves "the textural, deeply colored bark and handsome exposed branches." At their bases is *Eriogonum arborescens*.

Dudleya 'Frank Reinelt' and *Dudleya brittonii* provide contrasting textures in this planting.

Heuchera 'Opal' and California poppy (*Eschscholzia californica*) thrive in the waste soil berm Phil created in the front garden after an addition to the house.

Some of Phil's favorite dryland plants include *Festuca idahoensis*, and the bright yellow *Eriogonum umbellatum* var. *aureum* 'Kannah Creek', a selection that Phil admires for its habit and disease resistance. The lowest manzanita pictured is a natural hybrid between *Arctostaphylos uva-ursi* and *Arctostaphylos nummularia*.

← Phil placed a welcoming *Arctostaphylos* 'Sunset' near the entrance to the house from the street. This "very dry, tough west-facing" bed is underplanted with low-growing *Arctostaphylos hookeri* and *Arctostaphylos uva-ursi* draping over the stone wall, the native silvery succulent *Dudleya* 'Frank Reinelt', and low-growing California fuchsia (*Epilobium* 'Schieffelin's Choice').

'Kannah Creek', for example, from western Colorado, "grows much better here than the more regionally local 'Shasta Sulphur' [*Eriogonum umbellatum* var. *polyanthum* 'Shasta Sulphur']. Even though it's not exactly native, it evokes the feeling of what I'm used to seeing hiking out in the mountains." Similarly, he grows some of the *Heuchera maxima* × *H. sanguinea* hybrids "which aren't strictly local, in combination with local genetics of *Heuchera micrantha*, which I love because they're so floriferous."

Rainfall in the area comes mainly in winter, and averages 30 to 32 inches a year. Mary and Phil's lot and garden is at "the top of the neighborhood watershed," so they use downspouts as "an asset of seasonal irrigation." There is no other formal irrigation system, but they crafted two French drains to direct and percolate graywater out into the landscape. Phil also hand waters with a hose as needed. "Seems like such a primitive method in some sense, but it's the most sophisticated method when you think of it in terms of having water at your fingertips when you need it. It also keeps you finely attuned to what is happening and what is needed in the garden."

The back garden receives the bulk of the site's sunny western exposure, so a woodland garden flanks the north side of the house, and the south side harbors fruit trees. Phil mulches many areas of the garden with a protective stone chip known as Sonoma Gold. "It unifies the look of the garden and protects dry-loving plants from winter rain splash," he shares.

The couple regularly venture to the coast, taking various routes through different environs to hike and botanize. Once a year or so they get to the Sierra Nevada. Phil tries to honor the vignettes and feel of such wild spaces in his home garden, saying "I love to try and cultivate a feeling of what the undisturbed native landscape might have been. Even if I don't have exactly the same plants, I have analogues. I used to live on 200 acres, and I think I'm always trying to re-create that sense of the surprise of wild nature in my own tiny piece of gardened nature here. That is, the ability to walk outside and experience something new every single day of the year."

DAWN GARDENS

BARRY FRIESEN

The Place

It's not hard to guess why the gold rush town of Grass Valley might have been so named. Falling along the northwestern edge of the foothills of the Sierra Nevada, it lies just where dense coniferous forests, rich with yellow pines, cedars, red firs, alders, and the rugged mountains gently give way to the expansive oak-dotted savannahs and grasslands of California's fertile northern Sacramento Valley.

Trees often grow in a set elevation range and have evolved to a particular geology. Here, the valley oaks (*Quercus lobata*) and interior live oaks (*Quercus wislizeni*) are the dominant species on the valley floor. Rise just a bit, 200 feet or so, and the blue oaks (*Quercus douglasii*) come into the mix slowly and by 2000 feet have replaced the valley oaks as the dominant species. By 3500 feet, the California black oak (*Quercus kelloggii*) and canyon live oak (*Quercus chrysolepis*) dominate and climb the hills up to 6500 feet, when conifers begin their rule.

Much of tree—and indeed all plant life—distribution here depends on water, snow, and rain in the winter months and availability of surface or ground water in the hot, dry, and fire-prone months

237

between April and October. Dry Creek and Wolf Creek, originating in the snow pack of the Sierra that much of California depends on for summer water, meander through Grass Valley, trending generally southwest, making their way to the Bear River, a primary tributary of the Feather River, which in time finds its way to the Sacramento River, which moves south and west to its confluence with the San Joaquin River as they arrive in the Sacramento–San Joaquin Delta and filtering marshes and wetlands before heading out to sea.

You cannot craft a garden in California without some access to water. It was water, not gold, that landscape contractor Barry Friesen looked for when he determined to create a garden in gold country.

The Person

Barry and his family moved to coastal Humboldt County when he was six. There, his gardener mother developed his eye for beautiful floral forms. The harder work of day-to-day gardening came in his early teens, when Barry's father officially "handed the shovel and the mower" to him to take it all on. "I started really seeing the plants and had fun growing them," he reminisces. He began spending his own money at local nurseries, and then he "got a job at a nursery and brought my whole paycheck home in plants."

After earning his degree in landscape architecture from the University of California, Berkeley, he focused on landscape contracting, bringing designers' ideas to life on the ground. He also taught landscape horticulture at Merritt College in Oakland and served as the chair of that department from 1976 to 1984. In 2000, he formally incorporated his own landscape contracting company, Dawn Landscaping, and purchased 12 acres in Nevada County to begin crafting his own garden, now known as Dawn Gardens.

The Plants

"At this elevation of 1300 feet, there are still more oaks than pine and a lot of brush," Barry says. His first step in seeing what the garden could be was to begin clearing scrub out from around the mature specimen oaks—coast live oak, a few black oaks—and pines and manzanitas, which he retained for both canopy protection and as focal points.

He then fenced off 8 acres that were relatively level for protection from deer and left the most heavily sloped 4 acres of land wild. He created roadways for truck access (annual maintenance vehicles and fire trucks) and developed circular and meandering pathways through the gardens' organically shaped and graded primary planting areas.

PREVIOUS PAGES: In this woodland spring scene in Barry Friesen's garden in Grass Valley, a native interior live oak (*Quercus wislizeni*) is underplanted with a whole sweep of the annual native purple Chinese houses (*Collinsia heterophylla*) and a purple-leaved *Heuchera*, with silvery mounds of lavender (*Lavandula*) in the distance.

→ Barry planted out 100 dwarf Alberta spruce (*Picea glauca*) when he first started the garden more than twenty years ago. As they have matured, he cuts a few each year to thin and repurpose as Christmas trees for friends. Here they are interplanted with *Liatris punctata* and Russian sage (*Salvia yangii*) catching the afternoon light.

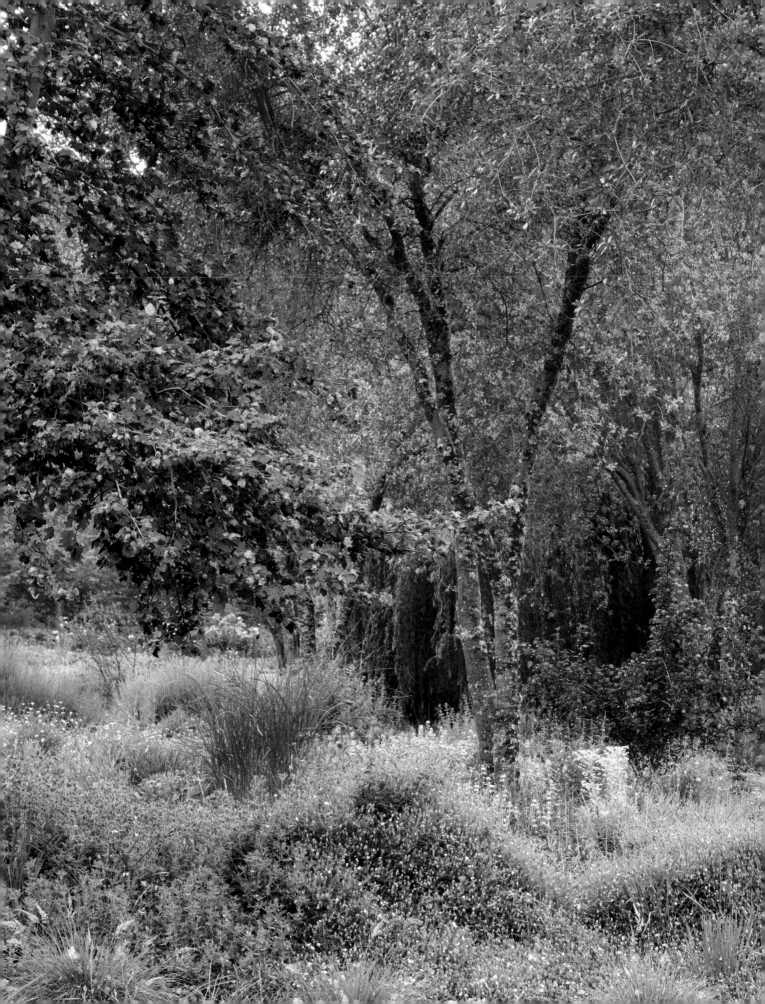

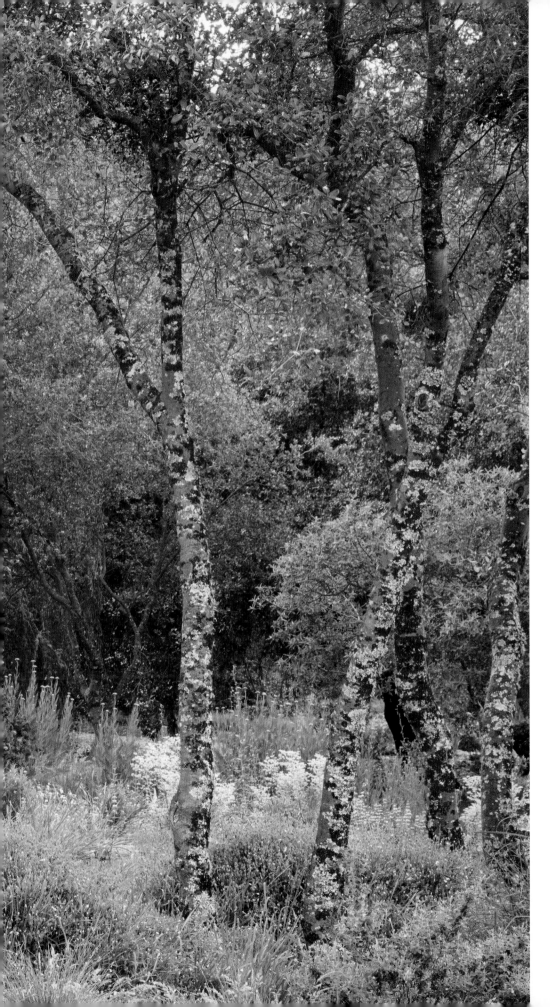

← A mature native flannel bush (*Fremontodendron*) is in full bloom to the left of this live oak (*Quercus wislizeni*) woodland scene in Barry's Spiral Garden. At center is the reddish foliage of diablo ninebark (*Physocarpus opulifolius* 'Diablo'). Mounding lavender (*Lavandula*), pink sunset rock rose (*Cistus* 'Sunset'), annual Chinese houses (*Collinsia heterophylla*), and yarrow (*Achillea*) add color throughout.

The second year was dedicated to establishing the irrigation infrastructure. Water is, of course, a determining force and organizing principle of this garden. "The lack of it, the seasonal abundance of it, the preciousness of it. I can't grow a garden like this without some idea of where and when there will be water," Barry notes. "Eighty percent of the garden is on low-water use drip irrigation, but the thirstier plants, the vegetable garden, rose garden, and some perennials [about twenty percent of the total cultivated space] also have spray backup."

He was also able to buy canal rights for overland irrigation water from old mining flumes, which were created by miners all over the foothills to redirect water from surface sources like rivers, creeks, and lakes. Without that historical intervention on the land, the garden could not have existed. Barry explains, "The canal water is easier to use and less expensive in terms of electrical use than pumping well water."

Barry aimed to enhance the area's seasonal color displays, especially fall color in trees. While creating roadways and setting the irrigation, he was also planting out trees to get them established. "Three hundred trees went in that first planting, including Japanese maples [*Acer palmatum*], red maples [*Acer rubrum*], fastigate hornbeam [*Carpinus betulus* 'Fastigiata'], which line the driveway, Japanese zelkova [*Zelkova*], and pistache trees [*Pistacia chinensis*]," he recalls.

Barry estimates that his garden now holds more than 3000 different species and cultivars. His plant choices have been directed by whatever catches his eye, followed by their ability to live with heat and summer drought, which are the realities of his homesite. Most planting areas are regularly mulched with shredded cedar, but the

constraints of summer heat and aridity intersect nicely with Barry's natural love of grasses. He has an entire garden area dedicated to them, and native and nonnatives also add form and a calming green or golden backdrop for other plantings. As with most gardeners over the last quarter century, an evolving understanding of invasive plants has been part of Barry's ongoing education. Aside from the grasses, other charismatic plant groups and areas of the garden include a spring-blooming, 250-foot mixed flowering perennial border, with peonies, coral bells, and yarrows along the drive as you enter. He's also planted more than 50,000 spring bulbs and many self-seeding annual wildflowers, including California poppies and Chinese houses (*Collinsia*).

Other thematic areas include "a rhodie and azalea garden for which Japanese maples and oaks provide the shade," and a rose garden. "I have over a hundred fifty roses, many of them on their own roots, which I prefer, rather than grafted. A lot of English roses, and climbers covering wire fencing," he adds. A heather garden is shaded by a dogwood grove including Pacific dogwood (*Cornus nuttallii*), as well as Eastern native and Asian cultivars and species. "I planted twenty-nine varieties of heather on the slope behind the house, trialing to see which would do well. So, I don't suppose I have twenty-nine anymore," he shares wryly, "but they do provide a nice fine texture along pathways." There's a German iris garden area and a fern garden, which adjoins a mixed shade garden, "with a lot of *Hosta*, *Brunnera*, *Rodgersia*, *Vancouveria*, shade stuff like that." And, finally, the really drought-tolerant rock rose (*Cistus*) and sage (*Salvia*) gardens, and a full-sun Spiral Garden around a central olive tree. Overall, there's more than two full miles of garden walk for Barry to enjoy as he takes in views of the surrounding foothills and native forest.

→ A *Fremontodendron* backlit in late day is underplanted with a line of lavender, a line of reddish and yellow *Gaillardia* ×*grandiflora*, and a line of grasses behind that.

↓ The charismatic weeping cherry (*Prunus subhirtella* 'Pendula') is just showing its yellow fall color, as are the hornbeams (*Carpinus betulus*) in the background. On the right a sour gum (*Nyssa sylvatica*) flushes red above a bronze restio (*Chondropetalum*).

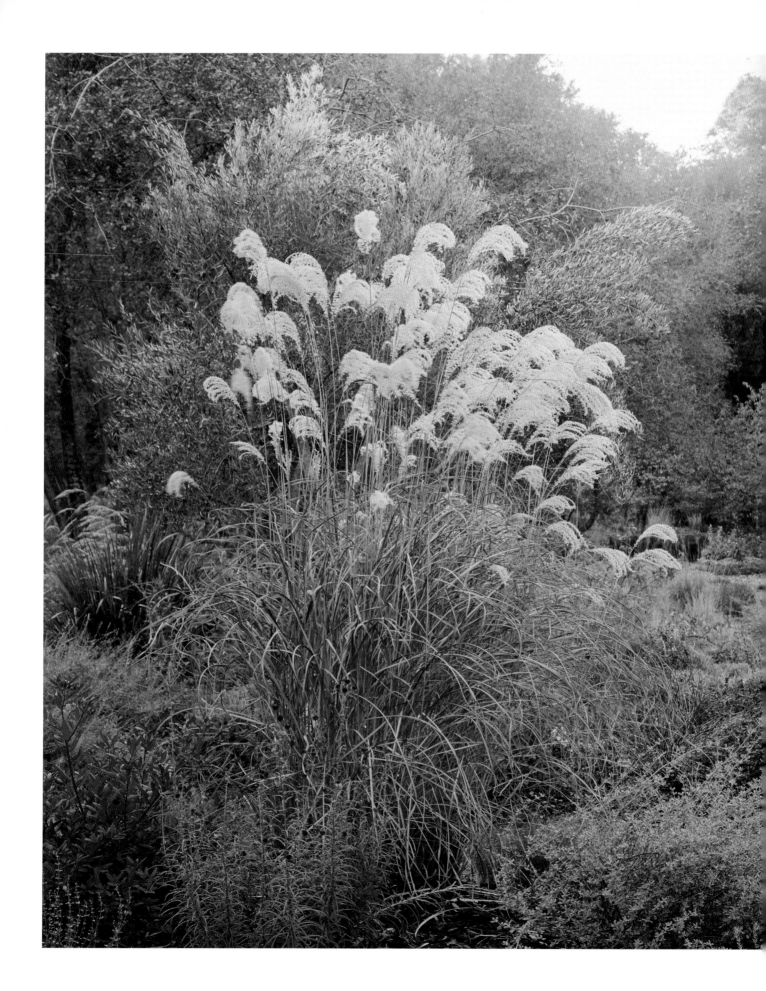

← *Miscanthus sinensis* in autumn color and seed backed by a fruitless olive (*Olea europaea* 'Majestic Beauty'). To the right, a patch of *Eriogonum fasciculatum* with its cinnamon-colored seed heads grows beneath a small interior live oak (*Quercus wislizeni*) and the red fall foliage of sour gum (*Nyssa sylvatica*).

247

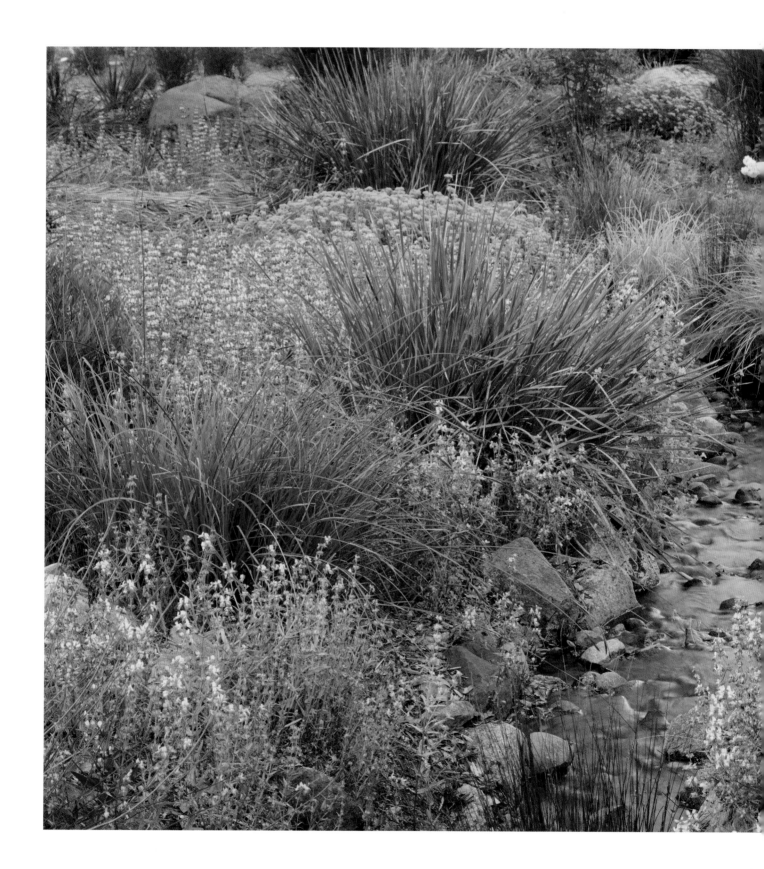

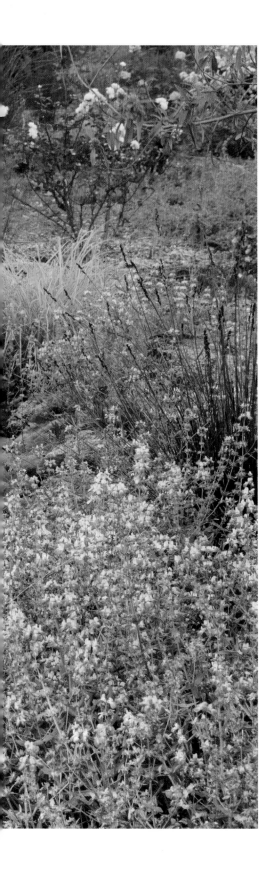

← Barry constructed a creek-like waterway that runs throughout much of the garden, connecting four manmade ponds and allowing for riparian plantings. Here spring interest includes purple Chinese houses (*Collinsia heterophylla*), Bowles' golden sedge (*Carex elata* 'Aurea'), and yellow buckwheat (*Eriogonum umbellatum*). The chocolate-colored seed heads are those of a restio (*Chondropetalum*).

↑ Barry's Grass Garden features upward of fifteen grass selections. The Mexican feathergrass (*Nassella tenuissima*) has since been removed due to its invasive nature and replaced with a nonseedy *Nassella* from Peru. The earthy purple of Joe Pye weed (*Eutrochium*) is highlighted against the hedge of little ollie olive (*Olea europaea* 'Little Ollie').

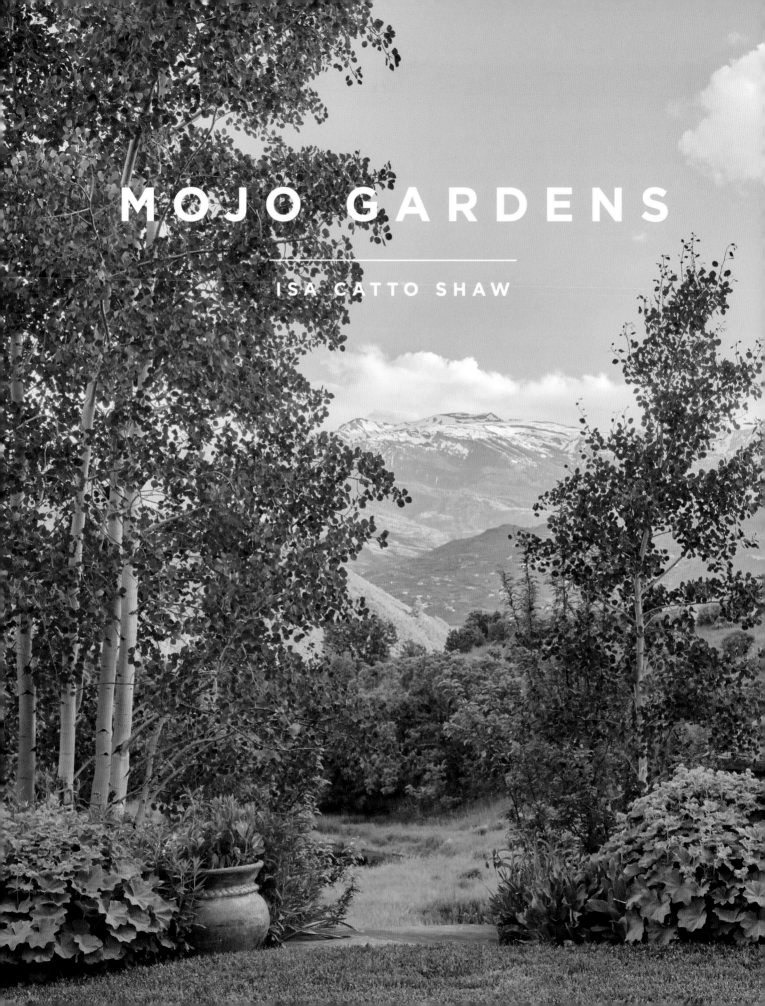

MOJO GARDENS

ISA CATTO SHAW

The Place

The Rocky Mountains, the dramatic 3000-mile-long ridge forming the eastern edge of what's known as the Intermountain West, are powerful, snow-capped symbols of and influences on life in the West generally. Running from British Columbia to New Mexico, through Wyoming and Colorado, these uplift mountains formed by tectonic plates colliding many millions of years ago form the Continental Divide. To one side the rivers and watersheds flow east and ultimately to the Atlantic, and to the other they flow west and to the Pacific. The western third of Colorado is defined by the topography of this range and a majority of the entire range's tallest peaks are found here. Colorado's "high country" refers to that lushly treed, snowy territory above the foothills and below the timberline.

The Roaring Fork Valley is carved out of the western slope of the Colorado Rockies by the Roaring Fork River, which runs northwest from its source at around 13,000 feet in the alpine zone until it feeds into the Colorado River past Glenwood Springs. The seventy miles of the Roaring Fork River run through mountain meadows, rich mountain scrub, and coniferous

forest higher up and sagebrush steppe, grasslands, willow, and cottonwood (*Populus fremontii*) in the lower reaches. The colorful mosaic of trees and shrubs of the higher elevations include scrub oaks, serviceberry (*Amelanchier alnifolia*), and mountain mahogany (*Cercocarpus montanus*), mixed forests of spruce, fir, and pine, and ancient shimmering colonies of white-barked quaking aspen (*Populus tremuloides*). These all thrive in the higher elevations' sunny cool summers and sunny cold winters and are adapted to the 20 inches of rain and, on average, more than 150 inches of snow each year.

For gardeners here, heavy snowfall, voles, marauding elk, winter winds, and frost dates that run from August to June are all parts of life. (One gardening source reports that "Gardeners can be confident of no frost from July 23 to August 1.") Thankfully, so are big trees, expansive mountain views, and spectacular displays of seasonal color in the forms of spring greening, summer wildflowers, and autumn foliage.

The Person

Fine artist, textile designer, writer, and philanthropist Isa Catto Shaw has been visiting this area of Colorado since spending summers here as a girl with her family. For many years, Isa and her husband, the writer Daniel Shaw, lived and worked in New York City, where she tended a rooftop garden. Isa became sick with a variety of autoimmune issues, which catalyzed their move to Colorado in 2004, as "a one-year experiment." The experiment on their sloping 17 acres of woodland and open grassland/meadow became their life, and now includes Isa's studio, Daniel's writing desk, and the collaborative cross-pollination with the wider community of plants, animals, and people.

Isa and Daniel initially worked with a landscaper who "literally ripped us and our topsoil off," says Isa. The group "graded" the existing topsoil away and charged them for the "thin layer of compost" they returned. Not surprisingly, the subsequent plantings failed to thrive across the board. Isa's sister said to her, "If there's one thing you are, it's resourceful." Isa took this to heart. This misfortune "was composted into opportunity," Isa says. She dug in, read, researched, and became a zealous composter, burying all household waste "bones and all," coffee grounds, truckloads of manure from neighbors, paper, and cardboard directly into the soil all around the site to slowly rebuild what had been lost.

Isa says, "I grew up in a family with a strong conservation ethos. I don't see the wildlife as foe. The voles do churn up a lot of stuff, but they are not the enemy." Isa works to be "a good citizen of the landscape" as she had respect for the land ingrained in her. Her current garden has deepened and emphasized that respect. "It's about reverence, and sanctuary, and hospitality. It's not just about bringing people to your garden, but bringing all life."

PREVIOUS PAGES: Looking southwest to the Elk Mountains framed in the distance, artist Isa Catto Shaw's Mojo Gardens just outside of Aspen, Colorado, are at their "June greenest." Tall blue lupine (*Lupinus*) is in full bloom, with lush mounds of lady's mantle (*Alchemilla mollis*) just behind in borders at the edge of the front garden backed by aspen and a tall self-seeded willow.

→ Lupine (*Lupinus*), *Nepeta racemosa* 'Walker's Low', *Stachys byzantina*, woolly thyme (*Thymus pulegioides*), cornflower (*Centaurea segetum*), oriental poppy (*Papaver orientale*), and *Sedum* have all naturalized themselves around the border and across the local stone. The wooden arch, designed by Isa and crafted by Ryan Skarpetowski, marks the threshold between garden and wildland.

FOLLOWING PAGES: Thriving in the microclimate created by the wall and flagstones are lupine (*Lupinus*), woolly thyme (*Thymus pulegioides*), lady's mantle (*Alchemilla mollis*), and hardy speedwell (*Veronica*). On the slope below are forget-me-not (*Myosotis scorpioides*), oriental poppy (*Papaver orientale*), and peonies (*Paeonia*) just coming into bloom.

The Plants

When Isa was ready to move forward with a new master plan, she turned to Sheri Sanzone of Bluegreen Studio for a world view that was more in line with her own. She also took inspiration from her mother's long-established mixed perennial garden—just next door—and from the dense herbaceous and woodland borders on all sides of the family home. "The upper Roaring Fork Valley has lots of really interesting [micro] climates and environments," explains Sheri. "Depending on where you are, different rocks, different exposures, different hydrology, and therefore plant communities are expressed. And Upper Woody Creek is unique in being at the top of the valley running to the Roaring Fork: it's an interesting microclimate that enjoys a lot of sun without getting too hot. It is not a dry landscape. You can't see little Woody Creek, but you know it's there, and this influences the plants you see. Having the view of the Elk Mountains, the valley floor, and the valleys beyond is inspiring. You know right where you are."

Sheri's work with Isa in 2011 and 2012 helped kickstart building the garden around the concept of a color wheel based on Isa's art. Though the garden is very different now and much bigger, the underlying scheme germinated from Isa and Sheri's collaboration ended up including 350 different perennials.

The steep slope was graded for circulation routes for family, kids, dogs, and any elk that might move through. Planting plans used green mulch—groundcovers and other smaller plants—to hold soil and to retain moisture around larger plants and to decrease open soil. Another technique well suited to Isa's garden style and location was combining the nonnatives that Isa had sentimental attachment to with many native plants, as both temperature and wildlife protection for the nonnatives.

The garden, which Isa dubbed Mojo after a beloved dog, has evolved into a dynamic living space. In many ways, though, her garden is a means of "honoring those who came before her, a way to compost grief." Many of Isa's garden plants came from her mother's garden—some her mother gifted to Isa, and some Isa collected after her mother's death. "She was very proud of her garden; and she had a lot of lupine, columbine, delphinium, Jupiter's beard [*Centranthus ruber*], Maltese cross [*Silene chalcedonica*], and Shasta daisies [*Leucanthemum ×superbum*]." When her sister died,

↓ Tucked into an inner spot of the shady entrance garden, a pink lupine (*Lupinus*) blooms beside a fountain. Isa had envisioned the fountain as a serene "mini-infinity reflecting pool, but it is in fact just a fancy dog bowl. They even sit in it," she laughs.

Isa similarly transplanted her sister's small collection of bulbs, to which she adds a "king's ransom" each fall. Now "there's a hillside of daffodils and tulips in spring. It's such reassurance to see my sister every day in the spring and my mother every day in the summer."

"You wake up and see the mountains and there's this invocation to be vigorous," Isa says. "It is something of a masculine energy or sensibility—inspirational, powerful, but a little intimidating too. The mountains are so wild and untamed." There's beauty in that, but also a demand for respect. "I don't want to conquer them. There are constant reminders that you are not the top of the food chain and of your place in the universe. That's good. We damage our planet in so many ways—inadvertently mostly—humility is good. Making things grow in a world of loss is a great balancing act." Isa's artistic eye helped to determine the curved pathways and offer clear but unspoken direction in the space. She designed wooden arches, crafted by local artisan Ryan Skarpetowski, as wayfinders and visual clues for the eye. The highest arch is at the top of the garden, at the boundary between the cultivated and the wild. As a device, she also wanted each arch to be a "sculptural, lean element marking a sacred threshold."

Isa does not cut down the garden in the fall so wildlife can forage through the winter. "The seeds float around, softening the edges of the garden even while there's a clear boundary." Every other gardener told Isa not to let elk strip her native dogwood, but "it feeds them, and the dogwood comes back more vigorously in spring." Isa has watched plants she was not sure would survive assert their own "intelligence," as over the years they have "drifted through seed or rhizome to where they want to be." She says the beasts and birds help, "as if there's some hidden electricity that directs it all." And Isa credits the elk and birdlife "with their patterns of foraging and distribution" for how her garden now mimics the best wild natural plantings around them.

Isa refers to the daily dialogues she has with the garden as "gardening by gut." Several garden areas now dot the property, including a relatively new enclosed kitchen garden that Isa calls the Bluebird Garden for the western bluebirds who congregate on the fence line there. Elsewhere groves of aspen and conifers form islands of canopy over sweeps of interplanted smaller trees like dogwoods and old fruit trees, hedge shrubs, including willow, serviceberry (*Amelanchier*), chokecherry (*Prunus virginiana* var. *demissa*), old-fashioned lilac (*Syringa vulgaris*), and native roses. Then there is the wild rumpus of flowering perennials: brilliant orange oriental poppy (*Papaver orientale*) interplanted with towers of hybrid lupine (*Lupinus*), "sky high" delphinium, vivid magenta and pale pink peonies (*Paeonia*), upright false Solomon's seal (*Maianthemum racemosum*), alliums, campanula, spreading catmint (*Nepeta*), lady's mantle (*Alchemilla mollis*), hardy geraniums, and snow-in-summer (*Cerastium tomentosum*). She notes with pride how "asters native to the area have self-seeded. Lupine that grow a little here and there inside the garden and just out of it have crossed and crossed back." The result of Isa's efforts is dynamic, colorful, and above all, meaningful.

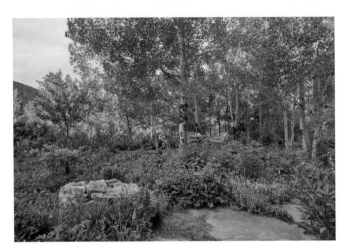

↑ **TOP:** Walking through the shady entrance garden's aspen grove and toward the house, the green roof on that front corner of the house is just visible. The old-fashioned white lilac (*Syringa vulgaris*) was transplanted from Isa's mother's neighboring garden years ago.

↑ **ABOVE:** In the entrance garden, Isa refinished rusty old chairs from her mother's house to be welcoming bright spots in the space. *Geum* cultivars, catmint (*Nepeta racemosa* 'Walker's Low'), and *Anemone sylvestris* are in bloom and "old-school big, white peonies, maybe 'Festiva Maxima'," Isa says, are coming on.

← Big clumps of *Calamagrostis ×acutiflora* 'Karl Foerster' accent dense plantings of *Nepeta racemosa* 'Walker's Low', lupine (*Lupinus*), *Stachys byzantina*, oriental poppy (*Papaver orientale*), and the beginning of native *Delphinium* just coming on (lower right). Pink-blooming red-leafed crab apples add canopy to the planting.

GREAT SALT
LAKE VALLEY

RED BUTTE GARDEN *and* FRITZ KOLLMANN

The Place

At first glance, the high-elevation desert that is the bright white expanse of the Salt Lake Valley in northern Utah looks almost devoid of life, floral or faunal. The desert conditions, however, have actually created unique and abundant life for those who care to look. The geological features of the arid, windy, broad bowl-shaped valley formed by the tall surrounding mountain ranges—the Wasatch Mountains to the east and the Oquirrh Mountains to the south and southwest—have given rise to this area's diversity. With the iconic Great Salt Lake rounding out the basin to the northeast, the area is home to an amazing and dynamic cohort of plants, animals, and ecosystems that have coevolved with and adapted to this place.

Twenty thousand square miles of this area was once covered by the ancient Lake Bonneville, a salt lake of which the Great Salt Lake is a remainder. The Great Salt Lake is a terminal lake, meaning that it has no outlet and the water coming in from the surrounding watersheds evaporates in place. This concentrates the water's natural mineral deposits and produces salty alkaline lake water and adjacent whitish desert landscape that defines so much of this region and determines the soils in

263

which people garden for many miles in all directions. Which plants survive and thrive here is directly related to their ability to cope with these salt lake soils.

The state of Utah is named for the Ute people, who have made this desert and mountain region between the Rocky Mountains and the Great Basin their home for thousands of years. Other Native peoples of the area include the Diné (Navajo), Paiute, Goshute, and Shoshone. Traditional plants for food and utility according to Southern Ute tribal history include "wild amaranth, wild onion, rice grass, chokecherry, wild raspberry, gooseberry, buffalo berry, dandelion, and yucca."

The Person

Fritz Kollmann grew up in Calgary, an hour and a half outside of Banff National Park, and he has embedded memories of a landscape of oil derricks and dry western foothills and the scent of tall pines. When Fritz first met his wife, Hannah Dolata Hase, her mother, Alice Dolata, was a practicing herbalist who tended an herb and vegetable garden on 38 acres in the Wisconsin countryside, and the two women introduced Fritz to farming and gardening. Alice began by saying, "You're going to learn the weeds first." She taught Fritz their names, if they were edible, what medicinal properties they might have, how to tell when they were ready to harvest, and when they were willing to come out of the ground. Then she let him graduate to the vegetable garden.

Fritz went on to earn a biology degree with an emphasis in botany at the University of Wisconsin, Stevens Point, and from there to an internship at the Olbrich Botanical Gardens in Madison. While in his early twenties, Fritz was sitting on his porch way out in the country and heard something in the nearby woods. When he stood up to look for the source of the sound, he realized that he could see all the different plants. "I could tell the differences between them by the different tones of green and the different forms. What had been a big green, undifferentiated mass became unique individuals in this moment." Since this epiphany, he remains as "intrigued by the weeds in the sidewalk cracks and medians as by grand gardens. Plant knowledge saved my life and gave me a life at the same time. Once I learned the names of the weeds and the plants, I felt like I belonged on Earth."

He and Hannah moved to Salt Lake City in 2007 so he could take a job as a horticulturist at the Red Butte Garden. Fritz finds "great beauty in the intersections of mountains, the vegetation of the Great Salt Lake, and the wetlands at the bottom of the valley."

PREVIOUS PAGES: Water-loving *Juncus effusus* and white iris edge the water feature retention pond in the Low Water Garden at Red Butte Garden. Foxtail lily (*Eremurus*) spikes shine in the sunlight, and white lilac against the fence line marks the boundary between the cultivated garden and the open space beyond. *Deschampsia flexuosa* 'Aurea' is in the foreground.

→ Looking southeast from Red Butte Garden toward snow-capped peaks of the Wasatch Range, a low red beardtongue (*Penstemon pinifolius*) acts as a ground cover to *Yucca baccata* and *Yucca glauca* and a stand of blue foothills penstemon (*Penstemon heterophyllus* 'Blue Springs') to the far left.

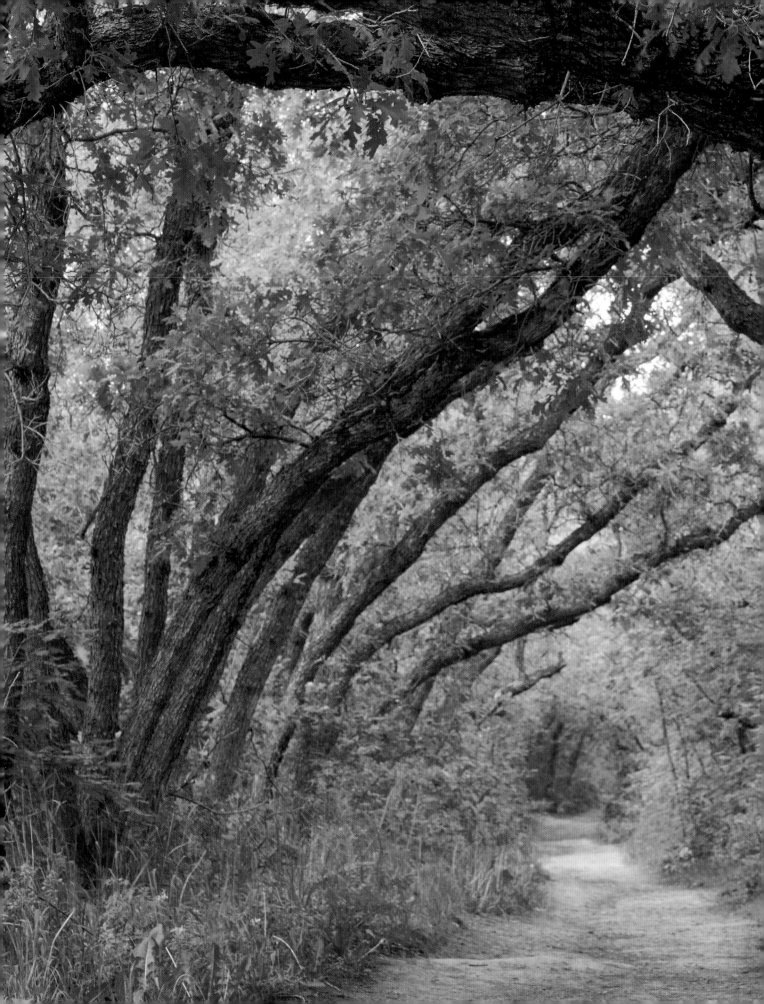

← The iconic native Gambel oak (*Quercus gambelii*) tunnel at Red Butte Garden dates back to the days when a small mining train traveled this path carrying the stone being quarried on the hillside above. This shady walkway connects the more cultivated part of the garden and native trails beyond.

The Plants

The Red Butte Garden on the campus of the University of Utah began in 1930 as a research collection under the direction of Dr. Walter P. Cottam, cofounder of the Nature Conservancy. The 21 acres of display gardens and more than five miles of hiking trails along the northeast bench of the Salt Lake Valley are now divided into sections devoted to specific types of plants or ecosystems. Among these is the 3-acre Water Conservation Garden, the bulk of which was designed by Studio Outside, a firm based in Dallas, Texas; the garden is comprised of twelve smaller garden areas, "demonstrating that beautiful gardens need not require heavy application of water." Fritz designed the Desert Harvest Garden portion and was its lead horticulturist until 2019, when he became the gardens curator at the Springs Preserve in Las Vegas, Nevada.

The Desert Harvest Garden is a series of roughly diamond-shaped basin plantings, no more than 14 inches deep in the center, which create passive water harvesting for the thirstiest plants, such as fruit trees, in the low points. As the plantings move out and up from the basin's centers, the plant choices become more and more adapted to drought and sharp drainage and increasingly include shrubs providing habitat and berries. At the outermost edges, Fritz incorporated native plants with ethnobotanical uses, as well as "filtration plants, like grasses, to slow bigger more aggressive weeds moving into the beds." He explains that "this is an adaptation of a traditional low-desert cultivation technique of the Indigenous peoples of the Southwest. The outermost shrubs protect the inner plants and trees from drying winds and predation, and the troughs sequester the water from brief, intense rainstorms typical of the desert, allowing the water to collect and infiltrate where it's needed."

Every plant Fritz chose for the Desert Harvest Garden "has some sort of 'value' to the other plants, to wildlife and insects for food or nesting, or to humans. Ideally," he states emphatically, "most of the plants have all of these characteristics." The Desert Harvest Garden is approximately forty-five percent plants native to the Great Basin, which are supplemented by plants "from the other steppe climates of the world." In another section of the garden, water run-off from other areas of the larger garden is directed to create a habitat boggy area for water-loving plants and wildlife.

As Fritz tells it, "The ruderal—the weedy zones along the edges of the city or in the pockets of the suburbs where wild land has been scraped and then things have come back—these are areas that really inspire me. There is both surprise and sheer determination in these areas where the native plants have retaken a foothold with resilience and arranged themselves in new ways."

His home grassland garden, which is nearly 50 feet wide and 40 feet deep, is an interlaced mosaic of plants that spans the entire front of the house. In designing and planting his home garden with his family, Fritz "wanted to present the neighborhood and passersby with the idea that wildness or semi-wildness or even faked wildness is something that is okay and lovely. We get sixteen inches of rain a year here, and

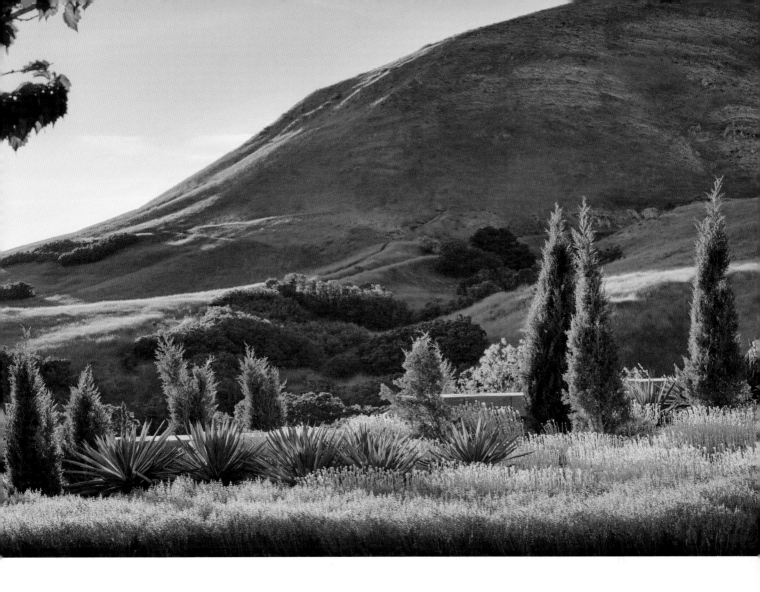

↑ In the Water Conservation Garden at Red Butte Garden, expansive swathes of red penstemon (*Penstemon pinifolius* 'Compactum') contrast with the bright silver foliage of partridge feather (*Tanacetum densum* subsp. *amani*) and the sharp structure of yucca (*Yucca gloriosa* var. *tristis*), demonstrating that even in arid environments low-water gardens can be colorful and full.

← The yellow flowers of greenthread (*Thelesperma filifolium*) weave their way through the misty blue of Mongolian ephedra (*Ephedra equisetina*), which grows 2 to 3 feet tall and spreads via rhizomes "but is easy to control with pulling," Fritz says.

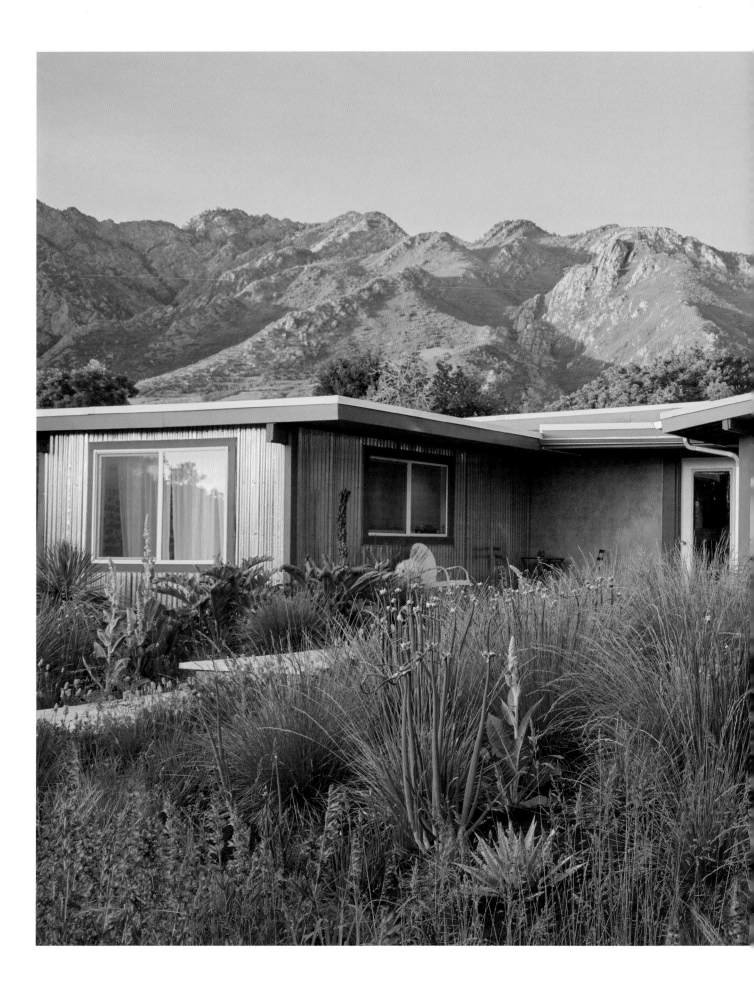

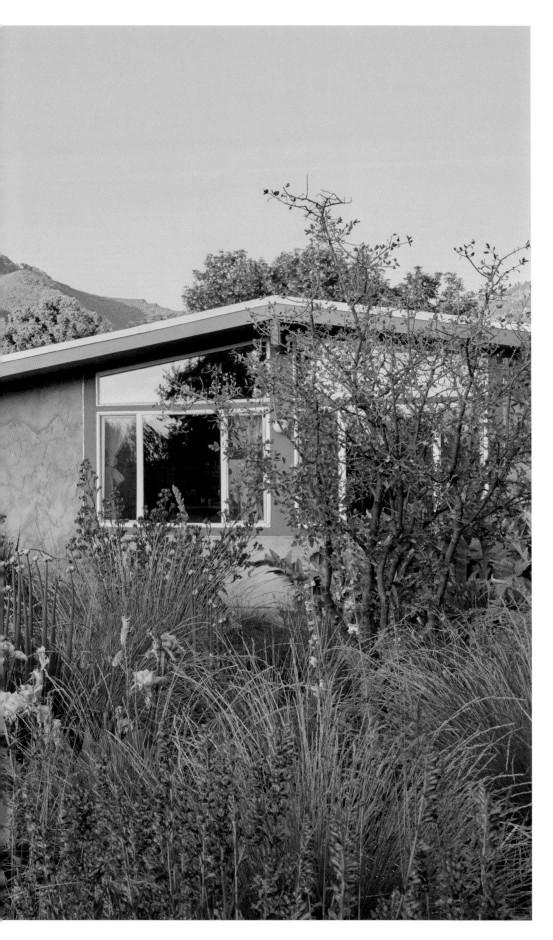

← Fritz Kollmann has created a lush, low-water front garden at his home in Salt Lake City. The Wasatch Mountains behind the house inspire and inform the garden with the microclimate they help to create and the floral and faunal biodiversity they hold. The garden features the fescue *Festuca mairei*, *Penstemon strictus*, *Penstemon palmeri*, *Agave parryi* subsp. *neomexicana*, and silver mullein (*Verbascum bombyciferum* 'Arctic Summer') intermingling with self-seeding California poppy (*Eschscholzia californica*), walking onions (*Allium ×proliferum*), and hybrid bearded iris 'Dodger Blue'. A tall nonnative *Anchusa azurea* blooms right in front of the living room window.

271

↑ Walking onions (*Allium ×proliferum*), Atlas fescue (*Festuca mairei*), blue *Penstemon strictus*, and pale pink *Penstemon palmeri* all play off each other in color and form.

↑ The boardwalk across Fritz Kollmann's front garden protects the plants and allows for dense planting right up to the edges without impeding access. Here Atlas fescue (*Festuca mairei*), silver mullein (*Verbascum bombyciferum* 'Arctic Summer'), and self-seeding California poppy (*Eschscholzia californica*) lap at the edges of the walk.

yet there are green turf lawns everywhere." To create the climate-adapted look he wanted, he "laid the initial plants out perfectly evenly spaced" and then went back and scrambled up a third of them to counteract that evenness. He wanted to see what would happen when he broke his own perceived rules. "If people don't like it, fine. If I don't like it, then I am learning something."

One day, Fritz was at work out of sight among the grasses when a group of teenagers walked by. He heard one of the girls say, "Hey guys, stop and look at this. It's beautiful." When he looked up from his spot, he saw the girl "just standing in front of the garden and taking it in, hands a little outstretched." He thought, "Wow. That's it."

Fritz's home and garden are situated at the mouth of a canyon leading up to the Wasatch Range, which "shoots up out of the valley" behind his house. One of the reasons he and Hannah chose this property was for the piney-scented cooling breeze that flows down from the mountains on summer evenings, transforming hot dusty days into something magical. Being at the mouth of this natural drainage path, however, means that "10 inches down in his garden is cobble that has washed down the canyon mouth over the millennia." To adapt to those conditions and to try and echo a sense of the native wildland that he loves, he took inspiration from the lands around him but "added enough flowers and plants that provide structure to hold a person through the season." He is drawn to the "grasses, which persist for so long, maintaining a softness and movement that is so soothing." To give the feeling of floating across a grassland meadow preserve, Hannah suggested the slightly elevated boardwalk that leads from the street across and through the garden to their front door.

Having worked at Red Butte Garden for several years before designing and planting his home garden afforded Fritz the chance to "observe good plants every day for years." He picked the "best of, the survivors, the toughest" to experiment with at home. Some came as salvage from Red Butte, including a good number of the *Yucca glauca*. He loves the interactions in nature when plants are "touching or almost touching." "The grasses serve as a solid visual background," interplanted by the flowers and edibles, including a big mullein, *Verbena bonariensis*, cardoon, walking onions, "a valuable food crop," orange Turkish horned poppy (*Glaucium flavum* var. *aurantiacum*), and wild arugula, "which the pollinators love." Fritz has very consciously integrated "the gold and tan tones of the summer cool-season grasses," which came to him as an acquired taste. When he first moved to Utah he thought the landscape looked "brown or dead" but over time he learned to love the nuances in these Western tones, "The brightness with the intense high-elevation sun, and the way shrubs and stronger evergreen plant forms contrast against these grasses and allow for patterns in the landscape."

Fritz set out to create an ecosystem in his home garden. Now, he watches hawkmoths nectaring at the white evening primrose and scrub jays come in after the moths. He notes, "I have insects coming to feed at an extremely regional native plant, and then becoming food for a native bird. The whole thing is working!"

BOISE VALLEY

IDAHO BOTANICAL GARDEN *and*

MARY ANN NEWCOMER

The Place

The Snake River Plain is a long crescent-shaped plateau running along the bottom edge of the Rocky Mountains in south-central Idaho. The capital city of Boise sits in the northwestern portion of the plain, with the Boise and Sawtooth National Forests and their remarkable wilderness areas spreading east and north. The Boise River forms the watershed for much of this area, starting high in the mountains as three forks that converge and run through the Boise Valley before feeding into the Snake River.

The diverse and hardy plant communities of the greater Boise Valley range from marshes, grasslands, camas prairies, and high desert sagebrush steppe up to foothill stream riparia, mountain forests and meadows, and extensive alpine areas. The intersection of the Boise River valley and Snake River Plain features dramatic topography and remarkable, often abrupt, shifts in climatic conditions based on elevation or exposure. It's "jaw-dropping drama," says Mary Ann Newcomer, a gardener and plantswoman whose family has lived in the state for generations. "It can be intimidating, and I love it. . . . The

275

Sawtooths, the Grand Tetons, the Rockies. I miss a horizon marked by mountains when I can't see them."

The region has long served as home to the Great Basin Shoshone and Bannock tribes. Although Boise is one of the fastest-growing cities in the United States, Mary Ann notes, "It's an unforgiving environment. You can't make a lot of mistakes out here and survive. It's a rugged landscape, so it's best for people who are kinda tough. We have rough roads, big elevation changes, harsh heat, cold, harsh light. It demands that you pay attention." She ends by reflecting how this scale dwarfs her own importance, "in a good way."

The Person

Mary Ann Newcomer is a well-known garden personality in Boise. She is a gardening book author—her books include *The Timber Press Guide to Vegetable Gardening in the Mountain States* and, as coauthor with John Cretti, *The Rocky Mountain Gardener's Handbook*—and for many years was the host of "Dirt Diva," a regional gardening radio program. She was born and raised north of Boise, not far from the Palouse in the Clearwater River Canyon of Lewis and Clark fame. This contrast in space and elevation from canyon to prairie to mountaintops informs her understanding of her place. "That term 'big sky' country—it's real. Looking up to the mountains asks you to rise up too. You can never be bigger than it, but it asks you to be bigger all the same."

When Mary Ann and her husband, Delos, settled in Boise she started volunteering at the Idaho Botanical Garden and was quickly tapped to be on the board of directors. In the late 1990s, she joined the team working to develop an adapted English garden, with climate-appropriate and native Idahoan plants. This was when her lifelong hobby became her "passion and calling."

A longtime student of the history and literature of the American West, Mary Ann is fascinated by tracing the stories behind plants—especially those like potatoes, sweet peas, roses, irises, peonies, lilacs, and narcissus that have stood the test of time in gardens of the Intermountain West—and gleaning the lessons they have to teach us as gardeners no matter where we live. She works to adapt some traditional concepts of garden design to the rugged climate of her region by using beautiful and colorful native plants, as well as adapted and storied heirlooms.

The Plants

Mary Ann's hillside home garden, on the northeastern edge of Boise and adjacent to the 260-acre Hillside to Hollow Reserve, is her anchor. She designed terraced layers around the house, opening the flow between the back, side, and front garden spaces,

PREVIOUS PAGES: Looking southwest across the Boise Valley from Mary Ann Newcomer's home, the garden "acts as foreground to the drama of the land and the view," she says. Oriental poppy (*Papaver orientale* 'Princess Victoria Louise'), *Echinops ritro* 'Veitch's Blue', *Iris*, and *Allium* 'Purple Sensation' grow beneath a weeping Norway spruce (*Picea abies* 'Pendula') and a compact eastern white pine (*Pinus strobus*). Mary Ann loves this pot for the way the colors "looked like the colors and ribbon-like horizontal lines of the foothills at sunset."

→ Looking east over a pool through *Echinacea pallida*, "which is very fragrant," Mary Ann notes, a little larkspur (*Delphinium*) has "just helped itself to the space and exposure." All along the pool edge are varieties of *Miscanthus*.

↑ In a border between her garden and her neighbor's, Mary Ann has combined the chartreuse green of low-growing Tiger Eyes™ sumac (*Rhus typhina* 'Bailtiger') with *Allium* 'Purple Sensation', foxtail lily (*Eremurus* 'Cleopatra'), and *Echinops ritro* 'Veitch's Blue'. California and breadseed poppies have seeded themselves around.

↑ Looking toward her neighbor's green lawn, Mary Ann cobbled this fountain together from a piece of Arizona ledge sandstone. The "ditch lily" (*Hemerocallis fulva*) coming on at the right is one she salvaged from an old farm. Mary Ann chose the 'Ashmead's Kernel' apple "because it was a favorite of Thomas Jefferson."

helping it become "as much a home as the house is." The back garden, which faces southwest and where they spend most of their time, is "definitely dominated by the view. We can see fifty miles from our perch." Rather than try to compete with that in her garden, she has focused on enhancing the foreground and "letting the background be the drama."

Mary Ann's suburban lot is about a third of an acre, giving her about 5000 square feet to garden. On the very steep hillside below the back of the house, underlain by sand and sandstone, she planted a "Western native grass mix to hold the soil." The entire area, uncultivated, would have been sagebrush steppe, so she has planted "natives and pioneer plants like my grandmother's German bearded iris and *Narcissus poeticus*, which can literally live here without water for about a hundred years." These are her "sentimental plants," but they are also water thrifty. "With less than twelve inches of moisture a year, and especially with such exposure and slope, we are always mindful of water use."

The garden has artful references to a Western aesthetic in rusted iron and pioneer farming embellishments. Purple allium and globe thistle (*Echinops*) run through yellow and orange daylilies and the fresh chartreuse-toothed foliage of sumac (*Rhus*). Echinacea and California and breadseed poppies offset larkspur, all underplanted with tough, heat-loving flowering Mediterranean herbs such as marjoram, oregano, and thyme. Blue grama grass and foxtail lily (*Eremurus*) add vertical color and understory to a variety of conifers throughout the garden. The region has few native deciduous shade trees but is rich in shrubs. Mary Ann uses these to advantage, including serviceberry (*Amelanchier utahensis*), hackberry (*Celtis occidentalis*), and mountain mahogany (*Cercocarpus montanus* var. *glaber*) for their endurance, form, fruits, and seasonal color.

"We need to be mindful and aware of the global nature of our civilization and our world, but we also need to be really anchored in where we live. It gives us strength and a sense of steadiness with which we can lead forward," Mary Ann believes. "This garden, physically and figuratively, is a good place to sit and have the long look, the long stare."

The Idaho Botanical Garden, which lies on the eastern edge of Boise abutting the foothills, stewards three rare Western species. "Aase's onion [*Allium aaseae*] bulbs were planted in 2006 after being salvaged from county lands slated for landfill expansion. The entire range of this species is in southwest Idaho, where it grows on deep sandy soils in about four counties," Mary Ann explains. McFarlane's four o'clock (*Mirabilis macfarlanei*) grows in Hells Canyon and in a few small populations along the Salmon River, with its entire range within just three counties. Finally, Sacajawea's bitterroot (*Lewisia sacajaweana*) is being grown in an attempt to gather seed for long-term seed-banking purposes. "This species, which comes and goes quickly," says Mary Ann, "is found on granitic soils only at six thousand to eight thousand feet elevation, and only in Idaho."

Mary Ann has served as a design and planting consultant on several key gardens within the Idaho Botanical Garden, including the Lewis and Clark Native Plant Garden, opened in 2006, and more recently the Tango Border. The 3-acre Lewis and Clark garden is at the highest viewpoint, overlooking and interfacing with wildlands. It displays a selection of plants that were collected during the Lewis and Clark Expedition, with a specific focus on the 145 species collected between Great Falls, Montana, and The Dalles, Oregon. Although the expedition did not go through Boise, interpretive materials throughout the garden discuss the significance of the expedition and how Indigenous cultures and individuals, including the young Lemhi Shoshone woman known as Sacajawea, contributed to its success. The garden was opened and a blessing bestowed on it by a descendant of Sacajawea.

Carved basalt pillars act as wayfinders along the stone-lined paths, underplanted with naturalistically dense plantings of wine cups (*Callirhoe involucrata*), woolly sunflower (*Eriophyllum lanatum*), selections of blanket flower (*Gaillardia aristata* 'Amber Wheels' and 'Burgundy'), desert four o'clock (*Mirabilis multiflora*), tufted evening primrose (*Oenothera caespitosa*), prairie jewels (*Penstemon grandiflorus*), and tall yellow wands of prince's plume (*Stanleya pinnata*). Shrubs like redosier dogwood (*Cornus sericea*) and the Idaho state flower, named for Lewis, *Philadelphus lewisii*, add bulk and dimension. Strategically, clumps of *Philadelphus*, "which only bloom for a month and a half in late spring, are situated close to the paths so that people who had never met this plant so characteristic of this place would come face-to-face with it."

The Lewis and Clark Native Plant Garden is grounded by the architecturally striking Gathering Place, a stone building referencing the design of Monticello, the Virginia home of Thomas Jefferson, who commissioned the Lewis and Clark Expedition, and to whom plant specimens were sent. It also references Indigenous design, with a central ceiling opening seen in traditional Native kivas and longhouses.

More recently, Mary Ann served as planting and design consultant for the Tango Border, "the latest of the [botanical] garden's water conservation gardens." The focus is on the state's native plants, other Great Basin selections, and plants adapted for the region. Many of the regionally adapted selections come from the Plant Select program, started by the Denver Botanic Garden. Mary Ann explains that the intention "is to showcase these plants as the hard workers they are and to use this planting as a teachable moment for the public. Plants are selected for their long bloom period, ease of maintenance, and low water requirements. We use a lot of small groundcover plants as living mulch. We don't do anything to prepare our plants or gardens for winter, for example, we just choose the right plants to start. We tidy up in the spring, but we leave all seed heads and stalks up for the winter as wildlife habitat and natural plant protection."

→ The Gathering Place stone rotunda is just beyond the local stone pillars at the entrance to the Lewis and Clark Garden. The rotunda's green roof is planted with native forbs and grasses, and its design, including the round opening (oculus) at the top of the roof, is a reference to the architecture of both Jefferson's Monticello and Native kivas.

↘ At the entry to the Idaho Botanical Garden's Western Waterwise Garden, climate-adapted, low-water use relatives and cultivars of native plants are on display. An oak-leaf mountain ash (*Sorbus ×hybrida*), the white flowers of Apache plume (*Fallugia paradoxa*), and a Great Basin wild rye (*Leymus cinereus*) take focus at the center of this planting, while red and yellow western columbine (*Aquilegia formosa*) fill out the front.

The Tango Border is 40 feet wide by 80 feet long and was built into what was a long piece of lawn beside the older English Garden. Mary Ann wanted to reflect not only good Idahoan and Western native plants, she also chose the shape, material, and colors of the planters to be reminiscent of "mountainous topography, prairie schooners, or iron-ore carts." She strove to "raise these jewels of plants up . . . in order to highlight their many attributes—their scent, their colors, their forms, and their textures and subsequent sounds, such as the rustle of the blue grama grasses. I wanted to honor and showcase the beauty of the plants of this place."

↑ Walking up to the Western Waterwise Garden, visitors see a little sunny dry combination of Indian ricegrass (*Achnatherum hymenoides*), as identified by the Idaho Botanical Garden's natural communities specialist, botanist Ann Debolt, and a native fleabane (*Erigeron subtrinervis*).

↑ *Sedum rupestre* 'Angelina' and 'Sunsplash' overflow the corten steel planters in the Tango Border.

→ Around the sandstone pillars in the Western Waterwise Garden are two types of rabbitbrush, the silvery leaf chamisa (*Ericameria nauseosa*) and the greener *Chrysothamnus viscidiflorus*, as well as western yarrow (*Achillea millefolium*). Downtown Boise is in the distance.

← The central sandstone and iron art work in the Tango Border speaks of the relationship between humans and the land. It is set in a meadow of blue grama (*Bouteloua gracilis* 'Blonde Ambition') accented throughout with stands of Rocky Mountain penstemon (*Penstemon strictus*). Above are the striking seeds of Hot Wings Tatarian maple (*Acer tataricum* 'GarAnn').

→ The Idaho Botanical Garden was created on the grounds of the historic Old Penitentiary. Purple *Rosa* 'Veilchenblau' scrambles across the arbor in an area of the garden dedicated to "heirloom roses bred and introduced before 1920."

PALOUSE GARDEN

SUZANNE ST. PIERRE *and*

SCOTTY THOMPSON

The Place

The Palouse bioregion is nearly 4 million acres of rolling grasslands in west-central Idaho, southeastern Washington, and northeastern Oregon between the western edge of the Rocky Mountains and the Columbia River basin. The region is extraordinarily rich in loess, fertile topsoil that is sometimes yards deep. Loess soils are formed, often over millions of years, by wind blowing over and across a dune-like topography. As it does, it continually deposits particulates, silt, and organic material.

Home to the Palouse, Cayuse, Walla Walla, Spokane, Coeur d'Alene, Yakama, and the Nez Perce peoples, the land and soils were recognized by European settlers in the 1800s as perfect for dry wheat, beans, and other grain and legume crops. Since the late 1880s the area has been a major agricultural region. Pullman is home to Washington State University, which was founded as Washington Agricultural College in 1890, just a few years after the territory became a state. It is one of the oldest land-grant universities in the West, contributing to a settled culture steeped in the cultivation of plants.

287

Mimicking most life in the lay of this land, Suzanne St. Pierre and Scotty Thompson nestled their home in the lowest contour of the topography of their small parcel. The adjacent rolling fields are offset only slightly by the visual contrast of conifer-covered buttes in the distance. "Our sky is huge, and we have really good cloud formations here," Suzanne says. "It's sort of desert-like in some ways—open and vast, windy." The USDA zone 5a–6b climate offers on average a little over 21 inches of precipitation annually, with frost and snow from October through early April. But the average lows of mid-to-low 20s in the winter and average highs in the summer in the low 80s make for a solid four seasons and mild gardening weather.

The People

The year that Suzanne St. Pierre was born on the Palouse, her parents started a nursery business. As she was completing a horticulture degree at Washington State University, her parents decided it was time to sell. Suzanne bought the business, went into debt moving it to a better retail location, and spent the next ten years making the full-service retail and wholesale growing of annuals and perennials a success. Feeling chained to a desk and needing to get back to the plants, however, she closed the nursery and pulled back to just wholesale growing and propagating for six years.

In 2008, she and her husband, Scotty, "who is artistic as anything and does the building, hardscape, and works the land while I plant" made the big decision to open a modified nursery and growing greenhouse at their 2-acre home and garden and to open it to the public seasonally. Known as Living in the Garden, this last home-based iteration of Suzanne's nursery business ran happily for four days a week, four months of the year through 2015, when she officially retired.

"There is a very soft, yin energy to the large rolling hills, the seasonally shifting colors of the patchwork agricultural crops of winter wheat, spring wheat, garbanzo beans, and dry peas blanketing them," Suzanne points out. "If my garden is the proverbial stone in the pond, the first ripple is that I want this space to be a refuge for life: for bird life, bug life, plant life, microbial life. So much of my beloved birth landscape is devoted to commodity crops that I really want to make a difference." Now that she is retired, Suzanne is "really taking time to see what is living here." She sees her gardening activities and cultivation instincts as her religion, her soil as her "emotional support animal." She gardens in bare feet to ensure contact every day. She takes to heart the Gandhi quote "In a gentle way you can shake the world."

Suzanne believes strongly that we were encoded as creatures to respond to beauty. "Is it ingrained in the soul? I'm not sure—but gardening is how I come to terms with it." She goes on, "To see everything in all the little tiny things, like the light gathered on a fresh raspberry leaves me in wonder. I keep thinking, 'Really, I get to do this? And tomorrow and the next day too?' I believe that everything is energy

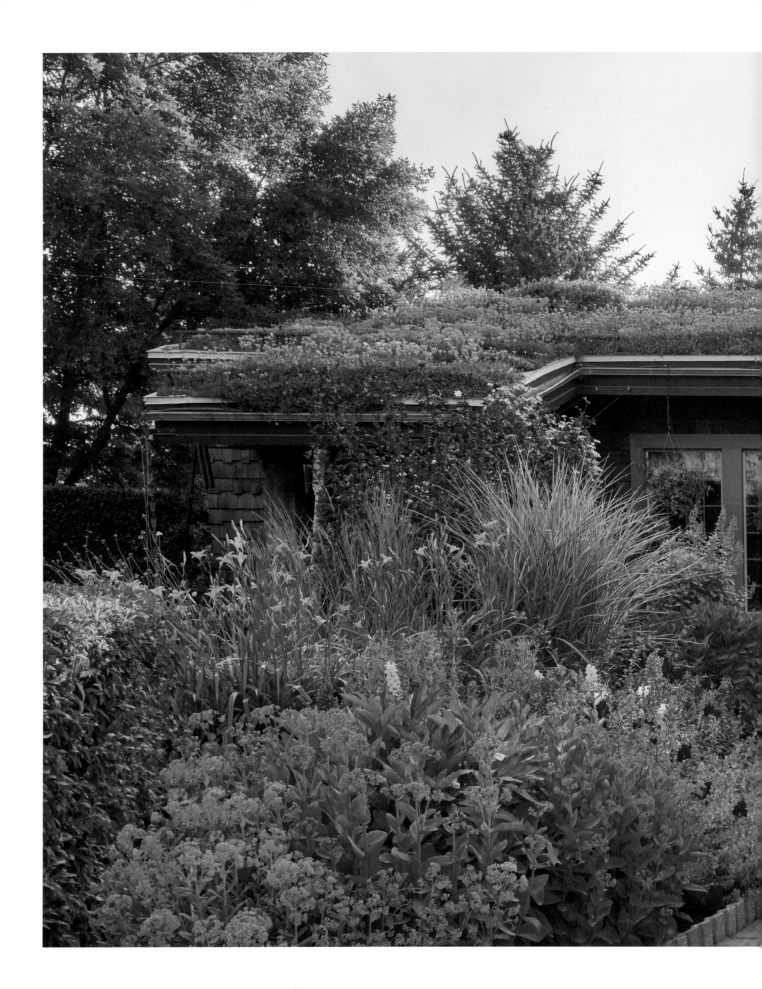

← The green roof of the studio is mostly planted with *Sedum rupestre* 'Blue Spruce' and 'Angelina'. In the bed across from the potted fig are *Hylotelephium spectabile* and an unnamed daylily Suzanne got from her father's garden. The ensemble is rounded out with overwintering snapdragons, *Miscanthus sinensis*, and diablo ninebark (*Physocarpus opulifolius* 'Diablo').

291

and the transference of energy. I hope holding and practicing the calm regenerative energy of the land and the garden may somehow counteract other more chaotic things in the world."

The Plants

The first plants that went in thirty-five years ago were trees for a windbreak, many leftover ugly ducklings from the nursery. "As the windbreak grew up, we could grow more plants. As a horticulturist, I was always pushing boundaries of what I could grow. I've been humbled by that a few times," she admits. She has come around to choosing plants that do not merely survive, but that thrive here.

Suzanne's layered, flowering annual and perennial plantings—many of which she still propagates—glow in her currently favored color scheme of reds, yellows, and oranges. Along clipped green hedges, cheerful snapdragons, daylilies, hostas, hebes, lolling hardy geraniums, and clambering honeysuckles intermingle with ornamental

↑ Suzanne and Scotty's dry shade garden is filling out under the original row of Scots pine (*Pinus sylvestris*) they planted as a windbreak with a strategically framed view to the rolling open Palouse. Scotty crafted the fence by standing old wood and metal combine belts on edge.

bunch grasses such as *Calamagrostis ×acutiflora* 'Karl Foerster' and *Miscanthus sinensis* 'Overdam', both of which are hardy here and neither of which seed about. Scotty's artful creations are featured throughout the garden, along with Suzanne's many pots of annuals and perennials. One way to extend both the garden's zonal constraints and the seasons is to overwinter tender "California babies" in the zone 7 conservatory. The higher-maintenance thirsty perennials are being exchanged for dwarf conifers, which Suzanne and Scotty both find soothing in a way they would never have expected.

Over the years they have added tons of organic, site-made compost using horse manure and wood shavings from a local boarding stable, their own household waste and the garden's biomass, and the food waste from a nearby natural food café. Their 6-by-15-foot long compost bed is turned and mixed with a small tractor.

Where their land meets the wider landscape, Suzanne is planting more and more natives for habitat. She notes that she was lucky enough to have inherited her mother's records on seed starting inventory from 1960 to 1983. "Every year on the same week if not the same day, my mother started her petunias, impatiens, snapdragons, and the like. One year, I realized that her start dates no longer meant anything. They no longer seemed to correlate at all with what was happening in nature around me." Suzanne felt disoriented when she realized the import of that fact.

For Suzanne, closing the carbon cycle means "replacing big bonfires in the fall with chipping and mulching, doubling down on composting, adding hugelkultur beds in the production greenhouse," in which you bury woody debris and then plant over it as it decomposes. The last two seasons a honey bee colony has taken up residence in one of their storage sheds, and the couple has welcomed them. "We are planting cover crops for them and the soil, and ever more forage for the insects and pollinators," she says. It's always been a "devotion to the top three inches of the soil with the understanding that everything would go up and down from there," they have just become more dedicated each year.

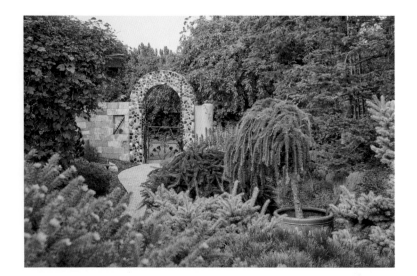

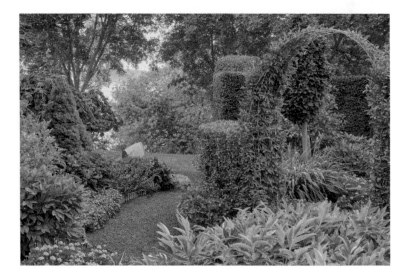

← Suzanne and Scotty replaced resource-intensive herbaceous perennial borders with additions to their growing conifer collection. This combination outside their living room window includes a potted weeping larch (*Larix decidua* 'Pendula'), with a more recently planted *Pinus sylvestris* 'Gold Coin' that "turns bright yellow in winter" and blue spruce (*Picea pungens* 'Glauca Globosa').

↑ **TOP:** At the far end of a dwarf evergreen border, the pathway leads to the driveway entrance to the garden. In 2019, Suzanne and Scotty added what they call Pieces Arch, made of broken glazed ceramic pots, to an existing cement block wall. A farrier friend of Suzanne's made the welded Rose Gate.

↑ **ABOVE:** Tree peonies, daylilies, and marigolds abound on a pathway on the southern side of the studio garden. On the far left, a golden elderberry (*Sambucus canadensis* 'Aurea') is in line with a dwarf Alberta spruce (*Picea glauca* 'Conica') and a weeping filbert (*Corylus avellana* 'Pendula'). Beyond, the Palouse Prairie and a neighbor's farm field glow in the sun.

HELLSTRIP
GARDEN

LAUREN SPRINGER

← The harmonious repetition of plant color and forms in the urban hellstrip Lauren Springer designed in Fort Collins, Colorado, ties into the look and feel of the native grassland beyond. The pink muhly grass, Undaunted™ ruby muhly (*Muhlenbergia reverchonii*), is Lauren's own introduction through the state's Plant Select program. *Iris pallida* 'Argentea Variegata' shines in the foreground, and the strong form of *Yucca pallida* is just beyond a low pool of Santa Fe phlox (*Phlox nana*).

The Place

The Front Range of Colorado is the first great uprise in the land moving west across the grassland prairies of the Great Plains. The city of Fort Collins, nestled along the Front Range north of Denver, lies on the traditional homelands of the Ute, Arapaho, Cheyenne, Lakota, Apache, and Comanche peoples. The Pawnee National Grasslands are to the northeast, and Arapahoe and Roosevelt National Forests and Rocky Mountain National Park sit to the west of the city. With rich grasslands and prairie stretching east and the foothills and mountains stretching west and rising to over 14,000 feet at the highest summits, the region is resplendent with a diversity of unique ecosystems and bioregions. A Colorado Natural Heritage Program survey of this region identified seventy-one rare or imperiled plant species and ninety-four plant communities of concern, particularly intact shortgrass prairie and foothills communities.

Fort Collins sits in the floodplain of the Cache la Poudre River, and many plants and animals rely on the riparian corridor or associated wetlands in this otherwise semi-arid steppe environment. Situated in the rain shadow of the mountains, as well as along a windy corridor created by the meeting of mountains and plains, the city receives an average of 16 inches of precipitation per year, with an average wind speed of 9 miles per hour from November through April.

The Person

Garden designer, plantswoman, and horticultural educator Lauren Springer was born and raised near Philadelphia, but she spent many summers hiking in the Alps with her extended family and developed a love of mountainous regions and their plants. When she first visited the Fort Collins area, the "contradictory nature of the drama *and* the serenity" of the big mountains, big sky, and big plains "broadsided her." She knew right then she wanted to live there.

Lauren began writing a garden column for the *Denver Post* and experimented passionately in her home gardens in and around Fort Collins. In 1994, she published her first book, *The Undaunted Garden*, which lushly highlighted her planting style,

climate attunement, and extensive plant knowledge as really showcased at her Front Range home, where she was "making gardens no one thought were possible in this climate, and using climate-adapted and native plants grown from seed few other people were using." She went on to write several more books, including *Passionate Gardening: Good Advice for Challenging Climates* (2000) cowritten with plantsman Rob Proctor, and *Plant-Driven Design: Creating Gardens That Honor Plants, Place, and Spirit* (2008) with plantsman Scott Ogden.

Lauren coined the term "hellstrip garden" for that unforgiving and either neglected or overwatered, inappropriately green-turfed strip of land between a sidewalk and a street. She saw it as a space full of plant and habitat potential. In 2004, she designed a hellstrip measuring 350 feet by 12 feet for the Gardens on Spring Creek, a community-based botanic garden and partnership between the city of Fort Collins and a nonprofit group of citizens interested in supporting a public garden, open space, and "fostering environmental stewardship through horticulture."

Integral to Lauren's entire career is her awareness and responsiveness to climate change, an interest in ecological and habitat gardens, and the ever-increasing importance of low-water native and regionally adapted plants for landscapes. In 2013, Lauren joined the staff of the Gardens on Spring Creek to design, oversee, and manage a three-quarter-acre garden space named The Undaunted Garden, echoing her first book's thesis about how to work with a site's climate and soils. She seeks to teach "how beautiful, sustainable, and wildlife friendly gardens can be made with the right plants, design, and approaches." But first, Lauren took on the renovation of the almost decade-old hellstrip garden.

The Plants

Lauren describes a hellstrip as a "kind of a haiku of a garden. The constraints are so incredible! What can I do with a space twelve feet wide, in a public right-of-way, with little water, constant car exhaust, tons of foot traffic, and restrictions for plants being lower than eighteen inches, for visibility?" In 2004, there were few buildings along the hellstrip, which lies along the south side of the Gardens on Spring Creek. By 2013, when Lauren began the renovation, surrounding development included a large student-based apartment complex and daycare center. The street had also been linked to a bike and walking trail. The "pressure and foot traffic of the site are very different than when the garden first went in."

Lauren is a big believer in using whatever soil exists on a site and seeking out plants that will work with it. She does not generally supplement soils beyond using a good dose of alfalfa pellets in heavily compacted soils to add structure and looseness and feed the microorganisms. "Many plants that thrive here," she explains "are finely textured to endure the extremes of sunlight and wind, such as grasses. They do well

→ The pinkish seed heads of sea lavender (*Limonium platyphyllum*), form an airy foreground to a hardy form of mealy cup sage (*Salvia farinacea*) and aromatic aster (*Symphyotrichum oblongifolium*), with another special pink form behind that (*Symphyotrichum oblongifolium* 'Dream of Beauty').

↑ Sea lavender (*Limonium platyphyllum*), rises above mop-heads of prairie dropseed (*Sporobolus heterolepis*). The more upright grass is pre-bloom Undaunted™ ruby muhly (*Muhlenbergia reverchonii*), and the silver to right is *Artemisia versicolor*, which Lauren introduced to the trade in northern Colorado.

↑ To provide a consistent, climate-adapted canopy down the length of the large hellstrip, Lauren selected West Texas red oak (*Quercus texana*), here underplanted with green-leaved seedlings of dwarf rabbitbrush (*Ericameria nauseosa* var. *nauseosa*). Sea lavender (*Limonium platyphyllum*), lavender (*Lavandula*), *Penstemon pinifolius*, and yellow cranesbill (*Erodium chrysanthum*) are in various stages of seasonal growth.

here, they look right here, and they play beautifully with the light. The fine-textured things also become animated in the wind, playing against the unmoving stone and soil that just sits there and either absorbs the light if it's dark or reflects the light if it's bright, exaggerating the contrast."

When Lauren dug back into the hellstrip after ten years, she was faced with an amazing amount of overgrowth, unchecked self-seeding from some of the original choices, invasive weeds, and quite a bit of loss to foot traffic. The best performers remain, including prairie dropseed (*Sporobolus heterolepis*), Arizona fescue (*Festuca arizonica*), and Lauren's own introduction through Colorado's Plant Select program, the Undaunted™ ruby muhly (*Muhlenbergia reverchonii*).

The originally planted West Texas red oak trees (*Quercus buckleyi*), which are adapted to dry alkaline soils and climate, stayed. These are kept limbed up enough for drivers and walkers to see under and are underplanted with Lauren's colorful and textural signature mosaic style of drought-adapted native and nonnative perennials, annuals, and low shrubs. Wheat- and pink-colored grasses play with the light, while yucca, hesperaloe, and manzanita add contrasting dark green foliage and sculptural form. Silvery gray, mounding dwarf rabbitbrush (*Ericameria nauseosa* var. *nauseosa*), with its soft yellow flowers and seed heads, draws the eye, as does the bright green and white strappy foliage of striped bearded iris. Seasonally, thousands of bulbs add color and interest: crocus, snow iris, star of Persia allium, species tulips, and grape hyacinth "pale, not dark blue, to show better against the tawny early spring backdrop of still-dormant plants."

Lauren admits she is "more in love with nature" than she is with gardens. "For me, gardens are a microcosm of the nature we have lost in the modern world." She wants her gardens to mirror nature. "Not everyone thinks of gardens this way—some people think of them as artistic or aesthetic expressions of themselves. Either way, you choose your Eden and create it and then you wind up having a relationship with it. I aim for a little bit of the experience of being on a wonderful hike, in a way, in my own garden every day." Her favorite gardens reflect what is important to her in terms of plants, place, and nature—even in a public streetside hellstrip.

THOMAS THE APOSTLE CENTER

CONNIE *and* JAY MOODY

The Place

The Bighorn Basin in northwestern Wyoming is a broad, windswept, mineral-rich basin between a constellation of Rocky Mountain ranges: the Absaroka Range and Beartooth Mountains on the west, the Pryor Mountains on the north, the Bighorn Mountains on the east, and the Bridger and Owl Creek Mountains rimming the south. The epitome of what many imagine the American West to be, this area was part of the larger territory of the Apsaalooké/ Absaroka peoples beginning in the 18th century. The region has a semi-arid climate with just over 10 inches of precipitation annually and cold, dry winters.

Although the vegetation feels relatively sparse, the sagebrush steppe and mixed shortgrass prairies of the region surrounding Cody have nearly 1000 unique plant species that have coevolved and thrive in the area's dry, windy, and rugged geological conditions. Intermingling with the diminutive bunchgrasses and pale silvery blue-green aromatic sagebrush (*Artemisia*)—of which there are more than twenty species in Wyoming—are myriad, often ephemeral, annual and perennial flowering herbaceous, geophytic, and woody plants.

Jay Moody, resident director of the Thomas the Apostle Center, says, "In spring, we are immersed in the green of the grasses and the gray of the ever-present sagebrush, dark green conifers cover the mountain sides. As we move toward summer, we turn to taupe/tawny colors. I find beauty in these colors, and in the sandstone rocks of lighter gray, darker gray, reddish gray. Lichen on some rocks offer starbursts of oranges, bright greens, yellows, and bright reds throughout the seasons."

The People

The Thomas the Apostle Center is owned by the Foundation for the Episcopal Diocese of Wyoming and is used for retreats that support and encourage individuals' and artists' spiritual journeys. Jay and Connie Moody, who have worked in the hospitality industry for some time, settled on the center's 350 acres of shortgrass prairie and sagebrush steppe in 2007. Jay grew up on a ranch about fifty miles from the center and has spent most of his life in northwestern Wyoming. His childhood ranch had small vegetable gardens and flower gardens around the houses, which included "plants that could be grown without much water or extra input, plants that would take the harsh environment."

Although he had never created or cared for a large garden before, Jay knew right away the landscaping at the center, which included struggling, irrigated bluegrass lawns, needed work. In the winter of 2008, he came across *Cutting Edge Gardening in the Intermountain West* by Colorado plantswoman Marcia Tatroe. He read the book thoroughly and then reached out to Marcia, who came to the center that spring and in later years to lead some workshops and give input on the garden. Marcia talked to Jay and Connie about landforms they might effectively use in the garden, using the local rocks for the hardscape of the garden, and the plants that might work well for them. Through Marcia, Jay met other notable Rocky Mountain plantspeople, all of whom have encouraged and consulted, including Panayoti Kelaidis, Mike Bone, and Mike Kintgen of the Denver Botanic Garden, Lauren Springer, and local naturalists and gardeners Susan J. Tweit and Stephanie Rose.

In the year between arriving at the retreat center and really getting started on the gardens, Jay developed deeper knowledge of the site and gained a sense of what "felt right and what felt wrong" about what was already there. For example, the site did not have enough water to maintain bluegrass lawns and the "English-style plantings that needed to be replaced almost every year because they did not survive the winter or did not survive the summer" were not only unsustainable but unattractive. He wanted guests' visits "to be a genuine respite and peace from their ordinary lives. One of the goals was to bring that sense and the peaceful colors of the landscape into the gardens as a way to reflect the beauty around us."

PREVIOUS PAGES: The Absaroka Mountains rise in the distance, southwest of the Thomas the Apostle Center just outside of Cody, Wyoming. Catmint (*Nepeta*), blue grama grass (*Bouteloua gracilis*), and Apache plume (*Fallugia paradoxa*) grow in an unirrigated gravel garden off one of the guest houses, in view of the center's local-stone labyrinth.

FOLLOWING PAGES: Jay Moody hand set the site-sourced stone labyrinth with its sweeping view of the Absaroka Mountains. The contemplative element is surrounded by the naturally occurring plants of the area, including rabbitbrush (*Ericameria nauseosa*), aromatic Great Basin sagebrush (*Artemisia tridentata*), and native grasses.

↑ Low-growing hardy geranium, showy milk-weed (*Asclepias speciosa*), and the upright grass *Calamagrostis* ×*acutiflora* 'Karl Foerster' grow along a walkway leading out to a stand of pink-blooming native *Penstemon parryi*.

↑ Around the center's main buildings, Jay created low-water, site appropriate plantings that are slightly lusher than the native vegetation, often using hybrid cultivars of native plants or plants from other arid regions. Here a large hybrid yarrow (*Achillea*) is in bud, with low-water catmint (*Nepeta*) and an ornamental grass.

The Plants

An early revelation was that a gravel expanse around one guesthouse was there because the structure was built directly on a pocket of bentonite clay. The clay had swelled and contracted with the irrigation coming on and off and, much like frost heaves, had damaged the building. The 2-inch cobble, difficult to walk on let alone look at, was the quick-fix replacement for a failed lawn. "The cobble ran the whole length of the building and twenty-five feet out—no plants, no form, no interest. . . . There was no invitation to be part of nature there."

Marcia pointed out that the rocky ridgeline just beyond the center had natural "crevice gardens" formed of little pockets of soil and plants nestled down into the rocks, out of the wind, where they capitalized on the warmth and runoff water. Taking this as a cue, Jay knew he needed to use what he had, so he added form to the cobble expanse with soil berms and a dry stream bed. He planted the berms with low-water, climate-adapted plants in a color scheme of "blues, grays, glaucous greens, a few small bursts of yellow, and the occasional red."

Jay estimates there are now about 2 acres of garden at the Thomas the Apostle Center, with more than a hundred plant species. There is no irrigation system and no bluegrass lawn. Jay admits to being a neophyte in the beginning. but he has focused on learning about plants every step of the way. "I chose some plants that didn't survive, but a lot of plants that did. Some I regret having chosen, they did so well." With Connie's help, Jay completed a stone labyrinth in 2012. It seemed the perfect contemplative addition. The labyrinth is laid out in the medieval, eleven-circuit pattern from Chartres Cathedral in France. Jay collected each of the 1800 rocks for the pattern from the surrounding land, being careful not to overly disturb habitat in any one area.

His starting list of hardy plants included some natives and some nonnatives: Russian sage (*Salvia yangii*), catmint (*Nepeta racemosa* 'Walker's Low'), which has been one of the more freely seeding and is a "wanderer that needs its spread curtailed sometimes," varieties of penstemon including Rocky Mountain penstemon (*Penstemon strictus*), true lavenders (*Lavandula*), and other plants with blue and lavender flowers, like sugarbowl clematis (*Clematis scottii*) and Colorado columbine (*Aquilegia caerulea*). He also chose brighter accents of yellows and reds to match those in the environment, such as pineleaf penstemon (*Penstemon pinifolius*). The second year he added sparsely collected divisions of cacti from the surrounding grasslands. This created "an entirely different kind of plant texture that also adds some bursts of bright yellow in bloom." Subsequent years have seen introductions of dwarf conifers, gaillardia, yarrow (*Achillea millefolium*), yucca, buckwheat (*Eriogonum*), prairie smoke (*Geum triflorum*), and pink penstemon (*Penstemon palmeri*).

Jay noticed in the first season with the garden that there was a distinct absence of the sound of birds and bees. He welcomes silence, but not that silence, so every year since he has made efforts to add pollinator plants. The Thomas the Apostle Center is now recognized by the Audubon Rockies as a Habitat Hero for restoring habitat crucial to the survival of songbirds and pollinators.

One of his greatest challenges, though, is actually finding plants as there are no native plant nurseries in his area. He serendipitously got several Apache plume (*Fallugia paradoxa*) from a local nursery, when they gave him the "terrible looking, root-bound, several-seasons-old plants because no one would buy them." He was able to resuscitate them in the ground and has come to love them for their "color, seasonal bloom, and texture" and the nectar, pollen, and habitat for wildlife. Panayoti has regularly provided plants from the Plant Select program. Susan shared some Sunset Crater penstemon (*Penstemon pseudospectabilis* subsp. *clutei*) with him, and it has done beautifully. Many others have also contributed plants and seed.

Over the years Jay and Connie have watched visitors "find themselves in the midst of the garden. They sit in it, walk through it, enjoy it as an active, integral part of the retreat experience." The garden is as much a calling as a task, and the place has also become an integral part of Jay's spirituality. "Tending the land and the plants has me on my hands and knees every day. . . . Creating the labyrinth brought me much closer to those who walked this place long before people of European descent were here. It has deepened my relationship with a creator, and it's very important to me to have my quiet time with these gardens and the labyrinth. Every experience with it is different and equal."

↓ Blue *Salvia nemorosa* and *Nepeta racemosa* 'Walker's Low' make a strong, drought-tolerant, cold-hardy combination.

↘ Catmint (*Nepeta*) and native flax (*Linum lewisii*) bloom in shades of blue at the Thomas the Apostle Center.

FRONT RANGE
GARDEN

MARY *and* LARRY SCRIPTER

with LAUREN SPRINGER

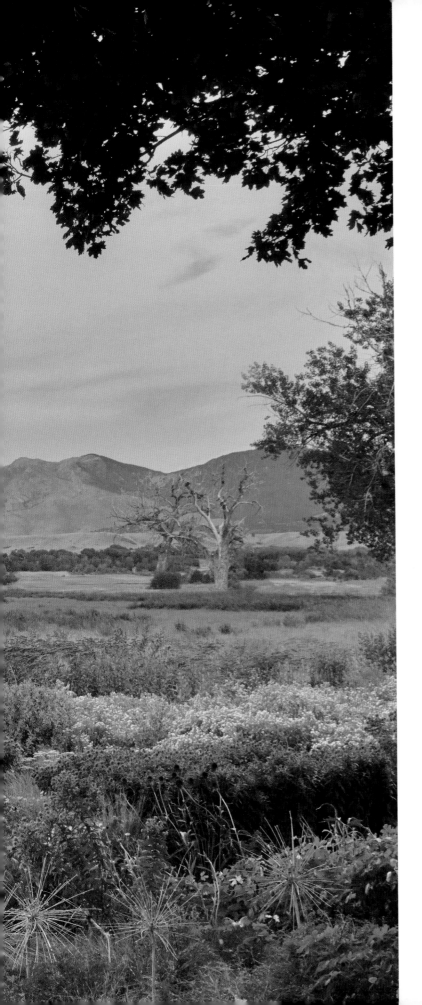

The Place

Boulder Valley, stretching between the cities of Boulder and Longmont along Colorado's Front Range, is a transition zone from Great Plains grasslands to ponderosa pine savannahs to ponderosa pine and Douglas fir forests in the foothills to the west. The diversity of topography supports a rich tapestry of plant and wildlife. Expansive views of open spaces—a mix of preserved open space, remnant shortgrass and mixed-grass prairie, and agricultural land—endear the region to its inhabitants. The Front Range is traditionally home to many Indigenous peoples, including the Ute, Cheyenne, Comanche, Southern Arapaho, and Sioux. The unincorporated town of Niwot, nearest to this garden, was named for a Southern Arapaho tribal chief. After European settlement in the mid-1800s, the town was a railroad stop.

Mary Scripter appreciates the view of the mountains and specifically how "it feels grounded with the short view across our prairie meadow garden, with the lime green leaves of spring followed by the yellows, and golds and reds of fall. We get a full mosaic of the intense colors of this region looking out from our spot—the

blue, blue sky, the unfiltered sun, the stark white of snow on the mountains in contrast to the green prairie grass."

According to Boulder County ecologists, this area has one of the highest breeding bird densities in the state and has added importance for birds that migrate to the tropics during the winter, given the worldwide declines in their numbers. There is also a high density of nesting raptors, such as golden eagles, prairie falcons, and the federally listed peregrine falcons, which nest on craggy rock outcrops. With residential development being the primary cause of natural habitat fragmentation, the provision of habitat within residential landscapes becomes especially important.

The People

Mary and Larry Scripter have made their home and garden in this region since 2009, though Larry bought the 68-acre property in 1990. Having grown up in the Midwest— Larry in Kansas and Mary in South Dakota—they both love wide open spaces. "He came from tallgrass prairie and I came from shortgrass prairie," Mary says.

Mary attended the University of Wyoming in Laramie and later moved to Colorado Springs, where she had a garden and landscaping business. Believing gardening in these areas "was a maverick science," she was a regular attendee at classes at the Denver Botanic Gardens throughout the 1980s and was introduced to plantswoman and garden designer Lauren Springer's work. When she moved to Niwot with Larry, Lauren was the clear choice to help them create a large, prairie-style garden.

The first things the couple asked of Lauren were not aesthetic but about supporting birdlife and habitat. "As we learn about the importance of the insects and the soil life, reflecting where we are and not trying to insert or duplicate another place is important. The preservation of our natural resources is also vital. This includes the diversity of wildlife and floral life and *water*. Our gardens are so much more pleasing to the eye and relaxing to the spirit when they meet the natural environment where it is," Mary reflects. A large bald eagle nest is situated on the edge of their property, and an eagle pair returns to it annually.

The Plants

When they first took on cultivating a portion of the land around the house, it had a half dozen overgrown old junipers and weedy areas, all of which blocked and detracted from the view. Some initial clearing of the junipers revealed a tremendous vista that bore enhancing across open land and beyond to the mountains.

When Lauren saw the space for the first time in 2009, Larry expressed his love of birds, noting that they did not have many visiting. Lauren suggested clearing more of

PREVIOUS PAGES: Mary and Larry Scripter's garden in Boulder County, Colorado, conceived by designer Lauren Springer, was carefully crafted to complement and take full advantage of their view due west over their open hayfield and the Rocky Mountains beyond. Here, the "the morning light alpenglow" that Mary loves is reflected in the colors of the herbaceous perennials and grasses. Pink muhly Undaunted™ (*Muhlenbergia reverchonii*) and little blue fescue (*Festuca idahoensis* 'Siskiyou Blue') line the gravel path, while *Allium schubertii*, *Aster*, and *Sedum* are repeated in groups.

↗ A pair of bald eagles perch in the cottonwood snags in the distance when they return each February. A taller prairie dropseed (*Sporobolus heterolepis*) catches the light, growing along with Undaunted™ pink muhly grass (*Muhlenbergia reverchonii*), *Echinacea angustifolia*, a mix of asters (*Symphyotrichum novae-angliae* 'Purple Dome', *S. oblongifolium*, and *S. laeve* 'Bluebird'), and *Hylotelephium spectabile* 'Neon'.

→ For Mary and Larry's garden, Lauren chose an aspen cultivar (*Populus tremuloides* 'Prairie Gold') from Nebraska, as native Colorado aspen tends to have fungal issues at lower elevations. *Rudbeckia fulgida* spreads in the sun to the right of the trees, and beyond them are Russian sage (*Salvia yangii*) and *Calamagrostis* ×*acutiflora* 'Overdam'.

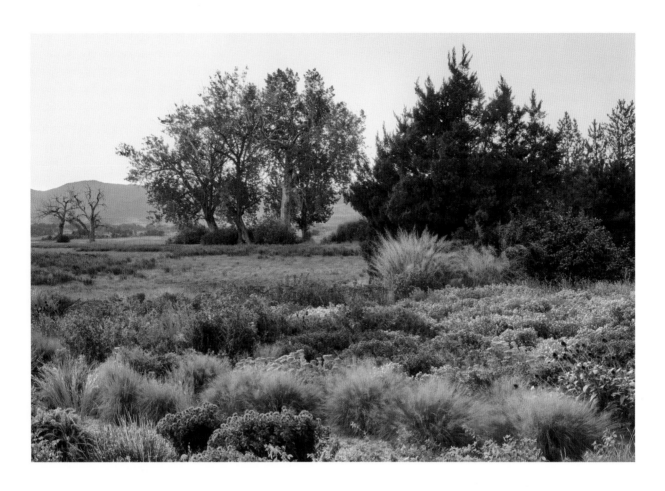

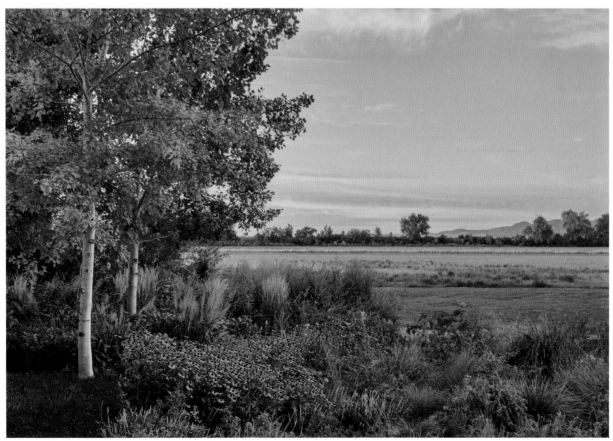

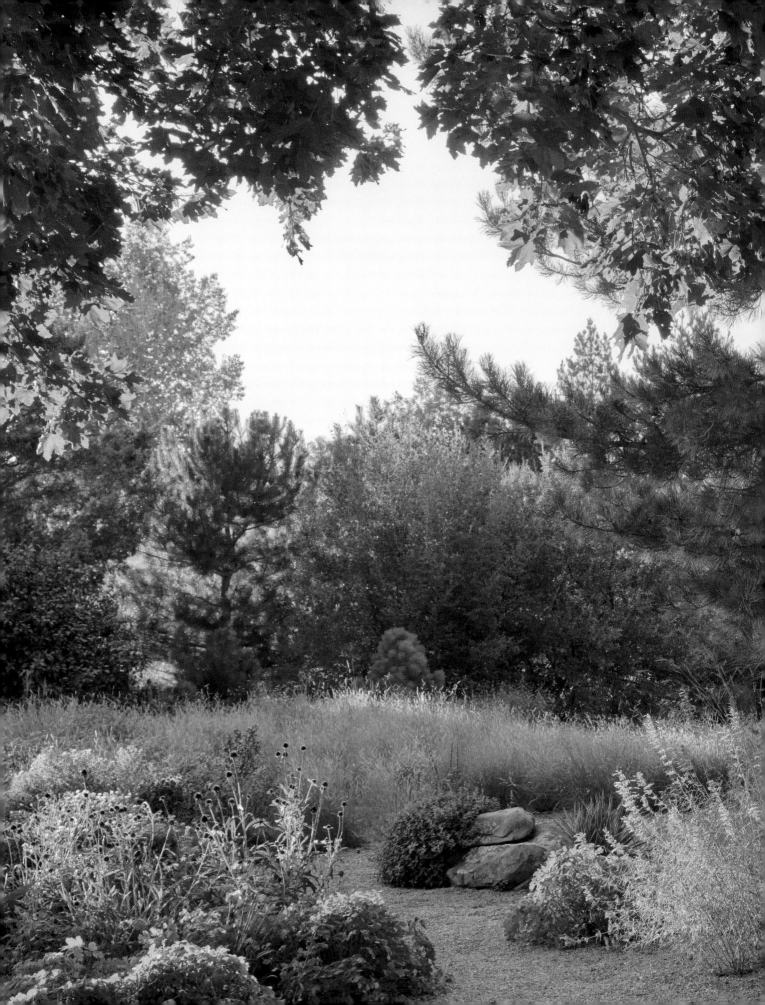

← Under a large ponderosa pine (*Pinus ponderosa*), a seed-grown hummingbird mint (*Agastache*) flourishes, to its right a red yucca (*Hesperaloe parviflora*) is in bloom, and to its left the leading edge of the meadow, with columbine (*Aquilegia chrysantha*) and seed heads of *Echinacea angustifolia*.

315

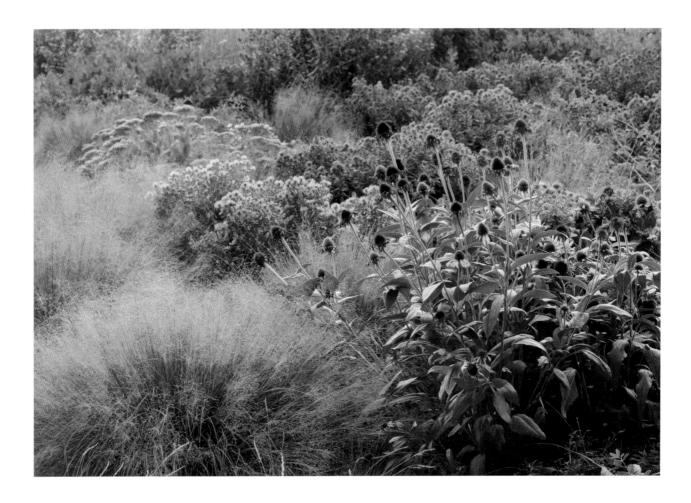

what was there, in particular a mess of invasive Russian olives. Two distinct bird and privacy screening areas on the northwest corner would frame the quarter-acre prairie and wildflower garden with a short-view foreground to the long view of fields and mountains. "To create a woodsy aspen grove on the south end, we planted a lower elevation variety of aspen and native shrubs with an underplanting of shade-tolerant grasses and perennials," Mary explains.

After clearing was complete, Larry and Mary planted more than sixty shrubs and trees with the help of a backhoe. In 2011, Mary underplanted them with more than 600 blue grama and little bluestem grass plugs, while Lauren created a design and planting plan focused on attracting wildlife, long-season flowers, and structural interest. The garden space is on the west side of the house, "fully exposed to the sun and wind coming from the south and west." The region averages between 12 and 14 inches of precipitation a year, although in drought years—including the first year that the main garden planting was done—it receives as little as 5 inches. The average no-frost dates are mid-May through mid-October. The plants had to survive those conditions.

↑ A dense planting of Undaunted™ pink muhly grass (*Muhlenbergia reverchonii*), *Echinacea angustifolia*, and mix of purple dome aster (*Symphyotrichum novae-angliae* 'Purple Dome'), aromatic aster (*Symphyotrichum oblongifolium*), smooth aster (*Symphyotrichum laeve* 'Bluebird'), and *Hylotelephium spectabile* 'Neon'.

With nearly a hundred different trees, shrubs, flowering herbaceous perennials, groundcovers, and bulbs, Lauren's prairie garden plan called for matrices for the overall design, interconnected by organically shaped pathways. During three weeks in May of 2012, the actual planting was up to the couple. "Larry spray-painted the ground in sections, starting with two paths first, to replicate Lauren's design." After a little demonstration from Lauren, Mary then laid out 1800 plants section by section, starting with grasses first. The wildflowers were laid out unevenly in small groups between the grasses. With the occasional help from family, they planted it all methodically. That fall, they planted 1500 bulbs—*Narcissus, Camassia, Gladiolus, Eremurus*, tiger lilies, and various allium—throughout the prairie meadow.

Lauren loves the colors of the area's rocks, but she feels that "in some cases they are overkill and look out of place and out of scale. They can also be expensive grand gestures that can compete" with the feel and look she is cultivating, like that of the pure prairie she and Mary were after. Instead of using large accent rocks, "Larry spread twenty-five tons of gravel chips with a wheelbarrow after the plants were in," Mary remembers. He mulched every plant well and created the pathways through the garden. He also cleared a narrow gravel road on the outer edge of the meadow to act as a barrier for the weed seeds blowing in off the field.

Now, eight years on, pinks, blues, and yellows spike and mound, pool and sway in and among white aspen and with nearby dark brown ponderosa trunks. Ribbons of naturalized color pull your eye out, in, and then out again. "There is a particular strength to the silhouette of the mountain ranges in the evening with the setting sun and the morning alpenglow," Mary says, that she worked so hard to mirror in her own prairie.

"This is not a garden that I can control," laughs Mary. "I just try to manage it a little." Regular weeding and editing out of the over-seeders, such as the blue grama (*Bouteloua gracilis* 'Blonde Ambition'), asters, and allium, the annual cutting back, and the occasional watering needed throughout the six-month season keep them busy.

But the labor- and time-heavy startup investment has more than paid off. Populations of birds and insects have increased every year, Mary notes with happiness. "We have hundreds and hundreds of bees depending on what's in bloom, as well as dragonflies, monarch and other butterflies, hummingbirds, songbirds, owls, toads, grasshoppers (when quite dry), insects of all kinds, rabbits, dogs, and an occasional fox and bobcat. The monarchs lay eggs on the milkweed, and the birds pick off seed. Every day is slightly different, with something always in bloom. It's like a symphony out there."

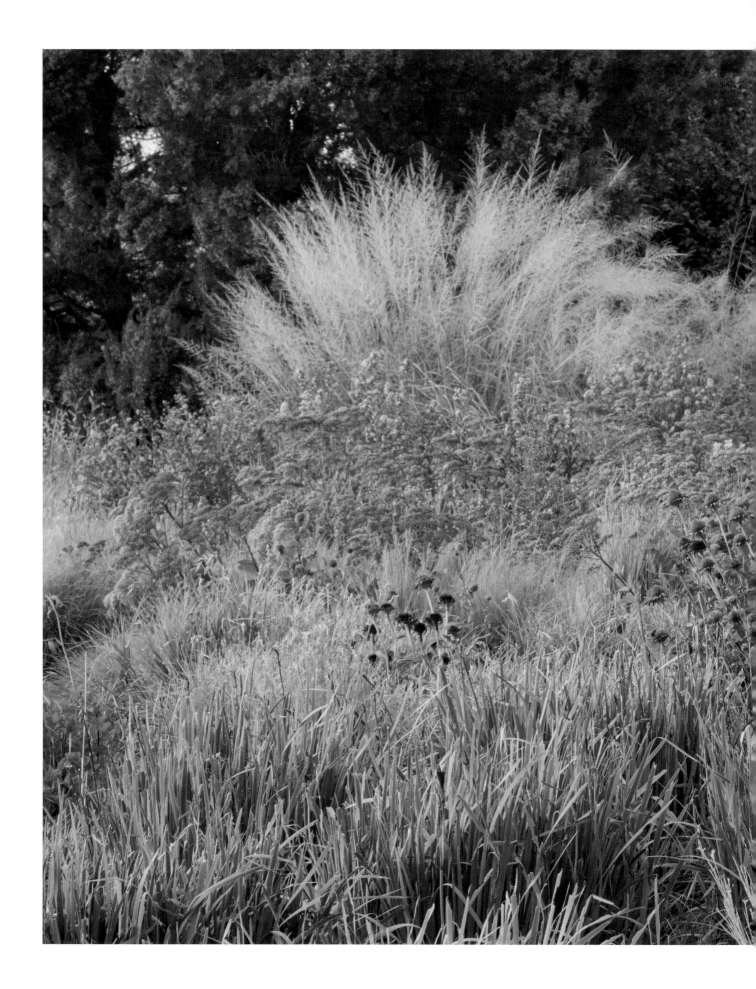

← Of the tall prairie dropseed (*Sporobolus heterolepis*), Mary reports, "It reseeds and the voles cherish it like their personal Taj Mahal, but it's worth it." By late summer *Sedum* 'Matrona' adds a deep tone, and in the foreground are the beige/gray seed heads of *Schizachyrium scoparium* 'Prairie Blues' and tufted hairgrass (*Deschampsia cespitosa*).

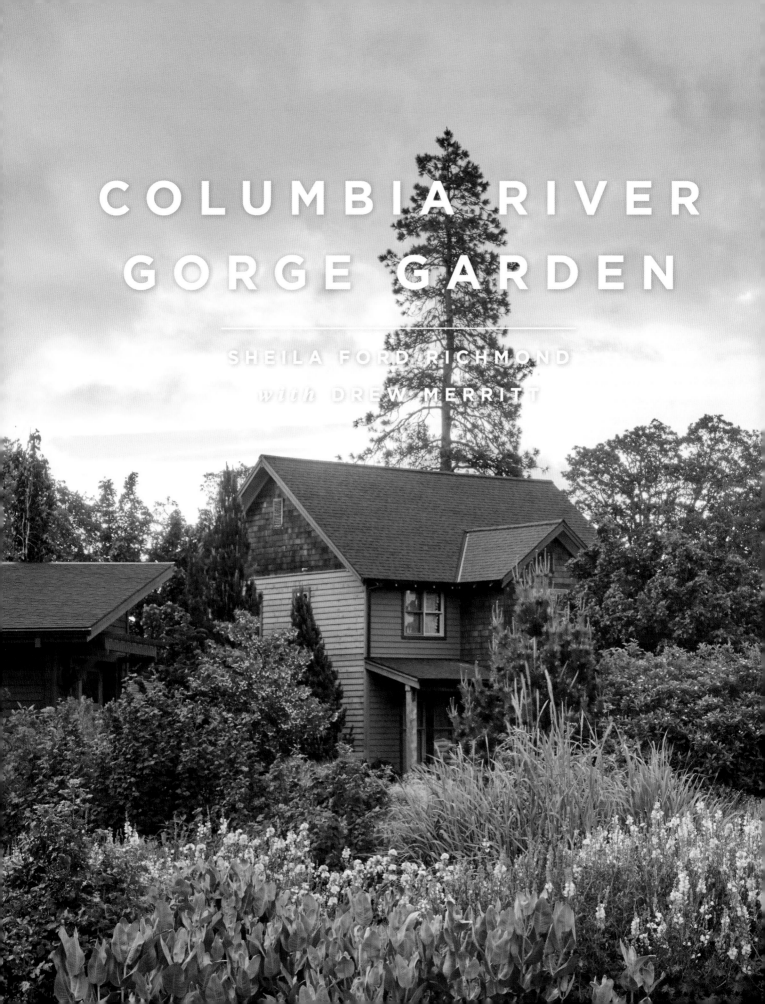

COLUMBIA RIVER GORGE GARDEN

SHEILA FORD RICHMOND

with DREW MERRITT

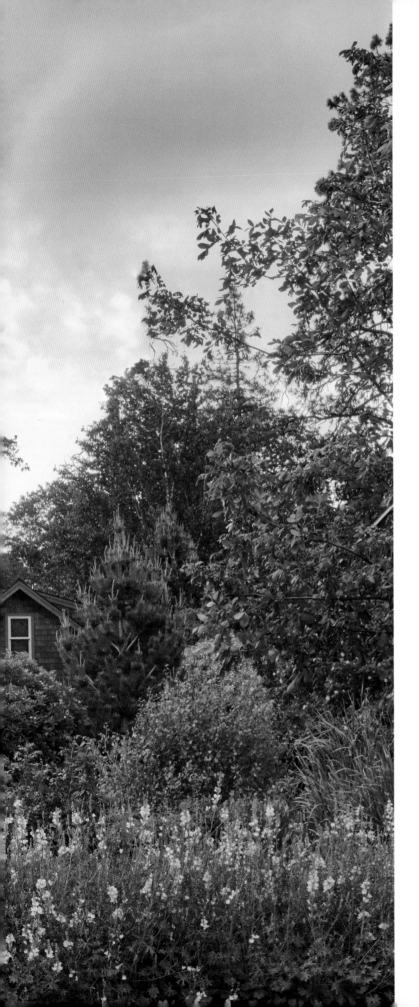

The Place

The extensive Columbia River Gorge formed over millennia as its namesake river made its way west through the Cascade Range. Eighty miles of rising and falling walls line the dramatic winding river in Oregon. Humans have relied on the Columbia for its fish, riparian plants, and animals and as a navigable waterway through the mountains throughout human history in the area, which archaeological evidence dates back more than 15,000 years.

In 1986, Congress designated the Columbia River Gorge as the country's second National Scenic Area, making it a federally protected area based on its outstanding natural and scenic value. About midway into the gorge, the town of Hood River, Oregon, sits at a point where the White Salmon River flows into the Columbia from the north and Hood River flows in from the south. The confluence creates fertile open wetland plains.

This section of the Columbia River Gorge is famous for its strong wind and as a transition zone between the wetter, temperate rain forest to the west and the dry Columbia Plateau to the east. Hood River receives an average of 30 inches of

precipitation annually, with most coming in the winter months, as both snow and rainfall. Due to the extreme structure of the gorge—hard to get into and hard to get out of—plants have evolved here for millennia in relative isolation, resulting in a large number of endemic plants.

The People

Retired fiber and colorwork artist and arts educator Sheila Ford Richmond was born in Hawaii and spent her childhood "outside all of the time." Her parents always had a big garden and big beautiful, luscious plants all around. "I could not live in the desert. My soul gets thirsty," she says.

Sheila has lived in the Pacific Northwest for close to fifty years. She very much sees her art as "connected to nature," and she knew she wanted her home and garden to be about connecting to and supporting nature as well. Sheila has invested her time, energy, and experience into two different gardens: her home garden and the common space wetland area of her neighborhood.

In her home garden, the initial hardscape layout for the corner two-lot parcel was created with the help of designer Paden Prichard. Curved garden walls and paths of local stone helped to formalize the space and make raised planting areas accessible, raised out of necessity on this essentially soil-free space built over old volcanic ash flow, for Sheila's vegetables and annual flowers. For the planning and planting of the site with native, climate-appropriate trees, shrubs, and perennials to feed the birds and pollinators, Sheila called on Drew Merritt of Humble Roots Farm and Nursery.

Drew was also part of the five-person team who worked with Sheila to develop the habitat planting list for the wildlife garden in the neighborhood's common wetland. Drew continues to work with Sheila to care for and maintain both garden spaces; hers is the only garden where he consults regularly because he so believes in her restoration, rehabilitation, and habitat vision for the spaces. Sheila jokes that when he comes seasonally to work in the garden, "the plants whisper happily 'Drew's here.' Drew loves and understands and cares for every single plant."

"I have to hand it to Sheila," Drew says admiringly. "She put a lot of effort into getting the community on board to restore the open space, which had become an invasive blackberry patch, to a really diverse space full of life." He gets excited when people begin to realize that a garden is more than just a pretty space, that it can also be giving back to the ecosystem around it.

PREVIOUS PAGES: "Natives for a neighborhood" is how Sheila Ford Richmond thinks of the native habitat garden she conceived of for a wetland open area in her suburban Hood River, Oregon, community. "It's a gift for pollinators, birds, and children." Some of the visible plant diversity includes welcoming masses of showy milkweed (*Asclepias speciosa*) on the left, Oregon checker mallow (*Sidalcea oregana*) on the right, and Great Basin wild rye (*Leymus cinereus*) behind them.

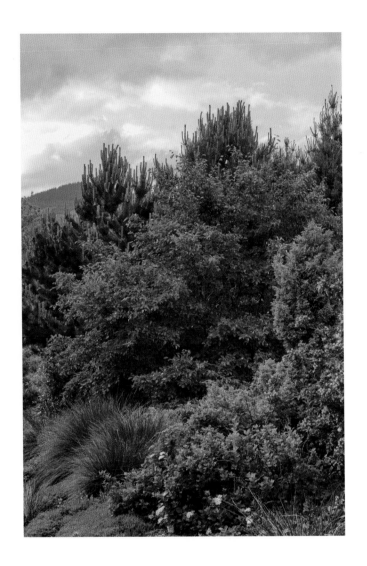

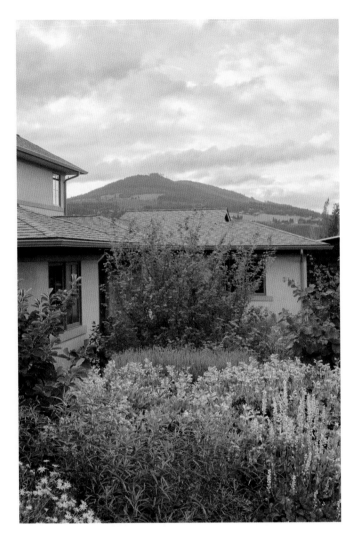

↑ In this layered planting good for bird cover and forage, the center serviceberry (*Amelanchier*) is loaded with berries and a pink *Weigelia* cultivar blooms brightly to the right.

↑ One tenet of planting for pollinators is offering flowers with different forms. In Sheila's home garden, the tubular flowers of Barrett's penstemon (*Penstemon barrettiae*) are joined by the ray flowers of Oregon sunshine (*Eriophyllum lanatum*) at lower left and the tall spikes of small bell-shaped flowers of gooseberry alumroot (*Heuchera grossulariifolia*) at lower right.

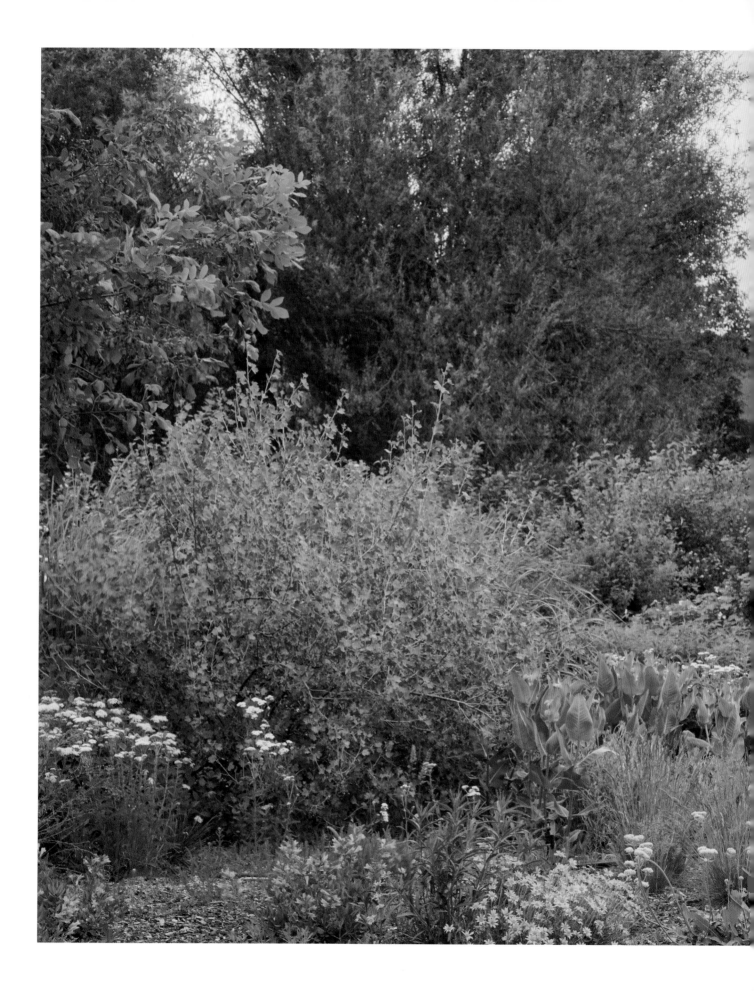

← In the native plant garden, lower growing showy milkweed (*Asclepias speciosa*), Barrett's penstemon (*Penstemon barrettiae*), Oregon sunshine (*Eriophyllum lanatum*), heartleaf buckwheat (*Eriogonum compositum*), lilac penstemon (*Penstemon gracilis* var. *gracilis*), and Idaho fescue (*Festuca idahoensis*) are backed up by a shrubby layer of red and golden currant (*Ribes sanguineum* and *Ribes aureum*).

327

The Plants

Sheila started her habitat garden journey with her home garden, which she estimates is about one-third acre. The basics included getting to know the site, the exposure, the soil, and then deciding which native plants could do well there. "If you are going to ask a native plant to come and live with you in a domestic garden, you need to understand what it wants, how it thrives, and provide for it."

"The home garden is a process and evolution of trying to observe and learn when things don't work, trying to figure out what might work," says Drew. One corner of the property at the road intersection is "southern exposure, with very little soil before you get to bedrock. We've tried many things over the years and not a lot really took well, but then one year a little buckwheat [*Eriogonum*] took off, so we've added more."

The raised vegetable and annual flower beds are right outside the kitchen door, facing southwest. The plantings gradually feather out to more wild and native arrangements toward the edges of the lot. To the north and west, Sheila planted pine trees for their shade and cooling effect, as well as for bird habitat. Her grandson calls it "Grandma's woods."

The garden is a registered wildlife sanctuary garden. "There are birds in the garden all the time," Sheila says. "They want cover and they want food." She has strived to offer both of these in abundance by planting for nuts, berries, and other seeds, including western serviceberry (*Amelanchier alnifolia*), California hazelnut (*Corylus cornuta*), black hawthorn (*Crataegus douglasii*), black twinberry (*Lonicera involucrata*), tall Oregon grape (*Mahonia aquifolium*), dwarf Oregon grape (*Mahonia nervosa*), and currants (*Ribes aureum* and *Ribes sanguineum*). According to Sheila, "the most glorious plant is this huge beautiful elderberry [*Sambucus nigra* subsp. *caerulea*], which provides habitat and berries for the birds. When it's in flower, it's covered with bees and all kinds of other insects."

She is out in the garden almost daily in the growing season, from March through November. Sheila deadheads to improve flowering and harvest but she does not cut flowers for the house, saying "Those are for the insects and birds." The way she sees it, "rather than putting gas in the car and driving *to* nature," she brings it right home.

In 2015, when the "invasive weed patch that was the common area" she had to look at from the front of her garden started to drive her crazy, Sheila became determined to do something about it. She rallied other grandparents in the community first, noting, "Grandparents have time *and* grandchildren, and so they were willing. It was a big, hard job, but they cut all the blackberries back and got them out of there."

After clearing the site, she reached out to Cindy Thieman, coordinator of the Hood River Watershed Group and a biologist for soil and water conservation who restores wetlands in the area, as well as Cathy Flick, a local wildlife biologist. With Drew, they

created a plan for nine months of bloom time. Every plant was chosen for its habitat value. "We started by asking what birds and animals are here. What do they need for food, for cover, for nesting materials? A lot of people plant native plants all over the place," notes Sheila. "But why? Who are you putting it in for? I was interested in *who* needed these plants."

The wetland area is about 20,000 square feet, but with both time and money in mind, Sheila took on 5000 feet of it for the restoration plantings. The team planted groups of thirty-three native species directly into the native soil, placing trees and shrubs in the back and flowers in the front. Sheila pays someone to come and weed the area once a month to keep the invasive seedlings under control. She had a drip irrigation system installed to help establish the plants, and the planting receives one deep watering a month in the dry summertime. "The amazing thing about the native plants is how beautifully they create community when you're not manipulating them. We have planted a lot of milkweed, and it is spreading beautifully."

Drew and Sheila are trying to encourage a culture of restoration and rehabilitation. "I am so concerned about climate change, and I want to be an example of what I believe in," Sheila says. She dreams that every piece of land in the Hood River valley, "would have a minimum of twenty-five percent native plants so that the wildlife would have habitat everywhere!" Since her own garden went in, Sheila has seen signs of positive impact. "After our planting, the developer of Willow Ponds [her community] planted a few natives to the north and south of my planting as well as a big field in an adjacent common area. Some local bee keepers have been inspired as well."

Sheila describes learning from native plants as she watches the garden grow. "I am seeing how nature plants herself—in these great sweeps of color in curvilinear lines. A lot of gardens are based on straight lines, but nature loves curves. When the wind blows, there's all this music and dancing. Watching it is astonishingly beautiful to me because of what nature does if we just let her."

↑ Blue lupine (*Lupinus polyphyllus*) flowers in the neighborhood native plant garden. Sheila reports, "Those seeds are wind dispersed and expanding the planting beautifully." Flax (*Linum lewisii*) and yarrow (*Achillea*) bloom alongside. Behind the planting is a naturalized rose hedge enjoyed by birds and insects.

↑ A *Spirea* cultivar blooms at the base of the wall crafted of local stone. Along the wall on the left are Barrett's penstemon (*Penstemon barrettiae*) and native Columbian larkspur (*Delphinium trolliifolium*), "which seeds around beautifully." On the lower right the silvery silk tassels of *Garrya elliptica* are just visible.

→ Three columns of local basalt set here with the help of a Feng Shui advisor for protection rise from a mass of bluestar (*Amsonia tabernaemontana* 'Bluestar').

HARBORTON HILL

BOB HYLAND *and* ANDREW BECKMAN

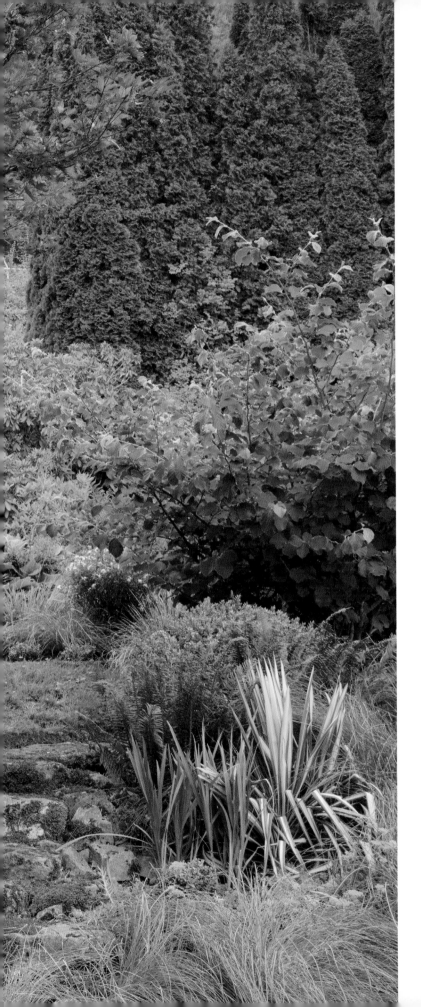

The Place

Like much of the Pacific Northwest, the greater Portland area is defined by the water that interlaces every part of the city. The area is the traditional home-lands of the Chinook peoples, including the Multnomah and the Clackamas. The Multnomah people lived on and cultivated Sauvie Island, one of the larger islands and now a well-known agricultural area, formed by the branching of the Willamette River prior to its confluence with the Columbia at the northern edge of the city. Archeological evidence indicates people lived in the region up to 15,800 years ago.

Portland is also marked by the charismatic signifiers of the volcanic legacy and moun-tains that shape and contain the water-shed and viewshed. Mount Hood rises visibly to the southeast of the city, while Washington's Mount St. Helens and Mount Adams can be seen to the northeast.

With the mild USDA zone 8b climate and rich alluvial soils of the floodplains, the area has long been a gardening mecca. Plantspeople from all over the world have settled in the area, importing, growing, and breeding plants of all kinds—from

333

fine fruit to special-interest ornamentals such as heritage roses, irises, peonies, and specimen conifers.

Bob Hyland and Andrew Beckman live in Portland's West Hills on a property that overlooks the Multnomah Channel and the confluence of the Willamette and Columbia Rivers, with Mount St. Helens in the distance and the diversity of Forest Park, one of the largest municipal parks in the United States, at the top of their hillside. "There's nothing quite like a volcano as the primary focal point on axis with your house and garden to put you in your place," remarks Bob. "As Andrew points out, it's the largest element we've ever gardened around. Even on days when it's not visible, we know it's there."

The People

Andrew Beckman and Bob Hyland have tended their two-thirds acre home garden north of downtown Portland for nearly a decade. They relocated to the area in 2010 for Andrew's job as publisher of Timber Press. They left behind their business of almost a decade, Loomis Creek Nursery, located 100 miles north of New York City. "It was a regional, destination retail nursery specializing in uncommon and connoisseur perennials, shrubs, and annuals. We owned twenty-four acres of hayed fields, creek, and wetlands," Bob reminisces. Their work in the nursery deepened their understanding of "working with—rather than against—the larger natural elements of climate and place."

Even before Loomis Creek, both were heavily involved in the horticultural world. Bob trained and worked at Longwood Gardens in Pennsylvania, and then he managed the horticulture, gardens, and education programs at Brooklyn Botanic Garden. Andrew, who is trained as a landscape architect and horticulturist, was the garden editor at *Martha Stewart Living* from 1997 to 2010.

Despite many years rooted in the culture of the East Coast gardening scene, the move to Portland was not Bob's first taste of gardening in the West. He had already "developed an appetite for West Coast natives and other Mediterranean-climate plants including hopbush [*Dodonaea*], *Grevillea*, *Arbutus*, *Ceanothus*, *Melianthus*, and lots of native herbaceous perennials, sedges, and grasses," when he was living in San Francisco and working at the Strybing Arboretum (now the San Francisco Botanical Garden) in the 1980s and early 1990s.

Both Andrew and Bob are inveterate and deeply knowledgeable plantsmen, and their garden is a worldly collection that illustrates the depth and breadth of the two men's horticultural knowledge. Their garden is "very much plant-driven" but also relaxed and welcoming, with what they both note with pleasure as increasing wildness the longer they are in it. When Andrew and Bob decided to relocate to Portland, they ultimately chose their hillside spot in the northernmost part of the city's West Hills,

PREVIOUS PAGES: Looking up toward the richly planted upper terraces of Bob Hyland and Andrew Beckman's hillside garden on the outskirts of Portland, an inherited bloodgood Japanese maple (*Acer palmatum* 'Bloodgood') stands opposite the early-blooming Diane witch hazel (*Hamamelis* ×*intermedia* 'Diane'), which together frame the view up the stone stairs into the borders beyond. Along the lower right edge, caramel-colored *Carex tenuiculmis* holds the slope. Andrew and Bob use sedges "to tie things together visually and texturally throughout garden."

→ Looking out across the expansive view from the top, the layers of the garden flow downhill and out to borrowed landscape and horizon. Bob and Andrew let *Verbena bonariensis* and oxeye daisy (*Leucanthemum vulgare*) play through the zinc sphere. *Miscanthus sinensis* 'Morning Light' comes on just beyond.

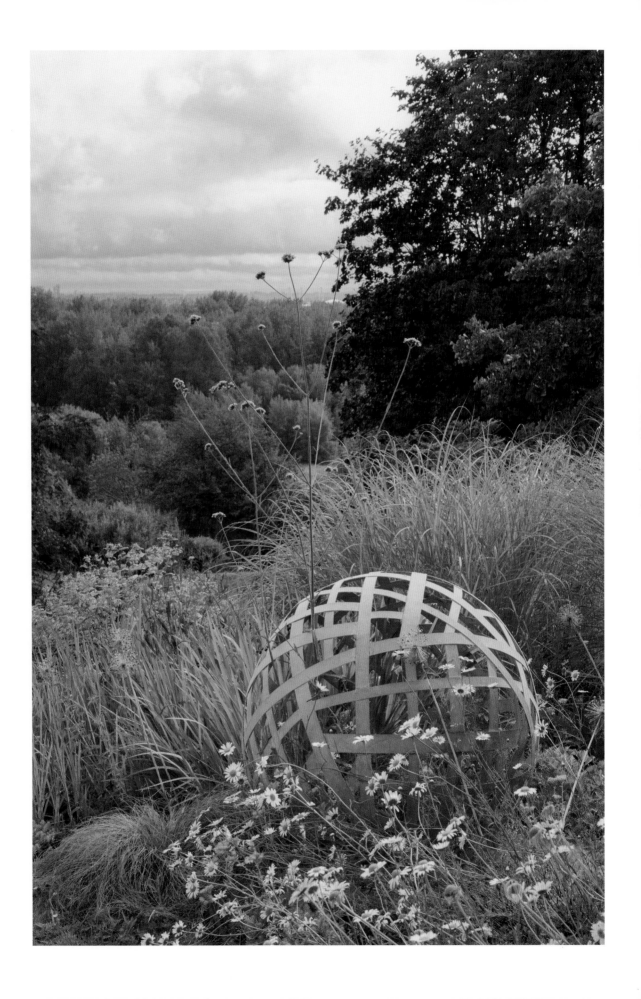

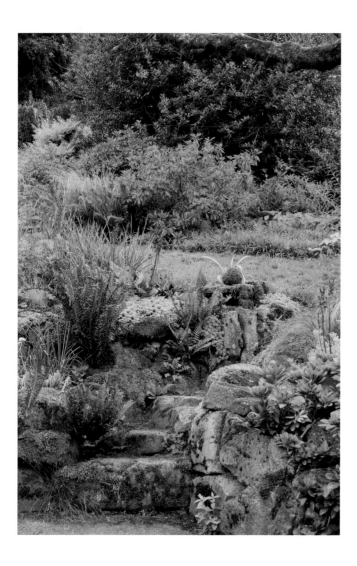

↑ Along mossy stone steps connecting one level of the upper terraces to another, *Sedum spathulifolium* 'Cape Blanco' spills down the top right corner around native ferns growing in the crevices. Rhododendrons that were in place when Bob and Andrew arrived, against a male English holly, screen the road above.

→ Lining what they affectionately call the "Meadow of Mismanagement," turf grass allowed to grow out to its dynamic fullness, Bob and Andrew have added a line of coral bark willows, which they pollard annually in early spring to encourage gorgeous red stem clusters in winter. An errant *Yucca* blooms beside one of the many spheres throughout the garden.

← A sculptural English walnut
stands amid a planting of
Kniphofia 'Timothy', *Salvia
nemorosa* 'Caradonna', the
summer-blooming *Ceanothus
×delilianus* 'Topaz', and
self-seeding white dai-
sies. At the back, China fir
(*Cunninghamia lanceolata*
'Glauca'), peeks out from
behind a hedge, with Tiger
Eyes™ sumac (*Rhus typhina*
'Bailtiger') just behind.

↘ The firepit sitting area fea-
tures *Mahonia ×media* 'Charity',
Coprosma 'Black Cloud',
and orange poppy (*Papaver
atlanticum*) that seeds freely.
A *Ginkgo biloba* grows behind
the chairs, and to the right
Salix 'Flame' is coppiced to
encourage "brilliant flaming
coral-orange stems for four
months in winter." *Persicaria
amplexicaulis* 'Firetail' and
'Firedance' (taller ones) and
Persicaria affinis 'Dimity' add
seasonal color.

as a compromise between the very rural, agricultural and the very urban sites of
their past. Harborton Hill, as their home and garden is known, had its own dynamic
personality. "Rivers, volcanoes, and forests—it's the ring of fire, you know? All three
of these form the view and inform the property," says Bob. In the Northwest, he says
"the drama of the greater natural beauty has led our garden to be more blousy, lay-
ered, naturalistic. It's not fussy. Continuing to include plants we love from other parts
of the world, we've chosen an overall plant palette that feels in sync with the natural
surroundings, within the constraints of the summer-dry climate. And that view also
always puts you in your place."

The Plants

Entering the garden from the south along the drive, which essentially bisects the
space along its north–south axis, and moving toward the house at the center, the
garden colorfully and texturally encircles you. Mossy stone walls help to define the
terraces that articulate and smoothly connect the distinct spaces of the garden. The
incredible number and diversity of plants are often framed by and spilling over these
regional Columbia Gorge basalt walls, some of which were here and some of which
are new, adding a sense of the garden having been at home here for a long time.

Bob and Andrew had no set garden style in mind when they started out here. They
knew they did not want to merely replicate their eastern gardens, and they realized
the sloping site, the large view, and the overall lack of coherence to the spaces around
the house needed grappling with. They happily took on the new adventure. Despite

having very different personalities and both being accomplished plantspeople and designers, they have always gardened easily together. "We rarely disagree over garden decisions," says Bob.

The terracing was more or less in place, although it was all disconnected. The drive was solidly lined with barberry (*Berberis thunbergii*) and *Euonymus japonicus* "clipped into perfect untouching cubes. Plants aren't supposed to touch, right?" Bob jokes. "The Japanese maple that hovers over the deck in the front was here, as was the amazingly big *Ficus carica* 'Desert King'."

Andrew and Bob started with the existing elements they liked and began "formalizing and making more natural connections" between the terracing that had been carved out, while working to "make the plants holding those terraces in place visible." For privacy, wind protection, and diversification, they extended the existing arborvitae hedge on the upper terrace by adding Japanese cedar (*Cryptomeria japonica* and *Cryptomeria japonica* 'Elegans'). They also planted perennial and shrub borders on each terrace, grounding, accentuating, and adding a stateliness to the hedge as background to the now flower- and texture-rich garden it protects.

In selecting new plants to accompany their longtime favorites from around the world, the two really worked to honor the region's summer-dry conditions. When Bob's shop, Contained Exuberance, opened right next to the nursery Xera Plants, plenty of species carried by Xera resonated with him and influenced even more introductions to the Harborton Hill garden that are "climate adaptive to our summer dry realities." Some of the strongest plant groups Andrew and Bob have added include *Arctostaphylos*, *Ceanothus*, *Ribes*, *Allium*, and Australian native *Ozothamnus*.

The Harborton Hill garden emanates throughout with a sense of fun and colorful sophistication. Creatively composed vignettes tucked throughout the garden might include interesting container groupings planted and accessorized with unusual plants and artful objects, painted allium seed heads arranged into the arborvitae hedge, bright marbles or glass floats in a water pot around a corner. A series of young coral bark willows lines the uphill side of the meadow, and they pollard these annually in early spring to encourage "this vibrant whippy growth in summer and then these gorgeous medusa head red stems in winter." Bob uses the striking red stems in pots.

There was a "wacky old English walnut, which had been pollarded before us," Bob laments. It really struggled in recent years, and in 2018, "it pushed so little foliage, we proclaimed it dead." They had it cut back to its pollarding scars, and it took on a "a very Venus de Milo look with great presence and architecture," says Bob. They had initially toyed with the idea of creating an "intentional drill pattern" into the tree, like a Morse code message to the universe. But, after time and consideration, they realized that "the sapsuckers had already gotten to the tree and drilled a much better

↑ Arching feathery plumes of *Rhodocoma capensis*, low-growing Siberian cypress (*Microbiota decussata*), and hardy orange (*Poncirus trifoliata* 'Flying Dragon') grace the center of a courtyard, along with *Astelia nervosa* 'Westland' and spiky *Verbascum thapsus*, which they allow to colonize from the edges of Forest Park. *Aralia elata* 'Variegata' grows in front of *Acer palmatum* 'Bloodgood'.

design than we ever could have. So we left it." They installed wire over and around the tree to twine clematis for fun.

With Portland's large natural Forest Park above and behind their garden and the expansive view in front, Andrew and Bob are very aware of their garden's connection to the bigger world. The forest can cast long shade in the winter, but the bright light from the big sky to the east helps. They are attuned to caring for their resources, including watching water use and being careful to control what invasive plants they can and to not introduce more. They don't feed or fertilize but "let biomass compost in place." This, Bob notes, is an example of some of the attempted control they have given up since coming west. They are more "self-interrogating and self-aware" in this new place, in this community, and as the global consciousness shifts. As Bob muses, "And maybe simply as we mature in place?"

↑ *Tetrapanax papyifera* 'Steroidal Giant' looms large over the striking stems of a wingthorn rose (*Rosa sericea*). The feathery texture and rust color of giant cape restio (*Rhodocoma capensis*) is echoed by the *Carex* below. Bob lightly spray painted these *Allium rosenbachianum* seed heads, and *Phormium* 'Jester' and *Echeveria agavoides* 'Rubra' have been hardy in the pot for two winters.

← Silvery gray *Mentha longifolia* wraps through the raised planting, and daisies have crept in from the edges of Forest Park, creating this "lovely white ribbon swirling through these upper borders." Clumps of native western sword fern (*Polystichum munitum*), naturalizing cardoons, silvery *Artemisia* 'Powis Castle', and dark sprays of *Ceanothus* 'Dark Star' are all players here.

FAMILY HERITAGE GARDEN

EVAN BEAN

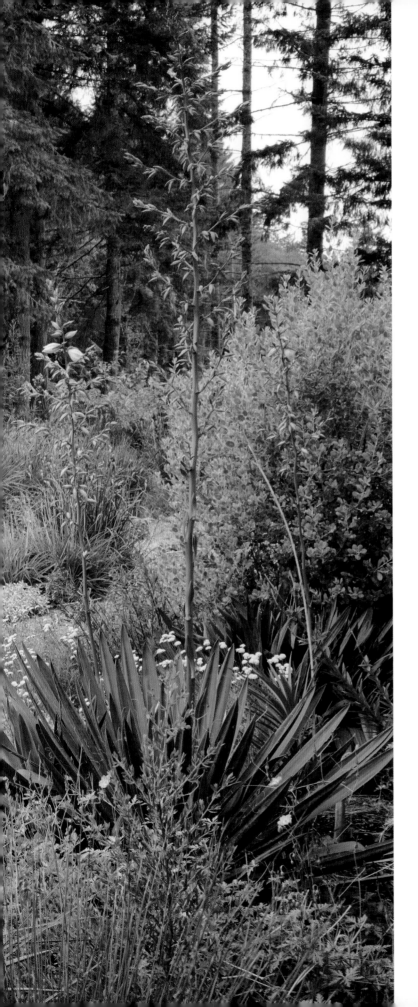

The Place

Travel eleven miles up the Cowlitz River from its confluence with the Columbia River, with Mount St. Helens rising dramatically in front of you, and you will find yourself in Castle Rock, Washington. The town is named for a volcanic outcropping that stands 190 feet high and has long been a wayfinder on the ancestral land of the Cowlitz people, for whom the river and the county were named.

The more than 500 acres of nearby Seaquest State Park and the interpretive Mount St. Helens Visitor Center give a powerful sense of the lush, forested side of the Cascadia Bioregion, which encompasses the entire Columbia River watershed and the Cascade Range. The mountains, the rivers, and the trees of the West—red cedar, Douglas fir, and western hemlock well hydrated by about 50 inches of rain a year—grow big here.

Castle Rock was once a steamboat port, a trading center for valley farms, and a logging and sawmill center, all of which speak to the fertility of the region. In many ways, it is a gardener's heaven. Another five miles or so overland directly east toward Mount St. Helens, the

intermittent volcanic activity of which has defined much of the natural history in this area, is the semi-forest garden of one such gardener, Evan Bean.

The Person

Evan Bean has gardened on his family's property since childhood. For him, the natural beauty of the region is embodied in the forest. He notes the many different kinds of forest nearby, "Coastal forest of windswept shore pines so dense you can almost walk across the tops of them, more open tall Sitka spruce forest, with thick undergrowth of ferns and salal [*Gaultheria shallon*], subalpine forest with little alpine firs and larches, even the open, drier pine forests on the eastern slopes of the Cascades." These forests, especially after a dry summer, "when they get a little sad and brown looking and then resurrect with the rains of fall and winter and are fat and green again—they represent the beauty of the Pacific Northwest to me."

Evan's family has been rooted in the Pacific Northwest for several generations. He learned a love of plants from both parents, but he took their light hobby and "turned it into an obsession." When still in high school, he redesigned and installed the planting area in the middle of the family's circular drive as a school project.

Evan studied horticulture at Washington State University in Pullman and interned in the orchid collection at the Smithsonian Institution in Washington, D.C. After graduating, he went on to curatorial work with the Native Plant Trust (then the New England Wildflower Society) in Massachusetts, Longwood Gardens in Pennsylvania, and Plant Delights Nursery in North Carolina. Eventually he realized he missed his home climate. Since returning in 2015, he has worked with independent nurseries, including a formative time as a propagator for Sean Hogan at Cistus Nursery in Portland. Back at home and now a professional horticulturist, Evan designed a major expansion of his family's entire garden, which now defines the 1.5-acre cultivated space.

The Plants

More than anything, this garden is an experimental station for Evan as he grows as a gardener and citizen of this region. "It's been a laboratory for me to test and learn about plants and microclimates and to discover my own preferences," he says. The garden is a space in relational and dynamic flux characterized by plant-rich bright spots in the shade of tall native trees. Eclectic combinations of natives and nonnatives are sometimes energizing contrasts and sometimes peaceful gradients of green. Evan works at balancing his own plant passion with his retired parents' needs and preferences. For instance, "There's more lawn area than I might want, but it's country lawn." By that he means it is adorned with English daisies, dandelions, and other wildflowers (or weeds, depending on your view). "Every year, [my] plant lust wins

PREVIOUS PAGES: Looking southwest along a meandering garden path skirting a dry creek bed and tall existing native conifers, this scene encompasses the alternately wet and dry, shady and sunny conditions of this site. Around the base of the *Yucca filamentosa* are *Santolina* 'Lemon Queen' and a few blooms of *Geranium robustum* and behind that *Arctostaphylos silvicola* 'Ghostly' and the red spike blooms of *Lobelia laxiflora* subsp. *angustifolia*. Across the path, hugging the edge is *Epilobium septentrionale* 'Wayne's Silver'.

→ In front of Port Orford cedars (*Chamaecyparis lawsoniana*), a seven-son tree (*Heptacodium miconioides*) is underplanted with *Alstroemeria* and cape fuchsia (*Phygelius*). Across the path, deep purple slipper flower (*Calceolaria arachnoidea*) intermingles with western sword fern (*Polystichum munitum*), *Rhododendron impeditum*, and *Bolax gummifera*. The textural trunk of paperbark maple (*Acer griseum*) is just visible at top right.

↘ An intimate grouping of *Rhododendron impeditum* combines with the bronzy foliage of *Hebe ochracea* 'James Stirling' behind and the deep purple blooms of slipper flower (*Calceolaria arachnoidea*). *Alchemilla mollis* grows along the base of the fallen decomposing log, and at the upper left is a healthy stand of native scarlet monkeyflower (*Mimulus cardinalis*).

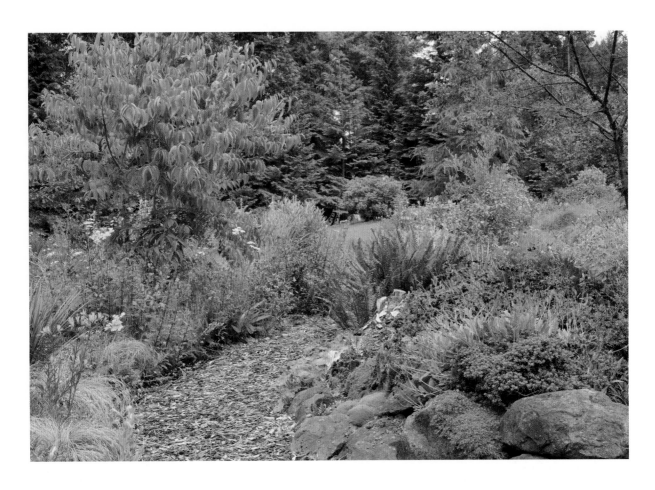

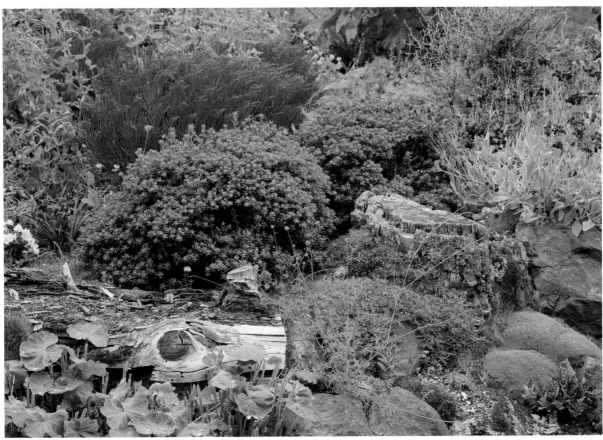

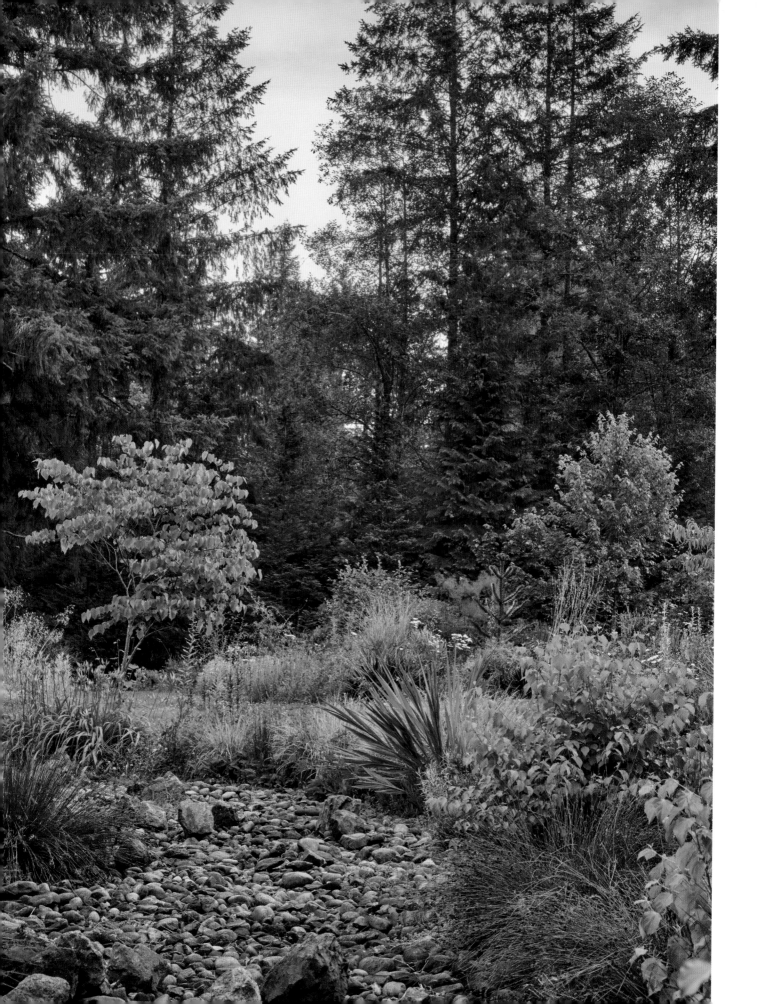

← Along a constructed dry creek bed, a western red-bud (*Cercis occidentalis*) is underplanted with orange daylily (*Hemerocallis fulva*). To the right along the curve, *Crocosmia* 'Lucifer' "hitched a ride" with a grass Evan sited there, *Molinia caerulea* 'Variegata'. *Juncus patens* and *Juncus effusus* grow along the creek bed on both sides.

↓ A weeping blue atlas cedar (*Cedrus atlantica* 'Pendula') grows with *Ceanothus gloriosus* at its feet, and the contrasting lacy skein of *Muhlenbergia* grasses veil the section of the garden behind. A staghorn sumac (*Rhus typhina*) can be seen in the distance.

fewer points," he says, and curating creative spaces with native plants wins more. He discovers native plants when out exploring the forests and wetlands around Castle Rock, and in alpine meadows of native heaths, grasses, paintbrush (*Castilleja*), and other wildflowers while hiking higher in the Cascades. This intentional balancing and continued plant learning, with traditional plants interwoven nicely with more horticulturally unusual ones, backs up his plant-world moniker, The Practical Plant Geek.

When his family moved in, the lot was dominated by the tall Douglas fir (*Pseudotsuga menziesii*) planted years before, and the trees still encircle the garden on several sides. Prevailing winds out of the south, however, made the family decide to remove the tallest of the trees closest to the house on that side. Most of the garden lies there now, enjoying full sun in the middle of the day.

Evan dreams of a mixed-forest garden, and to this end he has planted many new trees, including deodar cedar (*Cedrus deodara*), cork oaks (*Quercus suber*), quite a few other oaks (including *Quercus mexicana, Quercus hypoleucoides, Quercus arizonica*), a couple of southern beech (*Nothofagus pumilio*), a monkey puzzle tree (*Araucaria araucana*), and a paperbark maple (*Acer griseum*). Several Port Orford cedars

(*Chamaecyparis lawsoniana*) were planted for screening years ago. He gardens with the canopy these trees will create at maturity in mind, and in places it already hints at the forest floor it will become.

The biggest consideration, Evan says, is the climate. "We have dry summers but really wet winters." Once established, he wants the plants he introduces "to be self-sufficient for the most part in terms of not needing supplemental summer water," but they cannot be so drought tolerant they rot in winter. He placed many of the water-loving plants in naturally moist areas of the garden, using the landforms and soil type variations to advantage, though some plants will always need hand-holding. He tries to combine his love for higher elevation natives with his interest in planting for his climate. For instance, he says, "while I can't grow the native heathers at my elevation, I can grow other ericaceous plants, like the Scotch heathers [*Calluna vulgaris*] that remind me of the native, in a similar low-mounding tapestry."

Evan is also "slowly phasing out plants that need more than a monthly watering. Either I'm actively removing them, or simply letting them fade away while more drought-tolerant plants fill in." He spends around five

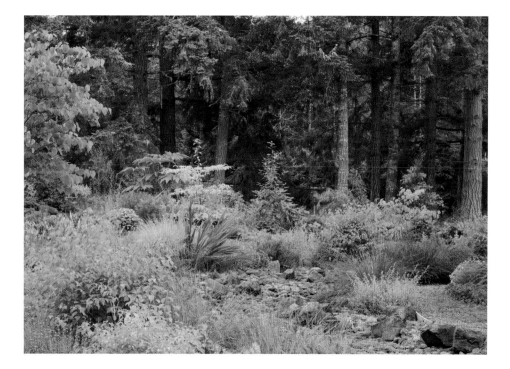

← This damper location in the garden supports *Rhododendron*, *Tetrapanax*, a variegated pagoda dogwood (*Cornus alternifolia* 'W. Stackman'), and a shorter dogwood (*Cornus sanguinea* 'Midwinter Fire'). The pyramid form in the center is a *Rhododendron* with native Indian plum (*Oemleria cerasiformis*) growing up through it.

hours each week actively gardening in this zone 8a space. On its silty clay loam, the whole garden needs minimal summer watering overall now that most of the plants are fully established. He plants new selections in fall through to early March to allow for winter rains to settle the newcomers in.

In a location with a large deer population, Evan eventually found that he could not garden with only deer-resistant plants, so he had the garden area fenced. He still selects new plant choices to work with the local rabbits, voles, and moles. To deal with pests, "animal, fungal, insect, or otherwise, I'm not overly sentimental or attached. I stop using [affected plants]. I'm not going to be at war to keep a plant." Over the last couple of years he has had issues with verticillium wilt and—disappointing as it was—he chose to remove some of the larger of his young trees that were not able to withstand the infection. "I was not going to try to save them with soil fumigants or the like. I'd rather find something resistant now and save time, money, and stress," he says, referring to effects both on him and the environment.

"In the changing environmental and cultural world," he says, "I think we're looking for models of how to thrive and adapt conscientiously. I try to creatively adapt the natural areas I am inspired by into the garden. That's my goal. I think this is becoming more common at the same time that it's becoming more and more important."

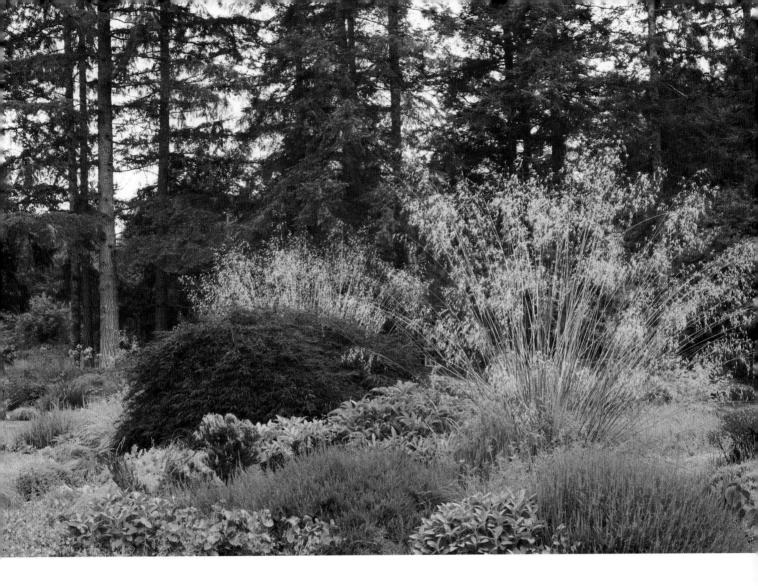

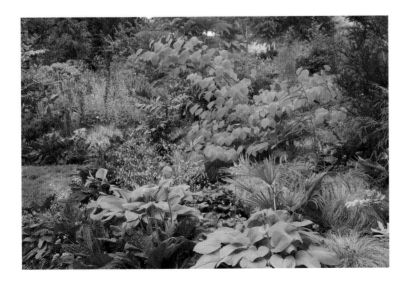

↑ The light-catching blooms of *Stipa gigantea* contrast against the purple foliage of a lace-leaf Japanese maple (*Acer palmatum*). To the lower left is the flush of pink-blooming oregano (*Origanum* 'Kent Beauty'). Silver swathes of *Salvia officinalis* 'Berggarten' and red flashes of scarlet monkeyflower (*Mimulus cardinalis*) add to the mix.

← Representative of a more traditional damp-climate Pacific Northwest garden, this grouping of purple-leaved plantain (*Plantago major*), *Hosta*, and blooming *Begonia* is planted in an area of the garden that has more natural water-retaining qualities—clay soil and lower aspect.

351

HERONSWOOD

JOAN GARROW *with* DAN HINKLEY
and NATHAN LAMB

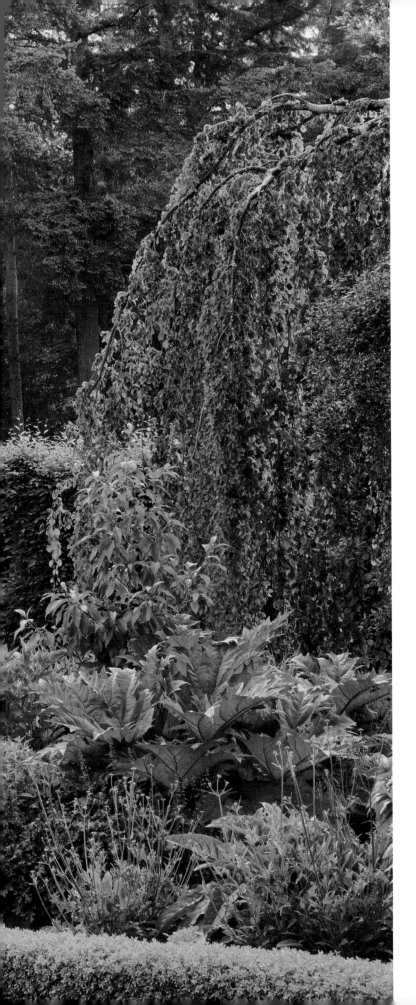

The Place

The Kitsap Peninsula is situated between the larger Olympic Peninsula and mainland Washington State. To its east lies Puget Sound and to the west the Hood Canal. The Kitsap Peninsula is a deeply lobed landform, with the lobes creating many inlets and smaller peninsular stretches of land on all sides. Along the Kitsap's northwesternmost aspect is a particularly deep lobe forming a large protected bay, now known as Port Gamble Bay.

This area of the peninsula is the traditional homeland of the Suquamish, the Twana/Skokomish, and the S'Klallam peoples. Between the town of Kingston on the Puget Sound side of the Kitsap Peninsula and Port Gamble Bay is the Port Gamble S'Klallam Reservation, a tribal holding of approximately 1700 acres of land held in trust by the federal government.

The land here is characterized by dense native Douglas fir, western hemlock, red alder, and white pine forests and their associated lush understory, all well-watered by nearly 40 inches of rain a year. On the Olympic Peninsula to the west, the temperate rain forests of the Olympic Mountains receive between 144 and 168 inches of rain, whereas areas of the Olympic and Kitsap

Peninsulas just east of and in the rain shadow of the mountains receive 20 inches of rain or less. The Washington State Biodiversity Council has recognized this diverse and variable marine, estuarine, and nearshore environment as among the most threatened of the state's ecosystems. Rich with plant and animal biodiversity, including southern resident orcas and spawning Chinook salmon, the marine and freshwater aquatic fauna's life cycles are intimately and symbiotically interwoven with the health of the bordering terrestrial flora in wetlands, riparian meadows, and forests.

Just inland from the southeastern edge of Port Gamble Bay lies a 15-acre woodland botanical garden, Heronswood, owned by the Port Gamble S'Klallam Tribe and managed by its nonprofit entity, the Port Gamble S'Klallam Foundation. For Joan Garrow, executive director of the foundation, the beauty of the region she is duty-bound to help protect can be distilled to "green foothills in the foreground and majestic snow-capped peaks in the distance. . . . Although the green sometimes comes from the predominance of managed forests, there are also amazingly tall Douglas fir and western red cedar, underscored by lush vegetation. And the profuse and often confusing constellations of bodies of water such as the sound, inlets, passages, coves, bays, lakes, rivers, creeks, and waterfalls and the land formations that bring definition to those waters." To her, the area's native beauty is "untamed in feel, not tailored and not fussy, with borders both overlapping and profuse." And for Joan, "much of Heronswood" feels true to the surrounding native beauty as well.

The People

Heronswood was founded in 1987 by the horticulturist Dan Hinkley, and his partner the architect Robert Jones. Through the course of many plant- and seed-collecting trips around the world, Dan built the world-class woodland plant collection. Heronswood Nursery grew into a well-known specialty mail-order and destination garden offering "rare, unusual, and beautiful garden-worthy plants" and often introduced new species and cultivars to the trade. In 2000, Dan and Robert sold the garden and business to W. Atlee Burpee & Company, a national seed and plant distribution firm.

When the Burpee company owned the nursery and garden (with Dan managing), it moved the nursery stock to the Northeast. The garden was only open to the public a handful of days a year, so the complex gardens and plant collections were less meticulously maintained. Plants reseeded, and trees grew and shaded out other plants. By 2006, the Burpee company had declared bankruptcy and stopped maintaining the property. In 2012, the Port Gamble S'Klallam Tribe purchased Heronswood at auction.

Reconnecting the Heronswood property to the tribal community is "very important" to Joan, "as it returns some of the tribe's traditional land base to them, but framed within a contemporary context of land ownership. The tribe is an outstanding

PREVIOUS PAGES: Looking down the radiating lines of Heronswood's potager beds, lined with dwarf boxwood (*Buxus sempervirens* 'Suffruticosa'), a dawn redwood (*Metasequoia glyptostroboides*) stands tall to the left, a weeping beech (*Fagus sylvatica* 'Pendula') to the right, and the famous sculpted *Carpinus betulus* hedge center.

→ CLOCKWISE FROM TOP LEFT: Peering through *Primula japonica* blooms into the Woodland Garden, *Lysimachia nummularia* 'Aurea' blankets the ground around stepping stones. To the left of the walk, *Iris ensata* rises and *Cornus controversa* 'Variegata' drapes down.

The Woodland Garden's Folly architectural piece sits beneath windmill palm (*Trachycarpus fortunei*) fronds that hang down from overhead. Long-stalked *Darmera peltata* colonizes the base of the palm, and *Dryopteris affinis* 'Cristata' unfurls in the foreground.

Inside the Arbor Beds, a dramatic weeping katsura tree (*Cercidiphyllum*) forms the backdrop for a weeping *Styrax japonicus*. Shrubby *Mahonia fortunei* grows on the left, with *Chamaecyparis obtusa* 'Nana Aurea' in the center.

The cast concrete Folly in the Woodland Garden is surrounded by *Trachycarpus fortunei*, *Stachyurus salicifolius*, and tall *Darmera peltata*. The leaves of *Magnolia macrophylla* are seen overhead, top right.

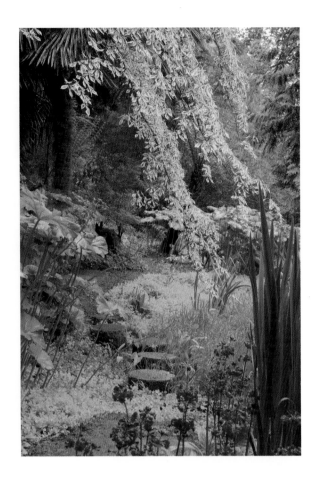

← The *Welcome Pole* totem created by artist Brian Perry, a Port Gamble S'Klallam carver, now graces the entrance to the garden. *Davidia involucrata* 'Sonoma' leans toward the carving from the right.

steward of all of its lands and waters, and it invites those from beyond the community to join them in learning about and protecting the environment."

For Joan, some of the greatest successes of the garden in its newest iteration include bringing Dan Hinkley on as director and putting together a steering committee with diverse backgrounds that includes "horticulturalists, curators and managers of botanical gardens and arboreta, experts in tribal governance and culture, and gardening enthusiasts." Working together, the Port Gamble S'Klallam Tribe and the garden staff, advisors, and volunteers, reimagined Heronswood, "incorporating and reflecting elements related to S'Klallam culture and tradition," the first being a Heron and Frog totem pole by S'Klallam artist Hopi-Cheelth (Brian Perry), and having tribal community members working at the garden.

Dan, with whom the name Heronswood is virtually synonymous, first moved to the region from Michigan, where he was born and raised. He quickly grew to love the "prominent mountain ranges and the active volcanoes" along with the "magnificent forests" of the Pacific Northwest. With this landscape as reference, he and Robert established the significant international woodland plant collection at Heronswood. Nathan Lamb served as assistant director and curator of Heronswood from 2018 to 2020 (after which Dr. Ross Baytun, a biologist and taxonomist came on board). Born in North Carolina, Nathan trained in ecology and worked in public gardens in New York City and Chicago. Based on his lens as an ecologist with particular interest in wetland and stream restoration, he is "drawn to these landscapes as examples of how people have been managing and relating to the land intentionally and conscientiously for eons."

The garden staff works to meet the stated goals of the tribe's master plan, which prioritizes "protection of the collection [of plants originally begun by Dan and Robert], protection of the native plants of Indigenous significance, and managing the garden in a way that puts the health of the broader ecosystem (watershed, seed shed, viewshed) first," Nathan noted. To him, a self-described "tree-hugging ecologist," the garden today offers an "exciting opportunity to really combine respect for Indigenous history, native plants, and Indigenous plant ways with respect and celebration for newcomer plants and the history of ornamental horticulture." For many of the staff, in the new iteration of the garden there is a "specific beauty" in seeing elements side by side "that honor both of these histories."

The Plants

Heronswood Garden is a landscape evolving with intent. When Dan and Robert first started the formal ornamental garden on the original 7.5 acres in 1987, they worked within the native woodland landscape surrounding the property. As Dan describes, they cleared the understory of native and nonnative plants for the cultivation of the garden, keeping the native plants they loved to evoke the feel of the Pacific

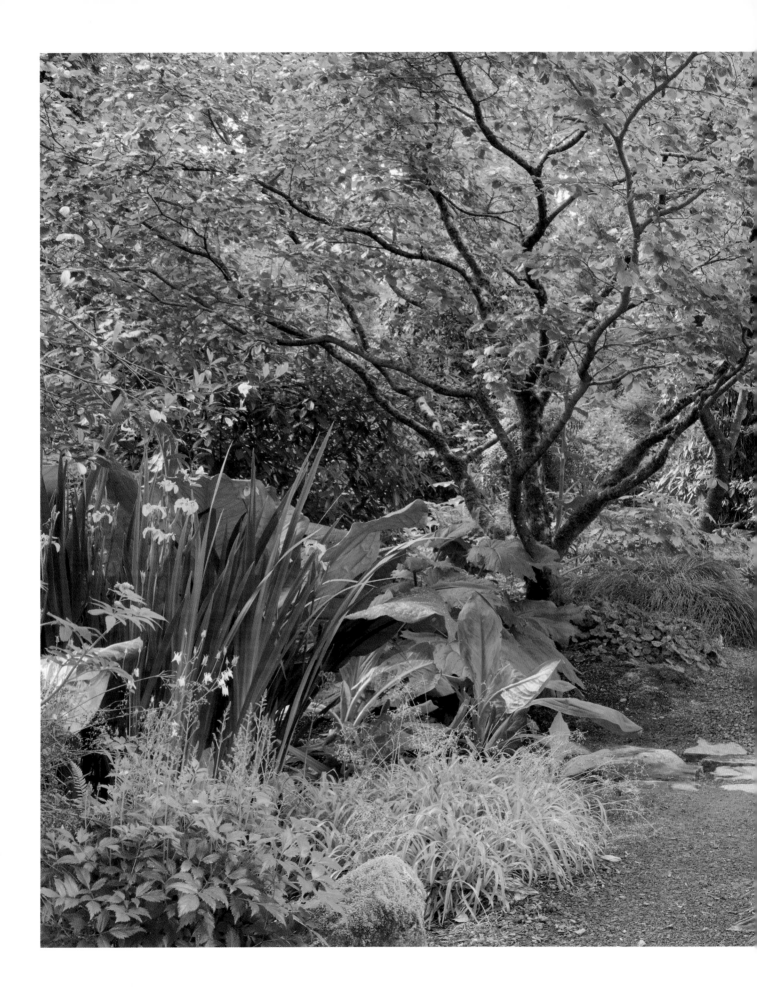

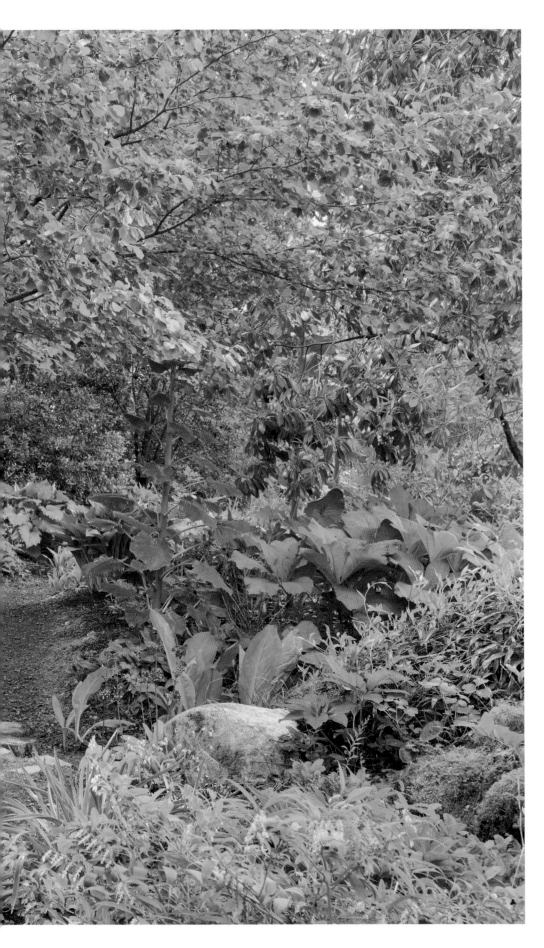

← Looking down a shady pathway
in the Woodland Garden, natural
stone steps lead over the upper
bog. The open vase framework of
Parrotiopsis jacquemontiana to
the left is underplanted with many
damp-loving woodland plants,
including Japanese skunk cabbage
(*Lysichiton campschatensis*), native
sedges, and Bowles' golden grass
(*Milium effusum* 'Aureum').

359

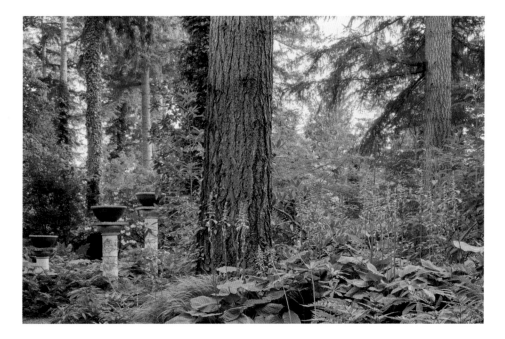

Northwest. He explains, "Our native salal was maintained, *Mahonia nervosa* was kept and encouraged, two species of huckleberry [*Vaccinium ovatum* and *Vaccinium parvifolium*], red alder and bigleaf maple, native cascara [*Frangula purshiana*], which the band-tailed pigeons relish for their fruit, and native Pacific dogwood [*Cornus*]. All of these evoke the place."

As Dan established the cultivated garden and nursery, the collection of plants grew to include trees, shrubs, vines, and perennials, along with a vast number of plants Dan collected or grew from seed from collections made throughout the world. Images of the garden and nursery's more than 10,000 species of plants and famous open days from these years are iconic and recognizable to gardeners the world over: the famous pleached hornbeam arches separating two distinct "garden rooms," the sunny potager with its boxwood-lined geometric wedge beds, the full-sun perennial borders near the house, a bog garden and other formal water features, and of course the 2.5-acre woodland garden comprised of hundreds of native and exotic woodland plants from Dan's collecting trips, all interwoven under the native conifers and deciduous under-story of *Magnolia*, *Cornus*, *Hydrangea*, *Primula*, *Podophyllum*, and *Arisaema*.

All of the region's lowland conifers are represented in the garden's primarily second-growth forest, Douglas fir, western red cedar, grand fir, western hemlock, and Sitka spruce. Dan says the current garden is lucky to have maturing cedars. "They are becoming a respectable size and are beginning to evoke what it must have been like a hundred twenty-five years ago, how extraordinary it must have been, before they were all clear-cut."

Today, the Port Gamble S'Klallam Foundation manages Heronswood through the support of the tribe, individual and group memberships, and donations, tours, and special events. "First and foremost, it's at the pleasure of the tribe that I am working here," explains Dan. "We are not trying to create a memorial to what Heronswood was. Now we want to showcase the tribal history. There's a growing interest in and a renaissance of Indigenous craftspeople working with plants—makers, weavers, dyers—who want to be able to gather traditional plants in traditional ways, but also to learn about the plants. If, for instance, we need to take out a red alder, we let the tribe know in advance so that we take it out at a time when the bark is best harvested for other uses. In this way, the garden carries on with the vision and message of the tribe in mind. We still add natives and exotics, but their vision leads." Educational outreach and curatorial work help tie the garden into the goals of the tribe, namely developing and hosting more classes with traditional ecological knowledge at their foundation. For instance, Heronswood has hosted a class on traditional edible and medicinal uses of plants with an instructor from the neighboring Suquamish tribe, a plant dye workshop, and a cedar weaving exhibition.

Having signifiers of place interwoven with ornamentals from elsewhere is powerful symbolism for many. As Nathan says, "Climbing hydrangeas seamlessly interweave themselves into the big conifers; that's a nice conversation between native landscape and cultivated. As you walk through the Woodland Garden, quiet little nurse logs are in almost every bed. Were they cut or did they fall twenty years ago? A hundred years? They support evergreen huckleberry and red huckleberry, salal and sword ferns. It's a subtle homage to several layers of history. I appreciate that those were left to be an integral part of the ongoing cultivation."

"Big ecological and cultural crises can feel overwhelming to respond to: pollution, habitat loss, pollinator declines," notes Nathan. "Our gardens are a direct way to interface with and meet those challenges. Heronswood's current direction is one example of how gardening can be an act of reconciliation and a declaration of love for the land, even in small ways. We aim to alleviate some of those pressures for people by helping them think about water quality, water use, water conservation; providing and leaving plants and flowers for pollinators; leaving spent seed heads for wildlife."

Nathan adds, "Gardens are not islands. There is a responsibility to being part of the whole, but also joy and beauty. As gardeners we have the opportunity to invite people in and be that gateway to plants, landscapes, and cultures all around them."

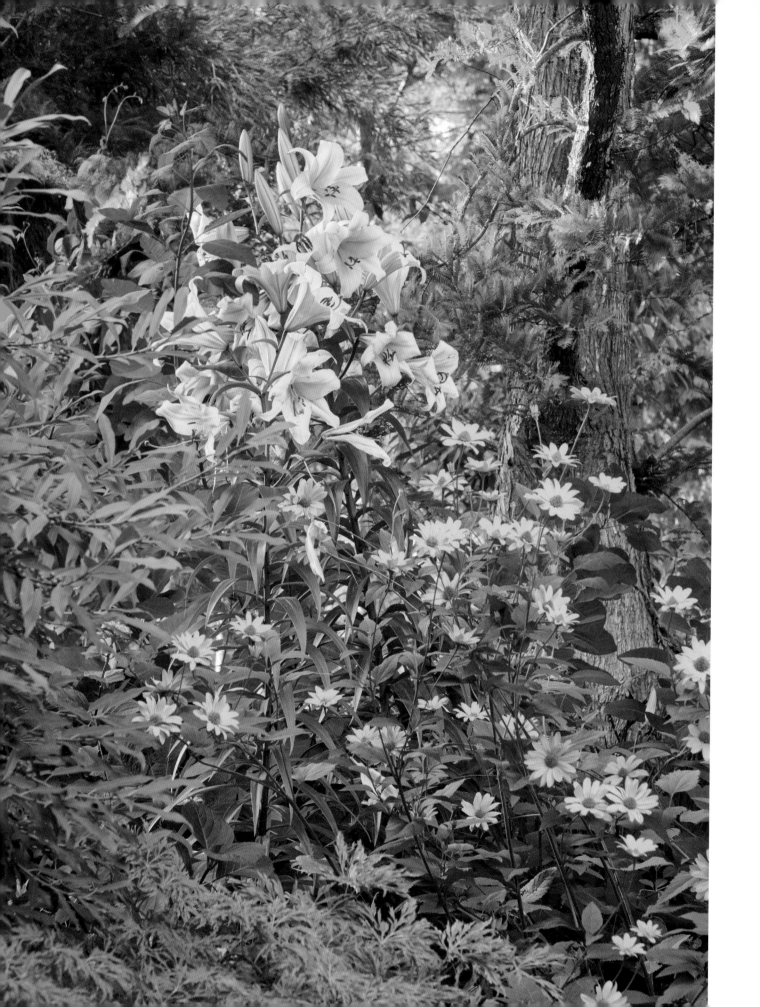

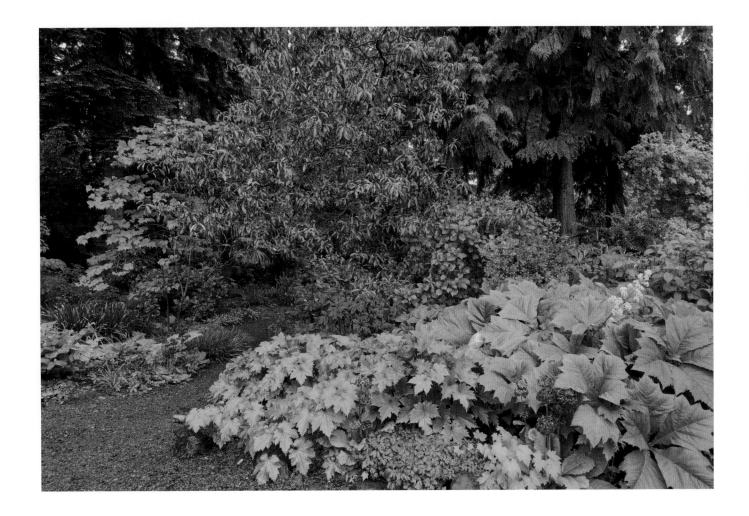

↑ In Heronswood's Woodland Garden, the bold foliage of *Rodgersia podophylla* 'Rotlaub' stands out next to the low-growing *Actaea japonica*. Red *Primula japonica* blooms in front between the showy leaves.

→ In the Blue Border, backed by a hedge planting of *Cupressus macrocarpa* 'Lutea', *Hakonechloa macra* 'Aureola' alternates with *Geranium* 'Rozanne', *Lilium* 'Conca d'Or', and *Symphytum ×uplandicum* 'Variegatum'. The taller blue blooms of *Buddleia* 'Lochinch' extend the color upward.

← In the perimeter planting of the potager is a lovely grouping of yellow *Heliopsis helianthoides* and creamy trumpets of *Lilium* 'Honeymoon'. *Acer japonicum* 'Green Cascade' is visible in the foreground.

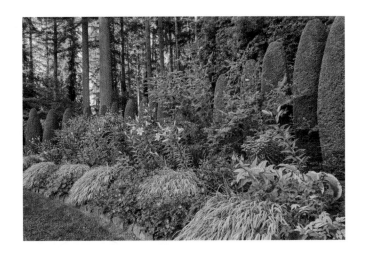

URBAN HABITAT

MANDA GALBRAITH

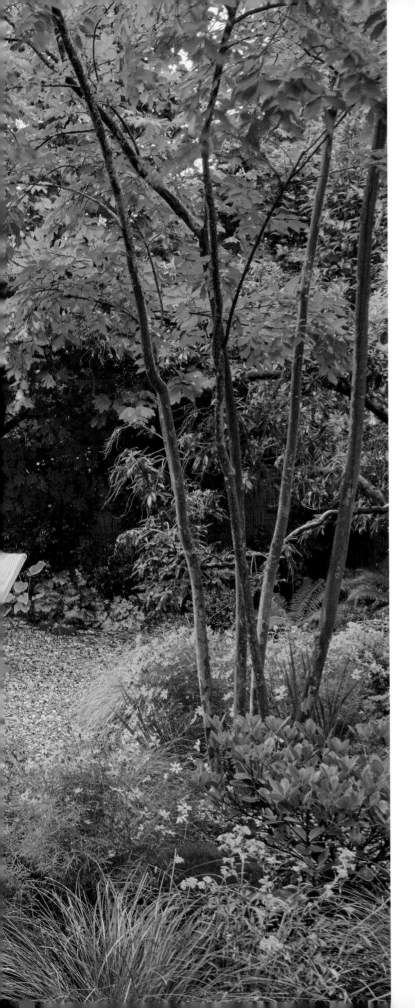

The Place

Seattle is the largest metropolitan area in the Pacific Northwest, with a population just under 4 million. Downtown Seattle is separated from the neighborhoods of North Seattle by an inland waterway, the Fremont Cut, which connects Lake Washington to Lake Union and ultimately flows out to Elliott Bay, on the city's western edge. Lakes carved out by glaciers dot North Seattle neighborhoods and provide habitat for residual wetland plants. The area is also home to outposts of Douglas fir (*Pseudotsuga menziesii*) and western red cedar (*Thuja plicata*) forest.

Indigenous peoples have been living in the area for close to 4000 years, according to archeological records. European contact began in the mid-1700s, and European settlement of the area was well established by the 1850s. Seattle was named in honor of the chief of the Suquamish and Duwamish peoples. For gardeners in this zone 8 region, with an average of 38 inches of rain a year, Seattle is a mecca with a mild, damp climate and highly diverse native plant palette, drawing an international population of plantspeople, plant selections, and a diversity of cultural garden styles.

The Person

For Manda Galbraith, conifer-covered mountains capture the natural beauty of her place in its most essential embodiment. She was born and raised in the Bay Area, and she laughingly "blames" her mother's contagious enthusiasm for gardening as having created her own love of the work and the garden world. In her teens, her family moved to Bellingham, Washington, and as an adult she moved to nearby Seattle, where she has stayed.

Manda trained and worked as a therapist with special needs children for many years. She loved the work, but it was a stressful job. She has always turned to gardening as a source of relaxation, enjoyment, and creativity and to find a needed personal connection to nature. "The more connections we make between people, plants, and wildlife, the better," she says. When a friend photographed her garden and submitted it to a garden magazine in 2015, the positive response it garnered encouraged her to move in the garden design direction professionally. After the idea took hold, she took classes in horticulture and landscape design in Seattle, and it "all just clicked." Her business, Flora & Bee Garden Design, focuses on making organic urban gardens as oases for people and urban wildlife.

The Plants

The mature cedar trees first attracted Manda to the lot that contains her house. The overlap between therapeutic modalities of her first career and her work as a garden designer are important threads in her life—as she sees it, gardens are their own form of therapy—on human and environmental scales. "Western red cedars are failing as the conditions here morph due to urban development and climate change. Those cedars anchor the entire garden, so I let other plants and combinations I see on hikes in the bigger landscape inspire how I design the rest of the space," she says. "My desire is to support the trees with other like-climate plants, to create a place that circles back and echoes what I love about where we live: the beautiful, lush green." Gardening for wildlife and creating good drainage and supportive conditions to care for the cedars were the driving forces behind this garden.

The home's previous owner had worked for the U.S. Forest Service, and "he definitely had an appreciation for native plants, the cedars, vine maples, deciduous huckleberry [*Vaccinium*], so there were some other good bones in the plantings to work with from the outset as well." While Manda feels that "we should be looking at planting more trees whenever we can," she also feels lucky to have "edges with sun where flowers want to be, and habitat space for pollinating insects and birds." Urban wildlife is a big impetus for Manda in her plant choices and garden design as well. She added evergreen understory plants to support year-round habitat, such as manzanita and

PREVIOUS PAGES: Designer Manda Galbraith's home garden in North Seattle features a relaxed seating and fire pit space, surrounded by loose woodland plantings. Flowering perennials include *Coreopsis verticillata* 'Zagreb', Big Bang™ *Coreopsis* 'Star Cluster', *Echinacea* 'Flame Thrower', and orange sedge (*Carex testacea*), as well as understory shrubs *Vaccinium erythrinum* and *Camellia sinensis*. The overstory includes an old plum tree at the entry, western red cedar (*Thuja plicata*) in the far corner, and the open trunks of *Lagerstroemia* 'Natchez' to the far right.

→ The streetside entrance to Manda's home garden is sheltered by an old European plum, which she thinks is *Prunus domestica* 'Yellow Egg'. She and her husband, Zach, designed and constructed the horizontal corten steel fencing that embraces a pot of maidenhair fern (*Adiantum pedatum*) and grassy sweet flag (*Acorus gramineus* 'Ogon').

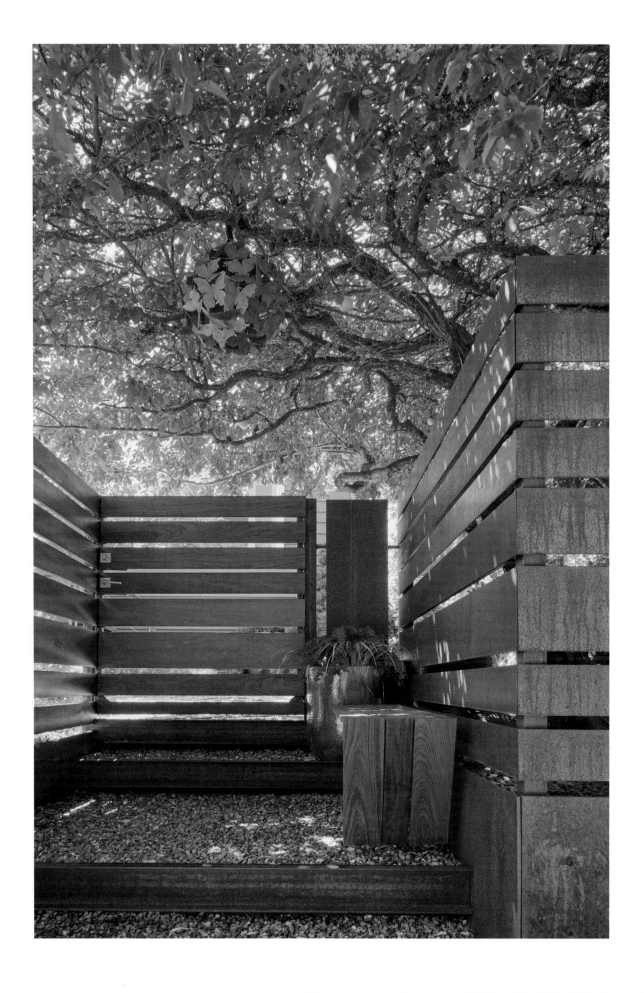

A potted *Acer palmatum*
'Amber Ghost' grows along
the north wall of the garage.
Around the base of the pot,
moonlight Chinese fairy bells
(*Epimedium ×versicolor*)
spread. A groundcover of
Sedum makinoi 'Ogon' stands
out brightly under *Astilbe chin-
ensis* 'Diamonds and Pearls'.

In a shady private spot tucked
into a corner of the front yard,
Coreopsis verticillata 'Zagreb'
and Big Bang™ *Coreopsis* 'Star
Cluster' bloom below, while
intermingling stems of *Cornus*
'Hedgerow Gold', *Vaccinium
erythrinum*, and *Camellia sin-
ensis* lean in from the left.

The sheltered, narrow walk
on the north side of house is
planted with *Heuchera* 'Lemon
Lime' on both sides beneath a
native deciduous huckleberry
(*Vaccinium*) on the left. On
the right, heuchera and the
strappy leaves of *Iris foetidis-
sima* intermingle with glass
flames by local artist Jesse
Kelly, with *Chamaecyparis
obtusa* 'Gracilis' behind.

At the corner of the front
garden, wallflower (*Erysimum*
'Apricot Twist'), *Echinacea*
'Flame Thrower', and orange
sedge (*Carex testacea*) grow
beneath *Camellia sinensis* and
Arbutus unedo 'Compacta'.

bunch grasses. Then she moved out to the edges to add drought-tolerant flowering perennials and wildflowers.

Manda's house is positioned halfway into the 10,000 square foot urban lot, mean-ing there's room for both front and back garden areas. The cedars reign over the front entrance, intermingling with a sculpturally branching old plum tree and other smaller understory trees and shrubs. Manda started with the front garden, enhanc-ing and articulating the open seating area around and beneath the cedars. She chose corten steel for a horizontal-slat fence because its rusty color pairs well with the red cedar bark. Her husband, Zach Galbraith, who is in charge of the hardscape in the garden and who works in the machining sector, co-designed, fabricated, and installed the fence.

With her ethos for all-organic, low-carbon-footprint gardening, Manda wanted to work with as much of the existing plant palette as she could. The time it takes to establish a mature tree is not to be taken lightly, in her estimation. For instance, in the garden is a big old *Camellia japonica* with coral flowers; she sees it as "nothing fancy" and she would never have chosen it herself, but the thick foliage and nesting birds it supports each year compelled her to work with it. She also appreciates how it screens sound from the street. "So, huzzah!" Similarly, once she realized an existing and fairly large old birch tree was dead from borer beetle, she worked with an arborist friend to craft the dead tree into a snag for birds; she has incorporated the remaining white-barked wood into the landscape to decompose in place.

The fate of a dead Douglas fir in the alley was slightly different. It was too hollowed out to be safe, so Manda sliced the solid part of the remaining trunk into cross sections and laid down an organic "paving of sorts" in the gravel of the front seating area. Manda loves circles and textures as well as repurposing materials—especially rusty metal—in her design work, and these are all recurring motifs in her gardens. For example, old metal machine gears, salvaged from Zach's shop in Georgetown, sit in conversation with the Douglas fir tree rounds as "pavers" in the front garden.

"This is not a demanding garden to maintain," Manda confirms. She spends less than one hour a week in the growing season—not including walking with her cof-fee through the garden each morning to check in with it and sitting in the garden listening to the birds. She uses arborists' chips for pathways, and she lets seasonal clippings and biomass compost in place, including a big brush pile that she keeps covered under the trees behind the water-feature pots in the front garden, saying that "it supports a lot of bird activity!"

Our gardens are crucibles for lessons on adaptation. Western gardeners have always lived with big scale, wind, fire, and drought, but there are ways to garden respectfully and beautifully with these elements. One issue Manda has been thinking a lot about recently is the issue of natives versus nonnatives in supplementing a garden. "There's

a portion of the garden world who look to natives to solve all of our problems," she says. However, in observing the current changes to our ecosystems, Manda believes in looking judiciously to all of our options with an open mind. She is careful to make sure she is never using noxious weeds, yet she is simultaneously interested in experimenting with the tough new plants being introduced all the time. Manda feels that anything is fair game if it will not cause problems, is "happy in our climate, and can provide habitat, food, and beauty."

→ Manda sited the trunk of a dead common European birch (*Betula pendula*) from elsewhere to use here as a snag behind a western red cedar (*Thuja plicata*) in the front garden. The bright yellow to the left is *Robinia pseudoacacia* 'Frisia'.

← Along lengths of old telephone poles Manda used to frame the entry stairs, native salal (*Gaultheria shallon*) and native mahonia (*Berberis*) hold the bank.

KITSAP PENINSULA GARDEN

NANCY HECKLER

The Place

West of Seattle, across the cold depths of Puget Sound, lies the Kitsap Peninsula. On the southern edge of one of the peninsula's many jutting contours is the small town of Indianola. Much of the northern end of the Kitsap Peninsula, including Indianola, is on tribal land belonging to the Suquamish nation, part of the Coast Salish. The Suquamish are famed for their fishery management, canoe building, waterproof cedar basketry, and wool weaving.

Protected by the Cascade Range to the east, the Olympic Mountains to the west, and the tempering effect of the water, Indianola and much of the Kitsap Peninsula has a moderate climate in USDA zones 7–8. Thick, tall Douglas fir (*Pseudotsuga menziesii*) and western red cedar (*Thuja plicata*) forests, with a dense understory of salal (*Gaultheria shallon*), mahonia (*Mahonia nervosa*), evergreen huckleberry (*Vaccinium ovatum*), and ferns, thrive with 42 inches of rain annually.

The Person

Artist, lamp maker, and home gardener Nancy Heckler loves the Pacific Northwest. She grew up in Illinois, and she "hated the Midwest for its flatness, its lack of big trees, mountains, or ocean." Her mother gardened, albeit "in a Midwest kind of way—rows of zinnias and a kidney-shaped bed in the back yard." After a few years living in Chicago, she moved west and eventually settled in Seattle, where she and her then-husband, artist Terry Heckler, bought a house and created a small urban garden.

She and Terry eventually discovered a run-down 1925 farmhouse and barn with beautiful but overgrown acreage on the western side of Kitsap Peninsula, on the Hood Canal, which they dubbed Oyster Point. Nancy worked full-time there for over a decade. "It was a dream, a waterfront farm." She created a potager, orchard, rose garden, woodland garden, and grotto. Oyster Point soon became a destination for traveling gardeners visiting Dan Hinkley's nearby Heronswood. After Martha Stewart featured Nancy and her garden in print and on television, "There were tours all the time. It was fun, but also a little nuts. I had to be ready for visitors all the time, and I worked at it all day, every day."

Following a few years of personal upheaval, Nancy moved on from Oyster Point. In 2007, she found land and a 1934 summer cabin for sale on a posting in the Indianola general store. "It had great bones, and a magical feeling." She made an offer the same day she saw the posting, and then she took her time winterizing and renovating the house over the next few years.

After moving in, she found her creative gardening head and heart were not yet in the new place—she was still attached to what the Oyster Point garden had been. With such a different feel and scale, it took her a while to decide what the new space's garden should be. By 2009, with the house complete, her lamp studios operational in the outbuildings, and a fence in place around the perimeter of the lot for her two dogs, Niki and Blue, she started to have glimmers of what kind of garden she could create within the embrace of the surrounding big trees. "Not the same garden as I once had, but one that sparked a new kind of interest."

The Plants

The trees spoke to her and provided fresh inspiration. "I think of my garden as embellished woods. I have added plants that I love. They are not native per se, but they are not too removed from what is here and wants to be here," she says. For instance, Nancy has not planted native rhododendrons but lots of their relatives from other parts of the world. "We used to call cultivars that were relatives of natives, like the mahonia cultivars, 'near natives,'" she adds.

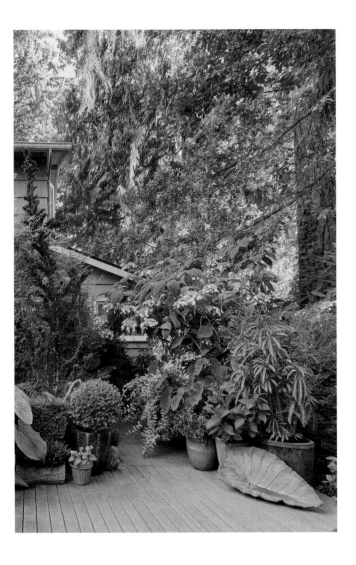

↑ Nancy loves using containers throughout the garden to add space and height differences. "They are like punctuation marks around the garden," she says. The potted collection on her deck includes *Hydrangea aspera* (top far left), *Begonia luxurians* (near left), *Fuchsia*, pruned boxwood (*Buxus*), *Hosta*, and elephant ear-like *Begonia* 'Gene Daniels', which reaches 5 feet tall.

↑ Nancy has many perennial and permanent container plantings in the garden, including these featuring miniature marigolds (*Tagetes signata* 'Lemon Gem' and 'Tangerine Gem'), black mondo grass (*Ophiopogon planiscapus* 'Nigrescens'), *Hydrangea macrophylla* 'Sol' (at center), and two variegated boxwood (*Buxus sempervirens* 'Variegata').

Nancy started by removing overgrowth and limbing up some of the surrounding big trees to create planting space below. "The Doug firs, the vine maples, and the western red cedars have all been buffed up. When they're cleaned up like that, you get to enjoy the gnarled trunks," she points out. "The Doug firs *want* to shed their lower limbs, but the branches of the western red cedar naturally swoop down," and she is glad to have enough space in her garden to let them do this in a few places. "They will frequently tip-root where their branches touch the ground. It's so interesting to see them propagate and colonize that way."

"My garden here gives me a sense of being nestled around the house, which is in turn nestled into the woods around us," Nancy says. The highest compliment from a garden visitor is when they say "the garden feels peaceful and relaxing." Nancy kept the preexisting small open lawn because her dogs loved it, and it gave "visual relief and pause" from otherwise dense plantings. Next she "felt her way" to where paths wanted to go. She could see that she wanted to walk around a certain tree and be able "to enjoy its personality from all aspects," for example, and then she could envision how "big hydrangeas wanted to flop up against the gnarly trunk. I love that merging of things together." The pathways meandering around the garden now create a greater sense of space and add planting and focal point opportunities for Nancy's many containers—about 150 at last count—which are mostly perennial/permanent plantings.

This woodland garden has deepened Nancy's love of "foliage, texture, and the many shades and textures of green," especially the brighter greens that light up and glow against the darker tall conifer background and its native salal (*Gaultheria shallon*) and mahonia understory. And ferns, Nancy notes, "work well in pots, are good ground covers, and are so textural." She is also taken with "big-leaved species of rhododendrons with the fuzzy indumentum under the leaves. And begonias! They are a huge passion." Add to those Nancy's many *Podophyllum*, *Paeonia*, *Rodgersia*, and *Philadelphus*. Although the limey *Philadelphus* take up too much room in the relatively small space, she cannot resist the way they brighten the woodland shade. She also has more than eighty kinds of hydrangea and keeps adding more.

Nancy is in the garden every day and has regular seasonal help. Her largest maintenance tasks include watering the main garden in the dry summer periods and watering the many pots. She is a "religious mulcher" in order to maintain soil moisture and temperature and keep weeds down. Starting in November as plants begin to drop their leaves, she begins cutting back and mulching with a fine mixture of "local organic compost, sand, and ground-up bark." She fertilizes her containers, but the mulch feeds the in-ground plantings. In the spring, a multitude of pruning tasks with all the woody shrubs are a priority.

The garden is characterized by generous plantings as well as a good deal of garden art, much of which is designed to make Nancy smile. "You can't be too serious about it all,"

← A corner of the path leading through to the back garden features a Pistachio™ hydrangea (*Hydrangea macrophylla* 'Horwack') on the left. In the center, a perennial nasturtium (*Tropaeolum speciosum*) climbs through the large purple blooms of *Hydrangea aspera* 'Sam MacDonald'.

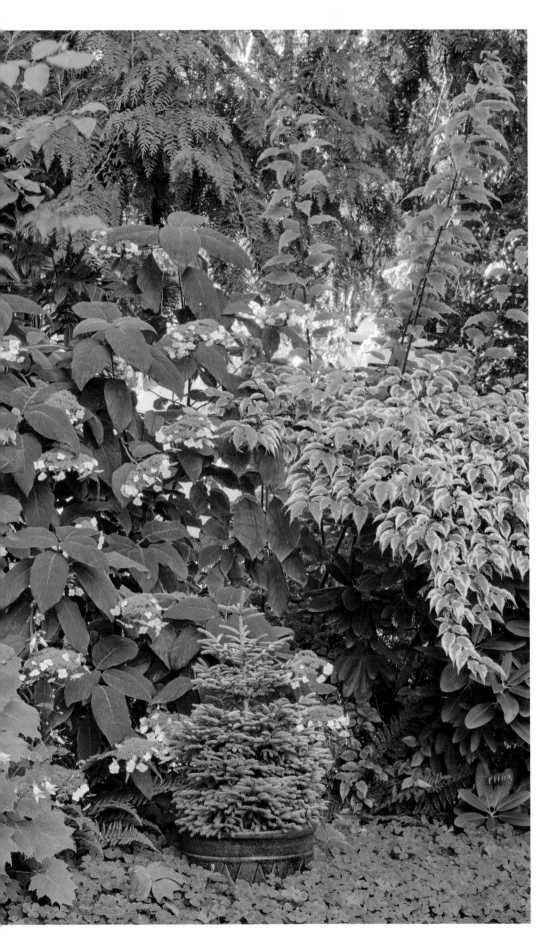

← A grouping within the western border around the back great lawn includes yellow wax bells (*Kirengeshoma palmata*), *Hydrangea aspera*, which has fuzzy leaves, and black-stemmed *Hydrangea macrophylla* 'Zorro'. Both conifers are potted.

she advises. Visitors come across vintage concrete frogs and mushrooms and antique fishing floats, but also moments like the upright Indianola beach driftwood tent around the base of a big cedar, which is a memento of her now-passed border collie, Niki, "who got in the habit of chasing squirrels up into cedar trees." Nancy smiles, thinking of her dog, every time she passes the artistic, protective barrier lovingly placed so that dog, squirrels, and tree could all live happily here.

↑ Accompanying Nancy's powder-coated and repurposed phonograph horn, ferns and *Epimedium* grow to the left, *Hydrangea aspera* 'Sam MacDonald' is overhead, and just along the path martagon lilies (*Lilium martagon*) are just fin-ished blooming in this dense and very textural planting.

↑ Exotically large tree peonies are on either side of this cob-ble garden path, underplanted with *Podophyllum pleianthum × versipelle* on the left. A small white *Hydrangea serrata* 'Shirofuji' blooms nearby. Holly-leaved variegated *Osmanthus heterophyllus* 'Goshiki' drapes down at front left.

→ At lower right, the grass *Hakonechloa macra* and cypress (*Cupressus macrocarpa*) are in pots on the corner of Nancy's deck. In the distance is *Cornus sericea* 'Hedgerows Gold'; to the right a climbing hydrangea makes its way into the native cedars, and right of that a *Clerodendrum* marks the start of a woodland path.

COUGAR ANNIE'S GARDEN AT BOAT BASIN

PETER BUCKLAND

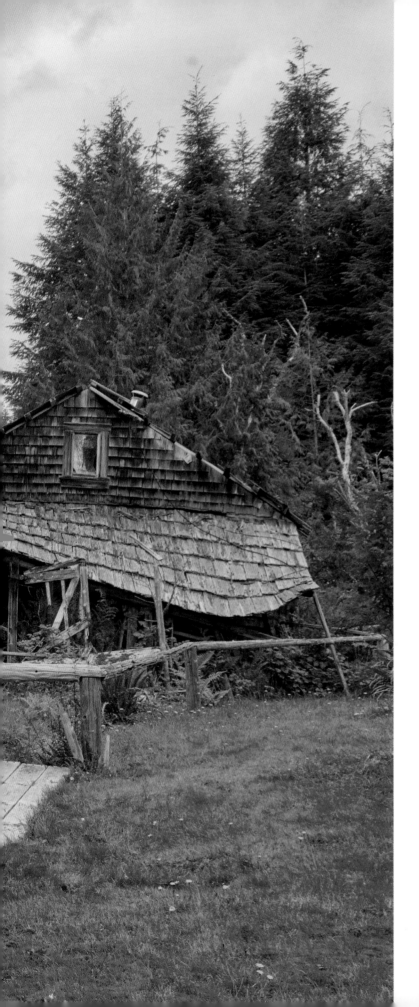

The Place

Geologically, much of what makes up Vancouver Island originated millions of years ago from volcanic activity south of the equator. Over eons, the land slowly drifted northward and eventually crashed into North America and then broke off again to its current position, separated from the mainland by the Strait of Georgia and Queen Charlotte Strait. This geology—along with its immense size, at 290 miles long and 62 miles wide—has contributed to the hydrology and soil conditions on the island over millennia.

Evidence suggests that people have lived on the island for more than 10,000 years, and its more recent history includes First Nations peoples and Indigenous cultures of the Kwakwaka'wakw, Nuu-chah-nulth, and Coast Salish. About halfway up Vancouver Island's rugged west coast is the Clayoquot Sound. Along the sound and just a few fjord-like inlets north of the town of Tofino is Hesquiat Harbour. The land all along Clayoquot Sound is the traditional homeland of the Hesquiaht First Nation, the most northerly of the Indigenous Nuu-chah-nulth cultures. In January 2000, Clayoquot Sound was designated for inclusion in UNESCO's World Network of Biosphere Reserves.

Along the inner north shore of Hesquiat Harbour on a landing beach known as Boat Basin, an early 1900s homesteader known as Cougar Annie carved out a temperate rain forest garden. Today, getting to Boat Basin and Cougar Annie's garden is most practically accomplished by flying in by floatplane and landing in Hesquiat Harbour. Or you can arrive more slowly by boat, as Annie did. The boat service along the coast, arriving at Hesquiat Harbour every ten days with passengers, goods, and mail, is what allowed Annie to craft the life, garden, and garden-based business that she did. Arriving by air now, though, allows for taking in the immensity of water and vast stretches of old-growth cedar and second-growth hemlock and balsam forest covering the mountainous wilderness over much of northwestern Vancouver Island.

The People

In 1915, Ada Annie and William Rae-Arthur moved to Boat Basin at the top of Hesquiat Harbour on the west coast of Vancouver Island as homesteaders with a young family. Ada Annie's nickname, Cougar Annie, is attributed to the many cougars she shot as part of her homesteader's life.

Cougar Annie and the first of her four husbands, Willie, removed themselves from city life in Vancouver due to his addiction to opium and subsequent near financial ruin. By the early 1920s, when the Rae-Arthurs had finally earned their deed for the land from the government, she had established fruit trees and was selling them along with other plants as nursery stock. During her almost seventy years of working the land at Boat Basin, Cougar Annie created—almost completely through her own sheer force of will and physical labor—a working and ornamental garden to feed herself and her family (along with chickens, goats, and rabbits), a produce garden for the regional market, and a mail-order plant nursery.

In her day, the cultivated garden comprised about 5 acres of the 117 acres of rain forest she and her husband were deeded. According to *Cougar Annie's Garden* by Margaret Horsfield, Annie "trapped and shot well over fifty cougars and black bears, first as a means of defense and eventually for a bounty offered by the Province of British Columbia. She gave birth to eight more children [for a total of eleven], ran a general store and post office, hand-cleared five acres of bush to grow gardens and run a small farm."

Peter Buckland, an investment broker and amateur prospector, first met Annie in 1968 on a prospecting visit to the area. Born in Montreal and raised in Vancouver, Peter would often accompany his father, a geologist, on wilderness trips throughout the island,

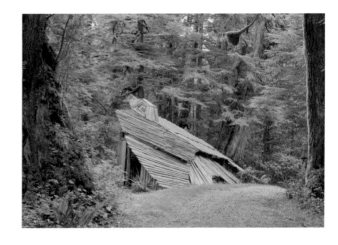

Cougar Annie's circa 1915 homestead cabin eases back into the landscape, with remnants of her once active home and commercial garden carved out of the vigorous temperate rain forest still evident

→ Peter's hand-planed boardwalk over a boggy area along what was once Cougar Annie's trap line, with the massive trunk of dead cedar to the right standing among young hemlock (*Tsuga heterophylla*) coming along.

↓ Between the landing beach and Cougar Annie's homestead farther inland, Peter's hand-built Eagle Wood Shed sits atmospherically among mature western red cedar (*Thuja plicata*) from which the building is constructed.

↑ Farther along the boardwalk along Annie's trap line trail, native lodgepole pine (*Pinus contorta*) grow stunted in the low-nutrient boggy conditions.

← A small hand-crafted boardwalk and chair create a destination near the Memorial Garden.

← CLOCKWISE FROM TOP
LEFT: Peter Buckland moved
this dead tree trunk from the
upper lake on the property
and inverted it into the ground
here as a memorial sculpture
looking toward Annie's house
beyond.

A native *Rhododendron* grows
to the left of Peter's hand-built
Shinto gates.

Peter designated this seat
he formed in an old "canoe
stump" red cedar as "the
Thomas Merton Center for
Contemplative Thinking."

The cedar Shake Shack
designed and built by Peter is
set among native alder (*Alnus
rubra*).

and he came to know the area around Tofino quite well. In 1968 he was on a trip with
an old family friend who had a cabin near Cougar Annie's. He remembers, "She was
around eighty at the time, eking out a living on the land and still running her nursery
business with the help of her son Tommy." Peter was taken by her grit, her love for her
garden, and the beauty of the land. After their first meeting, Peter visited Annie close
to once a month for the next fifteen years.

By the late 1940s, as her grown children began to leave, Annie's garden started to
slowly recede and blur back into the thick overgrowth of the wild. By the time Peter
met Annie, the garden was already in need of a lot more care if it was going to survive
in any form, a need that only increased in Annie's final years. In 1979, he recalls, "She
really started to work me over to buy the place." He purchased the land in 1981, with
provisions for her to continue to live and garden there until she died, even helping
to arrange and pay for caregivers for her in her final years. Against Annie's will, her
children moved her from her garden to Vancouver in 1983. She died two years later,
just shy of her ninety-seventh birthday.

Peter ultimately decided to try to take on the garden's recovery. In 1987, he moved
to Boat Basin, building his own house near the beach. With a chainsaw in hand, he
began the process of reestablishing pathways and marking Annie's surviving garden
plants from the native vegetation. He started what was initially a reclamation, but it
evolved into a garden story within a story within a story.

"There's hardly a person in the world who wouldn't call everything here beautiful;
the interface of the land and ocean. . . . Nature here is at one of its most extremes.
The garden is itself an oasis in the midst of the rain forest," Peter enthuses. "There
are layers of visible cultural history in and around the garden. For thousands of years,
Native peoples would cut down big cedars to craft their canoes from the lowest,
straightest, unknotted section of the tree from the base to the first branches. All
around Annie's garden, you see not just signs of *her* cultivation but historic signs
like these canoe stumps that are indicative of this longer dialogue between humans,
nature, and time."

Peter has now dedicated more than fifty-two years of his life, the last thirty-three full
time, to Cougar Annie's garden. He reminisces, "It's a humbling experience to walk
past a twelve hundred year old standing cedar, and to uncover yet another garden
plant established here by her decades ago." In this process, he says, "You see what
gardens stand for. It's important to realize that gardens do not often survive. The
ongoing dialogue is a constant give and take between nature and cultivation."

In the late 1990s, on behalf of the Boat Basin Foundation, Peter designed and oversaw
the creation of the Temperate Rainforest Field Study Centre, "seven cabins and a cen-
tral building on a ridge overlooking the garden and outward to the Pacific horizon."

COUGAR ANNIE'S GARDEN
AT BOAT BASIN

He established the nonprofit foundation that now owns the property through Peter's donation and has the mission of maintaining and continuing the heritage, promoting the appreciation of and education in cultural and natural history of the site, and preserving the garden.

The Plants

Sometimes gardens ask us to question what gardening means. And while all gardens are layered, few take the layering of time and space quite as actively, consciously, or literally as Cougar Annie's. The garden proper that Annie originally cleared and successfully established is on "a coastal bog, which also slopes toward the sea," Peter explains. "The water table wicks along the top of the sloping clay layer about one to one and a half feet below the surface, under sandy loam soil. Through capillary action roots of perennial plants are provided water, meaning the garden never needs watering. The surrounding ancient temperate rain forest trees turn the garden clearing into a heat sink, further promoting plant growth. Perfect soil, water, light and heat."

Annie's garden and nursery business included "everything from roses and fruit trees to shrubs and bulbs, to ferns and mosses." She brought in stock constantly. Sometimes no money would change hands, as she would exchange plants and produce from her own garden for stock from elsewhere. Stories tell of her receiving plants from as far away as Japan, Chile, and New Zealand, and sending bulbs overseas in return. She would also trade with growers in Vancouver and the Fraser Valley.

When Peter began his solo relationship with the garden, his first goal was to reestablish the most basic of the pathways. He simply began by removing the bulk of overgrowth—including invasive broom that Cougar Annie herself had planted—from the returning native plant understory. As he worked, he steadily asserted his own creative voice into the ongoing dialogue. He also uncovered more and more of what Cougar Annie had planted, with some plants appearing as if out nowhere after many years of dormancy, rebounding with the return of light and air that Peter encouraged.

Peter knew the native plants pretty well, and after a year or so of his initial "gardening" efforts, he recalls how "extensive groups of plants would start emerging. Whole plantings of hosta and lilies and things that had not had enough light under the canopy began to grow out fully for the first time in decades." *Cougar Annie's Garden* notes that by the late 1990s, "the garden still boast[ed] over 100 different species of trees and shrubs alone, representing decades of planting and experimenting and also representing what could be

→ Peter constructed this epic elevated wooden walkway out of hand-split cedar to link the historic garden below to the newer Boat Basin study center above. It extends 600 meters (approximately 1950 feet), rising and falling with the land.

↓ Along a trail near the back of Cougar Annie's garden, an old scented *Azalea* in fall color was underplanted by Annie with nonnative heather (*Calluna vulgaris*).

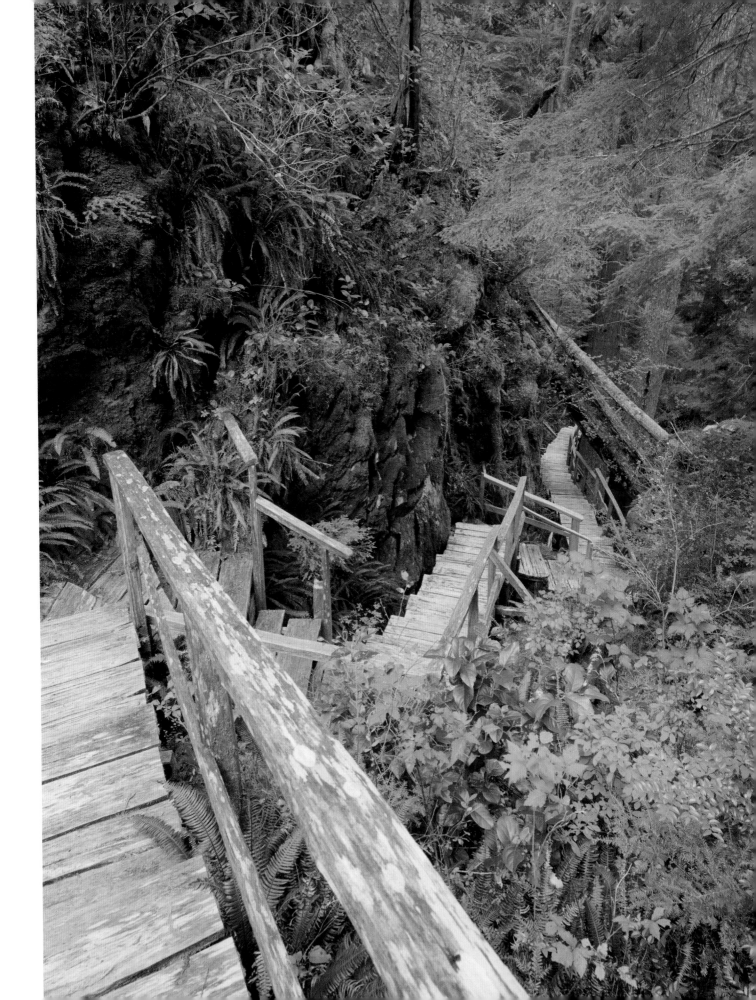

the earliest known introduction of some ornamental species on the coast. Among the trees she planted were linden, black locust, and English chestnut, a red-veined *Enkianthus*, a huge *Liriodendron*—now perhaps one of the oldest and largest of its kind in [British Columbia]—not to mention many varieties of ornamental cherry, crab-apple, plum, and dozens of other fruit trees."

Cougar Annie also sold bulbs: lilies, peonies, iris, montbretia, narcissus, gladioli, and most especially dahlias. Plant tags remaining on site apparently gave an indication of some of the more than 200 different varieties she grew and sold. While the peonies and dahlias did not survive, "Irises, daylilies and other perennials, as well as the rhododendrons and azaleas and countless flowering shrubs not only bloom, they go from strength to strength," Peter affirms.

Fairly early on, Peter developed a plan to restore the whole garden by first apportioning it into quadrants. He then worked his way into the center on his grass and moss or artistic handcrafted boardwalk pathways. "I've cleared over two kilometers [1.2 miles] of trails and made over seven hundred meters [2300 feet] of hand-split cedar plank walkways through the native bush and trees, with destination focal points created out of her recovered plantings, blending in the salal and fern hedging." Most of the wood for his construction projects comes from gleaning logging leftovers, logs washing up onto the beach, and windfall in the surrounding forest. From hand-milling these trees into 29-foot lengths, he has created two long boardwalk trails through the forest around the garden: a Walk of the Ancients through old-growth trees and another called Annie's Trap Line, which follows Annie's original trap lines. Another long, remarkable uphill shake boardwalk trail, with ingenious stairways, "links the Field Study Centre and Rae Lake to the garden." On the latter, visitors walk through or by some of Peter's creative constructions, such as the Shake Shack and Annie's Museum, a small building for material possessions salvaged from Cougar Annie's house.

While Peter has added more than sixty wooden construction projects to the land, he has introduced no new plants into the garden. "The remainder of the plants culti-vated by Annie have to live off their own wits." Now nearing his eighties himself, Peter recently undertook what he declared his last major project, clearing a field of salal against the southern fence line, which abuts the forest. From this field, he can see "deep, deep into the enclaves of the forest." Some of these enclaves he opened with light under- and midstory pruning in order to "open long views into the forest in several locations." He calls this newest section of the garden Theatre Row, as a "front-row view into the mystery of the forest. It has great charm and depth. It's wonderful to see the pathways between the big trees, to see the lives growing up and around and through each other."

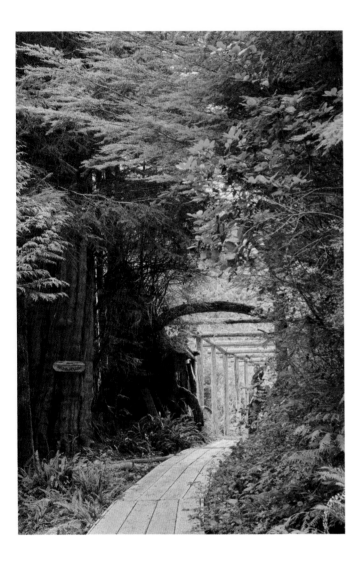

↑ At the entrance to Cougar Annie's garden, Peter built this pergola from standing dead trees (known as "gray ghosts") in the surrounding forest landscape. It gets narrower as you move through it, starting at 4 feet wide by the road to 2 feet at the end, creating the optical illusion of being longer than it is.

↑ Once cultivated *Azalea* showing fall color and now growing fully intertwined with native overgrowth.

ACKNOWLEDGMENTS

My deepest gratitude to the gardeners who opened their gardens to me and shared their visions, stories, and sometimes food and home with me. You are the soul of this book.

I could not have made this book without the research, conversations, and writing by Jennifer Jewell. I am so lucky to have you as a collaborator. I am indebted to you for the stories you've crafted and the support you've offered along the way.

Thanks to Timber Press for their continued commitment to creating garden books, and a special thank you to Stacee Gravelle Lawrence for taking this project on and working with me.

To Annamalai Nagaraj, thank you for your love and support as I abandoned you for weeks on end.

To my mother, Natalie, thank you for bringing me into the garden and the childhood spent with plants and soil.

To my dear friend and the endlessly knowledgeable horticulturist Jason Dewees, thank you for your conversations, intelligence, insights, plant knowledge, and general kindness. You are invaluable.

Thanks to all of the people who helped connect me to gardens and gardeners along the way: Mary Ann Newcomer, Johanna Silver, Janet Davis, and Matt Ritter.

To my friend and mentor, Marion Brenner, thank you for the years of support and for showing me the way with good humor, warmth, and endless energy.

Without the push from Flora Grubb, I would never have started taking pictures of gardens. I am eternally grateful.

And finally to the land, it is my anchor, the guiding force behind this project, and our future. May we continue to work toward change, grow, and sustain this beautiful place.

—*Caitlin Atkinson*

I was born and raised on Colorado's Front Range to a gardener mother and wildlife biologist father. I have lived and gardened in, traveled extensively around, and/or have gardening family in Washington, Oregon, California, Idaho, Wyoming, Colorado, New Mexico, and Arizona. The bioregions of the American West—their native plants, associated fauna, watersheds and geology, climates and cultures—are of inherent interest to me.

When Caitlin Atkinson and Timber Press editor Stacee Lawrence approached me about collaborating with Caitlin on her concept for a collective portrait of contemporary gardens and gardeners around the American West, I knew I was in. I am deeply grateful to them both for the invitation and opportunity to dive into these gardens, gardeners' stories, and Western places. Set to the beautiful tone of Caitlin's evocative and insightful photography, which melds beauty with meaning, it has been a wonderful adventure in plants, people, and places.

There would be no book in your hands without these gardeners whom I now consider friends, without the plant growers and nurseries, botanic gardens and museums, botanists and researchers whose hearts and hands are in the metaphoric and literal work of cultivating healthy soil here in the West—working to improve the integration and interrelationship between the gardens we grow and these remarkable places (physical and cultural) we call home. Every one of these gardens taught me something. And every one of them reiterated to me that as intentional, informed, thoughtful gardeners, we need (and want) to know and be good citizens of exactly where we are. All the species of this great planet need this from us as well. These gardeners are each doing that epic, daily work. Any failure of information or imaginative scope is mine alone.

I am as ever grateful to my sisters, Sabrina and Flora; my daughters, Delaney and Flannery; my father and stepmother, Sam and Isabel; my Aunt Diana; my cousin Linda; and my many friends (especially Mary Ginno, Lorene Edwards Forkner, Loree Bohl, Julie Nelson, and Nancy Bultema), who were patient, kind, supportive, and encouraging throughout this process. You kept me going.

As with my first book, great credit to my cousin Sheila Blackford Bloor who was again pre-editor of every profile—nudging me along, firmly and kindly. Bless you, cousin. Thank you as well to Lisa Brousseau for the thoughtful final copyediting.

If my mother and father were the gardeners and naturalists who first grew me, my partner, plantsman John Whittlesey, is the gardener who has grown me the most these past few years by introducing me to more and more plants and places of California and their relational intelligences and lives. He has given me the gift of a tremendous education in *love*, *presence*, and *place*.

—*Jennifer Jewell*

PROFILED FIRMS *and* PUBLIC GARDENS

Academy for the Love of Learning
Santa Fe, New Mexico
aloveoflearning.org

At Soil Level/Jim Martinez
Marfa, Texas
atsoillevel.com

California Scenario
South Coast Plaza, Costa Mesa, California
southcoastplaza.com/stories/2016/12/noguchi-garden

The Capri
Marfa, Texas
432-729-1984

Catto Shaw Foundation
Denver, Colorado
cattoshawfoundation.org

Chumash Indian Museum
Thousand Oaks, California
chumashmuseum.org

Colwell Shelor
Phoenix, Arizona
colwellshelor.com

Contained Exuberance/Hyland Garden Design
Portland, Oregon
hylandgardendesign.com

Cougar Annie's Garden/Boat Basin Foundation
Tofino, Vancouver Island
boatbasin.org

Dawn Landscaping
Grass Valley, California
dawnlandscaping.com

Desert Botanical Garden
Phoenix, Arizona
dbg.org

Flora & Bee Garden Design
North Seattle, Washington
floraandbee.com

Gardens on Spring Creek
Fort Collins, Colorado
fcgov.com/gardens

Ground Studio
Monterey and St. Helena, California
groundstudio.com

Heronswood
Kingston, Washington
heronswoodgarden.org

Humble Roots Nursery
Mosier, Oregon
humblerootsnursery.com

Idaho Botanical Garden
Boise, Idaho
idahobotanicalgarden.org

Lands End Lookout
Golden Gate National Recreation Area
San Francisco, California
nps.gov/goga

Natural History Museum of Los Angeles County
Los Angeles, California
nhm.org

Pine House Edible Gardens
Oakland, California
pinehouseediblegardens.com

Radicle
Santa Fe, New Mexico
beradicle.com

Red Butte Garden
The University of Utah
Salt Lake City, Utah
redbuttegarden.org

Studio-MLA
Los Angeles and San Francisco, California
studio-mla.com

Surfacedesign, Inc.
San Francisco, California
sdisf.com

Surroundings Studio
El Paso, Texas, and Santa Fe, New Mexico
surroundings.studio

Taft Gardens and Nature Preserve
Ojai, California
taftgardens.org

Ten Eyck Landscape Architects
Austin, Texas
teneyckla.com

Terremoto Landscape
Los Angeles and San Francisco, California
terremoto.la

Thomas the Apostle Center
Cody, Wyoming
tacwyoming.org

Vine Hill Preserve
Sonoma County, California
milobaker.cnps.org/index.php/conservation/preserves/vine-hill

WaterWise Landscapes Incorporated
Albuquerque, New Mexico
waterwiselandscapesnm.com

INDEX

Published in 2021 by Timber Press, Inc.
The Haseltine Building
133 S.W. Second Avenue, Suite 450
Portland, Oregon 97204-3527
timberpress.com

Printed in China

MIX
Paper from
responsible sources
FSC® C144853

Text design by Hillary Caudle
Cover design by Vincent James

ISBN 978-1-60469-999-9

Catalog records for this book are available from the Library of
Congress and the British Library.